DRAWING & PAINTING

Alfred Noble Library 32901 Plymouth Road Livonia, MI 48150-1793 (734) 421-6600

COMPLETE BOOK OF DRAWING & PAINTING

essential skills and techniques in drawing, watercolour, oil and pastel

MIKE CHAPLIN with Diana Vowles

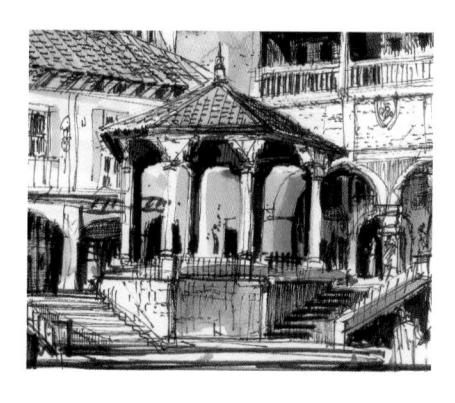

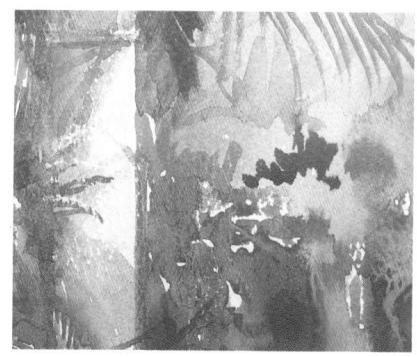

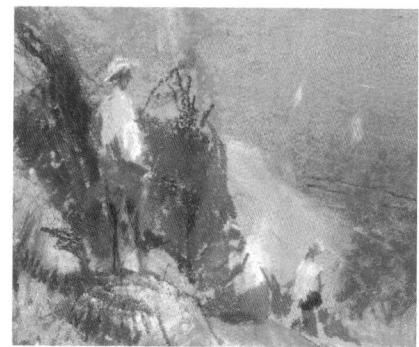

Alfred Noble Library 32901 Plymouth Road Livonia, MI 48150-1793 (734) 421-6600

Thanks to Gaynor Lloyd for the life drawings on pages 120,130,162,163, and for the Bonnard copies on page 153.

Arcturus Publishing Limited 26/27 Bickels Yard, 151–153 Bermondsey Street, London SE1 3HA

Published in association with foulsham

W. Foulsham & Co. Ltd, The Publishing House, Bennetts Close, Cippenham, Slough, Berkshire, SL1 5AP, England

ISBN 0-572-03091-6

Copyright © 2004, Mike Chaplin and Diana Vowles This edition published 2005

All rights reserved.

The Copyright Act prohibits (subject to certain very limited exceptions) the making of copies of any copyright work or of a substantial part of such a work, including the making of copies by photocopying or similar process. Written permission to make a copy or copies must therefore normally be obtained from the publisher in advance. It is advisable also to consult the publisher if in any doubt as to the legality of any copying which is to be undertaken.

Cover: Adele Morris

Design: Chris Smith and Adele Morris

3 9082 11321 1422

Printed in Malaysia

CONTENTS

Introduction	6		
DRAWING	9	PASTELS	93
Paper Drawing tools Equipment Organizing your workspace Line and how it works A sampler of marks Hard and soft Basic measuring Looking for basic shapes Negative shapes Format Tonal exercises Shadows Experimental mark-making Light on dark Midtoned paper Figures for scale and narrative Composition Perspective Texture Light sources Choosing subjects Building a vocabulary Towards painting A simple landscape A still life	10 11 12 13 14 16 17 18 20 21 22 24 25 26 28 30 31 32 34 36 37 38 40 44 46 48	Drawing tools Paper Equipment and workspace Basic marks Sketchbooks and format Colour Tone Dry pastels as a wet medium Resists and textures Organic shapes Manmade shapes Perspective Simple landscapes Still life Figures Architecture Watercolour pencils Watercolour pastels Oil pastels Charcoal A mixed media piece	94 95 96 98 100 102 104 106 108 110 112 114 116 118 120 122 124 126 128 130 132
WATERCOLOURS	51	OILS	135
Paints Brushes Paper types Equipment Organizing your workspace Putting down paint Resists Lifting off Basic colour Tone Using warm and cool colours Hard and soft marks Leaving white space Using sketchbooks Simple figures Perspective Establishing depth Composition Step-by-step: An urban scene Sky and water The seasons Exploring a landscape: Tereglio, Tuscany	52 53 54 56 57 58 62 63 64 66 68 70 72 74 76 78 80 82 84 86 88 90	Brushes and paints Supports A travel kit A studio set-up Palette layout and basic marks Sketchbooks Sketchbook studies Tone Colour Perspective Establishing space An urban landscape Still life Figures A beach landscape Light and weather The seasons Using photographs Looking for rhythms Manmade shapes Bringing it all together	136 137 138 139 140 142 144 146 148 150 152 154 158 160 164 166 168 170 171 172 173 176

INTRODUCTION

Learning to draw and paint is an exciting prospect, but many people approach it with the anxiety that they lack artistic talent. Of course, this is not given to us equally; not everyone can be on the same plane as Leonardo, Monet or Picasso. Nevertheless, it's a natural human instinct to want to make marks to record the world around us, and for proof of this you only have to look at the delight children take in

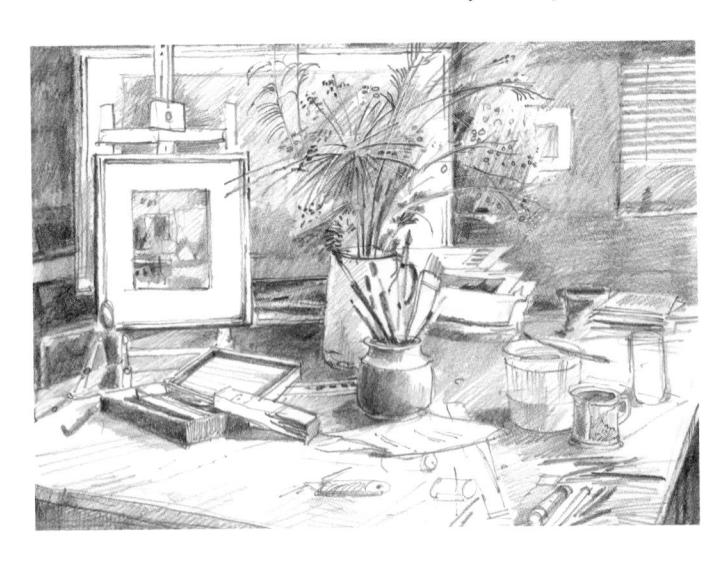

drawing. Sadly, their joy in mark-making is often lost when they begin to worry about getting things right rather than just expressing their creative urge, and this carries through to adulthood. In this book I want to help you to revisit the pleasure of mark-making for its own sake and to rediscover your creative talents.

Everyone wanting to paint needs to be able to draw to some degree. Even if you

have no wish to execute finely detailed drawings that are finished pieces of work in their own right, you will want to record subjects in your sketchbook for reference later on. As an artist, there is no lighter way to travel than with a 6B pencil and a pocket-sized sketchbook.

People are often inhibited about crossing the line from drawing to painting, but in fact it is a process that can happen almost without your realizing it. Ideally, your

sketches will have notes on tone, so that you will know how light is affecting the scene. Using a fountain pen rather than a pencil and then dissolving the line with water to give areas of tone is the first step towards painting. Adding a few watercolour pencils to your travelling kit gives you the option of adding colour to your sketches, and you will find you have crossed that barrier without anxiety.

Watercolour is an easy medium as far as equipping yourself with paint, brushes and paper goes, but it is harder to use than you might expect. The delicate luminosity which is its main characteristic is easily lost, and you cannot hide your mistakes. The main thing is to remember that every mistake has taught you something, and that your enjoyment in the process of painting is the most important thing.

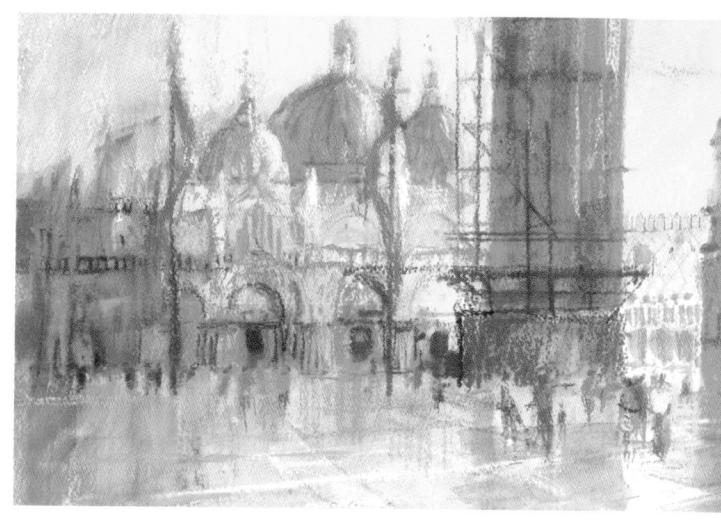

For stronger, more vibrant colours, pastels are exciting to use. Ideal for making lightning sketches of figures in movement, they are

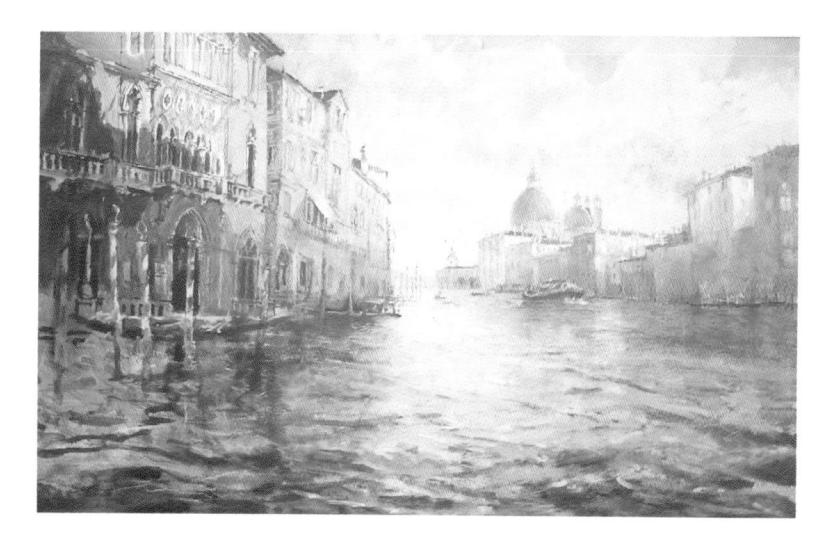

easily portable in their various forms. They also mix well with watercolours. allowing you to add texture and more intense hues. You will learn in this book how to handle them and even if they turn out not to be your favourite medium they will teach you to work with broad, bold gestures.

Oils are chosen by many artists for their strength of colour and the thick, textural surfaces that can be obtained. They are wonderfully tactile to use, and you will have the opportunity to work on a larger scale than is possible on paper and the freedom to scrape paint off the surface if you have a change of mind. They are very opposite of watercolour, and it is likely you will feel a particular affinity for one or the other.

This book aims to give you basic guidelines to help you on your way to becoming an artist. Experiment with the different media, use them together and explore their capabilities. Most of all, enjoy expressing yourself and your growing confidence will show in the quality of your work.

The ability to draw well is one of the fundamental skills of an artist, since it underpins every painting that is concerned with depicting the world in a recognizable way. Even if you deliberately choose to distort the shapes of the elements in your paintings, you should do it from a position of knowing how to draw them realistically.

Drawing is a skill, and skills can be learnt, so don't feel that you lack all talent if you find your early attempts are frustratingly poor. If you follow the advice here on how to tackle line drawing, tone, texture and other technical aspects and practise constantly to improve your hand and eye coordination, you will soon become good at drawing. Learning how to draw, and indeed how to use other media, is just a matter of performing the same simple movements over and over again until they become natural and easy.

So don't be discouraged by the mistakes you will make – they are all part of the learning process, and even if they go straight in the bin they will have been of use in teaching you what not to do. You may just want to draw sufficiently well to lay the groundwork for paintings, or you may wish to progress your drawings to the point where they are finished works of art in themselves. Whatever your eventual goal is, enjoy the journey to it.

PAPER

Paper is available in many different forms, and for practice sketches you can even use cheap lining paper designed for walls. However, paper such as this will generally be made from wood pulp with an acid component and, like newsprint, it will quite swiftly turn brown if exposed to light. For drawings you want to keep, you have to look a little further up the range.

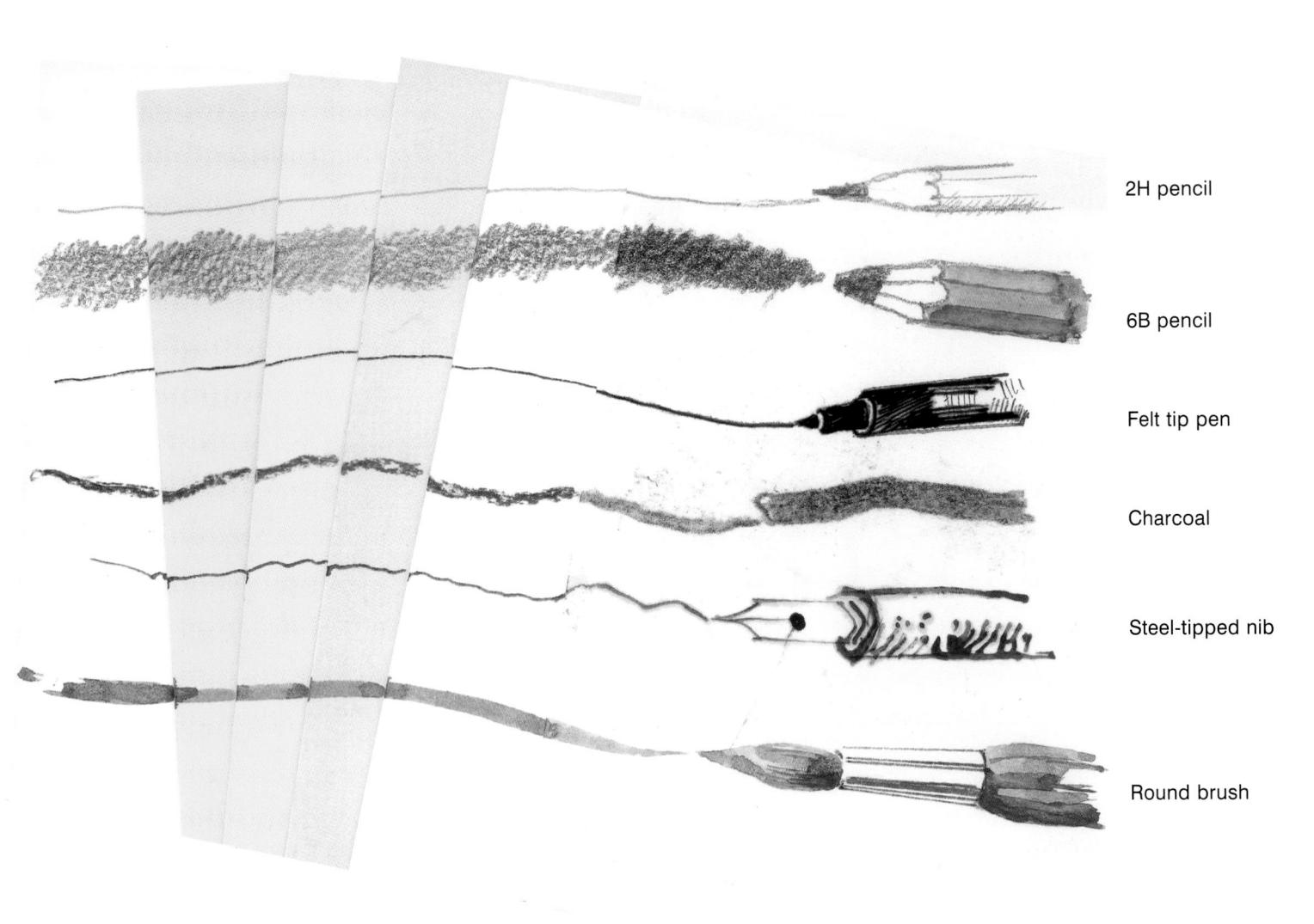

Today, most high street stationers have an art department where it is easy to browse and read the back of the pads to discover what purpose the paper is made for. A pad of cartridge paper will supply your needs for the early stages of drawing. Confusingly, this may be described as woodfree, though it is in fact made of wood-pulp but with the acid taken out so that it will not darken and become brittle.

As you progress you will want to try different qualities and brands of paper which can be bought from art materials suppliers or even specialist fine paper shops. Cotton rag paper is the best quality, with longer, stronger

fibres that will stand up better to washes and techniques that erode the surface such as are used by watercolourists. For drawing, surface is more important, from very smooth paper that will take detailed work with the finest of pens to a rough surface for dynamic textural pieces. As a beginner it is a good idea to make yourself a sketchbook from individual sheets of paper of varying surface held together with a bulldog clip so that when you are starting a drawing you have to make a positive decision as to which type of paper will be most suitable for your subject.

DRAWING TOOLS

There is a wide range of drawing tools available, but as a beginner you will only need to know the basics about each particular medium. As you become more skilled you can

enjoy exploring the differences between various manufacturers' products.

PENCILS

Pencils come in a range of grades from 9H (very hard) to 8B (very soft). When I want to make comments about tone as well as line I often work with a 6B, which, if sharpened frequently, is useful for both purposes. If you want to make a detailed drawing and then put tones in, a B and a 2B or 3B would be ideal. Most artists will generally have a 2B in their pocket for general use.

A pencil sharpened to a long point gives you line and tone.

CHARCOAL

Like pencils, charcoal comes in a range of grades from hard to soft. It produces lovely crumbly lines and is ideal for smudgy, dynamic drawing. People tend to love or hate charcoal, but if even your initial reaction is the latter, do give it a try as it encourages you to work with big gestural marks and is excellent if you want to loosen up your drawing or simply give yourself a change after a day spent doing a detailed drawing.

Charcoal is messy to carry about and you might prefer to buy sticks encased in wood for this purpose. However, the line they give is more even and and you lose the delightful unpredictability of the bare sticks.

PENS

The traditional choice here is a steel nib on a holder. They come in a variety of sizes and are good for detail, but make it difficult to draw fluidly since if you try to push away from you they will tend to dig into the paper, particularly if it has a rough surface. Fountain pens, biros and felt tip pens are handy to use, though only biros will produce permanent marks.

INKS

Water-soluble inks such as those for fountain pens will dissolve in water to produce thin washes but will not be lightfast. For permanence, you will need the more

expensive inks such as Rotring and Indian ink. Once these have dried they will not reconstitute with water so you can put washes over the top without disturbing them. For a softer line, you can draw into clean wet water on the paper.

CHALKS AND PASTELS

All the above media make dark marks on a lighter surface, but sometimes you may wish to draw light on dark. Ordinary schoolroom chalk is cheap and cheerful, and a large range of pastels is available in art shops.

Inks are available in permanent or water-soluble form.

MISCELLANEOUS MEDIA

A quill is a delightfully traditional medium to use, and while it is dipped in ink like a steel nib it can be pulled and pushed in all directions so will allow you to draw more fluidly. Cutting an oblique end to a stick picked up in the garden will give you a tool that is capable of thick or thin lines depending on the angle at which you are using it. An eraser can also be used for drawing by pulling white lines out of shaded areas. Try any implement you think might be suitable and see what marks it will make; there are no boundaries in art.

A stick with an obliquely sliced end will produce thick and thin marks.

EQUIPMENT

Art shops are stocked with all kinds of tempting equipment, but as a beginner it makes economic sense to keep tight hold of the purse strings until you discover what your

particular needs are. Some items are necessary, of course, but often you can find inexpensive substitutes.

DRAWING BOARDS

You need something to rest your paper on, and a piece of thick hardboard from a DIY shop is perfectly adequate for the purpose. Alternatively, lightweight foamboard,

which can be found in art shops, is excellent for field trips. When I am travelling I tape two pieces together, fold them to make a folio to keep my paper flat, then open them out to a double-sized drawing board when I want to

work. Foamboard dents easily, but when it becomes too battered to use I just throw it away and buy a new piece.

EASELS

You need to be able to angle your board up and down so that you are looking square on to it as much as possible. If your paper is flat, you will have a tendency to draw very tightly on the part nearest to you and will have to stretch to reach the far edge where the drawing will be distorted by perspective. Tilted upright, the bottom, top and sides of the paper will all be the same distance from you, allowing for better drawing and more comfortable posture too — which can become very important when you are engaged on a detailed drawing.

A proper drawing table that tilts is the ideal, since you will be able to stand up at it to get freer arm movement. Failing that, table easels are inexpensive, while a brick to rest the top of the board on is easy to obtain for nothing. A cardboard box with a bag of sand to weight it is another possibility.

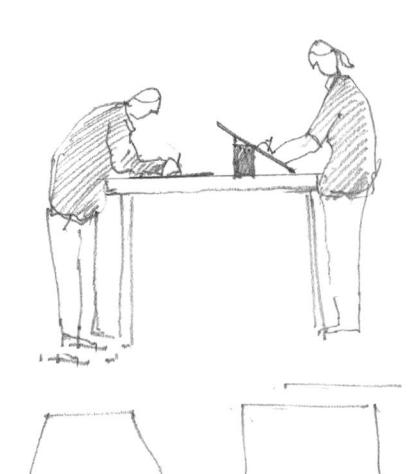

SEATING

Any comfortable chair will do for working at home, and for

working in the field the ideal solution is a rucksack with a folding stool attached. These can be found in art shops, but are much cheaper in camping and outdoor clothing shops.

MISCELLANEOUS

Other items you will need include a putty eraser and a craft knife for sharpening your pencils – not a pencil sharpener, as this will give you only a short point rather than the long one you need for rubbing in areas of tone. Disposable knives with snap-off blades are very cheap and are lighter to carry.

If you are using charcoal you will need spray-on fixative, available from art shops – though if you are out and about and discover you have forgotten to pack it, a can of hair lacquer will do the job. Wet wipes and a kitchen towel are a good idea with this messy medium. You'll need your sketchbooks, and if you are planning to do wet washes, a container of water. I keep the minibottles that airlines serve alcohol in, since I find them an ideal size.

On outdoor trips, always take an umbrella – mainly for the sun rather than the rain. The paper will blind you when the sun is too bright, particularly if you are working on a detailed drawing, and an umbrella will make it a more comfortable couple of tones darker. Sunglasses are also good when you are working in black and white, but are obviously not suitable for colour.

ORGANIZING YOUR WORKSPACE

The ideal workspace is of course a studio of your own, but if you are not lucky enough to possess one do try to have at least an area of a room which is yours alone to work in. If you have to get out your equipment every time you want to draw, you will wait until you have some clear time in which to do it. With everything laid out ready, you can pick up your sketchbook even if you have only five minutes to spare. Half an hour can usefully be spent drawing a simple object with several different angles of light, or perhaps investigating a particular aspect such as texture, so don't feel you always need to make time for a protracted drawing session.

A room with north light is best, since you won't get extremes of light and dark on your paper, nor cast shadow moving across your drawing and making it difficult to see tone. For working in electric light, buy daylight bulbs, which have a cold bluish light that resembles north light. These are available from craft shops or good lighting shops. Anglepoise lamps are useful for directional lighting.

If you have small children, a lockable cupboard is a good idea so that you can put knives, erasers, fixative and so forth safely out of reach. You also need somewhere to store your paper where it will be flat and dry. Keeping it on

the floor beneath your bed or a piece of furniture is one solution, provided you are quite sure that the floor is not damp; you will be able to acquire paper more cheaply if you buy it in bulk, but if you allow it to go mouldy that will be a false economy.

Zipped folders from an art shop are a safe way of keeping paper clean and free of dust and chemicals, and they can be kept upright. Never store cheap papers alongside good-quality rag paper, since the acid content in the former will attack the cellulose of the latter.

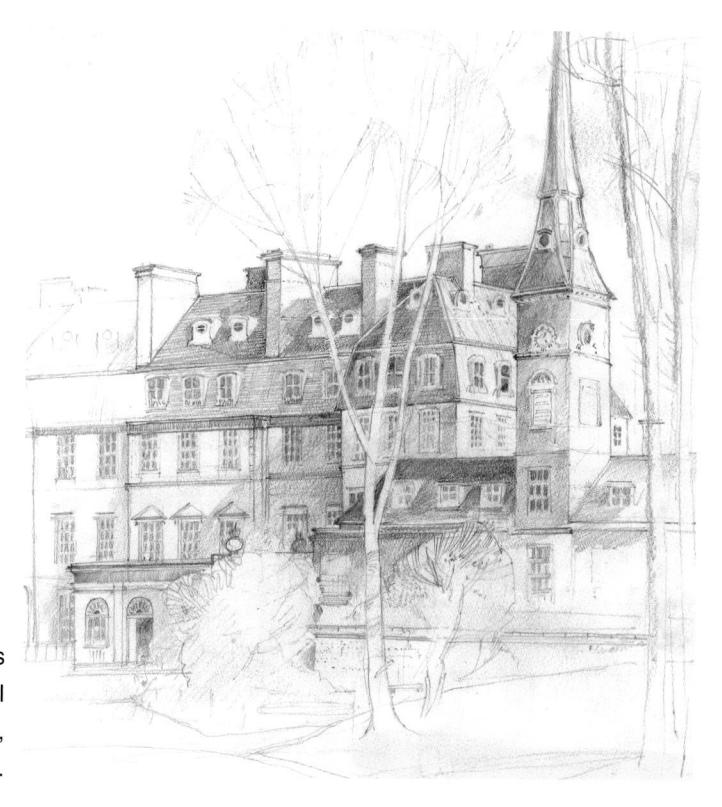

This architectural drawing of a school is very objective and carefully worked. I did it over a period of about four hours, comfortably seated in my studio.

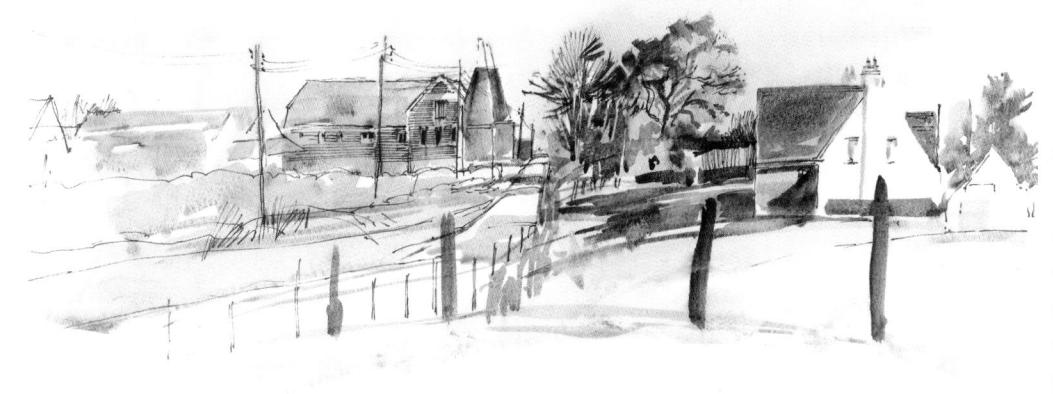

I made this very loose pen and wash drawing of rural building in about five minutes, standing up as I worked. A typical sketch done on the spot, it is still an architectural study but is very different from the other on this page because of the logistics of where it was done.

LINE AND HOW IT WORKS

Any time you put pen or pencil to paper to make a drawing, you will be using line to express yourself. As you gain experience, your hand and eye coordination will improve and you will learn the types of mark that will best suit your

subject and what you wish to convey. Hold your drawing tool like a sword, which will enable you to draw with a fluid movement of the arm. Holding it like a pen encourages tightness and a tendency to draw from the knuckle.

This example is not just of two sets of vertical marks; there is also an implied line running between them.

Varying a line from thick to thin expresses volume, while an unvarying line appears flat.

Pointilliste technique uses dots to show both line and tone.

Drawing fine parallel lines is known as hatching, used to show tone. For darker tone, another set of lines going in the opposite direction is added (crosshatching).

To show volume as well as tone, draw your hatching and crosshatching lines to follow the shape of the object.

Pick up a pen or pencil, place it on the paper and take it for a short staccato journey without taking your tool off the paper. Cover the area, working as quickly as you like. You will find you are holding your tool in a tight-knuckled, tense fashion, and your unbroken line will be thrusting, dynamic diagonals.

This time cover your paper with long, sweeping movements, again keeping your tool on the paper throughout. Your line will be languid and fluid and your hand and arm will be relaxed. Carrying out these two exercises will help you realize how these lines affect your emotions and, in turn, the viewers'.

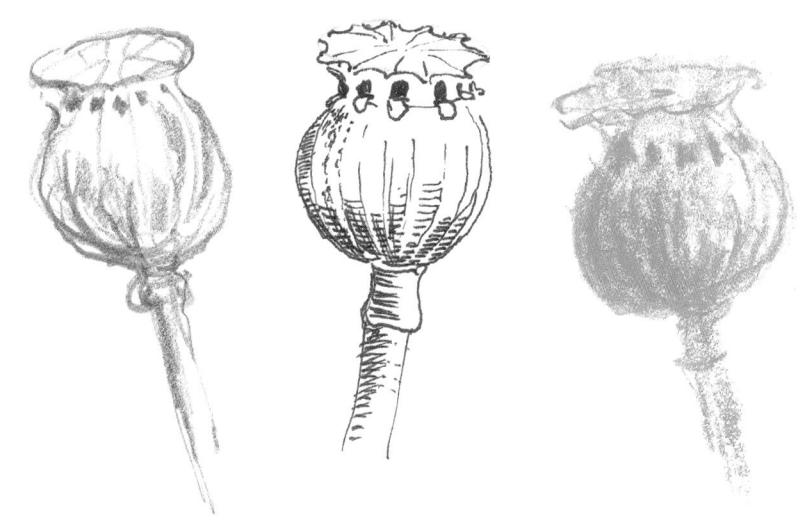

A SAMPLER OF MARKS

Get as much as you can from your drawing tools and be inventive with the way you make marks. Your tools are capable of far more types of mark than you would expect.

On this page is a sampler of marks, from which you can go on to develop more of your own.

Pointillism: holding your pencil vertically, stab the paper with it.

A simple example of hatching.

A line going round and round to fill a space.

Pencil-sharpening dust spread with a finger.

Crosshatching with a soft pencil smudged with a finger.

A jabbing technique with the pencil held obliquely to make a series of dashes.

Interlocking circles of the same tone to give a flat effect.

Interlocking hatched lines, varying in directions.

Evenly spaced light and dark lines.

A continuous line drawn as a spiral.

Charcoal lines.

Smudged charcoal.

The same as above, this time drawn with ink so the lines are harder and appear to come forward.

Ink splattered with a toothbrush.

A stick drawn into slightly wet paper so the edge softens.

HARD AND SOFT

Although in many drawings you will use both hard and soft marks, you may sometimes want to use their quality to sum up a whole scene. If you want to give the viewer a sense of looking across a space to the main focus of the drawing, use a softer medium which will introduce a sense of recession and make the eye search for the subject.

Conversely, hard lines will produce objects which are jumping off the page to confront the eye. Before you start a drawing, think about which way of expressing it would be best. Although the two drawings on this page are tonally quite close, their message is entirely different.

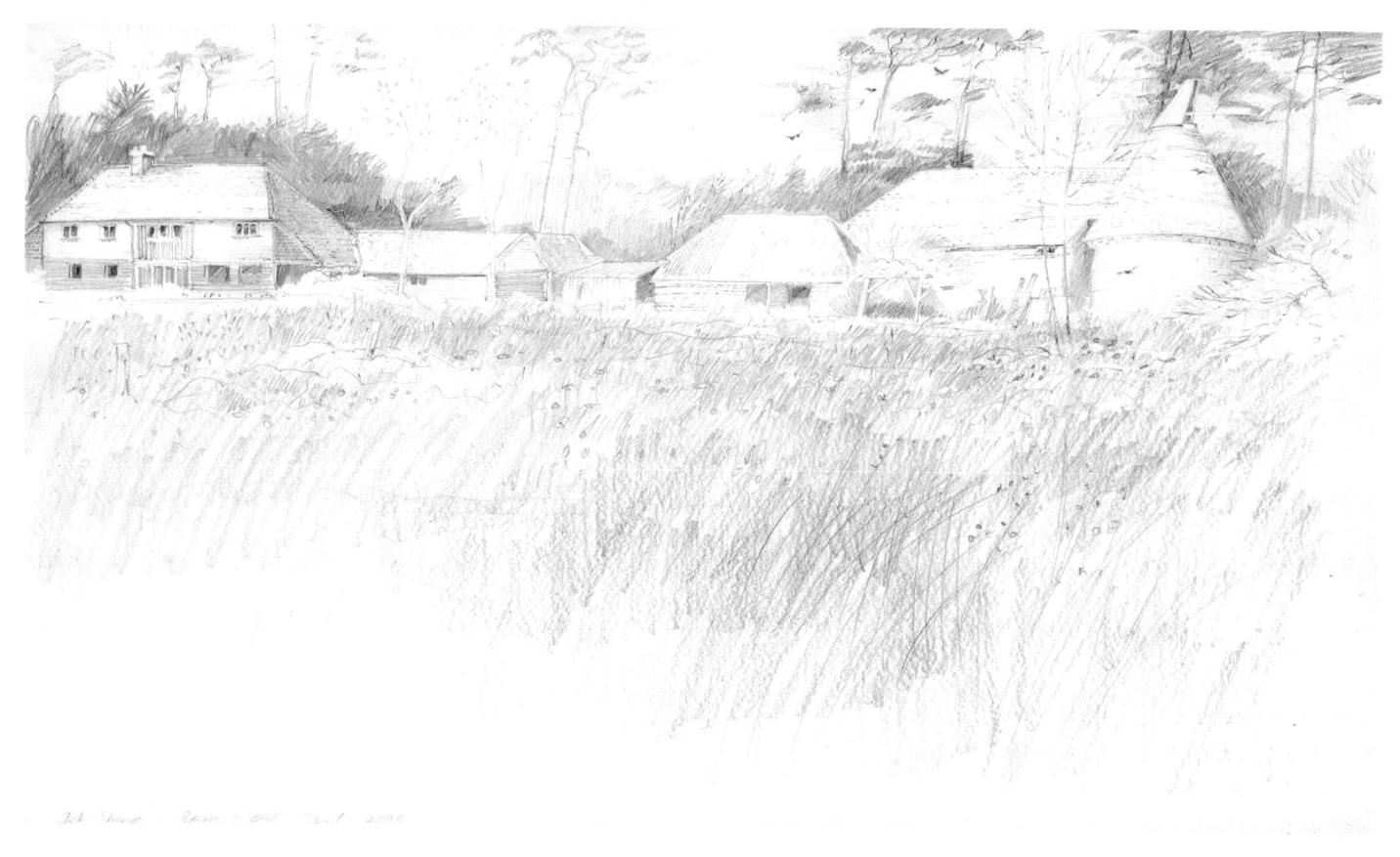

This drawing was done with soft-edged lines which are sitting back on the paper, seeming almost slightly out of focus. This technique is very well suited to a rural scene with soft leaves and grass and mellowed buildings.

The hard architecture of a bustling city is summed up here by hard lines that give the idea of a hardworking environment (a public washhouse) and Mediterranean light.

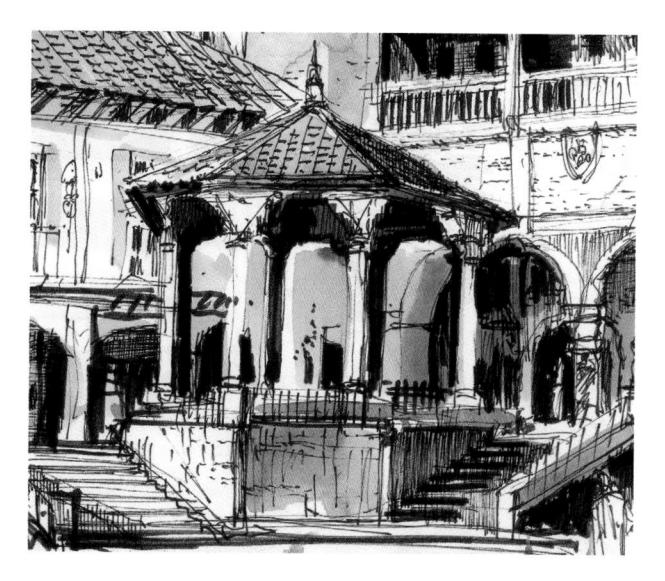

BASIC MEASURING

Measuring the elements in your composition accurately will give you the basic building blocks of a successful drawing, and it's important not to skimp this stage since the further you work your way into a piece the harder it is to correct mistakes. Practising with small still life groups is an easy way to develop your measuring skills.

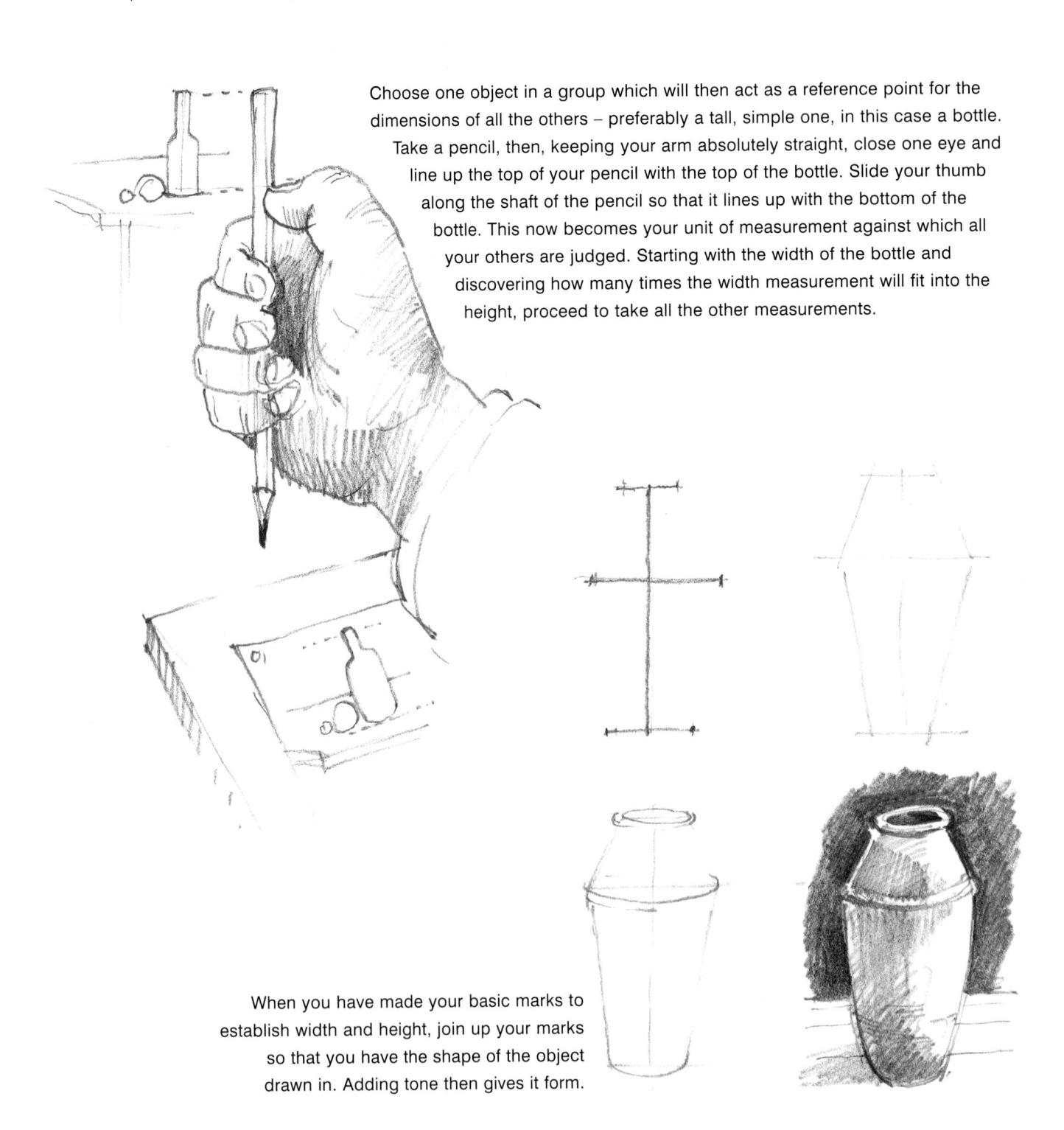

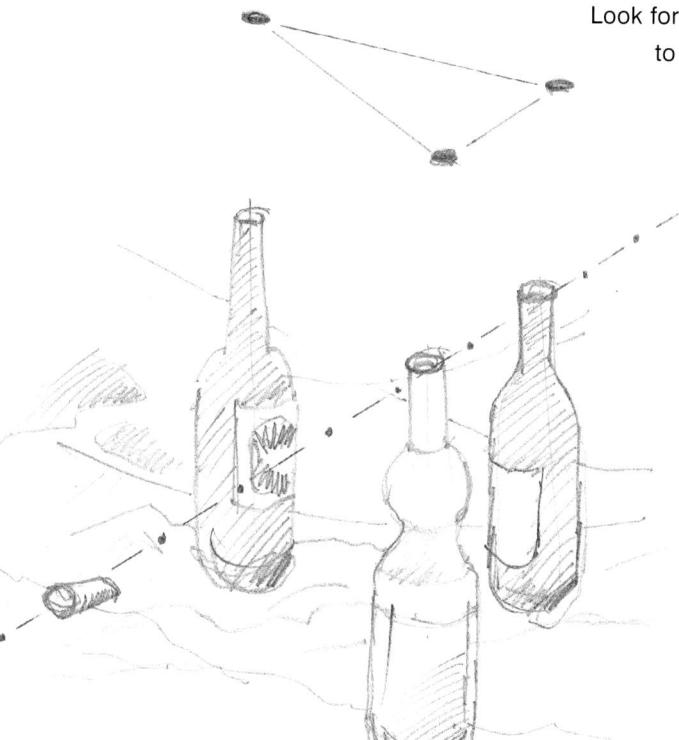

Look for geometric links within the composition. Closing one eye to get rid of the third dimension makes it much easier to see such things as the triangle formed between the tops of the bottles here, and you can drop the rest of the bottles down from those points. Look for other relationships of measurements; a line drawn through the tops of two of the bottles reaches the cork, for example.

SIGHT-SIZED DRAWING

The method of measuring described above gives you control over whether you have a small or large drawing, but it is very time-consuming in the case of a complicated subject such as architecture. Sight-sized drawing (right) is swifter, and mainly used for large-sized drawings.

Imagine you are holding up a piece of glass and tracing with a felt-tip pen the objects you can see behind it. If you bring the glass closer to you the objects will be smaller within the shape, and vice versa, making it easy to enlarge or reduce them. To translate that to paper and pencil, look over the top of your drawing board to see your objects and mark on the paper where an imaginary line drawn from the object would appear.

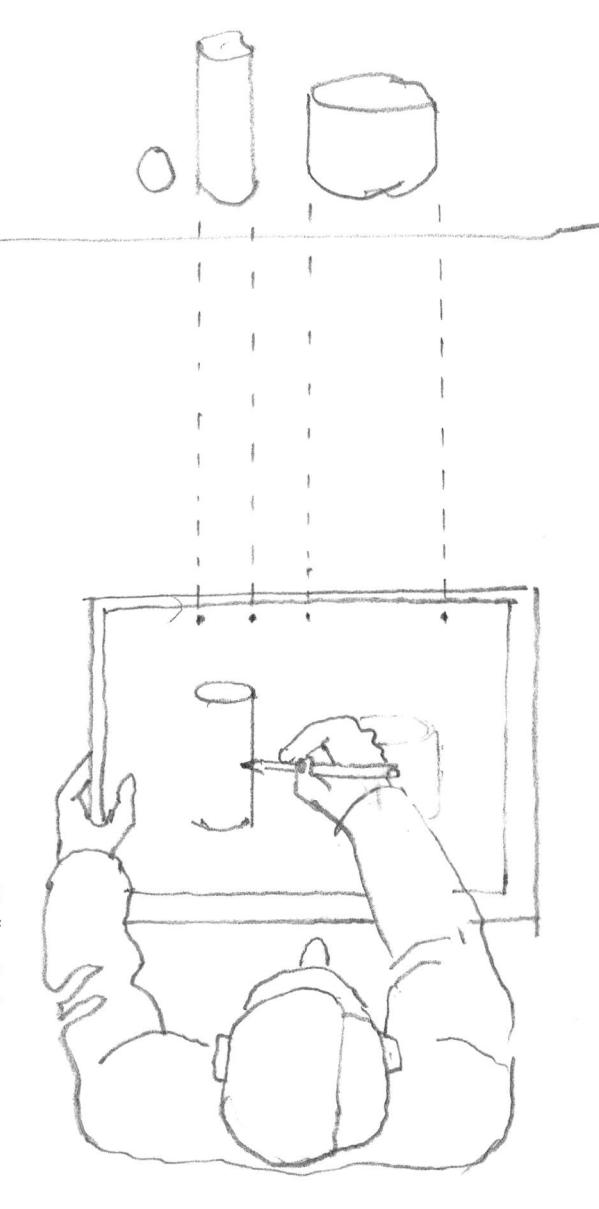

LOOKING FOR BASIC SHAPES

When you are drawing a compact still life group, check at the outset to see the simplest overall shape that the objects fit into at their extremities. You will then have a useful visual check that your basic measurements are correct, for if they are not you will discover that the objects will distort away from the overall shape – an easy way of spotting what is going wrong.

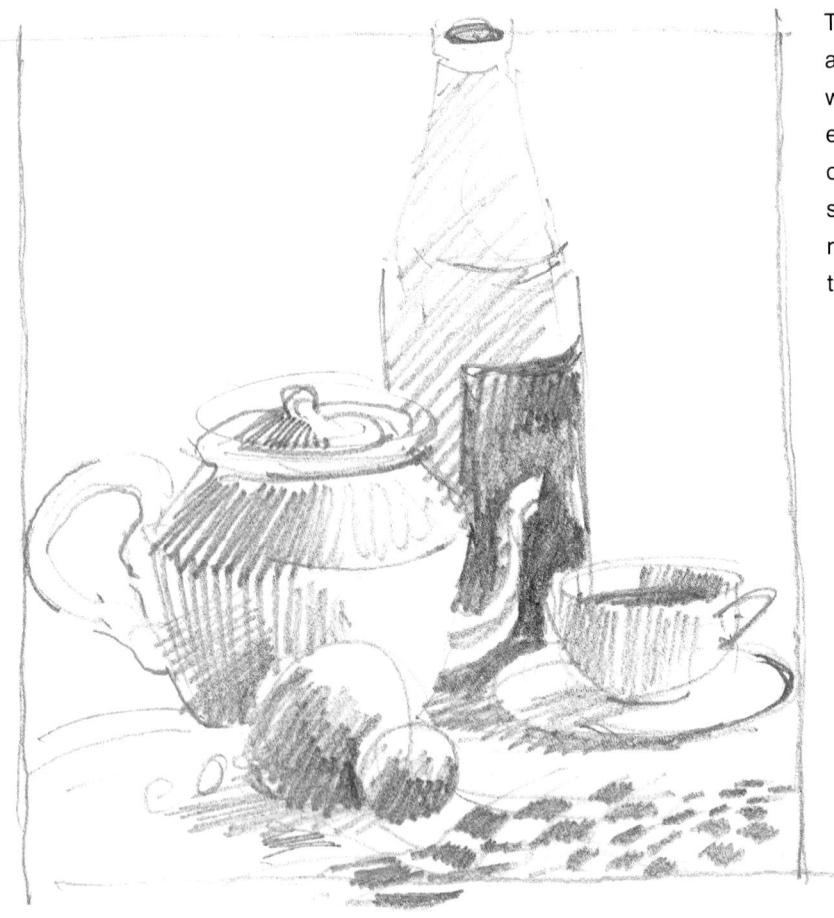

The objects here all fit neatly into a square. Within that group, see which simple geometric shape each object fits into – an oval, an oblong, a square or maybe two squares. Finding the geometric relationships will help you to see the design as a whole.

Looked at from an angle, a circle appears flattened into an oval known as an ellipse. The further the circle tilts away from you, the narrower the ellipse will be. If you imagine you are holding the bottom of this vase towards you, the base will appear as a circle; as you tilt the top back towards you, a series of watermarks up its length will appear as ellipses. As a very good hand-eye coordination exercise, do a whole series of quickly drawn one-stroke ovals top to bottom by the side of the bottle, making them fatten as you go down.

NEGATIVE SHAPES

When you are drawing a familiar shape you will tend to assume that you are getting the shape right, and if the end result is clearly wrong it's not always easy to see where the errors have crept in. Drawing the negative shapes – the

spaces in between – which you have no preconceived ideas about will help you to draw what you see, as opposed to what you think you see. Remember too that in a finished drawing every shape is important, be it positive or negative:

In decorative terms, some negative spaces produce lovely shapes that you would never invent.

Drawing plant material gives you the opportunity to draw more loosely and to make sure that the negative shapes are interesting.

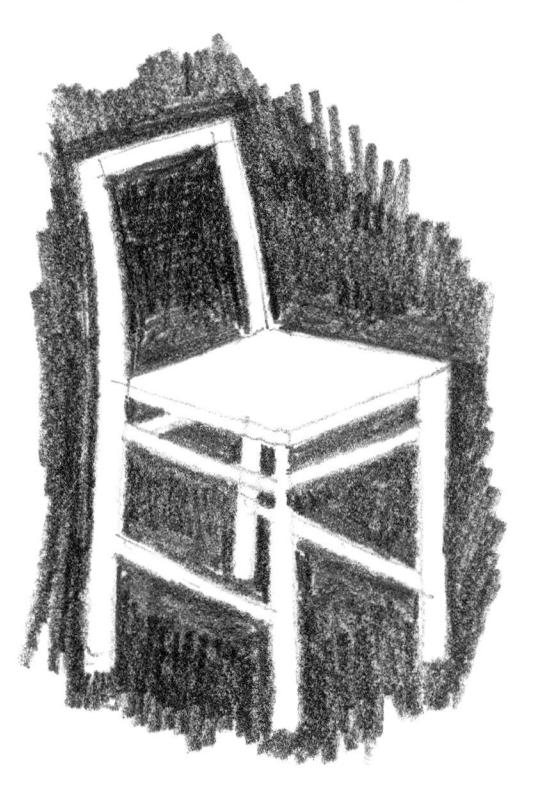

Try constructing a chair by drawing the simple geometric shapes that you can see in the spaces between the structure. Concentrate on each of those shapes rather than thinking about the form of the chair. The lozenges of tone that make up the interior shapes are sometimes quite unexpected, but it's easy to see if they are long and thin, or triangles, rhomboids and oblongs.

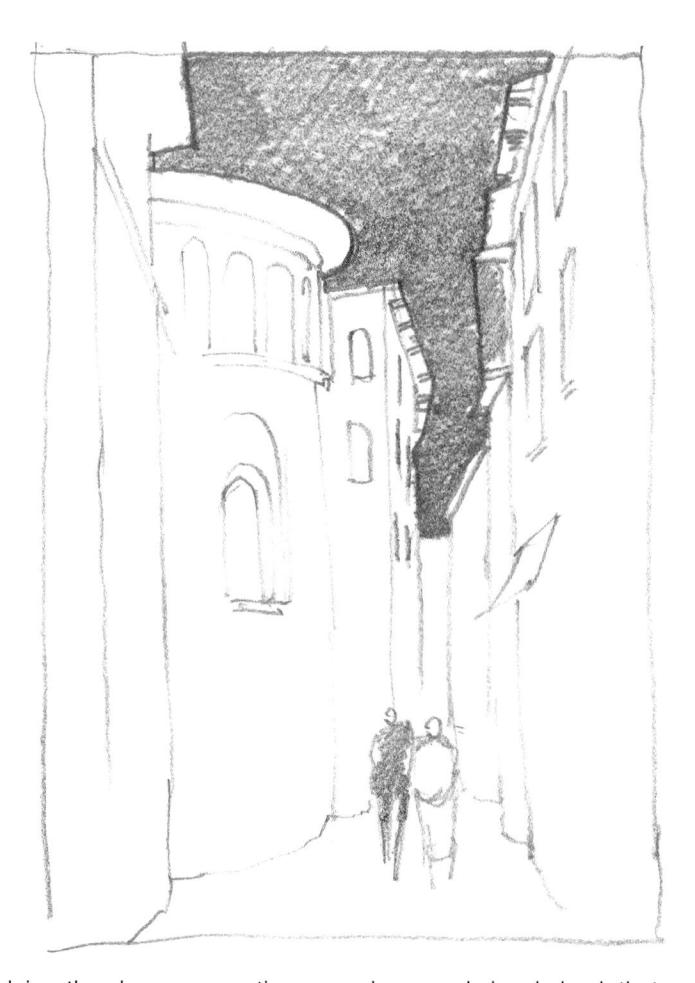

Studying the sky as a negative space is a good visual check that architecture and perspective are right. Here, it was easier for me to see the shape the sky made rather than trying to follow the oblique angles of the overhanging roof on the right. A sky that threatens to take over your composition can be knocked back by softening the edges or gradating the tone to make it recede.

FORMAT

The term 'format' refers to the shape you are working within. The first thing an oil painter will do before beginning work is establish size and format by making a stretcher on which to stretch the canvas, whereas artists working on paper tend to draw or paint until they reach the edge of the paper supplied by the manufacturer. However, it is much

better to make a purposeful effort to define the format you want to work in, even when you are drawing small thumbnails in your sketchbook; try a variety of thumbnails, making your composition long and thin, tall and thin, square, oblong, round or oval. All will give a slightly different feel to the finished piece.

Early English watercolourists often used an elliptical format. This little pen and wash drawing was inspired by William Gilpin (1724–1804).

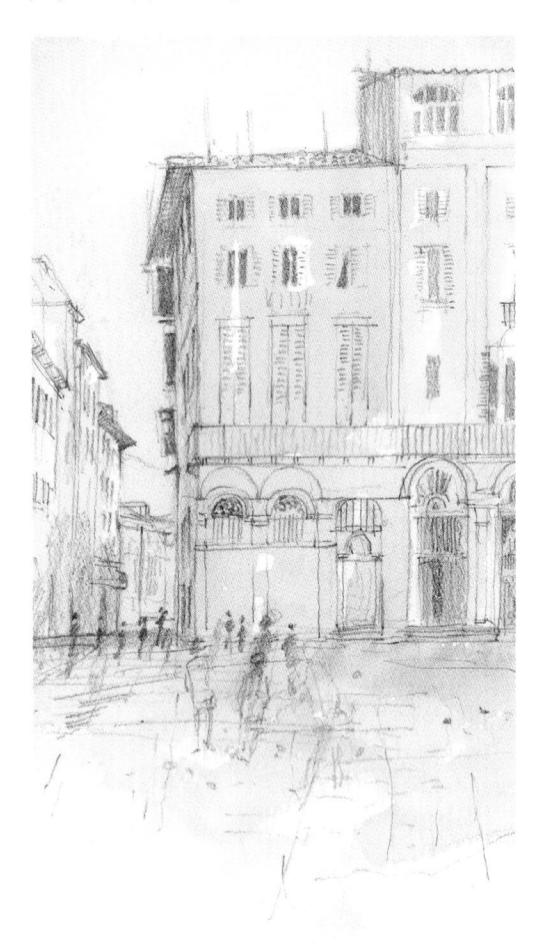

In this drawing of a scene in Florence, the upright (portrait) format makes the buildings appear to loom over the figures beneath so that the architecture dominates the scene.

that the architecture dominates the scene.

Buying two sketchbooks in different formats gives you the chance to

experiment. The top one when opened out makes a rather uncomfortable square, but the individual pages are good for drawings such as the urban scene above. The small square sketchbook opens out into a generous panoramic shape, and if you want to work on an even wider format you can simply tear extra pages out and attach them at the edge.

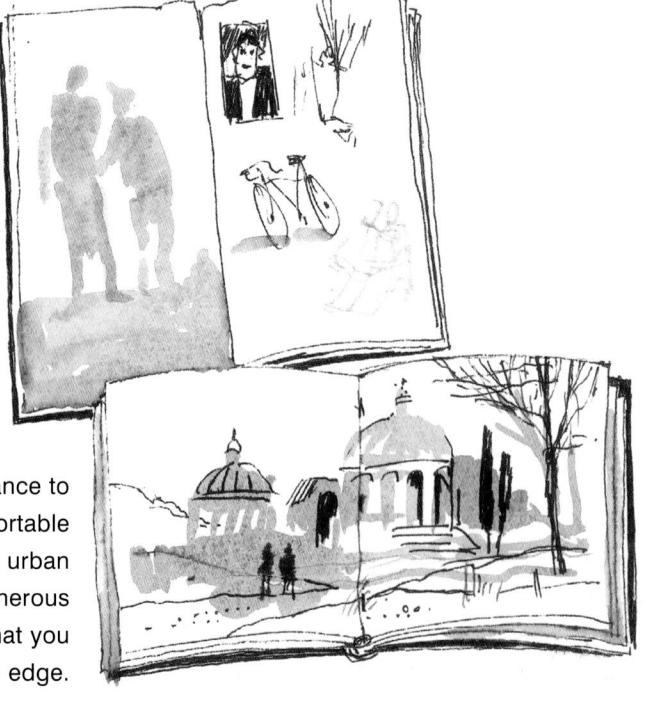

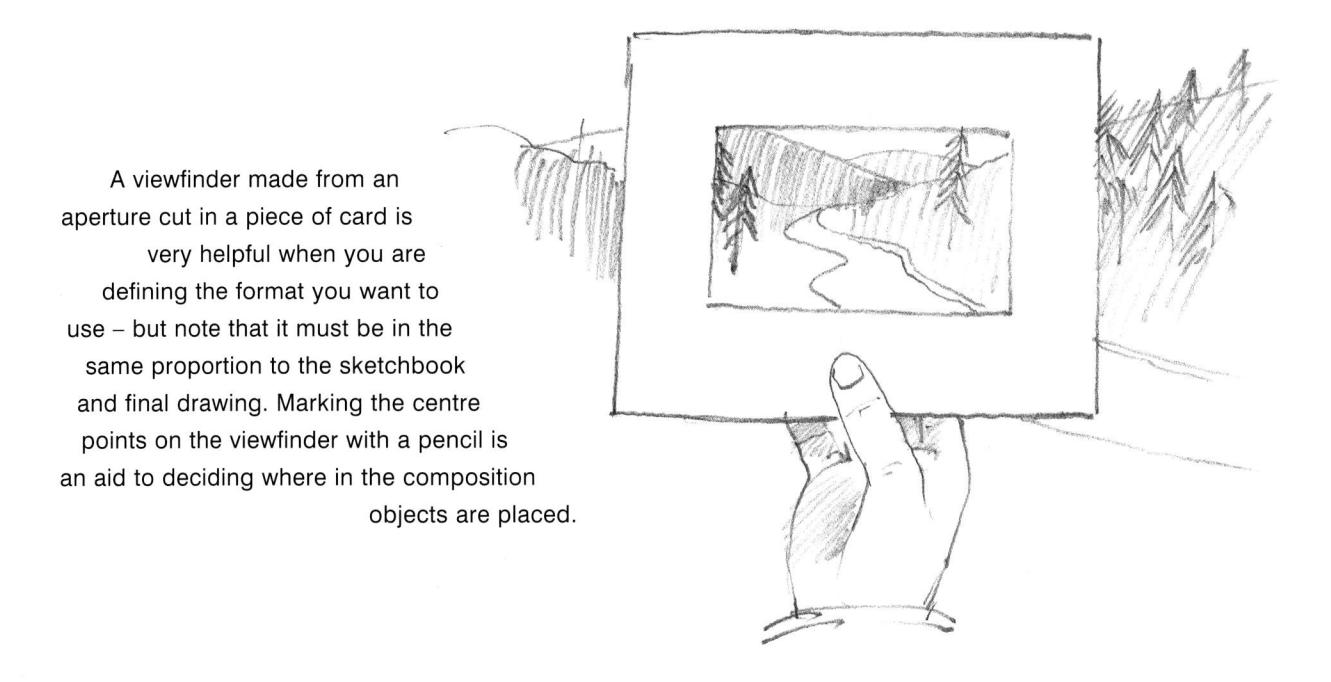

SCALING UP

When you decide to develop a drawing from a sketch you may often find that the format is not quite the same. Scaling up your drawing will make sure that the elements remain in the same relationship to each other.

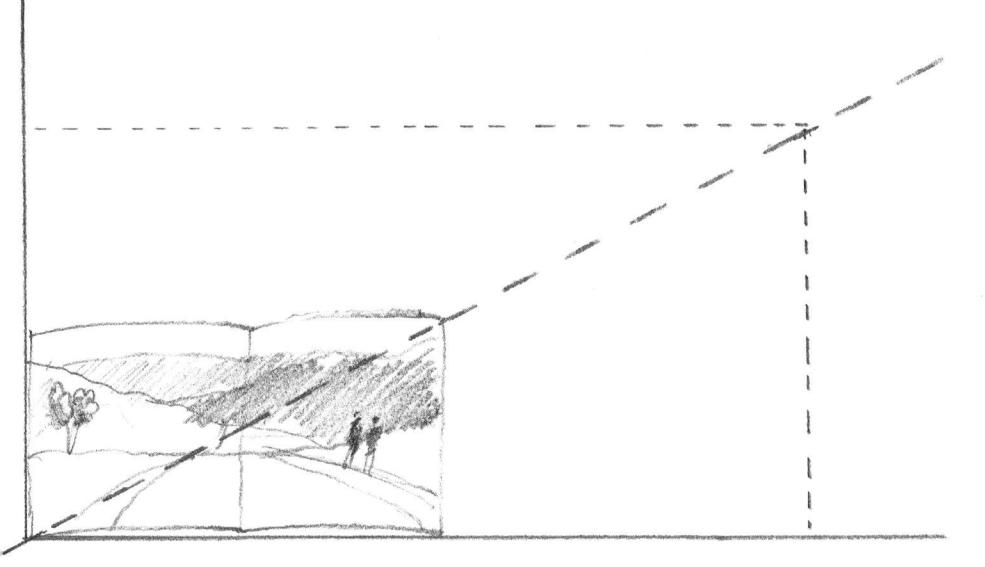

Lay your sketch in the corner of a piece of paper and draw a diagonal line from the bottom lefthand corner of the sketch to the righthand corner of the paper. Horizontal and vertical lines drawn from the side and bottom of the paper respectively to the diagonal line will give you the same format, no matter what size you choose.

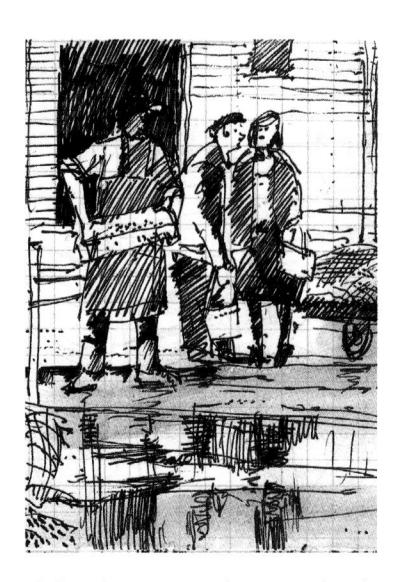

A lined or squared-up notebook from a stationery shop makes scaling up even easier because you can see exactly where each object is in the composition. A very faintly drawn grid of a few lines on your drawing paper will show you how this translates to a larger size.

TONAL EXERCISES

The word 'tone' refers to how light or how dark objects appear to be, which is governed by the amount of light falling upon them. However, you cannot make decisions about the tone of an object until you see it in relation to something else; you need other tones against which you can judge it. For example, if you hold up this book with a

light-coloured wall in front of you, close one eye and look across the top of the page with its tonal strip, you will see where the tone of the wall appears in the tonal range. Using a tonal strip in this way is very helpful, as novice artists tend to underestimate how dark tones are.

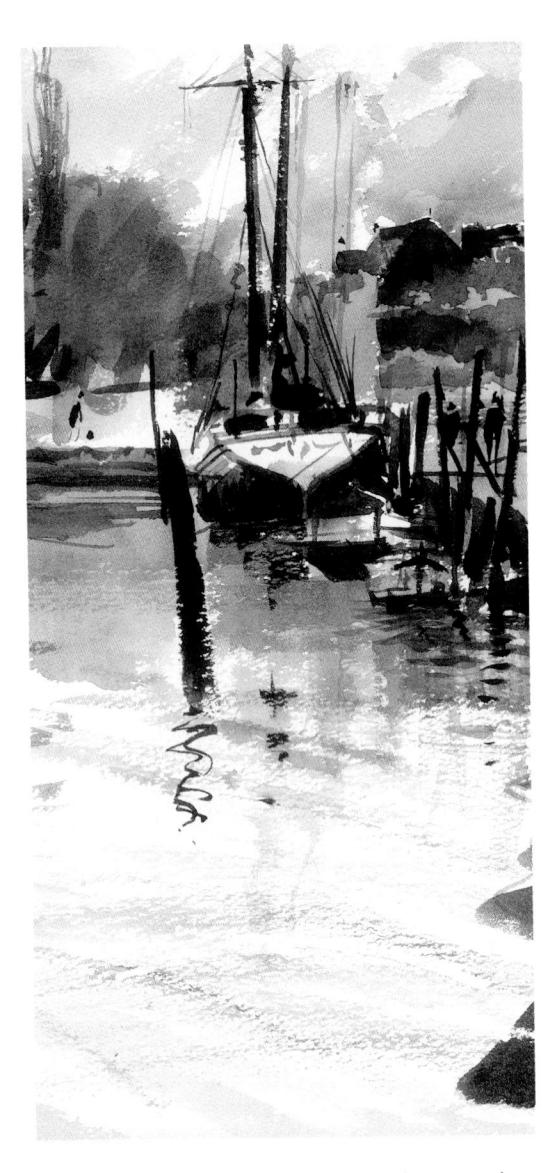

These two central squares are exactly the same tone, but one looks much darker because of the amount of white round it, while the other appears lighter in its dark surroundings.

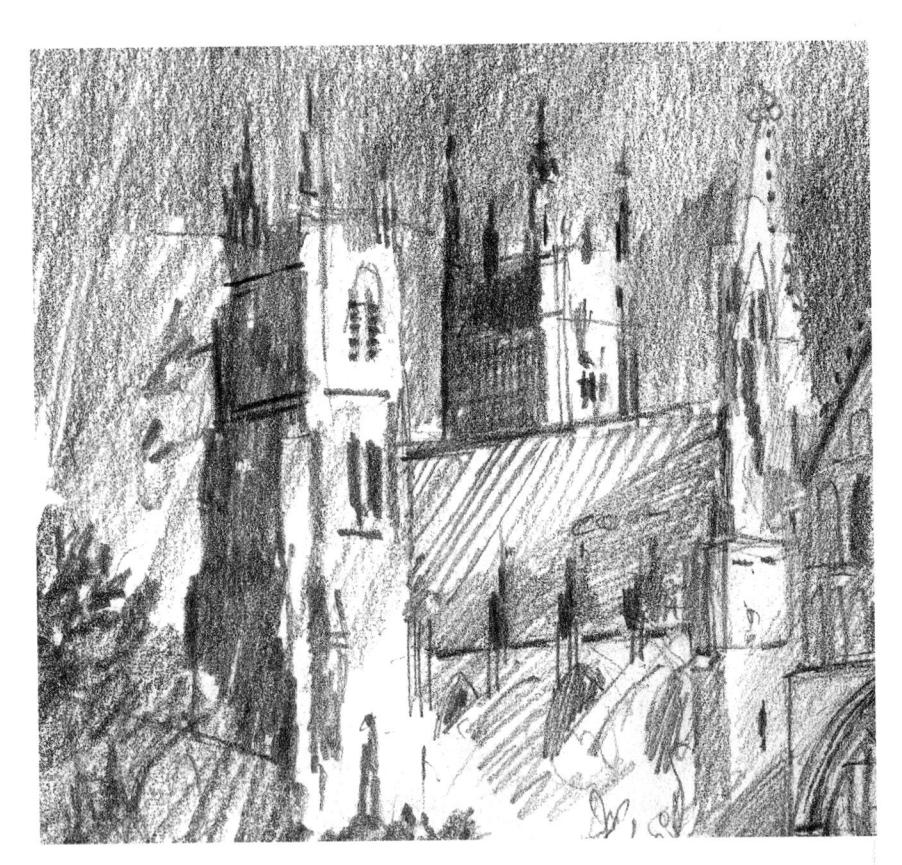

The main value of tone is that you can use it to show form and volume, because as light falls on an object it illuminates one side and the other appears darker. No matter how hastily you are making a sketch, you should always try to make some tonal notes so that if you develop the sketch into a more finished drawing the angle of light will be consistent.

SHADOWS

In their simplest form shadows act as anchoring devices, making objects and figures seem convincingly based on a surface. However, they are also useful for linking disparate parts of a composition, describing the form of the

landscape and making decorative patterns. Shadows are hard-edged close to the object from which they are cast and become softer and softer as they go away.

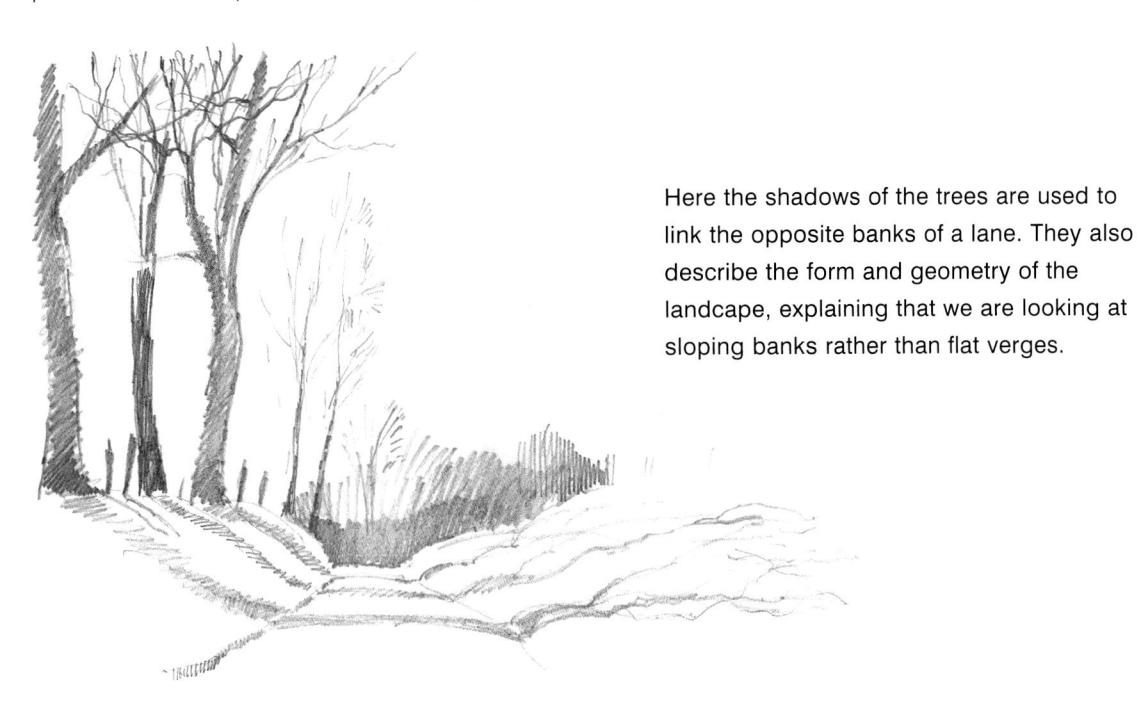

The hard geometry of the white windowframes becomes a very soft, undulating design on the curtains as the shadows find their way across their folds. Such subtleties of light are often not immediately obvious when you begin a drawing and it can be an unexpected pleasure to discover rhythmically beautiful passages such as these.

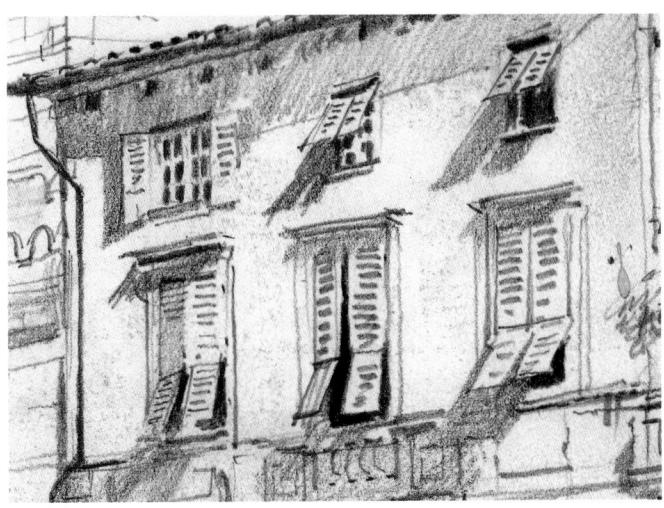

The shadows on these shutters define the strength and angle of the sunlight hitting them. Falling on a vertical surface, they add touches of drama.

EXPERIMENTAL MARK-MAKING

Being adventurous with different techniques and media will add interest and vitality to your work. Disposable pens can be slipped into your pocket for outdoor sketches, whereas sticks and quills dipped in ink are perhaps more suited for studio work where you can spread out your materials over a table top. As biros and felt tip pens aren't traditional fine art materials, they have the advantage that they are easy to use in a casual way. Quills have an honourable history in art, and as they are capable of making thick and thin marks they are very expressive.

A biro is good for making quick sketches and spontaneous drawings. It skims across the paper, making fluid marks, and as it is such a familiar everyday tool there is no anxiety about using it.

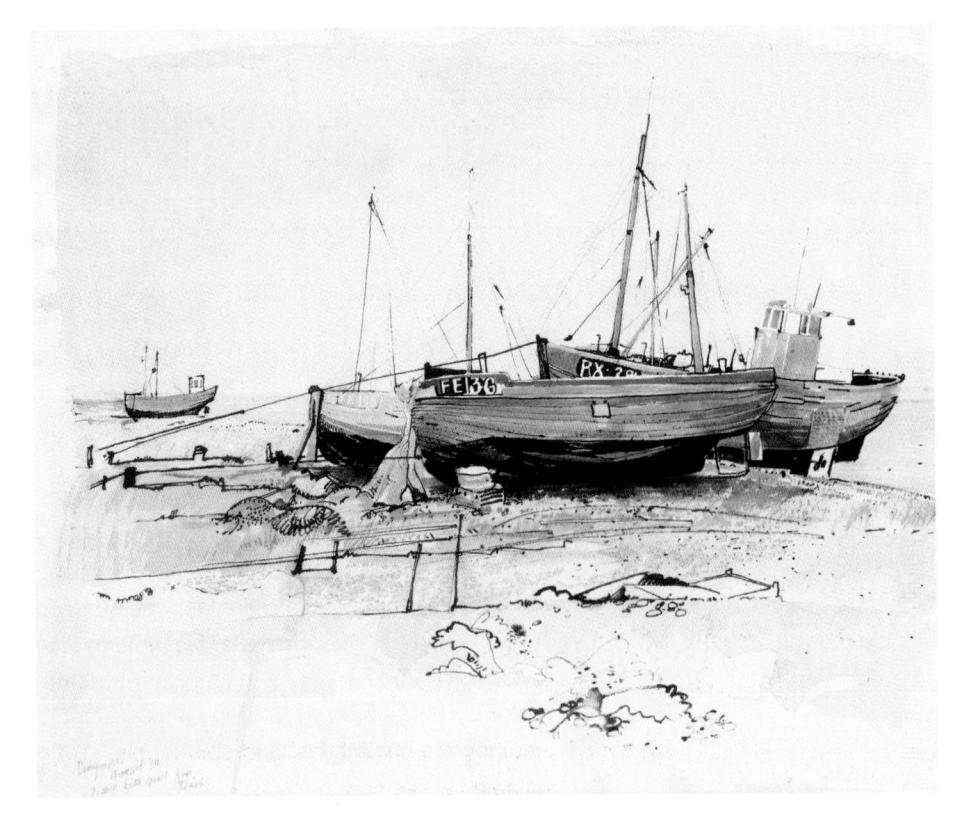

I forgot to take any brushes to the shore with me so I picked up a quill on the beach, sharpened the end and drew with that. I used the feathery end to brush loose colour on. You can push and pull a quill in all directions, giving splattery marks that are full of character.

I drew this bridge with its backdrop of trees using sticks, twigs and cotton buds to exploit all the different marks they would make.

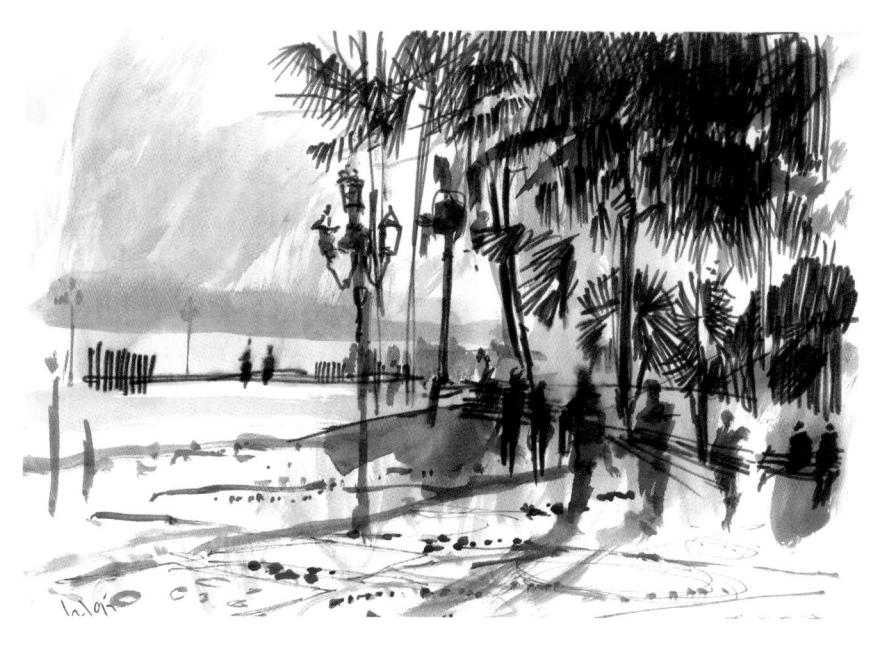

This swift sketch of a sunlit square in Barcelona was drawn with felt tip pens, which are ideal for describing extremes of tone. As it is not possible to vary the line of one pen by pressing harder or more softly I always carry three, with fine, medium and large tips. Remember though that they are not lightfast and so are only suitable for sketchbook work.

LIGHT ON DARK

Quite often we want to deal with white shapes, and the only way we can make them happen is to put dark shapes around them to leave the white paper showing through. This can be achieved either by reserving them as you draw

or by indenting the paper with your thumbnail, a knitting needle, a dried-up biro or some other pointed tool. When you rub a flat pencil over the top it cannot reach the indentations and they will consequently remain white.

This detail of the roof of the Palm House at Kew looks like a very complex drawing, but if you look at the enlarged section on the right you will see it is actually very simple, if painstaking, to do. The big white Victorian frame building can only be made by drawing the gaps in between the structure. The little detail shows that each arc contains simple tone, either light or dark, carrying the shadows of the palm trees from each arc to the next, so the white building appears by default.

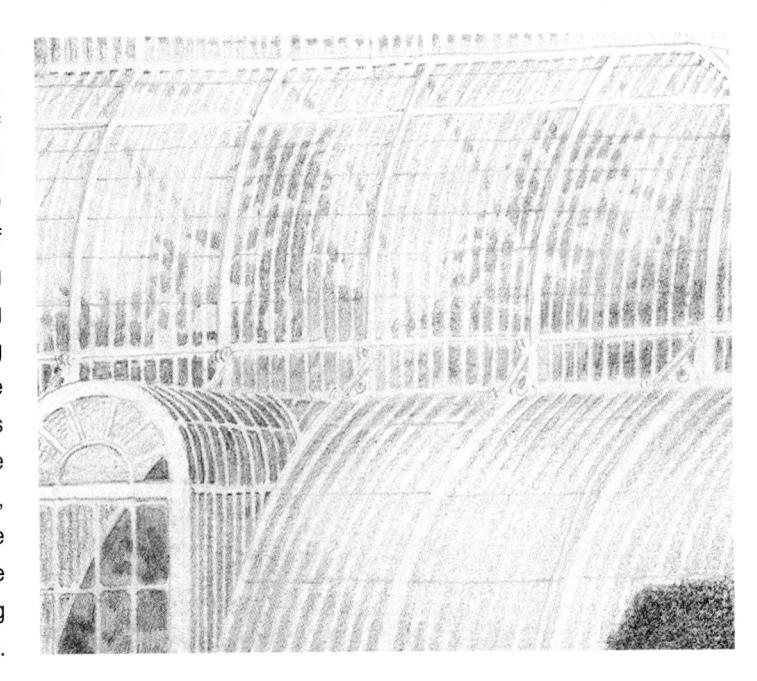

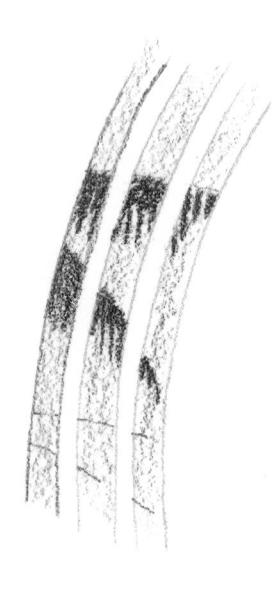

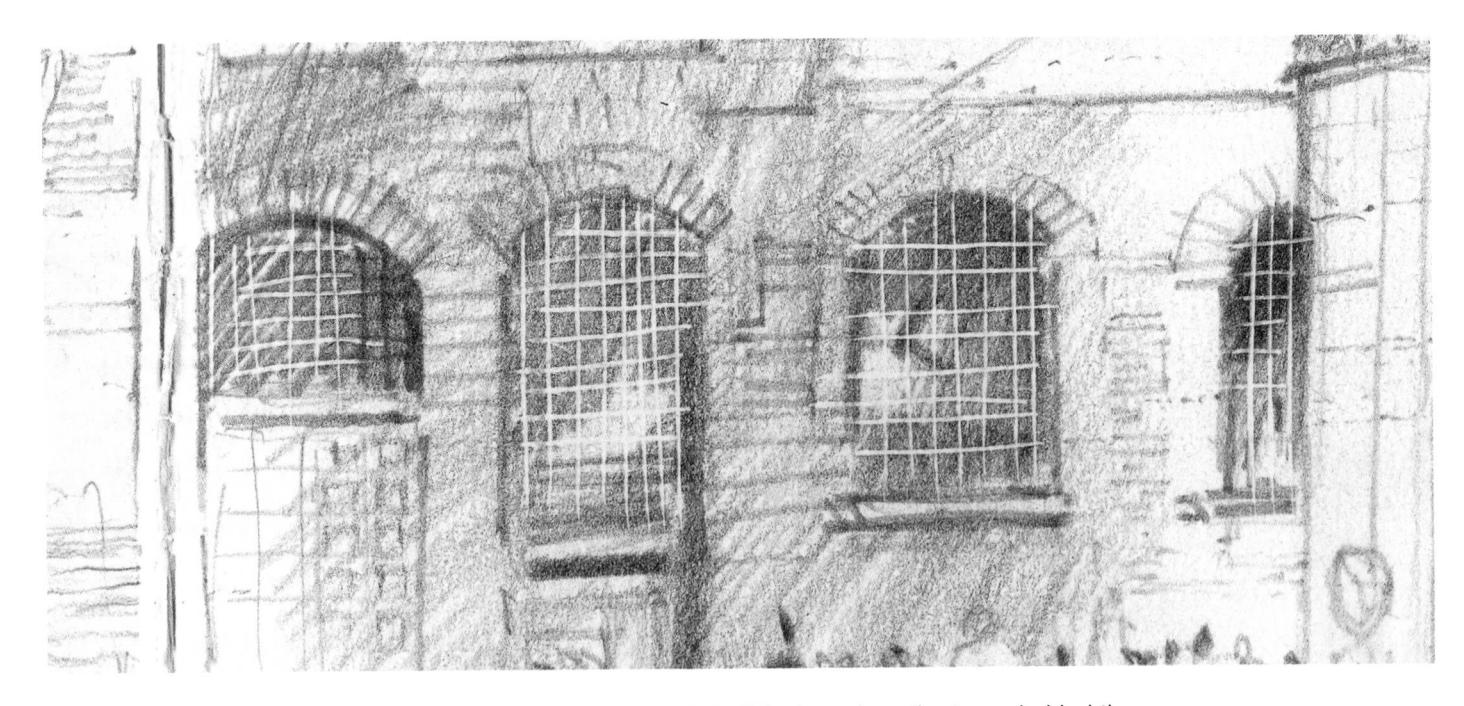

Drawing these window bars with dark lines would have made it difficult to show the tones behind them, while drawing little lozenges of dark tone to leave the bars white would have been very tedious. For this quick sketch I indented the paper with my thumbnail and then rubbed the flat of my pencil over the surface.

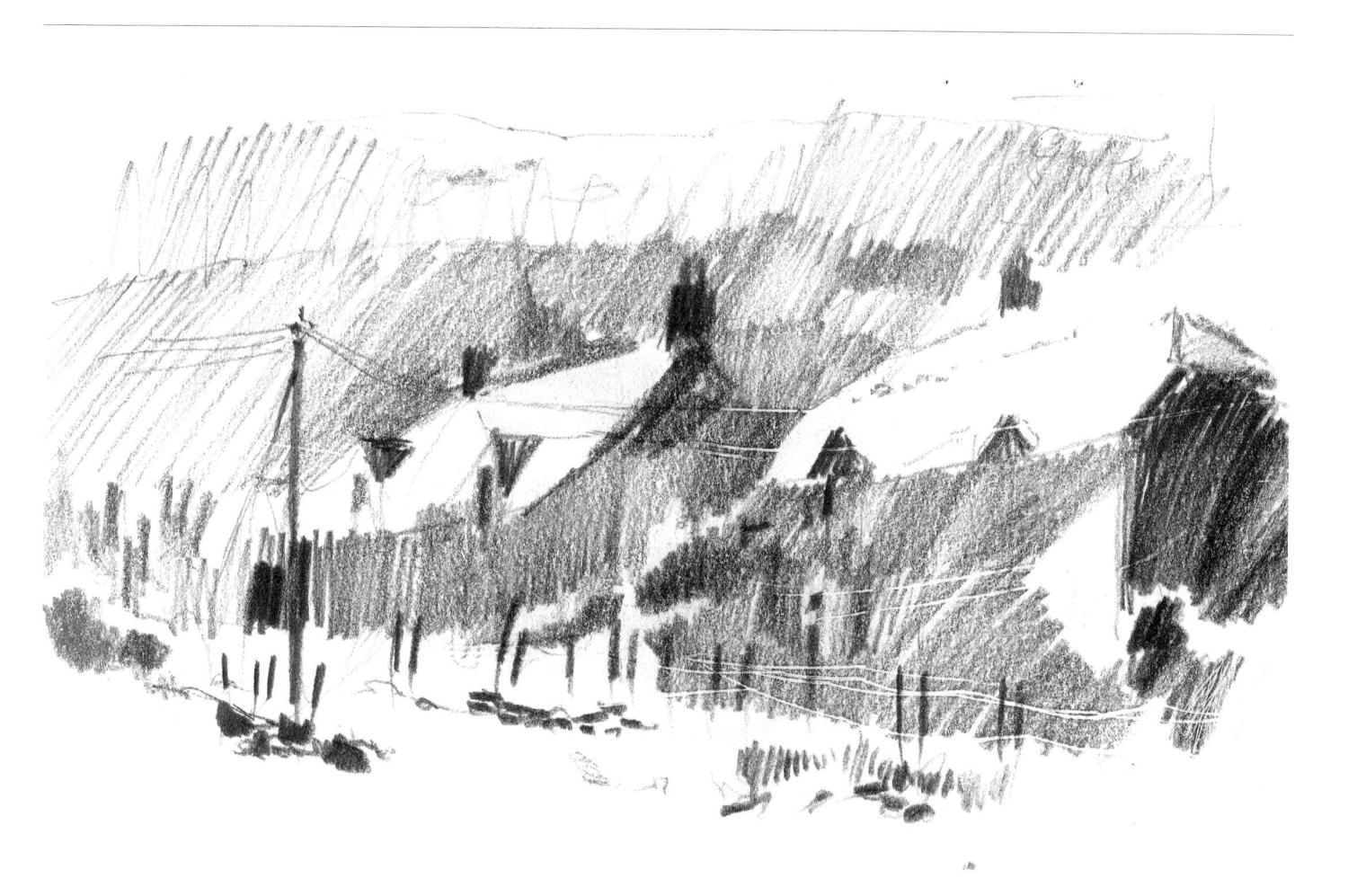

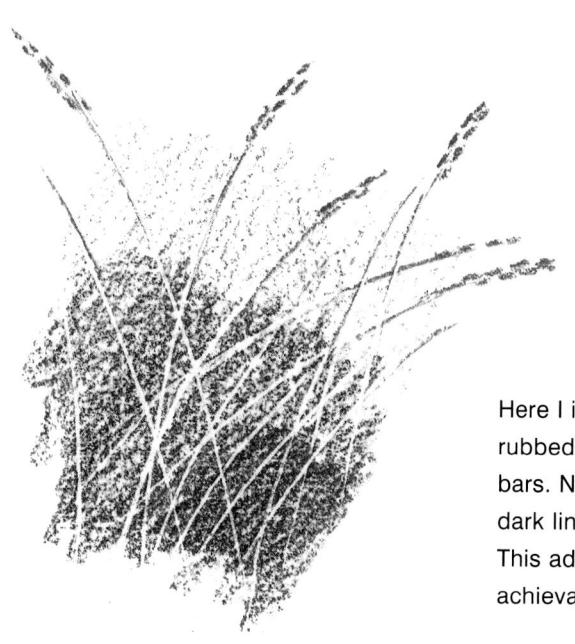

For this snowy landscape I drew strong darks to make the light areas the point of the drawing. There are few midtones in this three-minute sketch, which has tremendous drama.

Here I indented the paper with my thumbnail and rubbed over it, as in the drawing of the window bars. Notice how the light lines are transmuted into dark lines when they encounter light behind them. This adds great subtlety to a drawing but is easily achievable even for beginners.

MIDTONED PAPER

When we work on white paper, we either make positive dark marks or leave positive white marks. Using a midtoned paper and working with light chalk and dark charcoal, we give equal importance to both extremes of tone and nothing is left to default except for the midtone of the surface. This way of drawing is good training in that it

increases your awareness that nothing should be left to chance; in making one shape you are inevitably making another shape beside it. Often the shapes that are left are the largest areas of paper, and if you have neglected to notice what they are and make sure they are pleasing they may spoil your picture.

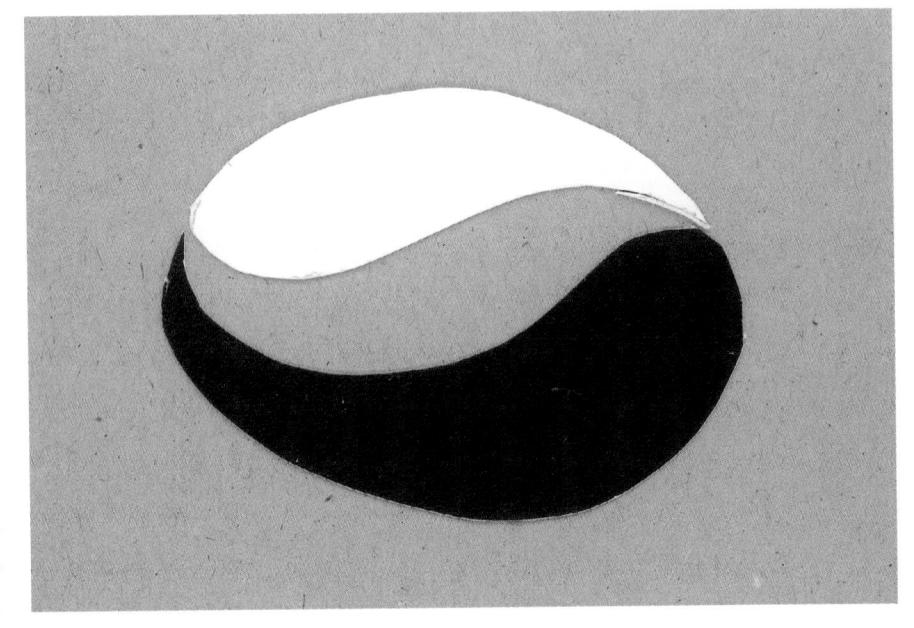

Here I have cut out two shapes, one light and one dark, and stuck them down on grey paper. This is a simplification of the shapes and tones of the rocks in the picture below to show that they are not as complex as they might appear.

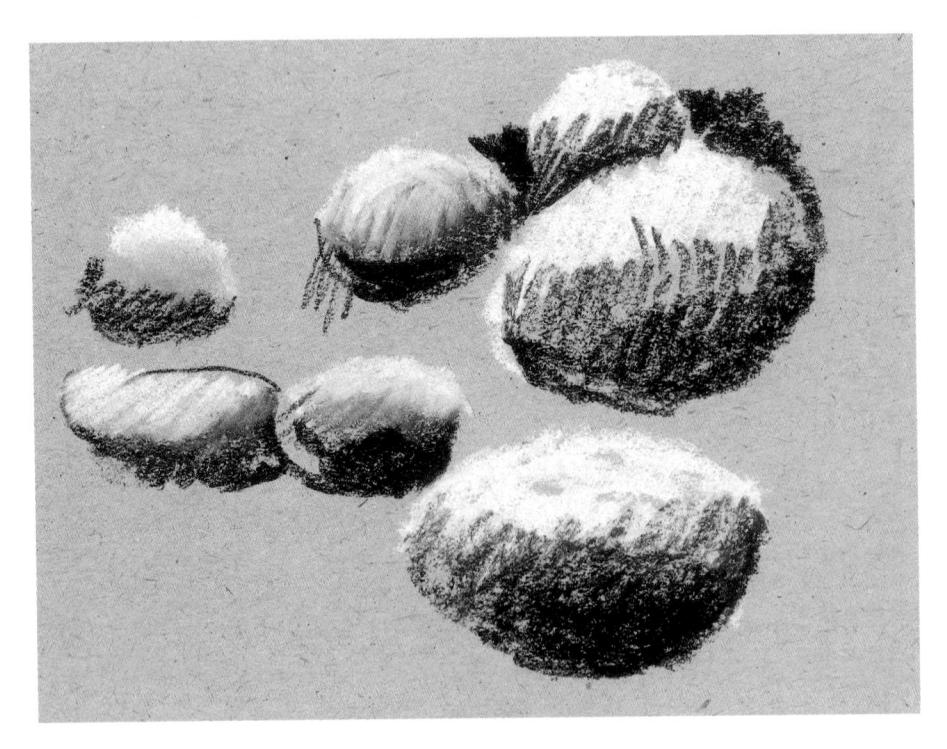

Using white chalk where the light hits and charcoal for the darker tones and shadows, it is possible to produce a sketch with a wide tonal range in a very short space of time. They are both very tactile media and as most of us used chalk in our childhood they encourage uninhibited drawing.

FIGURES FOR SCALE AND NARRATIVE

Figures in a picture not only provide human interest, they convey information about scale and add narrative. You do not need to embark upon complicated drawings to include them, as the viewer will understand more than is explained on paper.

Look at figures as matchstick figures with a head, a spine, the axes of shoulders and hips and the limbs. If you draw the head first and then the arms, it is simple to make the rest of the matchstick figure, and from there it is an easy step to add clothes. A lay figure – a small jointed model available from art shops – is a useful reference.

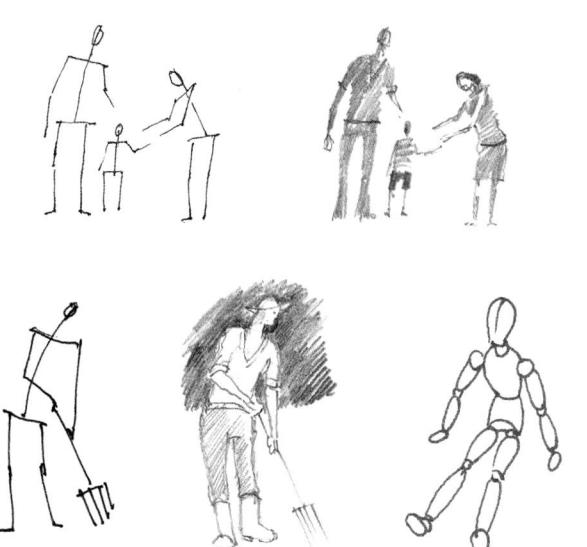

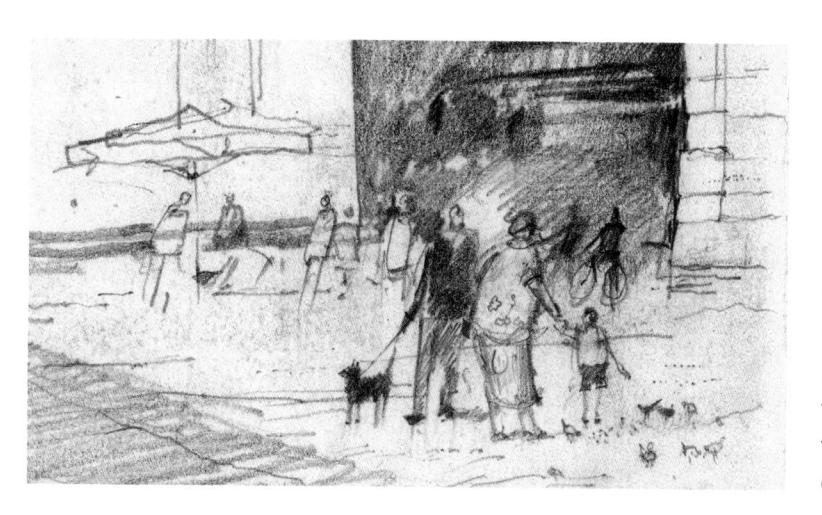

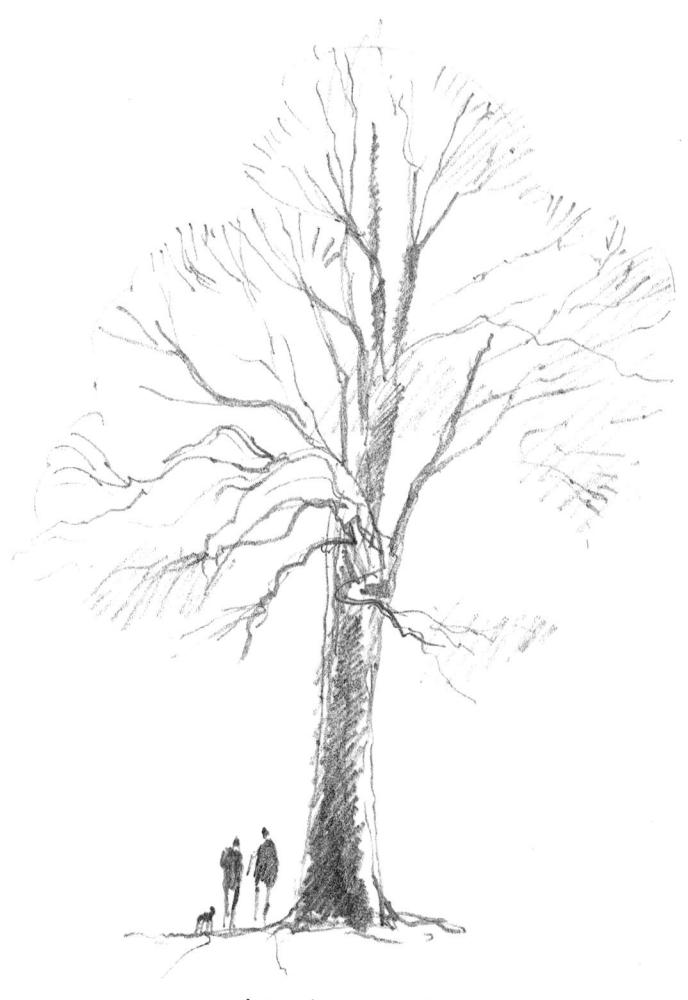

A tree has no scale until we have something to measure it against. Putting little figures standing alongside immediately gives a recognizable scale to the landscape as well as adding narrative.

This little anecdotal study of a family group is only a quick sketch, but these often have the vitality that more detailed drawings may lose. To develop an eye for the poses that people naturally fall into, watch them moving about and make numerous swift drawings in your sketchbook.

COMPOSITION

Making a picture is not simply a matter of trying to record accurately what we see in front of us; we want to show in the way that we place things within a format that we are expressing something beyond the mere depiction of reality. We can do this by the use of linework, tone and where we place objects within the picture plane.

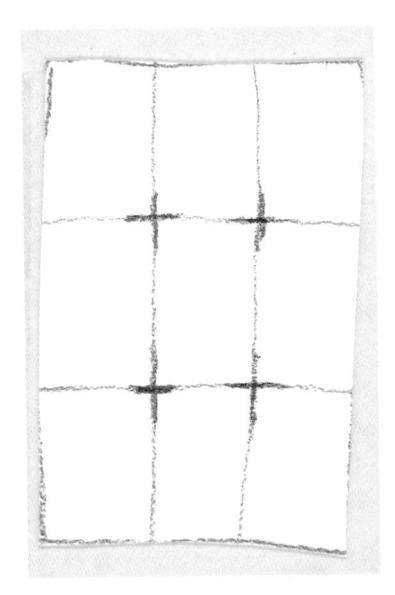

The rule of thirds

Artists commonly base their compositions on a theory known as the rule of thirds, where points of interest are placed on the intersection of imaginary lines dividing the picture plane into thirds. These points of interest may be narrative or strong tones, colours or textures. There is an instinct to place things in these aesthetically pleasing places; when I ask a new group of students to put a mark on a blank piece of paper they consistently put it where the bottom left-hand axis of the lines would fall.

Symmetry and asymmetry

Don't assume that just because you have planned something out in linework in a symmetrical way the final picture will necessarily be symmetrical too, because you have the opportunity to use tone to alter the balance. As linework this vase of flowers looks symmetrical and rather boring, but with strong tone added to it the composition becomes a diagonal one. Using colour too gives you another chance to influence the thrust of the composition.

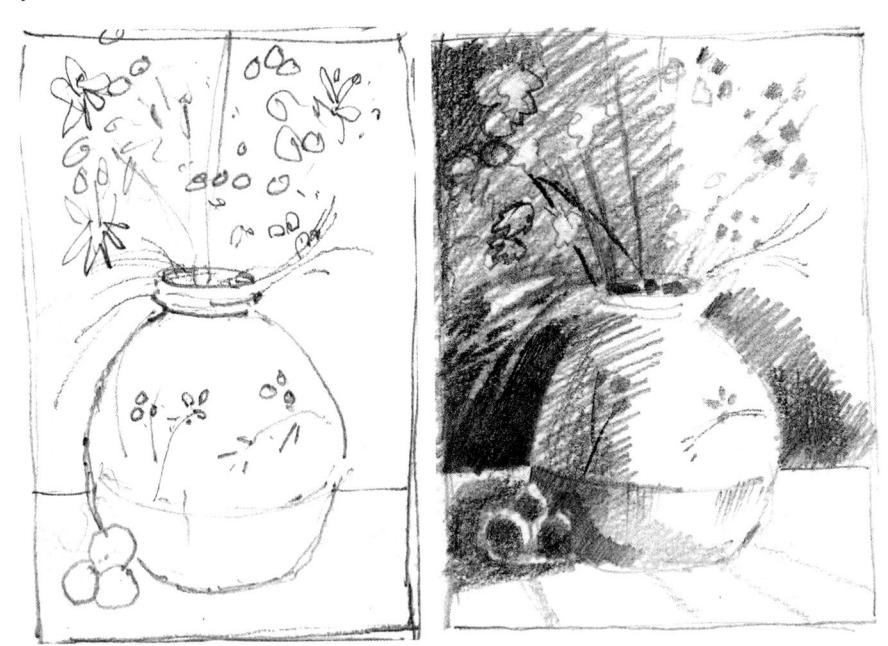

Lines

Horizontal lines give a feeling of calmness, while vertical lines represent aspiration and the soaring, uplifting feel that can be often be found in Gothic architecture. Diagonal lines bring a sense of drama. While we use line to describe the way objects are shaped, there is also an abstract concept involved in that the way we

choose to employ them stirs an emotional response in the viewer.

Placing on the page

When you first arrive at a subject matter it's all too easy to make a quick sketch of it in the middle of a page, and that very often translates to a subsequent painting. It is much better from the outset to guide the eye in a more positive way around the picture, taking advantage of the fact that we invariably scan a picture from left to right. Where the cathedral in the sketches below is placed to the left of quite a broad panoramic format,

the eye goes to the cathedral first and then travels along to the right and is led directly out of the paper. In the right-hand picture, as our eye travels along from left to right it encounters the cathedral as a climax to the visual experience. Turning your body slightly to the left and the right as you look at your subject will help you make decisions about the most satisfactory composition, especially with the aid of your viewfinder.

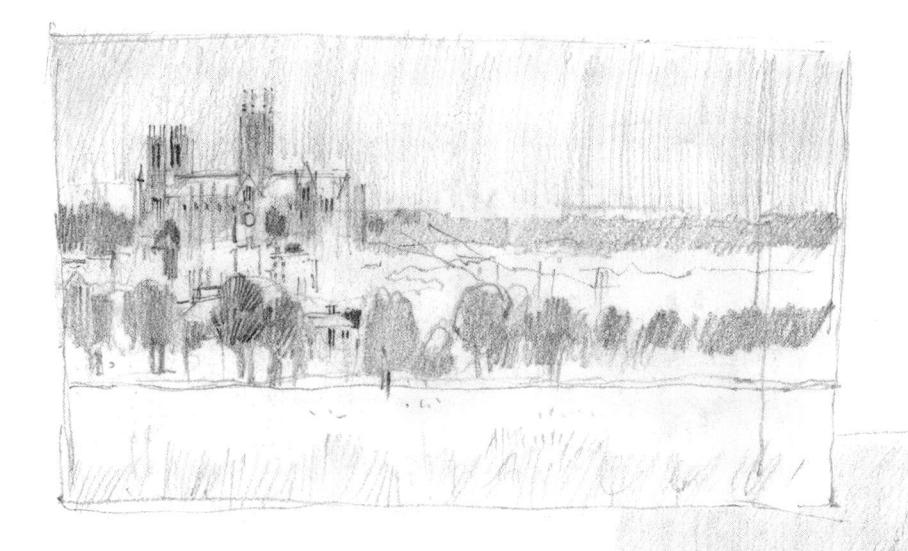

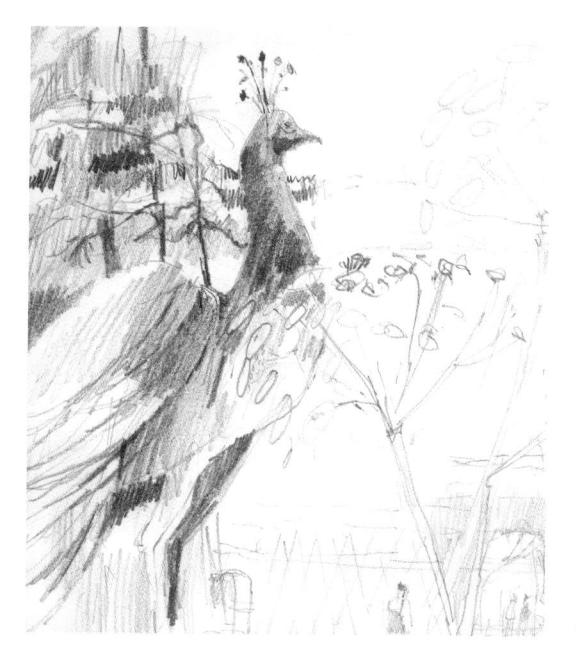

Repetitions

I like to find echoes in a composition, but it was only after I had drawn the peacock's comb and begun on the fennel plant that I suddenly noticed they shared exactly the same shape. Look for and enjoy unexpected repetitions like this, even though they may occur in very different objects.

PERSPECTIVE

LINEAR PERSPECTIVE

Linear perspective is an area that beginners find daunting, and indeed it is possible to buy entire books devoted to the subject. However, in-depth study is not necessary from the outset; all you need is an understanding of certain basic rules in order to show objects receding from the viewer, whether they be in a landscape, a street or an interior.

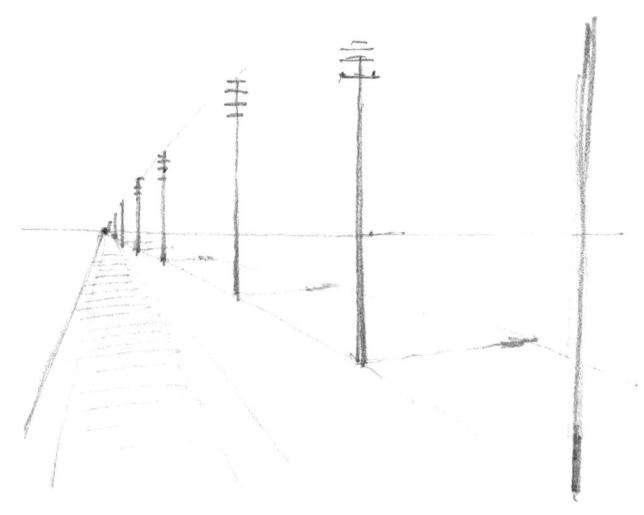

Imagine yourself standing in the centre of a straight road, looking ahead to the horizon. The sides of the road will appear to converge at a point on the horizon, called the vanishing point. All parallel lines running directly away from you will meet at the same point. The rule is known as single-point perspective.

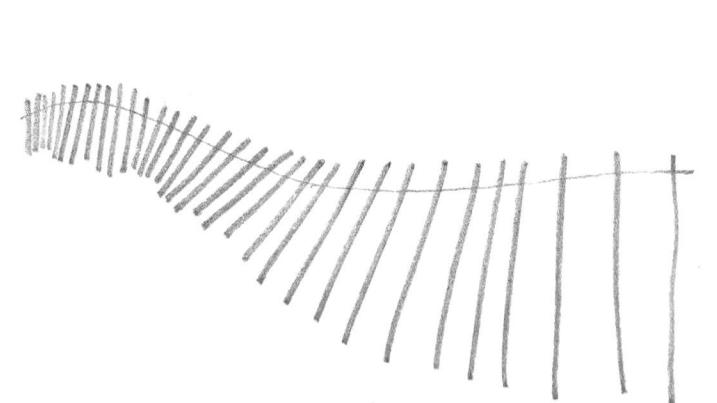

Here perspective is seen at work in a more interesting way, telling the viewer clearly that the rickety wooden fence is running from the foreground to the background of the picture.

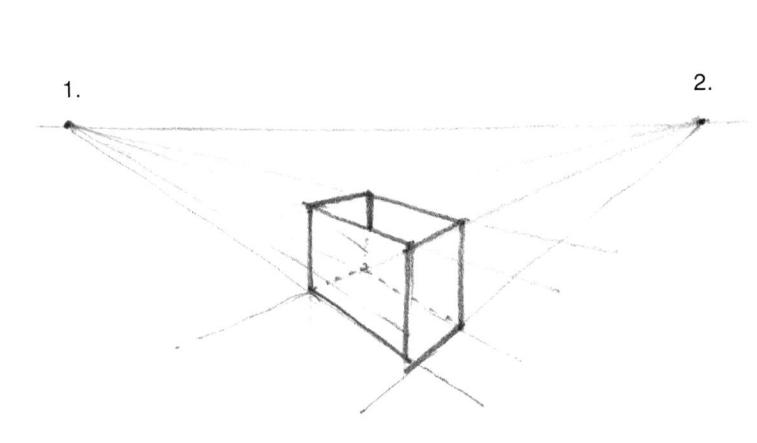

If you confront an object which is not parallel to you, as in the example of a box in three-quarter view, there will be separate sets of parallel lines on either side of the box going to vanishing points 1 and 2.

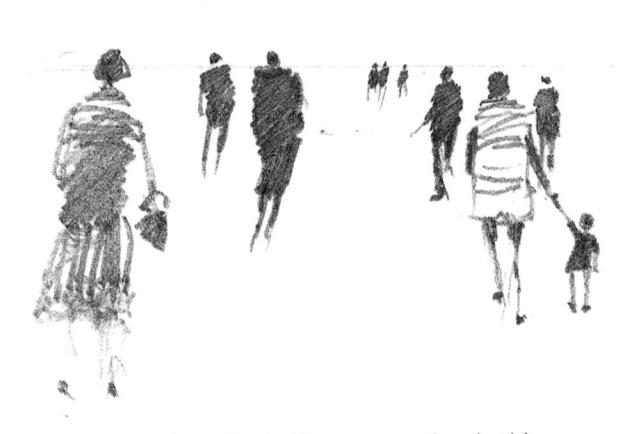

Figures are also affected by perspective. In this illustration, we are assuming that all the figures are adults, and all but one are the same height. Note how all their heads seem to be touching the horizon line and their bodies hang down from that point. In the case of the woman to the right, whose head is slightly below the horizon line, the viewer understands that she is shorter in stature.

AERIAL PERSPECTIVE

Atmospheric conditions cause tones and colours to fade the further they are away from us – think of the pale bluegrey of distant mountains, for example – and details to become softer and more obscure. This phenomenon is invaluable to the artist wanting to establish a sense of

depth in a painting or drawing. All the marks you can see on this page trick the eye into thinking there is recession. Generally speaking, an artist works from distance to foreground, from light to dark and from soft marks to hard-edged detail.

A simple way to show extreme space is to have a series of gradated bands proceeding from light in the distance through the mid tones towards dark in the foreground. This example is in tones from white through grey to black, but this is equally true of tones of colour.

Aerial perspective also comes into play in the density of linework. There are three different tones in this illustration: light, midtone and dark. The lines are all exactly the same width and the same weight, but the eye is tricked into thinking that some are in front of others because the darker ones appear to come forward and the lighter ones tend to recede.

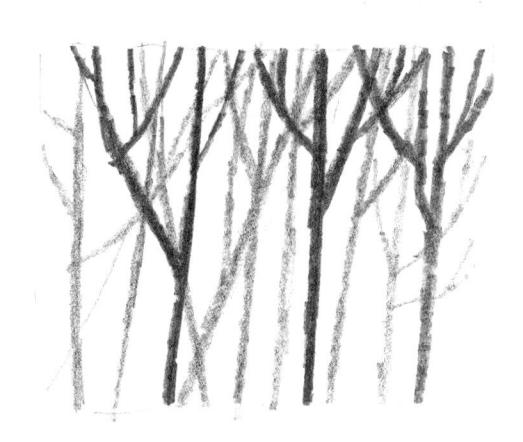

Here the light and dark tones sit side by side rather than crossing each other as in the case of the tree trunks. Nevertheless, they trick the viewer into thinking that the dark ones are in front and the lighter ones behind.

TEXTURE

The more you can understand about the surface and form of an object, the better you will be able to draw it. When I am drawing something with which I am unfamiliar, I usually run my hand over it to become acquainted with the texture. A good way of exploring textures is to take rubbings of surfaces by placing a thin sheet of paper over them and

then rubbing a flat drawing medium, such as the side of a crayon, over them. To show you some examples, I took some rubbings of surfaces in my garden and studio, including wood grains, the tread on a stepladder, the top of an electric heater and a feather.

Top of heater

Wood grain

Stepladder tread

Feather

Wood grain

Feather
LIGHT SOURCES

The appearance of an object can change radically when it is lit from different angles. To begin with, choose an item with a simple shape and set it on a table with an anglepoise lamp to provide a source of illumination that can easily be changed to direct light from different angles.

When you draw exterior scenes where you are not in control of the light, make notes as to where it is coming from. This is essential in architectural scenes where there may be complicated shadows that will change direction as the day progresses.

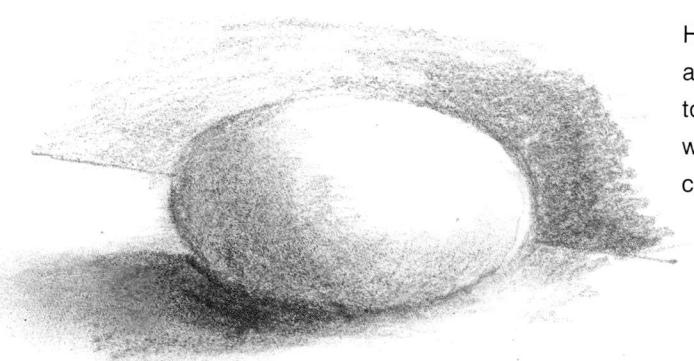

Here an egg is illuminated from a source above and to the right of it. The darkest tone is on the undersurface of the egg where it is furthest from the light. The cast shadow is also at its darkest here.

In this illustration the light source is behind the egg, creating what is known as rim lighting. The side of the egg nearest the viewer is in shade, and the cast shadow is thrown towards the foreground.

I find it useful to draw an arrow on my sketches if I may need information later about the exact source and angle of the light. Here the arrow shows the light source coming in from the right, causing the darkest tones to appear in the lefthand side of the building and the trees in that area. Making a simple directional note like this will help to keep you on track when you are making a more finished drawing.

CHOOSING SUBJECTS

Novice artists tend to draw subjects because they like them rather than for what they might offer aesthetically. To avoid limiting yourself in this way, make a positive decision to find subject matter where you would least expect it. Even if you have no interest in trains, for example, go to a location where there is a working steam engine and see the wonderful effects of steam and light. When I first became an artist I would often drive round all day looking for the

perfect composition and come home with no drawings at all until I discovered that even weeds growing in a ditch with barbed wire behind them could be fascinating in how they related to each other. Try setting yourself tests such as driving for ten minutes, stopping the car and drawing whatever you find there. If you draw everything and anything all the time you will develop your own style rather than trying to copy that of another artist.

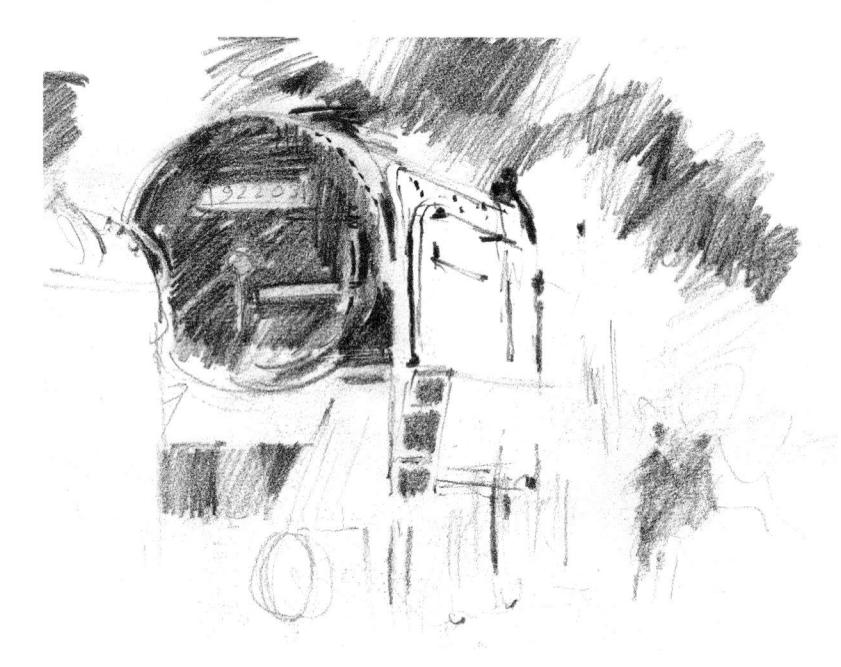

Although this drawing has its roots in heavy machinery, the intricacy of the train is simplified so that the focus is on the steam and space around it, with a couple of small shadowy figures caught in the steam adding some narrative. The drawing shows how you can find subtle things happening in the context of subject matter which you might not immediately think is sympathetic to you.

As this train came into the station I walked backwards along the platform sketching it. It took only as long to do the drawing as it did for the train to pull in, and the whole sense of the noise, the steam and the movement of it all was captured as I was in motion. This drawing is about thinking beyond the obvious and working with flair, speed and vivacity.

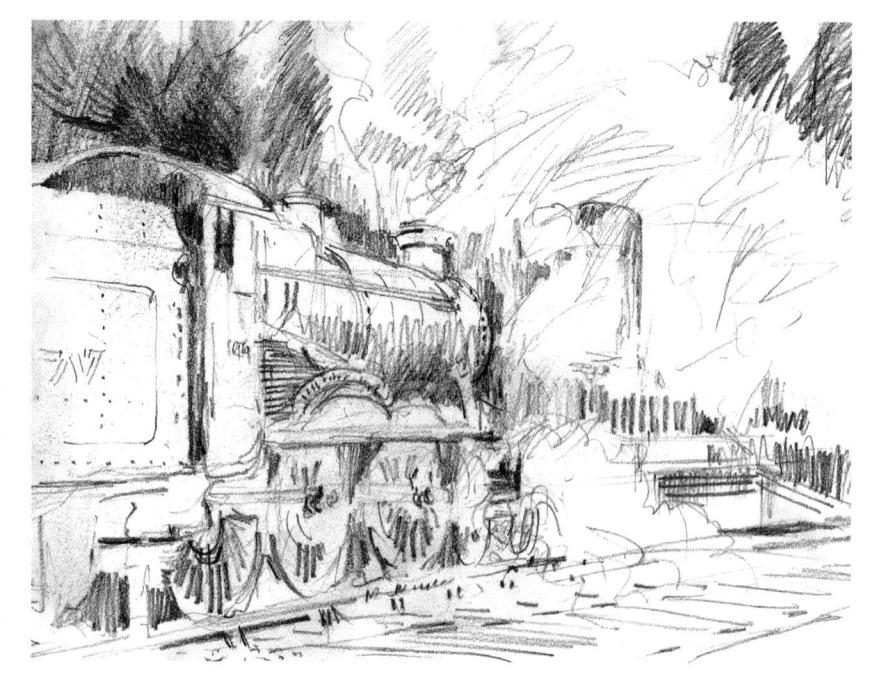

The obvious thing here would have been to move in closer and draw the foreground boat in the centre of the page, but I thought it was a nice idea to make a virtue of the rocky seashore. When you draw in a location such as this you will probably be very aware of the uncomfortable surface beneath your feet, and including that in the drawing will give a picture with a sense of the place rather than just an academic portrait of boats.

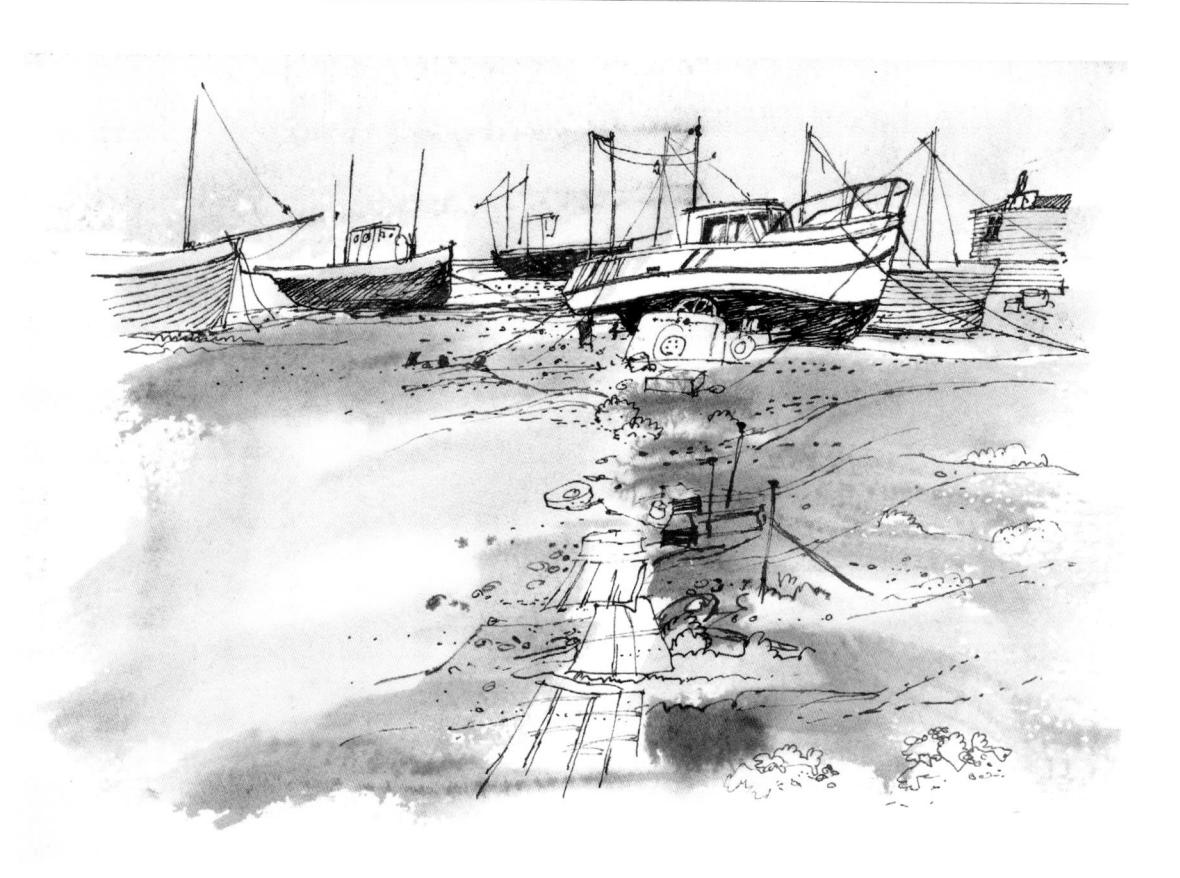

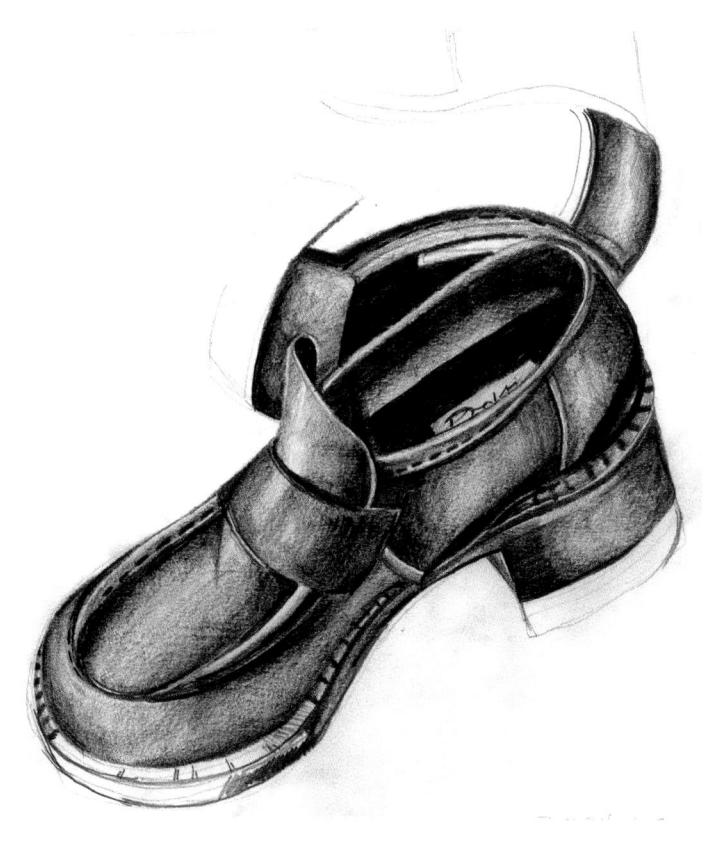

This shoe, drawn by my teenage daughter, demonstrates that it is always possible to find a subject where you can explore texture, tone, line and detail. If you are not able to go out of the house, draw what you can see within it; any drawing you do will add to your skills and your powers of observation.

BUILDING A VOCABULARY

MANMADE OBJECTS

If you constantly practise drawing all the scenes and objects that make up everyday life you will build a visual vocabulary which will become so familiar that you will use it with increasing skill, much as you express yourself with

increasingly fluency in a foreign language the more you use it. Pleasing patterns and rhythms can be found in the most mundane objects, so don't dismiss anything as unworthy of interest before giving it some consideration.

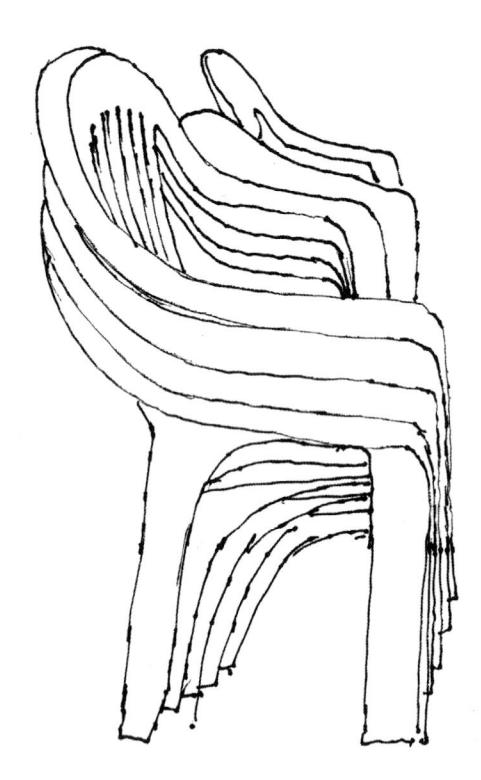

A stack of plastic chairs might not be aesthetically appealing at first glance, but the repetitive lines of this drawing provide a lot of linear interest and show the value of casting your net wide.

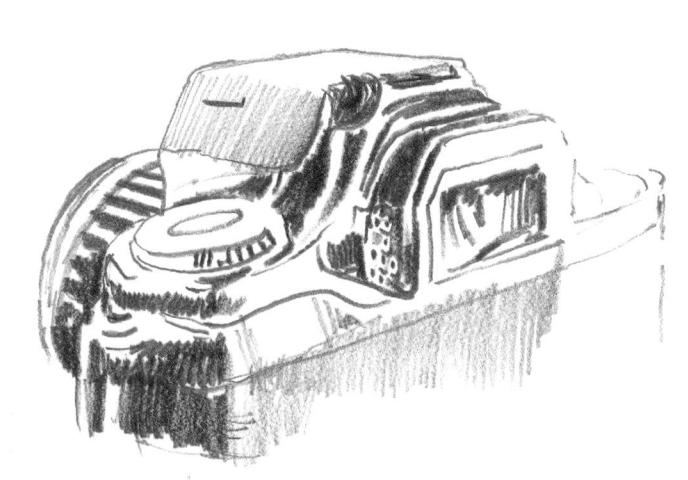

The back of a camera gave me a chance to make a tonal study of a hard, shiny plastic surface with many different planes.

If you move in really close you can find unexpectedly dynamic and vigorous compositions such as this little fragment of a wing mirror on the side of a car. Rather than thinking that a potentially good subject is marred by a car parked in the way, make the most of what you have in front of you.

ORGANIC OBJECTS

Whereas manmade objects tend to be hard and smooth, in the organic world you will tend to find weathered textures and patinas, worn edges and decaying vegetation.

In this strongly linear drawing of onion leaves I used more hesitant marks at the tips to show where they were beginning to wither.

A cut cabbage head called for another linear drawing, the tightly packed marks expressing the solidity and crunchiness of the cabbage heart.

This study of a shell possesses both line and tone to express its ridged form, crusted texture and hollow interior.

BUILDING A VOCABULARY

THE ELEMENTS

The vocabulary of an entire landscape is immense and might seem insurmountable, but by looking at details in certain scenes you will begin to see patterns and themes recurring on different scales. Don't always work at a polite distance from your subject; a farm nestling among hills is a favourite theme for artists, but try moving in really close and

studying the rust on a swinging door. Drawing large-scale studies of the sky will enable you to work at the opposite extreme. While studies such as this may not be interesting as a composition for finished drawing, you can build them into a larger-scale piece. A camera is a great boon in freezing moving subjects so that you can understand them better.

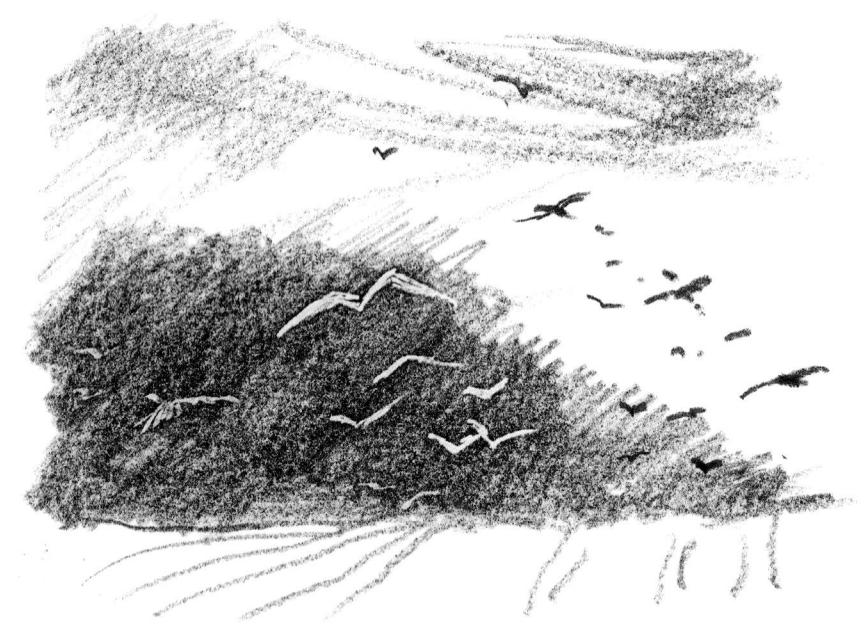

Even a five-minute drawing of the sky is time well spent, and since it is everchanging you are never short of a subject in this respect. There may also be the textural interest of seeing a flock of birds, which will provide narrative and anchor the picture at a moment in time. I sometimes clap my hands to make them fly up in a city scene. Notice here the interplay in how they appear light against dark clouds and dark against clear sky.

Reflections tell the viewer about the weather conditions as well as the nature of the water, be it a rock pool or large lake. If you understand in one small detail how two mooring poles will be reflected in slightly ruffled water you have the key to more complex subjects such as a lakeside forest, which will be essentially the same thing on a larger scale.

The surface beneath our feet is often a clue to the entire landscape. Nature often works to a formula, and one way to capitalize on this is to pick up a stone from where you are working and take it home for reference as to the colour and texture of the landscape. Seen in isolation, this rock cannot be judged as large or small; imagine a small figure standing in front of it, or the leaf of a plant placed next to it. When put into the context of other landscape elements it will establish itself.

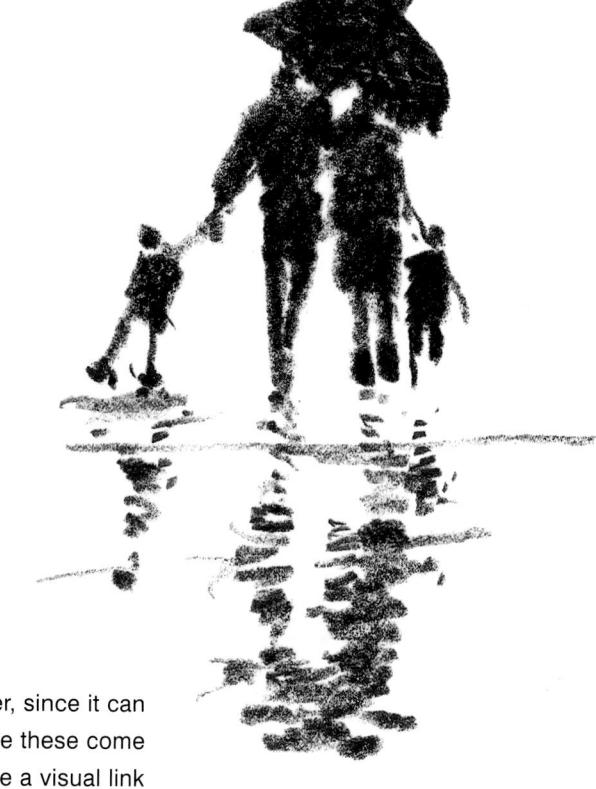

Don't be discouraged by bad weather, since it can produce wonderful reflections. Here these come down into the foreground and provide a visual link between our space and that of the figures, giving the drawing an intimate feel.

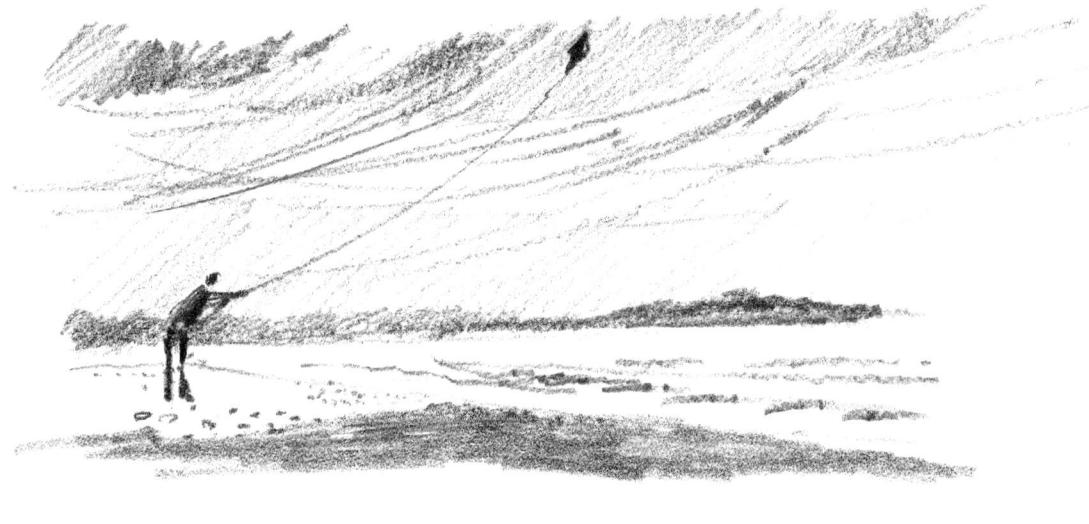

Try to react to the conditions in which you find yourself. I made this drawing of a man flying a kite with broad gestural marks to sum up the gustiness of the wind.

TOWARDS PAINTING

As you become increasingly confident of your drawing skills you will probably feel tempted to have a go at painting too. This may initially strike you as a daunting prospect, since painting can seem to be something difficult and remote. In fact, it is only an extension of drawing; if you

can draw you can paint by simply putting down your pencil and picking up a brush instead. Then, rather than drawing a line, you define areas with paint and the line just happens where two areas meet. Studying the sketches on these pages will help to ease you along the way.

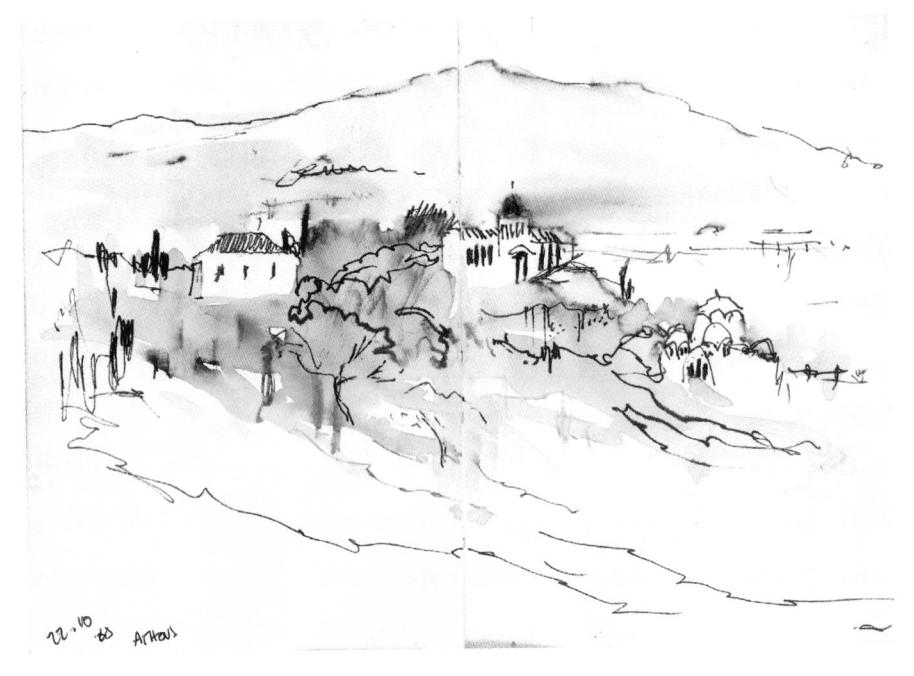

Whenever you make a sketch it is worth bearing in mind that you might want to make a painting from it later in the studio, so as well as making simple linear notes aim to make tonal notes too so that you can identify where the light is coming from and the time of day. This little pen and wash drawing of a Greek hillside has tonal washes, though as yet no hint of colour has been included. You can never collect too much information, so you may want to do a separate colour sketch at the time using watercolour pencils or crayons or even take a photograph to record colours.

In this sketch there is much more detail which may or may not be used in a finished painting. It is a more comprehensive drawing supported by washes on top to give generalized green for the grasses and foliage and red for the roofs, establishing colour notes as well as tone and allowing me to pick and choose what I might want to use in a painting.

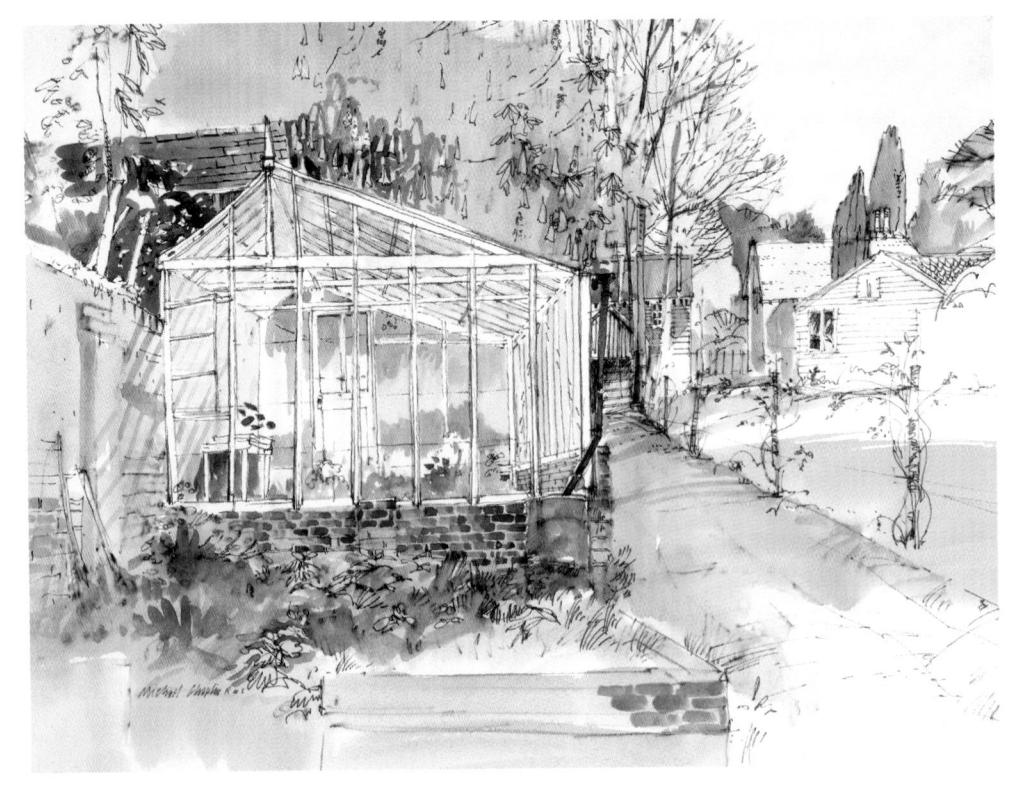

Here I have put the washes down first and then drawn on top of them in pen. In some areas the line is hard and in others soft, according to whether it has been drawn into a dry wash or wet wash respectively. In the interior of the barn you can see lines drawn in sepia ink onto a blue wash, spreading slightly to give a soft effect so that they sit back within the barn, whereas on the face of the door some of the linework is much harder, drawing attention to the door which is the main point of interest. The colour of the door is slightly hotter than the interior, reinforcing the point. Here line and wash are used together to establish depth and give a narrative in the inviting quality of the doorway.

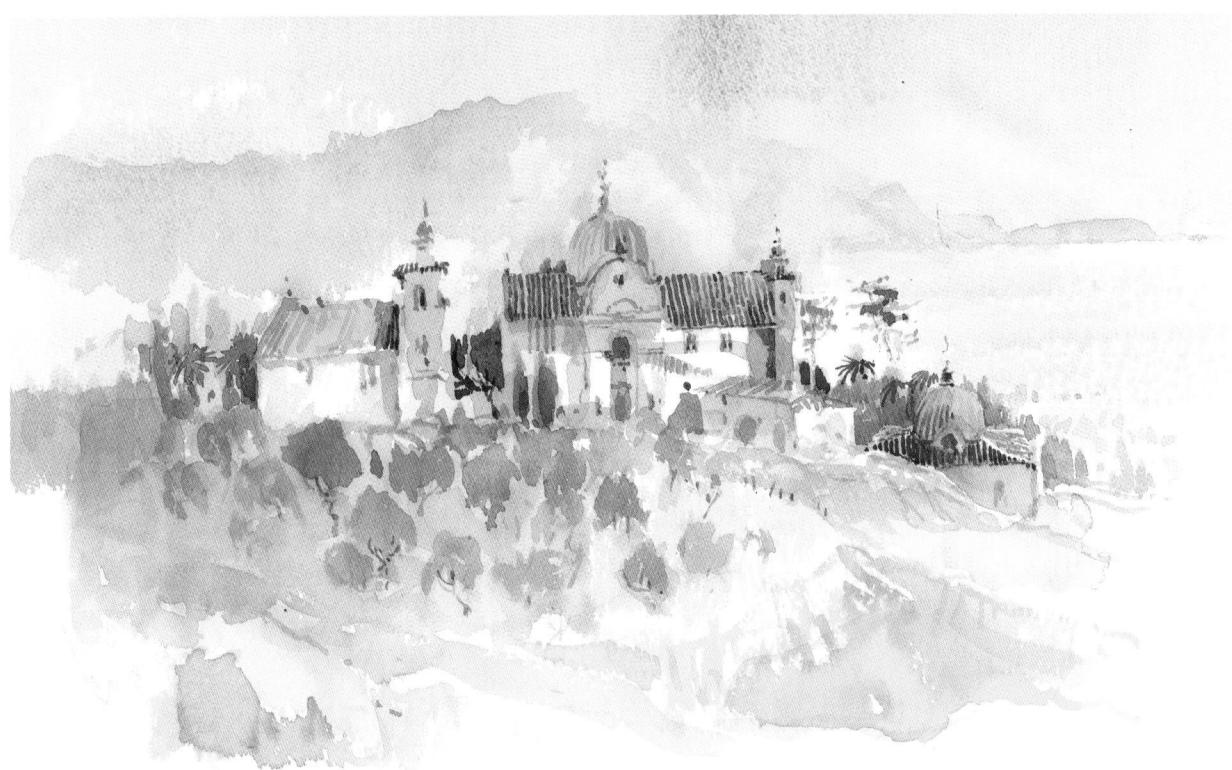

This picture is a coloured version of the Greek hillside sketch on the facing page. It demonstrates what has been done in the sketch of the barn in terms of putting drawing over washes, but here this has been done purely in paint. After laying on the washes loosely, I then added the drawing with smaller brushes, establishing harder edges and darker tones. While this contains elements of what might be considered a typical watercolour with loose areas of wet colour it can still be designated as a drawing, since almost exactly the same marks could have been produced by a pen.

A SIMPLE LANDSCAPE

This exercise shows you how to start off with simple linework and then develop tone, texture and detail within the frame you have created. The tendency is to just follow the shape that manufacturers give us in their sketchbook, but you will produce better compositions if you think

carefully whether that shape is most suitable for your picture. Don't be afraid to work across both pages, or even to stick extra pages on the sides if you want to expand the drawing further.

Step one

In my initial drawing the aim was to explore where the basic shapes fall and to introduce some of the basic rhythms of the landscape, as shown by the trees in the foreground. At this stage I was not trying to get any detail down.

A Service

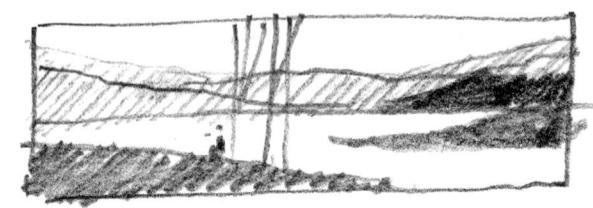

Step two

Having worked from one side of the page to the other, I used my L-shaped mounts to have another look at alternative compositions within that area; a standard oblong in portrait format, a square and a shape about three squares long, known as a panoramic format. The oblong feels a little cramped and the square is difficult to design in, while the panoramic shape gives a sense of the expanse of the landscape. Choosing your format is a matter of relying on your instinct as to what will work best for what you wish to portray. I finally chose a standard oblong in landscape format because I liked the intimacy of the shape.

Step three

If you wish to keep the relative position of objects on the page when you transfer the drawing to a fresh piece of paper, you will need to enlarge your drawing by squaring it up. Draw a simple grid on your sketch and on the paper, remembering that your paper must be the same format as the sketch. The gridlines on your paper should be so lightly drawn that you can barely see them. Then look for critical points of the drawing, and put them in. General measurements are all you need; if scaling up becomes a chore the impetus of the creative process will be lost and your drawing will become tight. If you feel confident enough to draw freehand without scaling up at all, the result may be a better drawing as you allow your creativity to flow.

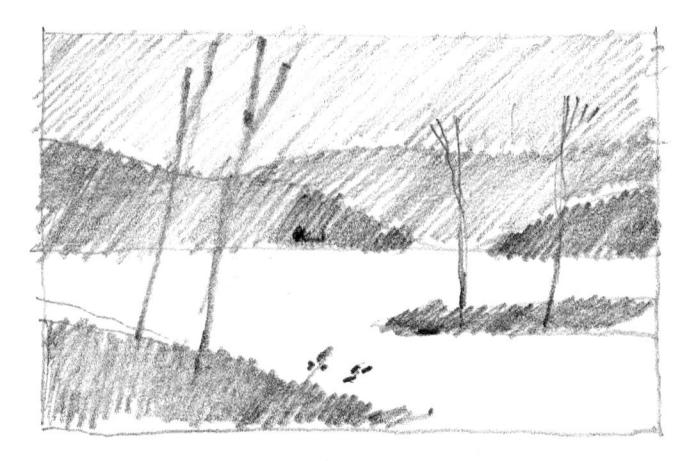

Step four

The next step was to make a tonal sketch. I wanted to make the water appear light and shimmery, so I tried putting some tone in the sky to see how the water would look in comparison. I also started to establish the recession that tonal values give us. When you are doing this, work from lighter tones in the background to darker in the foreground, but expect to have to change these as you go; every time you make one area darker you may find that you left another too light, and you will have to go back and work up the tone further.

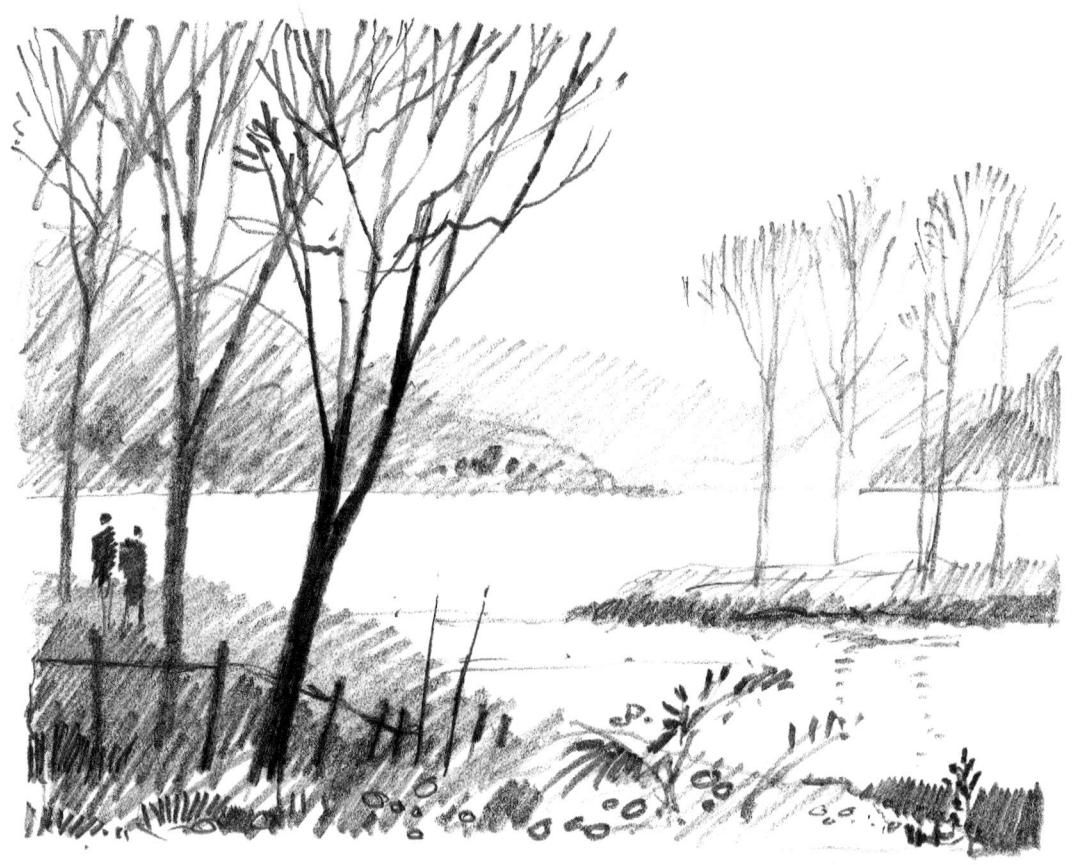

Step five

I now had a clear idea of what I wanted the tonal values to be, so I could embark on my final drawing. As I worked I established more detail and harder, sharper edges in the foreground, while in the background I made edges softer and detail sparser. The trees on the left are much harder, darker and more detailed than the soft fuzz of the trees on the right, which all helps to establish depth. By the time I had finished, the foreground was rich and dark, with midtone in the middle distance and the lightest tones on the far distant hills. The whole picture is linked together compositionally by the way that the trees in the foreground cross over the area of water to the far distance and go out of the top of the picture. They make good frames through which I could introduce little narrative subplots like the two figures framed in the square of light and mid tone.

A STILL LIFE

The photograph shown here merely demonstrates the range of subject matter that was available to me in my studio. You might think you couldn't possibly do a drawing from such an apparently complicated scene, but if you follow the steps you will see that breaking down the early stages into simple shapes and tones makes the final drawing much less daunting than you would expect.

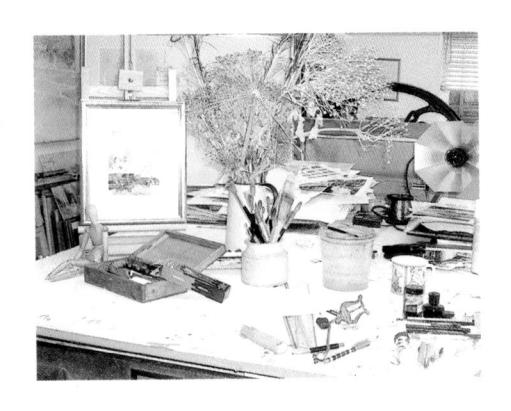

Step one

Looking at the jumble in my studio, I decided to move in much closer and do an intimate drawing of the items on my table. However, I moved in so close that I discovered I couldn't fit in all the objects I wanted to include.

By moving my easel back a little I made it possible to get everything in. I changed the format by ignoring the area of paper on the right (see the vertical line), making a conscious decision to stop drawing at this point rather than just filling the paper.

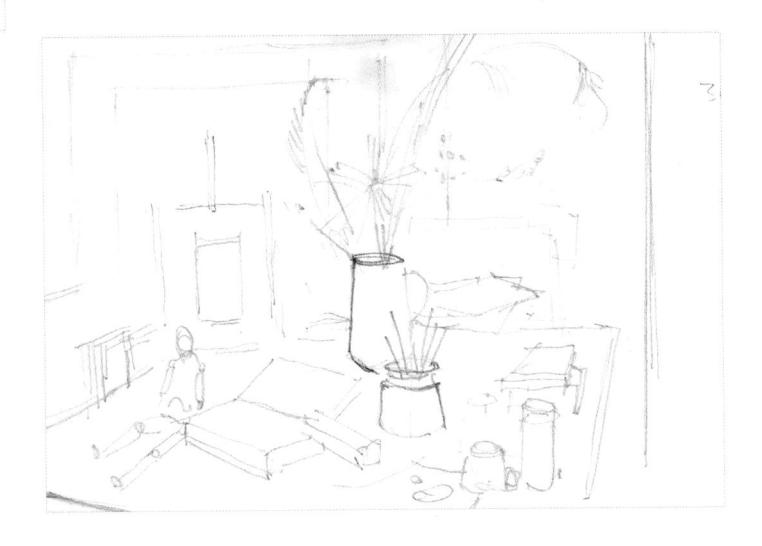

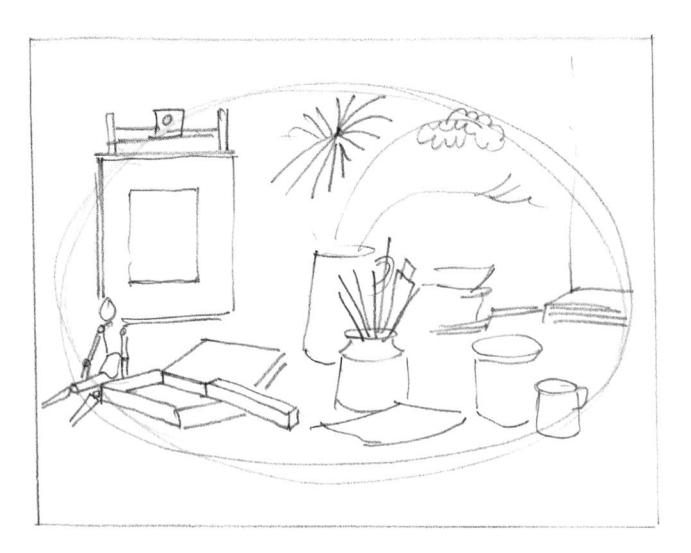

Step three

It is easy to become confused by a number of separate objects on a table top, but if you can see a cohesive overall form it helps you to focus the composition. Here, the objects all sit within an oval shape, with no disjointed elements scattered about the paper. At this stage, only simple outlines of the objects are needed to find out the main thrust of the composition.

Step four

An alternative to Step Three is to make a thumbnail drawing, squared up and with all the diagonals put in. This allows you to see the specifics of where the objects are placed. The jug is exactly in the middle of the picture, the open box is in the middle of the bottom left-hand corner and the two little jugs are in the middle of the bottom right-hand corner. Carrying out this exercise allows you to check exactly where objects are in relation to each other before you become so involved in your drawing that you are reluctant to change them if you discover they are misplaced.

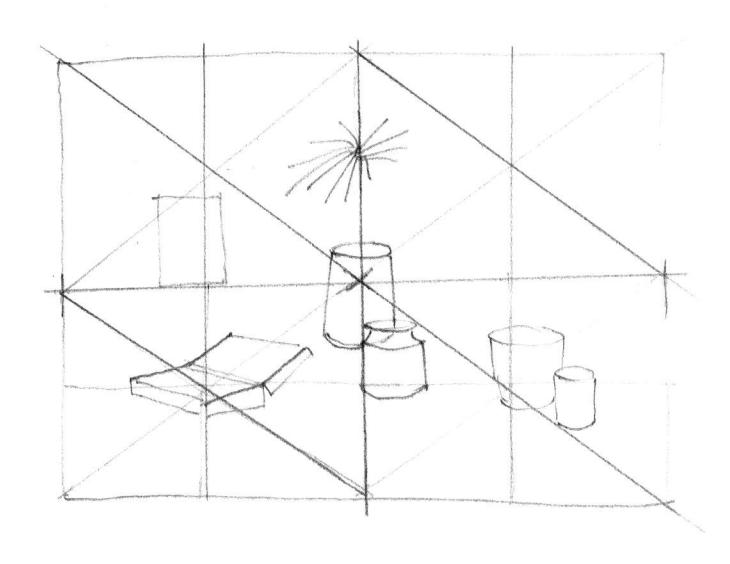

6533

Step five

Establishing the tonal values of the composition is the next step, scrubbing in broad areas with the side of the pencil for speed. This tonal sketch gave me a preview of how the finished drawing would look in terms of lights and darks. While laying down these basic tones I was thinking about the light shapes I was leaving which, though they were not drawn, would be a positive part of the finished work.

Now I was ready to start on the drawing proper. It is best to start with one object and use that to measure from, so in this case I drew the central vase first and then the jar with the brushes. Measuring as I worked, I placed all the various elements within the shape.

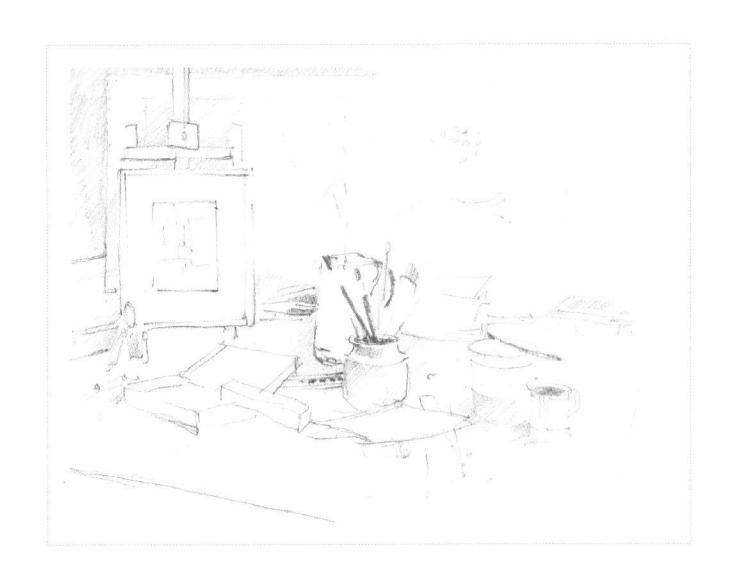

A STILL LIFE

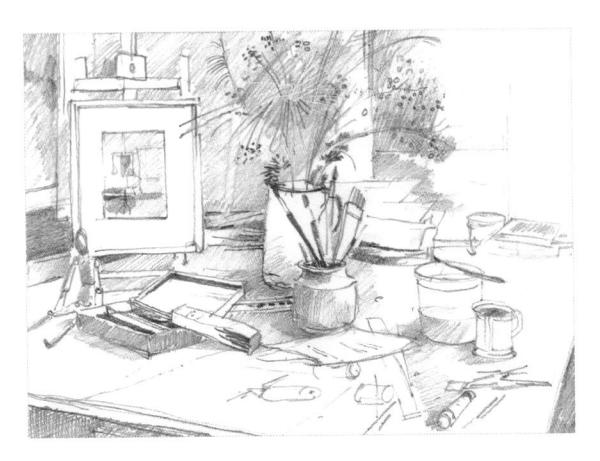

Step seven

I began laying in the tone and adding the detail, establishing hard and soft areas, looking for rhythms in the drawing and trying to make the surface interesting for the eye to travel across. I drew some of the foreground objects, such as the brushes, with more detail, while others I left loose and soft; the screen at the back of the studio, for example, is just a shadowy oblong. I used very hard, sharp lines around the gilt frame and pointilliste and stabbing marks on the plants to show the difference in texture between the hardness of the frame and the soft, feathery plant material.

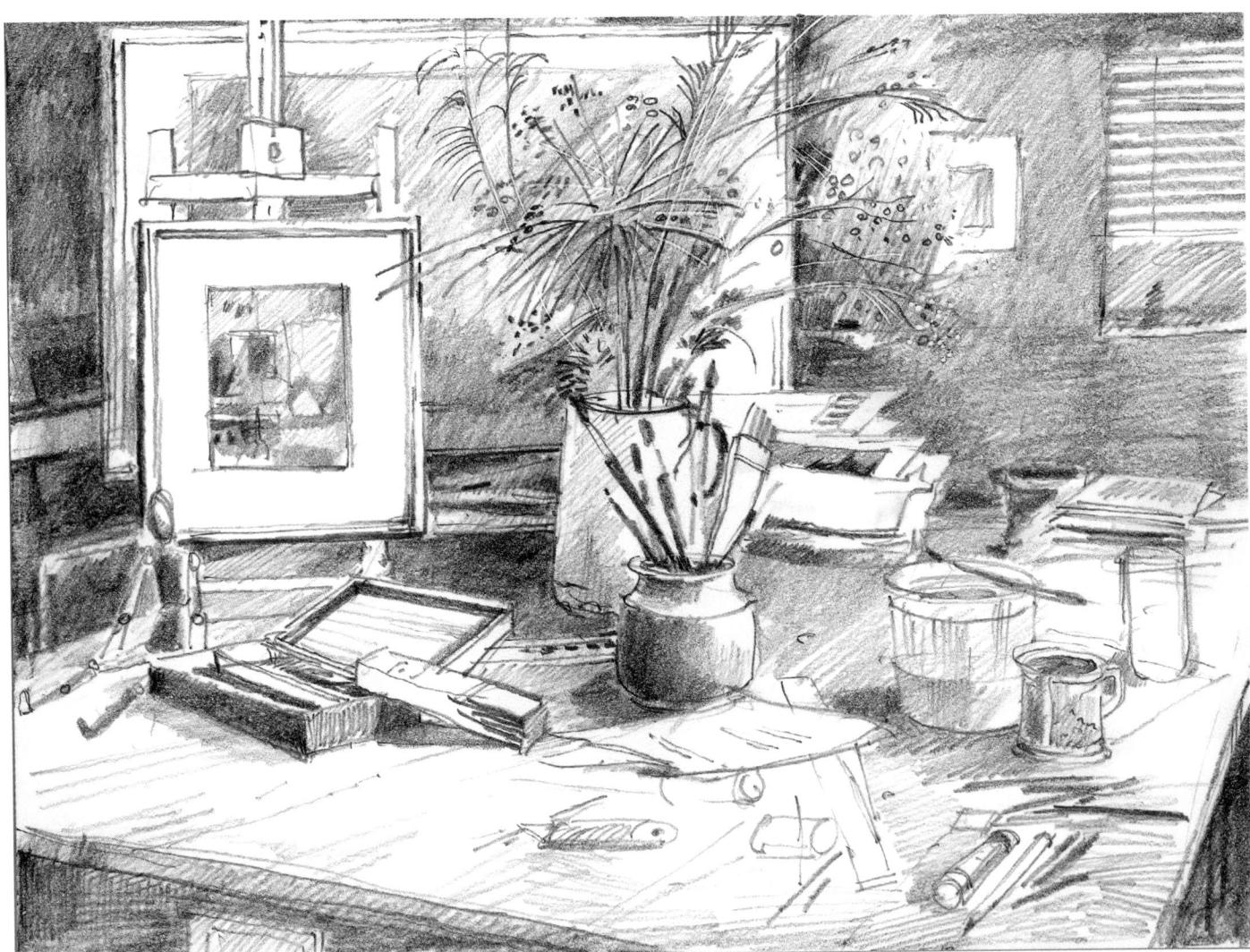

Step eight

The final step was to consolidate the tone and work up the final sharpened detail. The screen in the background now became quite a feature of the composition as I liked the sense of the repetition of oblongs in the gilt frame, the screen and the overall shape of the picture.

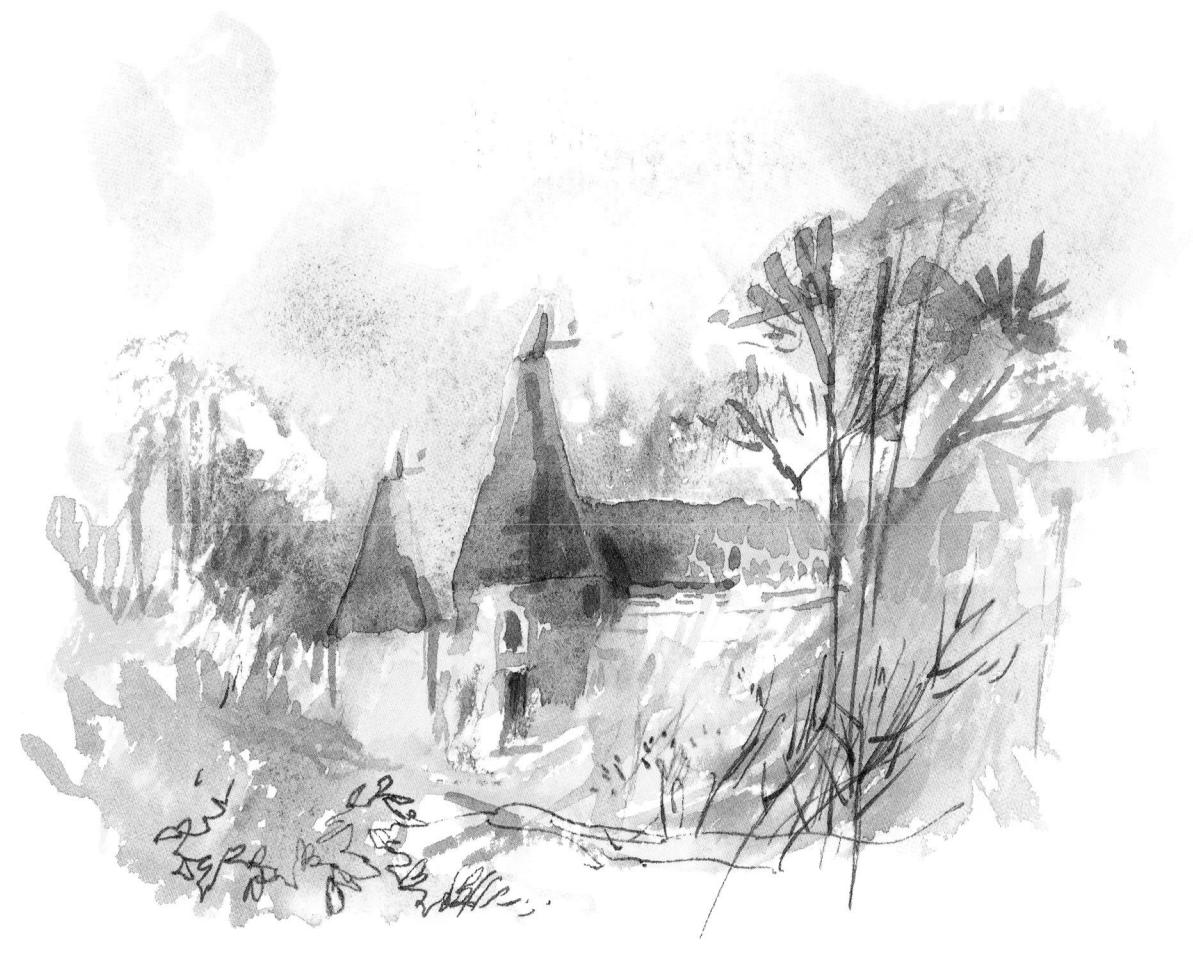

WATERCOLOURS

The accessibility of watercolours makes them a popular medium for novice painters. If you feel shy about your lack of knowledge, you need not even brave an art supplies shop, with its racks of confusing materials; many high street stationers stock paintboxes and watercolour paper, and you can set yourself up with basic equipment with no trouble at all.

Unfortunately, over the centuries their simplicity has made watercolours seem an inferior medium to oils. It was not until the golden age of watercolour in the late 18th and early 19th centuries that it was recognized as a painting medium in its own right, and until quite recently it was still regarded in some quarters as mainly something for amateurs to dabble with. In fact, watercolour is hard to work with, because you cannot completely control it and you cannot hide your mistakes. Watercolourists love it for its unpredictability and today, when artists are free to push the boundaries of how they use their media, it is possible to use it boldly and experimentally.

In the following pages you will discover basic watercolour techniques such as putting down and lifting off pigment, painting negative shapes and using resists. If you practise techniques such as laying a flat wash until you are proficient with them, you will have laid the groundwork for developing your own style and becoming a skilled watercolourist.

PAINTS

Watercolour paints are available in students' or artists' quality. Artists' colours are often more expensive, and today there is not a great deal of difference between the two; as manufacturers have improved their processes, quality has improved so that students' colours are now as good as artists' were 30 years ago. The colour range is smaller and the colours tend not to be quite so transparent, but if your budget is limited buy the best brushes and paper you can afford and economize on paint.

Pigments come from various sources, some natural and others manmade. The former are oxides, earth, vegetable and animal extracts, while the latter are dyes, often a byproduct of the petrochemical industry. As the natural products are much easier to lift off the paper than the dyes, which leave a permanent stain, you need to understand how your paints will behave. Ask manufacturers for their paint charts, which will describe whether each pigment is lightfast or fugitive and opaque or transparent.

PANS OR TUBES?

Pigments are available in either tubes or pans. Pans are convenient, especially half pans for travelling, but because they are laid out in front of you when you open the box there is a temptation to dip into all of them. With tubes, your decisions about colours are conscious ones and your palette will benefit.

Pans tend to dry out quite quickly, especially in hot weather, so if you want to keep them moist from day-to-day, dampen a piece of tissue paper, lay it in the paint box and put the box in a polythene bag overnight. You will not be able to make good strong watercolours from dried-out pans, so if you have not used your paints for a week or more, fill the sink with water and put the whole box in it for about 30 minutes. If a tube dries up, make a cross-shaped incision, peel the corners back and use it as a pan instead.

WATERCOLOUR PASTELS AND PENCILS

Watercolours are now manufactured in both pencil and pastel form. You can use the pencils as a drawing tool, applying colour with the point, although they also give you the chance to use clean water and a brush to feather out the line. With pastels, you can scrub in a large area of colour and then blend it with water and a brush.

Another way to use pastels and pencils is to pick up colour by working a wet brush round their ends. The colours are not as strong as pans or tubes, but they make an ideal store of paint if you want to travel light.

BRUSHES

The best brushes are made from sable hair, which has excellent waterholding qualities. They come to a fine point and have a lovely springiness to them, making them an excellent drawing tool. It is often assumed that if you are drawing a fine line you need a fine brush, but the problem is that it will quickly run out of paint and you will have to go back to your palette for more, thereby losing concentration on your line. A No. 8 or No. 10 sable brush will come to a one-hair point but will also hold enough colour for you to draw a line for five minutes. It will be expensive, but will save you buying a range of sizes and will last you for ten years if you look after it well.

Wash out your brushes at the end of each painting session, roll them in a piece of kitchen towel to dry them and stand them upright in a jar – never with the bristle end downwards. If your brushes do suffer from a build up of pigment at the base, wash them gently in soap (not detergent), work in a little hair conditioner to replenish the oils and rinse out. When you are storing sable brushes long-term, put them in a drawer with mothballs.

If you are wary of the expense of a sable brush while you still a beginner, buy a brush that is a mixture of sable and nylon filament. Nylon does not hold water well, but the mixture of the two hairs gives you the qualities of sable as well as the strength of nylon so that you can be rougher with the brush without worrying about damaging an expensive tool.

As well as your round brush, you will find a hake useful for spreading paint over large areas. Hake brushes are usually made of soft goat hair and are available in sizes up to 50 mm (2 in) wide. A flat brush of about 10 mm (½ in) can be used like an italic pen, giving a fine line used sideways or a broader one used flat. A soft mop brush, usually made from squirrel hair, is good for putting down paint loosely, wet-into-wet. For fine linework such as you might encounter in a winter tree, a rigger (originally used to paint rigging on boats) will give lovely straight lines. Finally, a travelling brush with a little cap to protect the hair is useful – but make sure it has a small hole in the cap or else it will go mouldy.

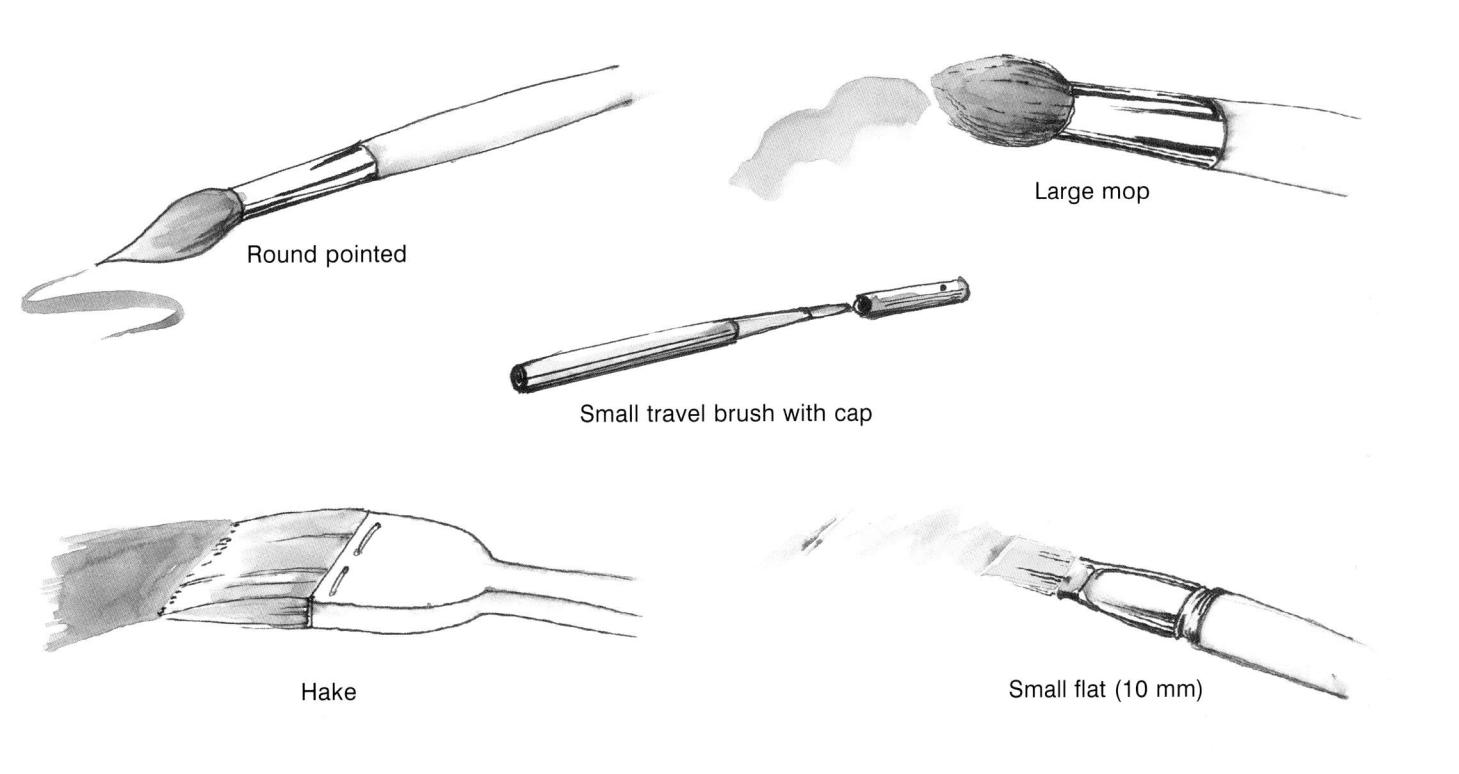

PAPER TYPES

Inexpensive papers such as cartridge paper have a high degree of acid wood pulp and will turn brown when exposed to light, so unless you are just making temporary sketches, always use cotton rag or woodfree paper (confusingly, the latter is made from wood pulp but has had the acid removed). Handmade cotton rag is the best quality paper, but as a beginner you may feel more inclined to risk experimental work if you use

mould-made paper, which is made of similar pulps but is cheaper.

Because they are not bleached, natural-fibre papers tend not to be pure white. A warm white is ideal for a painting with warm colours (see p. 68) but if you will be using a cool palette, look for the whitest paper possible or your cool colours may look quite muddy. Alternatively, paper is available already tinted in cool blue-greys.

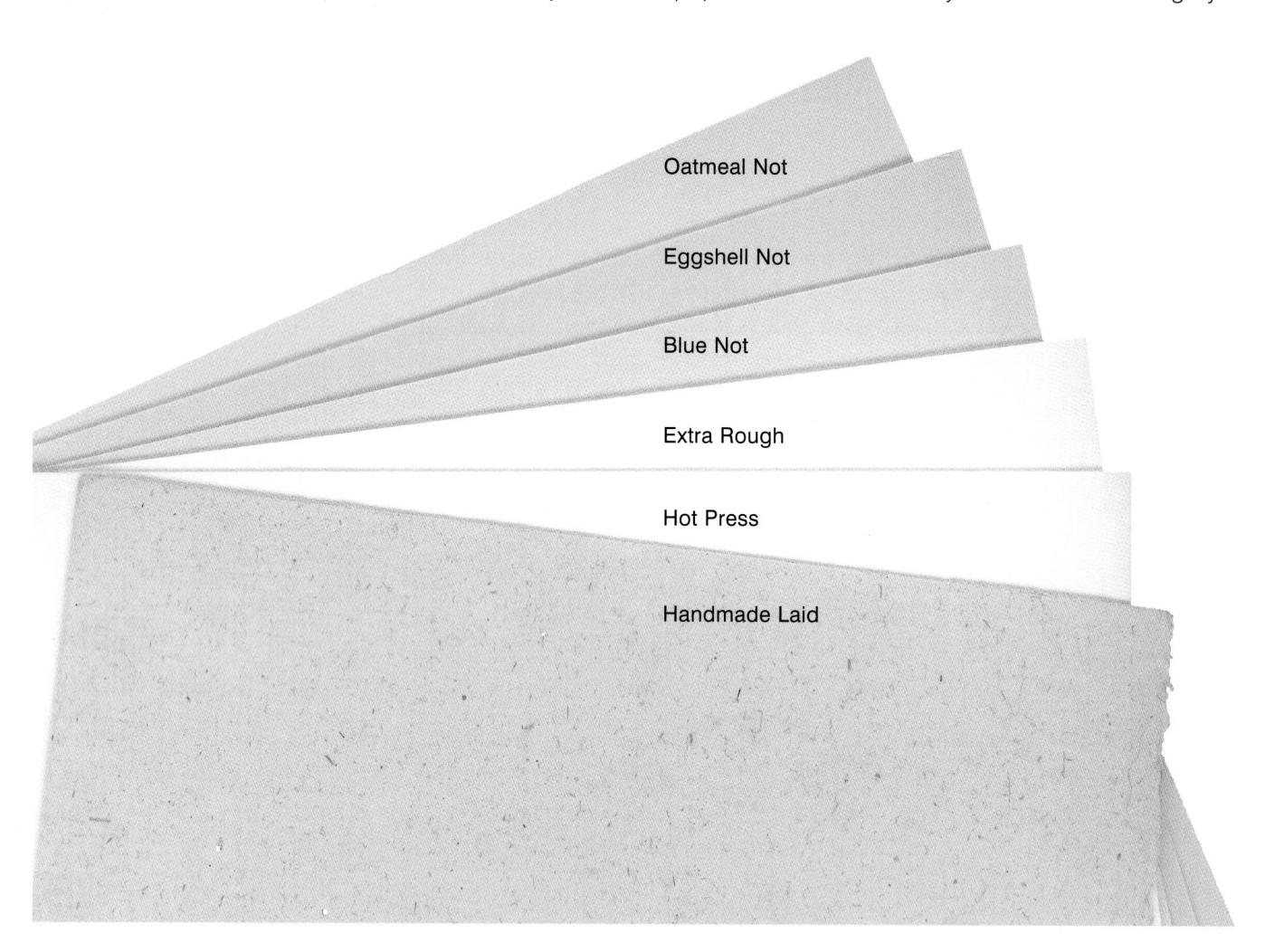

PAPER SURFACES

The surfaces available are Hot Pressed (smooth), Rough and Not, meaning Not Hot Pressed, an intermediate surface between the two. To cater for the current popularity of loose, impressionist painting, many manufacturers now also offer Extra Rough. Another option is Laid, which has the ridged surface found in some types of good-quality stationery.

The surface of the paper you are using is crucial, as it will greatly influence the quality of your marks. If you want a high degree of accuracy with hard, tightly defined edges, you will need a smooth paper which the brush can move over fluidly, whereas on a Rough paper, the brush tends to hop and skip over the surface, giving you a painting that is exciting in terms of texture and spontaneity.

The finely ridged surface of Laid paper makes it particularly suitable for architectural subjects, where it hints at the texture of hard, rough, manmade surfaces.

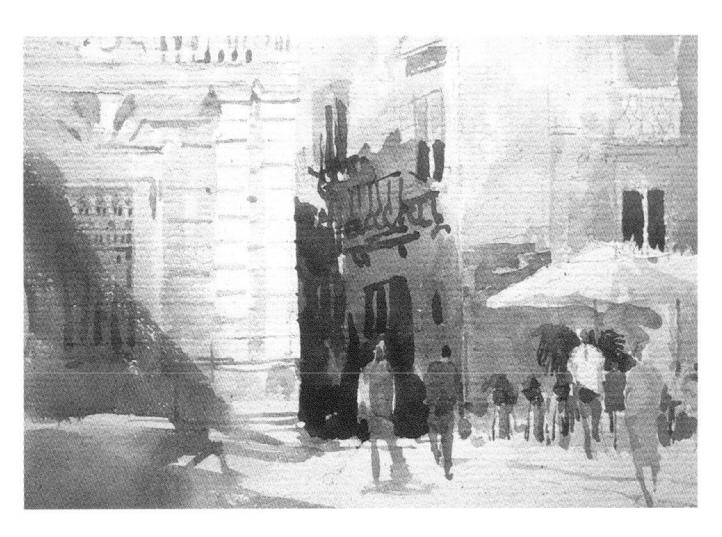

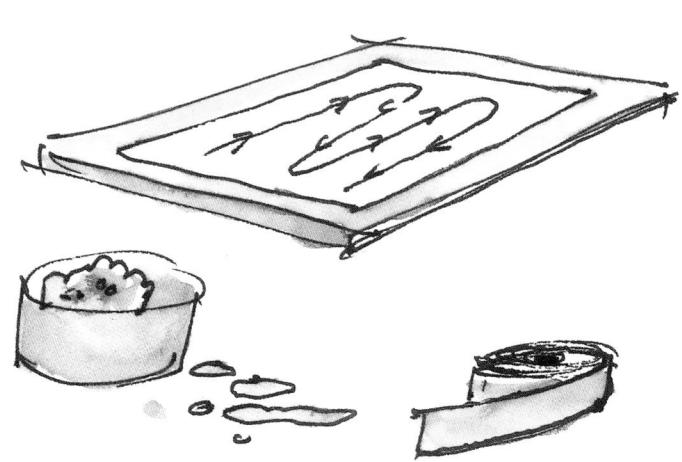

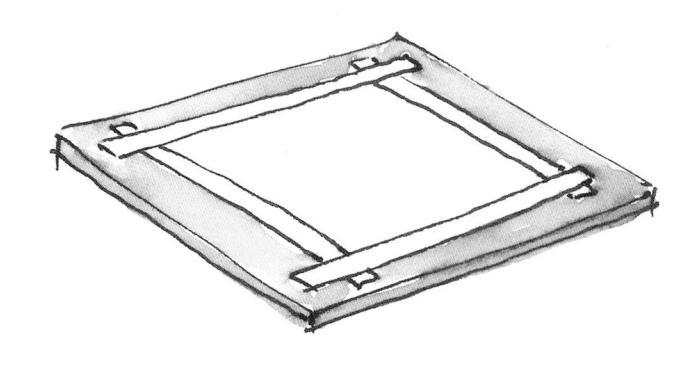

STRETCHING PAPER

Most amateurs, and many professionals too, work on paper of 300 gsm (140 lb) weight, which often does not require stretching. However, if you are laying very wet washes, or using a lighter-weight paper, you will need to stretch the paper before beginning work or it will shrink as it dries and your painting will be cockled.

To stretch paper, soak it thoroughly with a sponge, working from side to side to make sure you cover it evenly. While it is still wet, tape it firmly onto your drawing board with gummed tape (take care to keep the tape well away from the water, since if it gets wet it will glue itself together). As the paper dries, it will be held in place to prevent

shrinkage. A large piece of heavy paper may stretch by 1 cm (½ in) along its length and will exert enough tension as it dries to pull away from beneath the gum strip, so supplementing that with a few staples is a good precautionary measure.

If you are planning a painting with an overall warm or cool tone, you can tint it as you stretch it rather than using clean water. Not only does it give you a head start with the colour temperature of your work, it also removes the psychological difficulty that often comes with putting a first mark on a clean white sheet of paper.

EQUIPMENT

Brushes are not the only tools for putting down paint: try a sponge, cotton buds, a feather, twigs and your fingers. Any way you can pick up paint from a palette and transfer

> it to paper will make a mark, so be inventive.

You can buy texture paste for use with watercolour, either mixed with the pigment on the

palette or built up on the paper to make a texture into which you can then rub or float colour. You can spread it with a spatula and draw into it, press fabrics into it and play about with it to see how many different textures you can make.

Gum arabic is already present in watercolour pigment, but you can add more to your water jar to make the paint more viscous and tactile. It will sit on the surface of the paper for longer, giving you more time to manipulate it, and is particularly useful in hot climates.

Art shops stock a range of palettes. but an old white china saucer or plate will do just as well. I use a large plate with a fluted rim along which I can dot

the pigments so that they are kept separate and are easy to dip into.

You will need some sort of drawing board. A wooden one will be essential for stretching paper, but a piece of

foamboard is more practical when you are out and about. Two pieces of foamboard hinged together with tape will provide a safe way of transporting your paper safely.

Choose an easel that suits your way of working. A tabletop one will be cheaper than one on legs; a couple of bricks on which to prop your drawing board are cheaper still. A handrest made of a piece of wood with two chocks under it will provide a bridge so that you can work directly above your painting without putting your hand in the wet pigment.

If you want to dry pigment quickly, use a hairdryer held about 30 cm (12 in)

Masking fluid is available from art shops, and you will need an old brush to apply it. Never use your good brushes as they will be ruined. Have some cotton wool handy for lifting out paint, a craft knife for scratching out and kitchen towel for mopping up excess water on the paper. A putty eraser fulfils a double role of erasing your drawing marks and lifting off paint.

When working outdoors, you will find that an umbrella is essential, not to shield you from rain but to keep the glare of the sun off your paper and prevent your eyes from becoming tired. It will also enable you to see tone properly, which is not possible in strong sunlight. You can wear sunglasses for drawing, but these have to come off when you embark on colour.

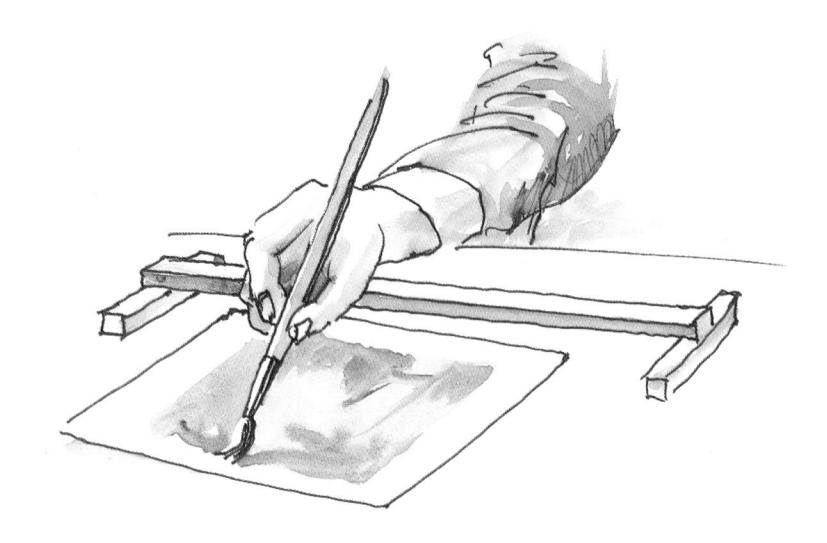

ORGANIZING YOUR WORKSPACE

You may not have the luxury of a room or studio all to yourself, but do try at least to have some bench space of your own, even if it is in the garage or a dry shed, so that you can leave your work out. With it in full view you may see the need for a few little marks that will be easily applied

with all your tools handy, whereas if you have to put everything away at the end of a painting session you will wait to find a clear stretch of free time before you begin to assemble everything again and the end result will be much less time for painting.

Your bench should be in front of a window, ideally one with north light so that shadows don't move across the paper. If you only get the chance to work at night, buy daylight bulbs, since ordinary household bulbs have a pronounced colour cast. You will need an anglepoise lamp, and of course a comfortable chair.

Find an arrangement of items on your bench that suits you and keep them in the same spot so that you don't interrupt your train of thought about your painting by searching for things. Your hand should be able to move easily from the pigments to the palette and water jar. It should not move so easily to your coffee or tea cup – have a house rule that no one puts drinks down near your bench. If you don't knock the cup over, sooner or later you will dip your brush in it by mistake.

Store your paper somewhere dry and safe from mice, which will chew it. A zipped folio from an art shop is the best option and it can be stored upright to save space.

PUTTING DOWN PAINT

LAYING A FLAT WASH

If you can lay a good flat wash then you are well on your way to a good painting. However, it is one of the most difficult watercolour techniques and you will need a lot of practice. There is no right or wrong way to do it: it is a matter of personal preference. Some people prefer to work on dry paper with a very big brush, flooding the paper with colour and allowing the paint to settle down unaided; others dampen the paper right through and work from side to side with a fully loaded brush, with generous strokes that sweep on to the drawing board on either side of the paper. A flat wash is best done with the board flat, on a table, the ground or even your knee.

I lay my washes on dry paper because I like to leave little areas of white paper to give me splashes of sunlight in the picture later on, but as a beginner you may find it easier to work on wet paper. The paint spreads more easily, and if you have put more down on one side than the other you

can tilt the board to encourage the colour to move across the paper.

Practise laying flat washes on small pieces of paper measuring about 10×15 cm $(4 \times 6$ in) to accustom yourself to how the brush travels across different types of paper and how much water you need to load the brush with so you cover the space. It is important not to run out of your colour mix halfway through a wash, and again the only way you can learn how much you need is by practising.

Sheppey Marshes 25 × 33 cm (10 × 13 in) Because I was working against the light in silhouette, this painting is about dramatic tone rather than colour and it required very simple flat washes. These were of Indigo laid over Cerulean Blue with a little touch of yellow to give it a slightly green tinge. The painting's spatial quality comes from the simple flat shapes and lack of detail, allowing the eye to travel back to the infinite recessive sky.

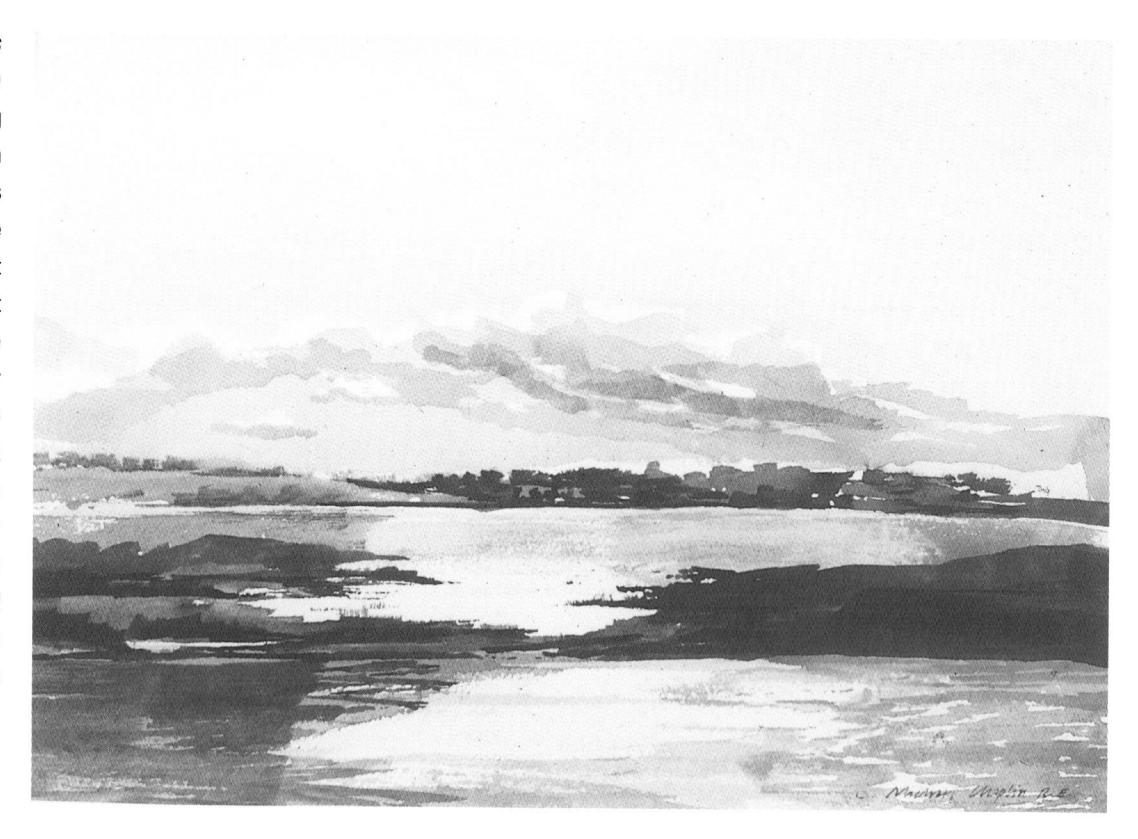

LAYING A GRADATED WASH

To lay a gradated tonal wash (that is to say, using just one colour that goes from light to dark), prop up your board and wet your paper. Take a broad brush and lay horizontal bands of colour from left to right, letting gravity take paint down to the bottom of the paper. You will see the tone changing as the pigment within the water runs down; when you feel it is the tone you want, lay the board flat. If a lot of water has collected at the bottom edge, blot it with kitchen towel before laying the board flat as it will begin to creep back into the wash, pushing pigment ahead of it into the drying paint at the top of the picture and causing what is known as a 'cauliflower'.

An alternative method of laying a gradated wash is to start with the lightest tone you want, adding more pigment into the colour mix with each stroke. Keep a blob of pigment ready at the side of the palette so that you can work fluidly, with the wetness of the paper blurring the

edges of the strokes. If you want the darkest tone at the top of the picture, for example when you are painting the sky, simply turn your board upside down.

Once you have practised laying gradated washes with one colour, try adding in extra colours, working quickly to prevent the paint drying as you go.

Venice from the Lido
25 × 33 cm (10 × 13 in)
For this painting I laid
one flat wash then
added gradated
washes in different
colours and angled
from different
directions, letting
them mix together
as I worked.

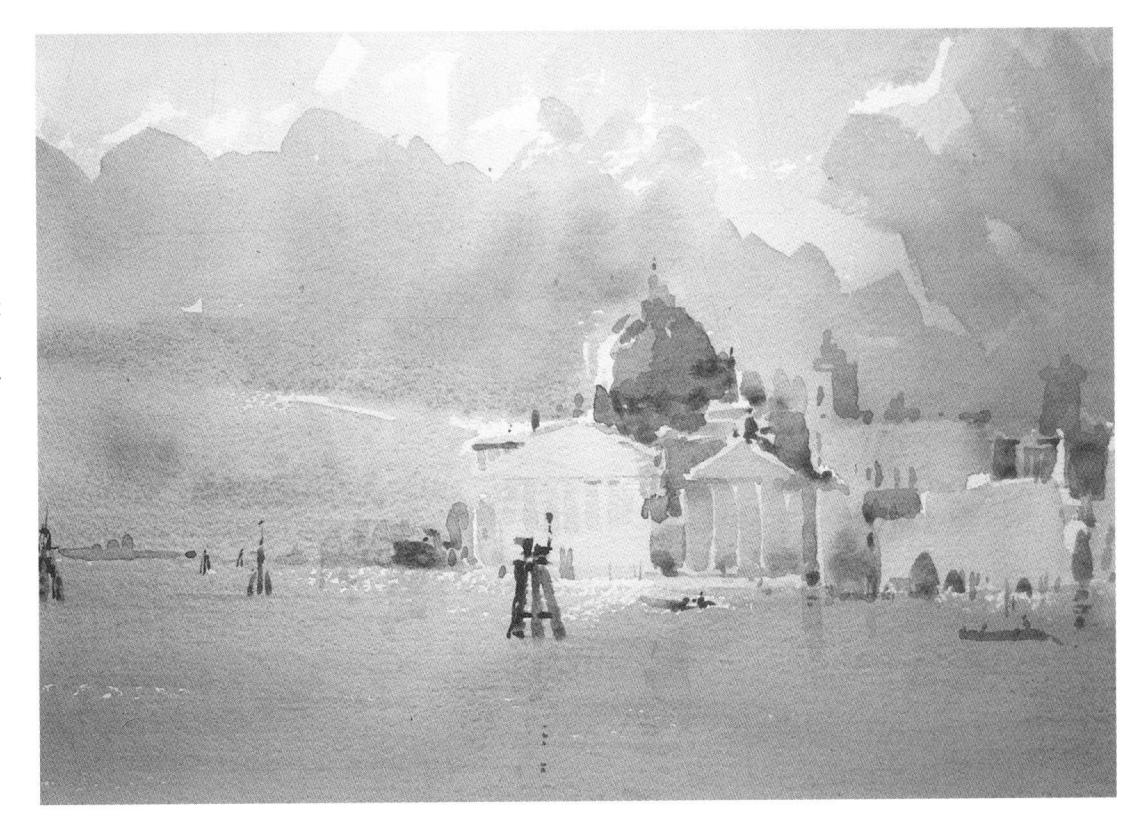

PUTTING DOWN PAINT

A perfectly laid flat wash can be beautiful in its simplicity, but you will want to try a range of different ways of adding textural interest to your paintings. The samples on these pages will help you to expand your repertoire by

showing you a range of possibilities. However, don't consider these to be the final word on putting down paint; explore your own ideas as you find new ways to express yourself in your paintings.

A gradated tonal wash (see p.59).

A new colour dropped into a wash that is still wet (known as painting wet-into-wet).

Some pigments are granulated, meaning that they produce a coarse-grained texture. French Ultramarine is one notable example. Manufacturers' charts will tell you which pigments are of this type.

Loading a toothbrush with colour and pulling your thumb across it splatters paint onto the paper. If you want this effect in a very localized area, cut out a paper stencil in the required shape.

Disturbing a wet wash by dragging and dabbing crumpled tissue paper on it produces a range of effects.

Pinching a round brush between fingers and thumb so that it splays out gives a combed texture.

Marks made with a 13 mm (½ in) flat brush, capturing light on water.

A dry brush dragged across rough paper leaves plenty of broken white areas.

Texture paste used with watercolour gives varying colour, deepest where the texture paste is

'Cauliflowers', where a wet area of water tries to push back into a damp area of paint, often occur by mistake and can spoil an area of painting. However, used judiciously, they can enhance a painting instead. Here I have dropped clean water into blue pigment.

Colour applied with watercolour pencils.

Dropping salt into a wash gives an interesting and unpredictable texture.

RESISTS

Using a resist to prevent paint from reaching the paper can give interesting textures while also leaving areas of the paper white or allowing for an extra layer of colour. Masking fluid is removed by rubbing it away with your finger once the paint around it is bone dry, while the other methods shown here remain as an integral part of the painting.

Painting on masking fluid leaves hard-edged whites.

Rubbing candle wax on to the paper prevents paint penetrating it. Colour collects into the wax, giving variable strength.

If you put a wash of colour over the top of oil pastel, the paint rolls away from the wax. Here the wax is red, with an orange wash over the top.

Chalk pastel is very powdery, with a lot of air in it. If you draw a big brush lightly and quickly over the top of it, the air stops the water reaching the paper.

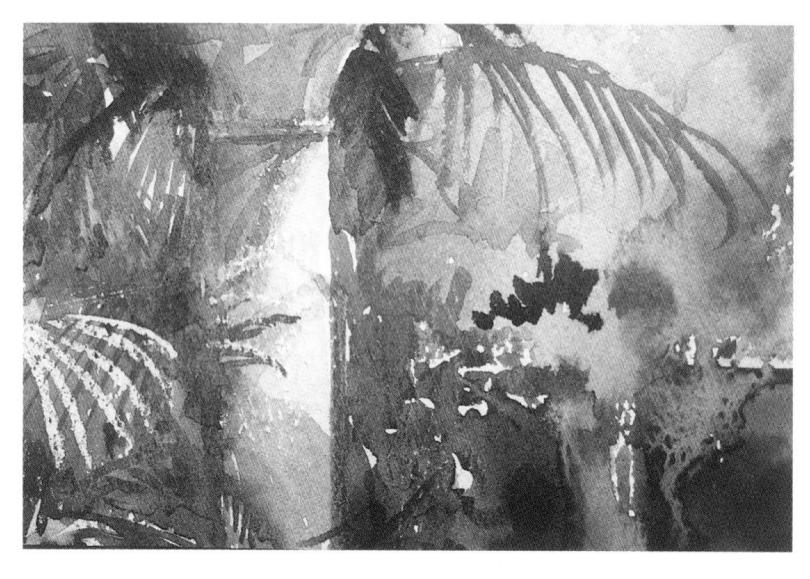

I rubbed candle wax on to this pillar to act as a resist and elsewhere on the pillar scratched out the paint with a knife blade.

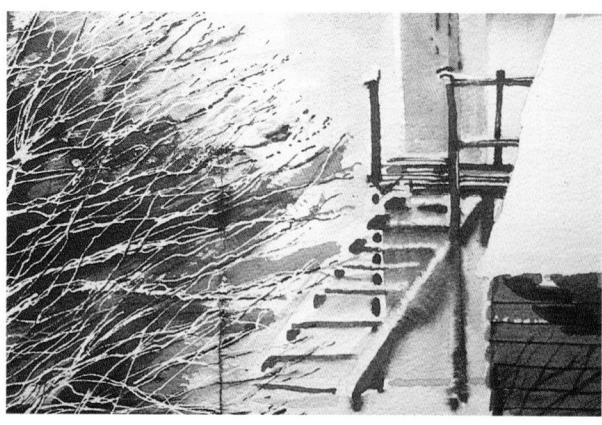

The hard-edged whites of the foliage have been created by the use of masking fluid, while the snow on the steps is a result of reserving white space, giving soft-edged shapes.

LIFTING OFF

Lifting off paint can be done to give textural interest as well as to reduce the intensity of colour in specific areas. Remember that some paints are more permanent than

others, so if you plan to lift colour out check that you are using a fugitive (less colour-fast) pigment.

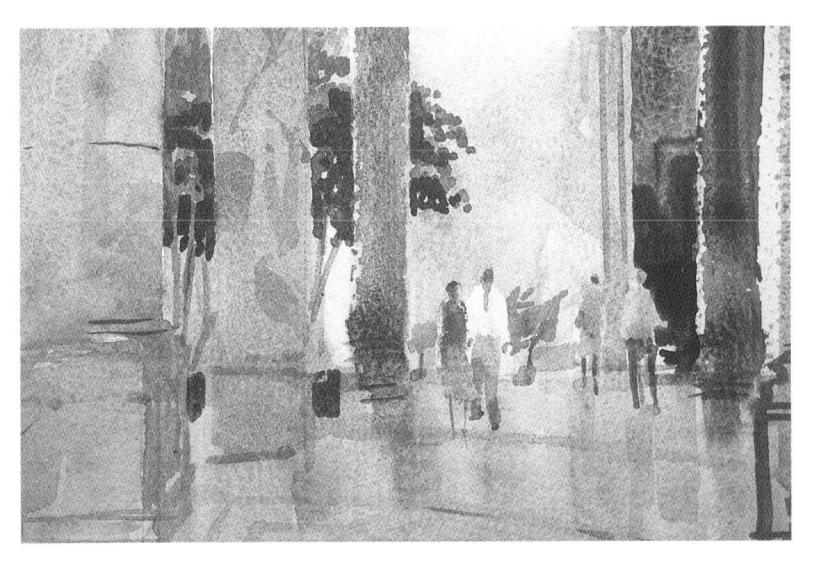

The soft reflections of the hard white shapes of the pillars in this painting of Monte Catini were produced by wiping a sponge vertically through the wash.

A dry wash lifted off with a sponge.

Using sandpaper on rough, dry paper gives a characteristic texture that is useful for old masonry.

Scratching out with either the point of a knife or the flat of the blade gives rough-edged white lines or broader broken areas of white respectively.

A putty eraser can be used as a drawing tool to lift off paint.

To bring out the umbrella in this painting I cut a triangular stencil from newspaper and took out the whole area of the umbrella with a quick swipe of my sponge. I then cut another stencil that covered up the bottom area of the umbrella and swiped out the light-reflecting top part still more with a second application of the sponge.

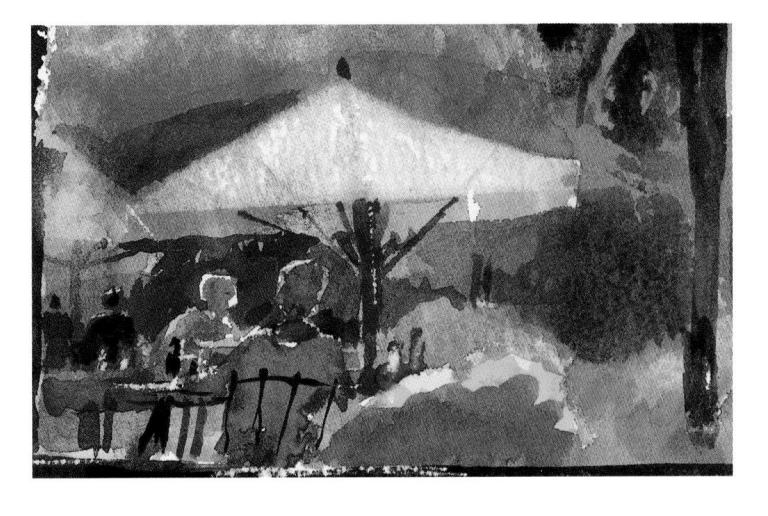

BASIC COLOUR

A personal palette is a very subjective choice that will be governed by your tastes and surroundings. To begin with, choose colours that you like; if you find that in practice you never use them, abandon them and replace them with those that suit your subjects and preferences. You may eventually assemble three different paint boxes, one for interiors, one for local scenes and one for travelling.

Colours are described as warm or cool, the former being the reds, oranges and browns we would expect to encounter in hot countries or in connection with fire. When we think of cool countries, blues and greys are what come to mind. Consequently, when we see these colours in a painting we associate them with cold.

The bar of colour shows the spectrum of a rainbow, while in the colour wheel beside it we can see that when the bar is turned into a circle the three primary colours of red, blue and yellow are interspersed by their secondary colours: red and blue make purple, blue and yellow make green, and red and yellow make orange. The secondary colours are considered complementary to the primaries to which they are opposite on the colour wheel, for example purple and yellow are complementary colours.

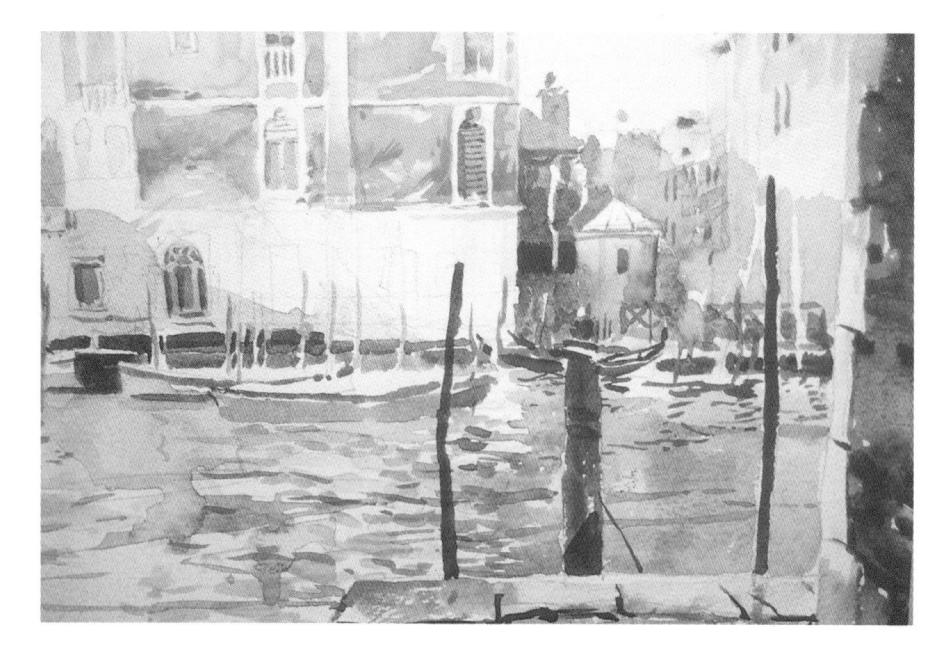

Grand Canal, Venice (detail)
This painting employs bright, simple colours taken directly from the spectrum to give a clean, buoyant feel to the scene.

When red is seen against white it looks quite dark, to the extent that it becomes a tonal statement as much as a colour statement. Seen against black, it looks lighter in tone and richer in colour. It is tonally the same as green, and as they are opposite on the colour wheel they enhance each other. The tonal values can be seen more clearly here with the same pigments shown in monochrome.

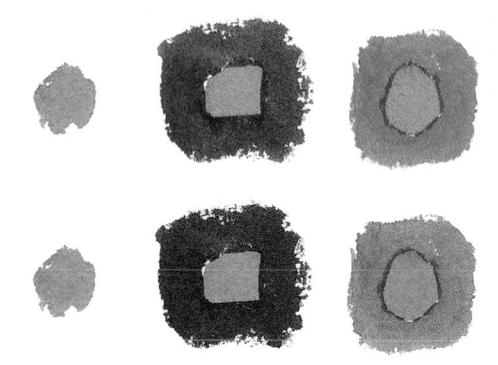

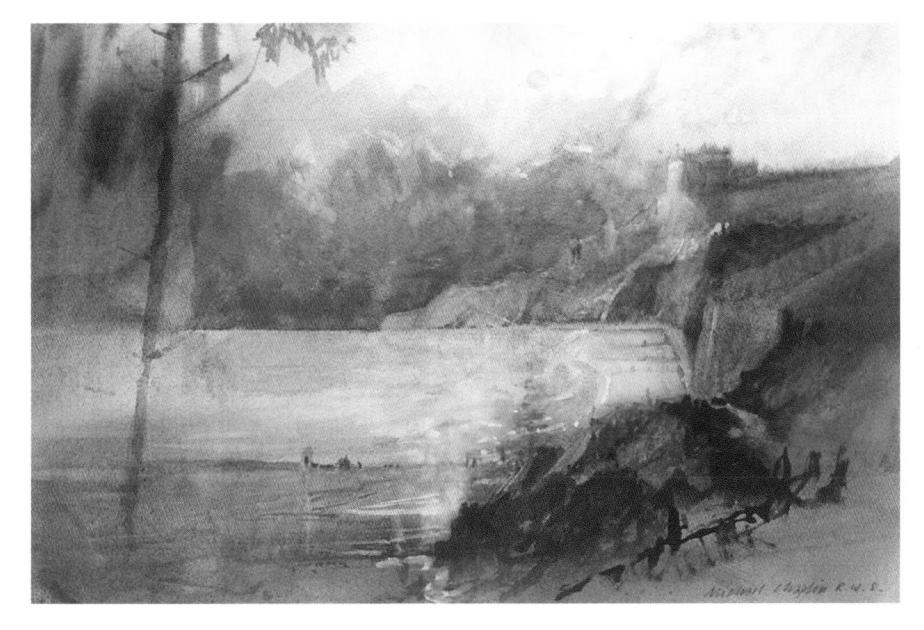

View from the Clifftop 20×25 cm $(8 \times 10 \text{ in})$ The palette of this painting is largely composed of the complementary colours of the yellowish-ochre in the sky and a deep purple. Mixed together, they give a large range of greys. While the greys produced by mixing complementary colours do have a colour bias, they are very subtle.

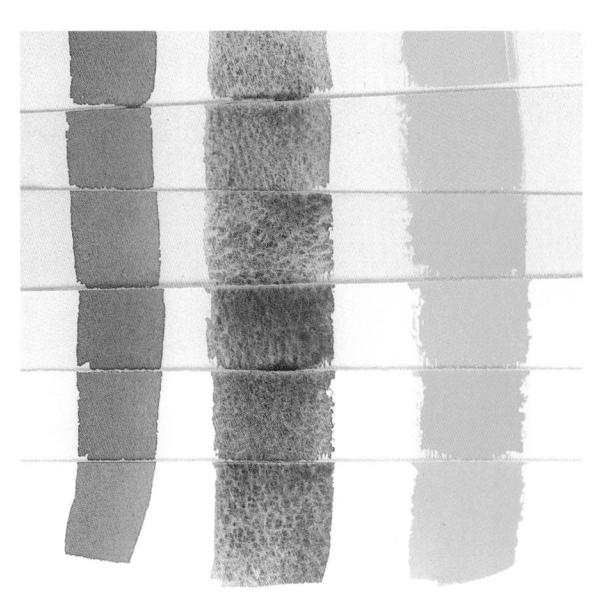

Colours are affected by the other colours around them. Notice how the colours pulled across this swatch of papers change according to the background against which they are seen.

TONE

Tone refers to how light or dark objects are, which is determined by the amount of light that is falling upon them. To the artist, tone has three basic uses: it explains form by making an object lighter where it is facing the light source and darker where it is in shade; it alters our perception of how strong or pale colours are and it acts as a

compositional device, providing drama when used in extremes and giving a sense of gentleness in a painting that is close-toned.

When you are putting down tone, remember that the pigment will look paler when it is dry and compensate for this to make sure your painting does not look weak.

To describe this cube, lit from above left, I mixed three separate tones of the same pigment.

The lightest tone is on the top, with a midtone lefthand face and a dark-toned righthand face. The problem with this approach is that you have white lines where the faces join or, if you overlap the paint, dark lines. It also takes a lot of time and perception to mix those three surfaces as different tones, and in fact I have made the darkest face too dark in

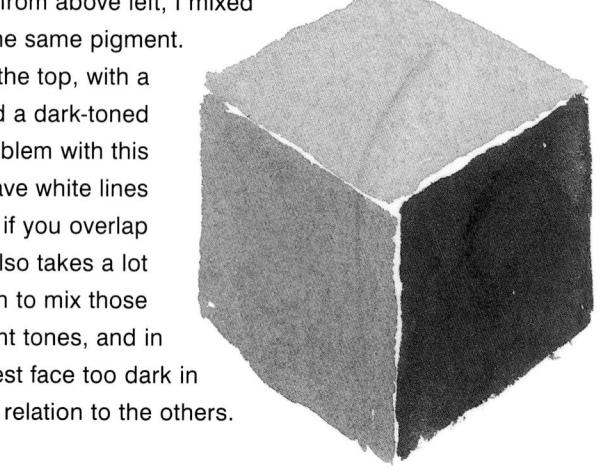

In this example I laid the whole square in one wash of tone. I let it dry, then gave the lefthand and righthand faces a second wash of the same tone. After this was dry, I put a final wash on the righthand face. This provides a much more convincing shape and is considerably easier to do.

I did a monochrome study to establish the tonal drama in this example of classical architecture. The light is coming through the distant portico, throwing into sharp relief the little wrought iron gate and shining on the marble floor. I used a very rough paper and worked quickly with a broad brush which allowed a lot of white paper to show through as the brush skipped across the paper.

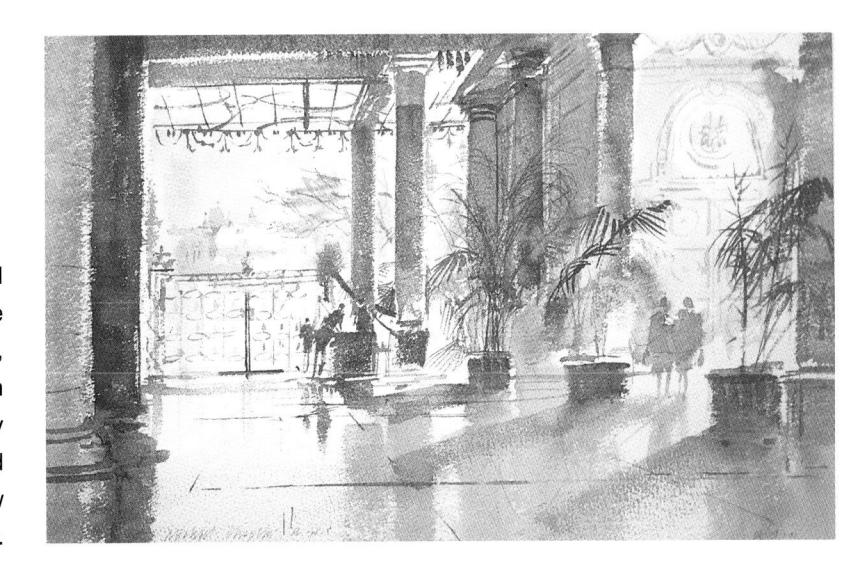

In this contre jour (against the light) painting, the darker tones are in the distance, against the sky. This reverses the normal expectation that darker tones will be in the foreground because the rocks across the bay are silhouetted, while the foreground is a flat plane reflecting the light.

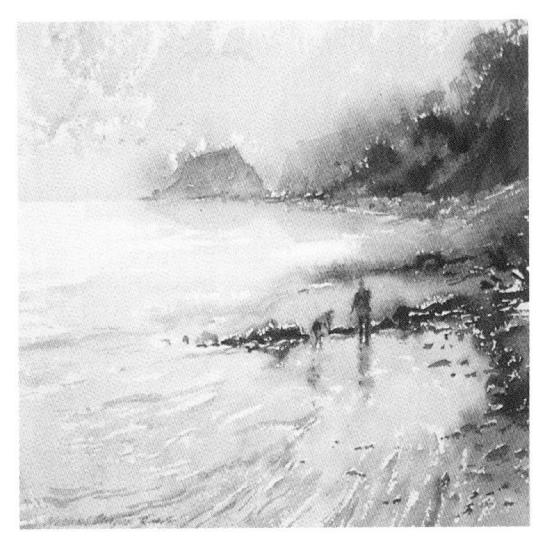

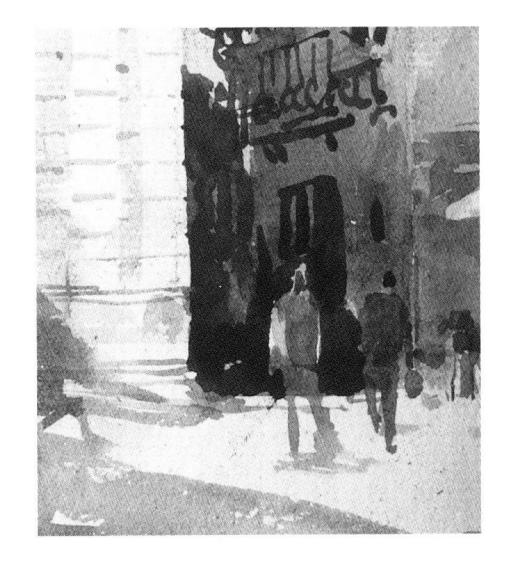

Setting these figures against the dark tone of the archway has intensified the red of the coat, demonstrating how tone is capable of affecting our perception of colour.

USING WARM AND COOL COLOURS

Cool colours such as blues and greys recede while hot reds and oranges advance, allowing the artist to achieve a sense of depth. In the painting below, the colours are working hard to establish the background, foreground and areas of interest. The patch of warm colour in the

foreground, reflected from the trees in the centre of the picture, is crucial in bringing it forward. It also adds to the trick the faint perspective lines are playing in taking the eye towards the centre of the picture.

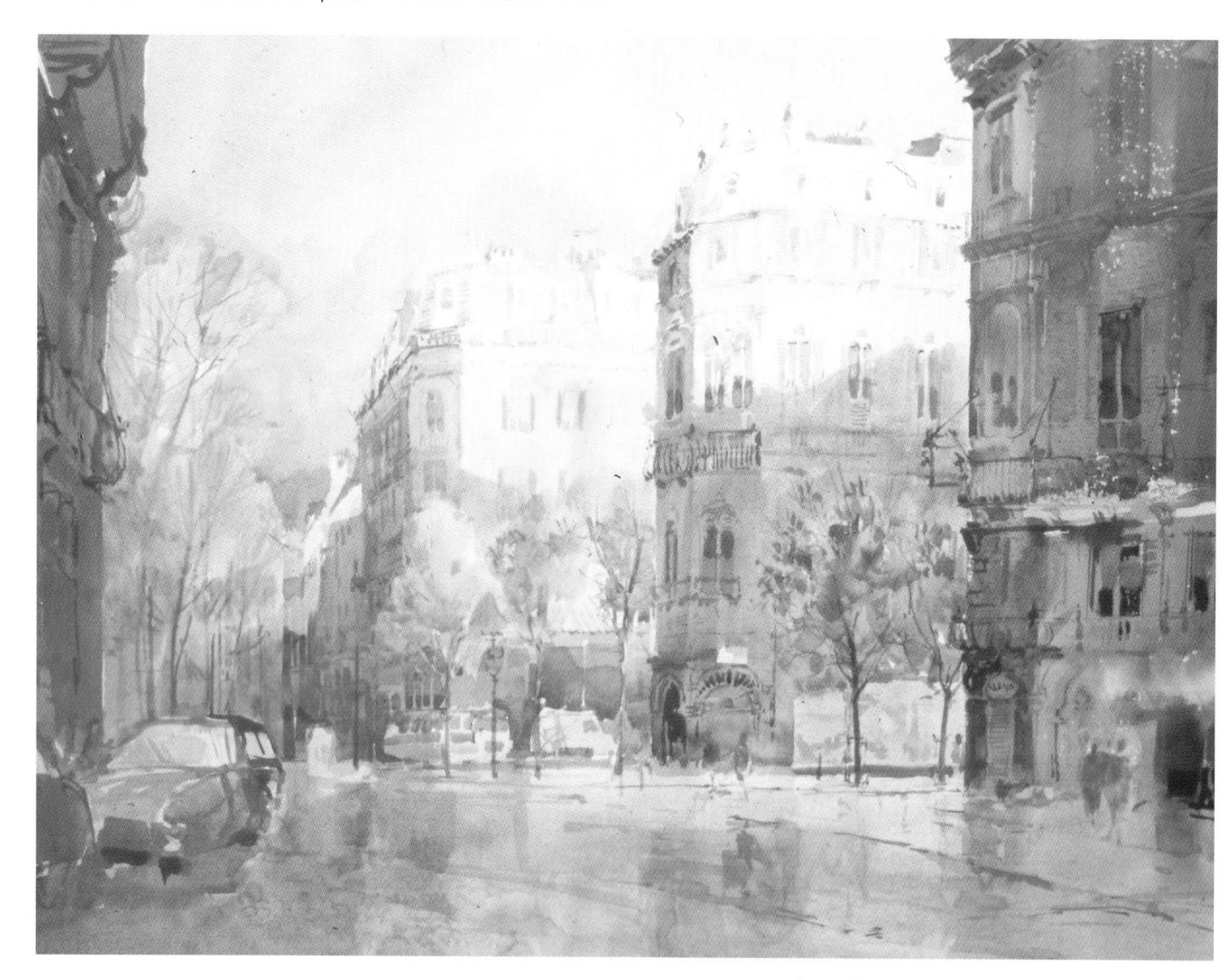

Late Afternoon, Paris, 51 × 61 cm (20 × 24 in)

Cerulean

Ultramarine

Alizarin Crimson

Cadmium Red

Although we speak of blue as cool and red as warm, there are variations within each colour. Here the blue to the left and the red to the right are both cool, while the two centre swatches are warm. It is a good idea to have a warm and cool version of each colour in your palette.

As with tones, our perception of colours is altered by the colours that are adjacent to them. Don't be afraid of using strong colour at the outset of a painting – it may look too

bold against the white paper, but as other colours are added it will sink back.

We can make a cool colour look cooler still by putting a warm one around it. The red in the swatch on the left makes the blue look cooler and also lighter, as the red is deeper in tone. Against the white paper, the blue looks much darker.

Here you can see the composition of the picture opposite, broken down into blocks of colour to show their tonal values and how they work in terms of temperature. When the lighter tones in the centre of the picture were laid down they looked quite dark, but once the darker slabs of architecture were put in on either side the central area looked both lighter and fresher.

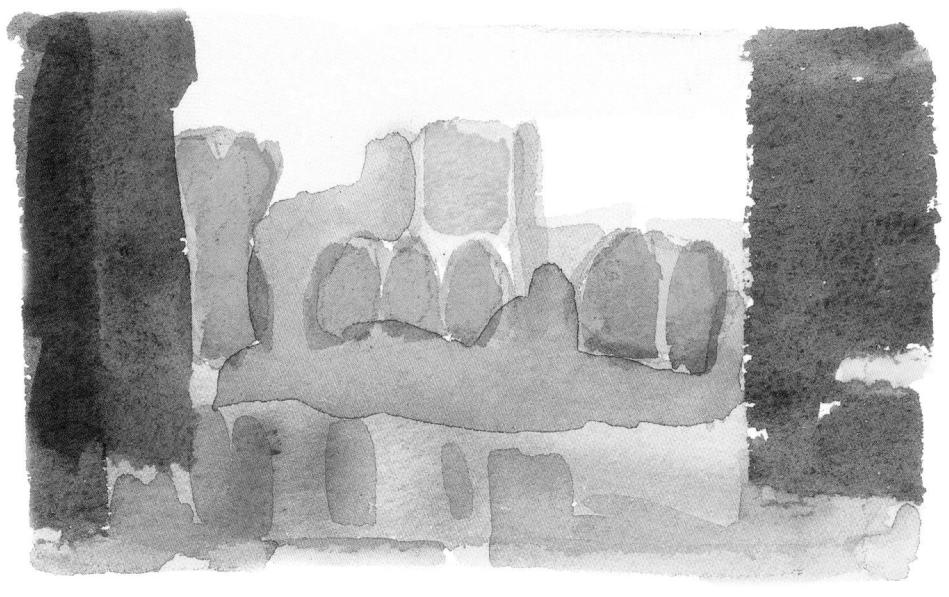

Laying a warm wash over a cool one, or vice versa, also suggests depth. The painting opposite was done on warm-toned paper, and where there is less pigment in the sky on the righthand side the warmth shows through. Depth is suggested there without the need for a second layer of paint.

HARD AND SOFT MARKS

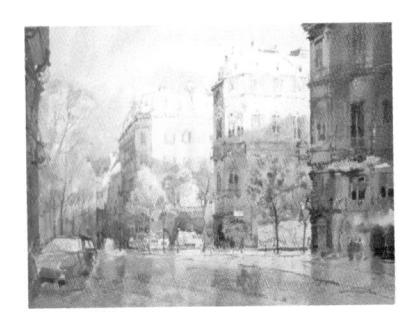

When you are painting out of doors, you will often be engaged with a rural landscape where there is an obvious foreground, middle distance and far distance. To establish the sense of space and depth you have various techniques at your disposal, such as foreground detail, warm and cool colours and aerial perspective (see pp. 80–1).

However, in a city the sense of space is much more compact: there is little distance between foreground and middle distance, and there may be no far distance other than the sky. In these circumstances you need to be even more careful how you use colour, tone and line to introduce space to a scene that is quite vertical and flat.

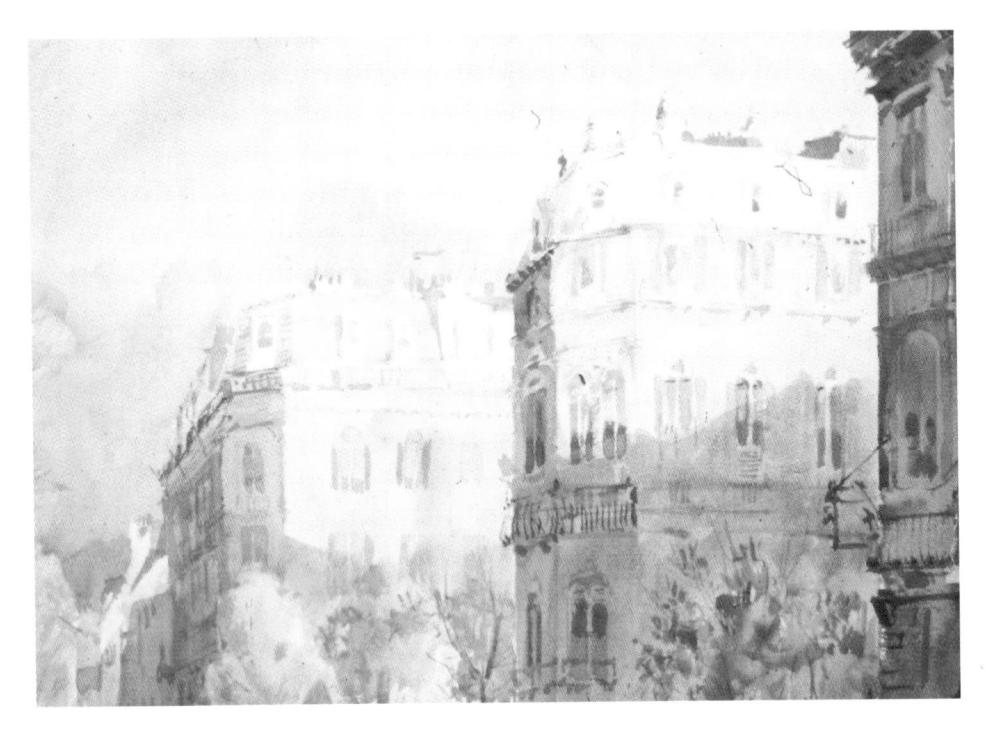

If you look at the area where the roofs of the green and white buildings stand against the sky you will see that the white roof has hard edges while the green roof is much looser and less defined. The shadows on the frontage of the white building are darker in tone and the architectural motifs are much harder-edged. There is also much less detail in the trees as they recede towards the green building.

If all the tree trunks were painted at the same strength they would act like a physical fence, stopping your eye from travelling into the depth of the picture. Instead, the foreground tree against the blue window has harder edges and darker tones to the trunk. Further down the street, the tree trunks are softer-edged and in cooler colours, while the foliage becomes a soft, diffuse mass.

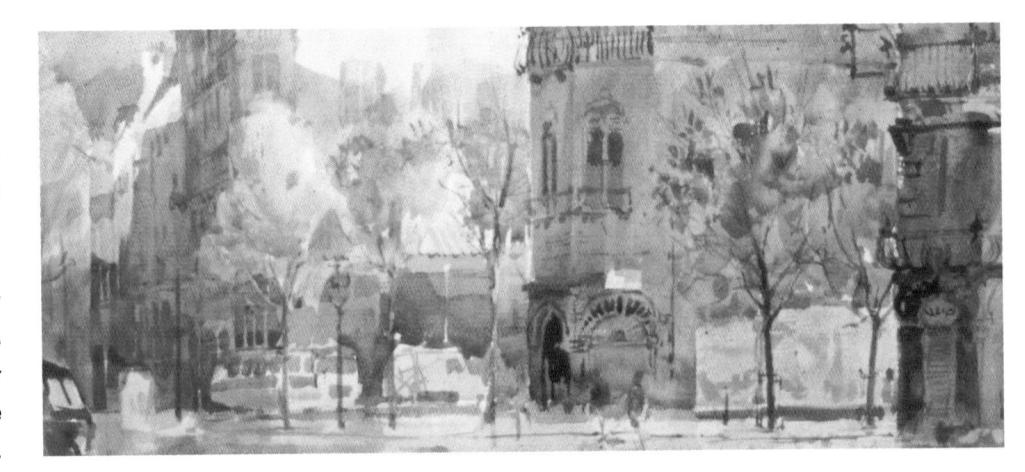

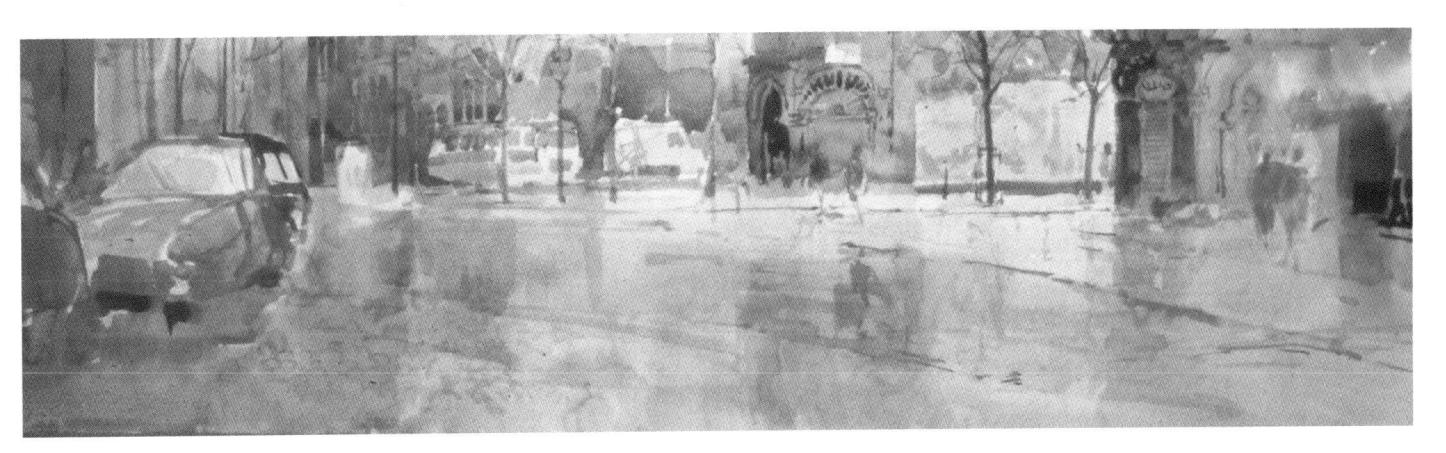

Notice how the perspective lines on the road move from hard in the foreground to soft in the middle distance. They begin warm and hard-edged, becoming cooler as they recede and finally tailing off into a series of soft-edged dashes.

Hard, crisp lines on the dark building on the right hand side of the painting push back the other buildings. The ironwork protruding from the building breaks up its hard edge and provides a linear overlap with the building behind, giving cohesion and also increasing the sense of space.

LEAVING WHITE SPACE

Generally speaking, we live in a midtone world within which light and dark tones occur. An artist working with oils or gouache is able to put light colours over dark, but this is not possible with watercolour without losing its

luminescence. Consequently, the challenge with this medium is to identify where the light areas are in your composition and decide how you will tackle them before you first put brush to paper.

Working around the subject

Rather than painting this little white pot I painted the background, allowing the shape of the pot to appear within the darker tone of its surroundings – a technique known as painting a negative shape. The only paint that has been applied to the pot itself is the shadowed interior and a little light tone beneath the rim to give some modelling to what would otherwise be a flat shape.

Using a resist

Here I rubbed candle wax on some of the paper to create a resist – an area that will not accept paint. I laid a midtone over the whole area and then, when it was dry, added a darker tone. This gave the pot light, middle and dark tones.

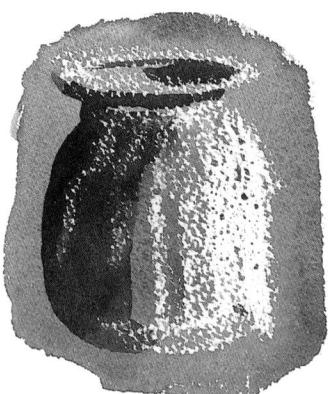

Scraping out

After laying a flat midtone wash I scraped out the shape of the jug with a knife. Scraping out more paint on the righthand side, using the flat of the blade, gave the pot some modelling. The linework on the left side of the pot was scraped out with the point of the blade.

This approach is best suited to a good-quality long-fibred paper such as cotton rag where the surface will hold together better. The paper must be completely dry right through before you start cutting into it otherwise the fibres will tend to split badly.
USING WHITE SPACE IN A COMPOSITION

As a project, do one or two sketches that concentrate on leaving white shapes to help you become accustomed to thinking about negative spaces. When you move on to paint, making a similar sketch first of your subject will help you enormously.

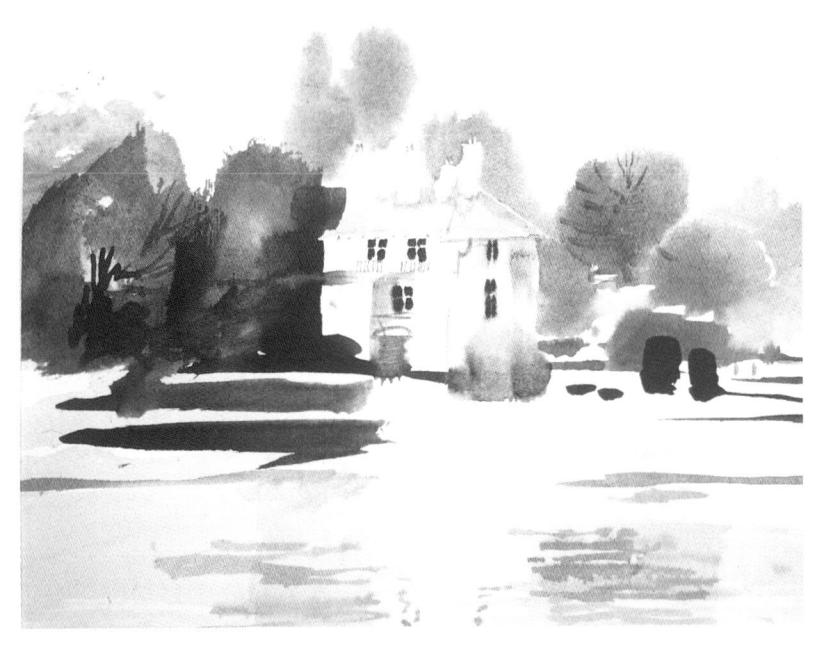

Balancing white space

Here white space has been used to make a tonal impact in a painting of a building. In this example the dark tones of the windows and door make the white shine out. Other forms within the shape of the building are hinted at by midtone washes on the changing planes of the architecture.

The off-centre placing of the building and the light and dark tones help the eye to scan across the picture. The two strong bars of dark tone coming in from the left are then picked up by lozenges of white where the light hits the bushes on the right-hand side and echoed by dark strokes leading off to the right. This counterpoint of tone makes the picture very lively.

Placing white shapes in space
White shapes can jump out from
the rest of the composition, making
for a tonal imbalance. Here the
white areas of clothing have been
reserved against a midtone
background, and have been
prevented from coming to the
foreground by putting dark tones in
front of them. The dark rails of the
chairs across the figures place
them further back in the
picture plane.

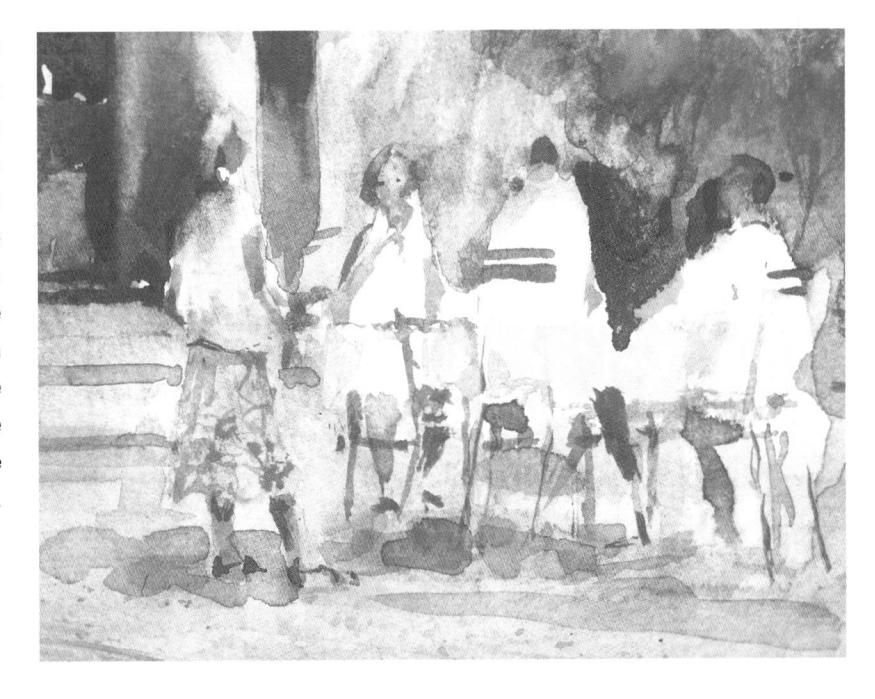

AN ALTERNATIVE PATH

If you find this approach very difficult at first you can use opaque white watercolour such as Titanium White or white

gouache. However, those whites will be very hard and flat and you will lose the luminosity of the paper.

USING SKETCHBOOKS

Your sketchbooks are among the most valuable pieces of equipment you have, for within them you can make quick studies that may later become the basis for finished paintings, try out different compositions of the same subject and build up a library of useful pictorial notes on themes that interest you..

To give you a good choice of formats, you will need two sketchbooks. A tall, upright sketchbook in a standard book shape gives you three formats: the portrait offered by each upright page, a square gained by opening the book flat and working right across both pages, and a panoramic landscape if the book is turned on its side. A square sketchbook can be used as individual pages and also gives a panoramic format if you work across both pages.

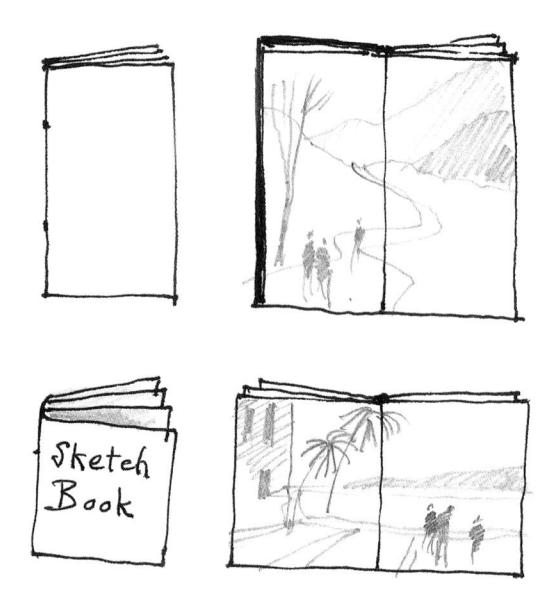

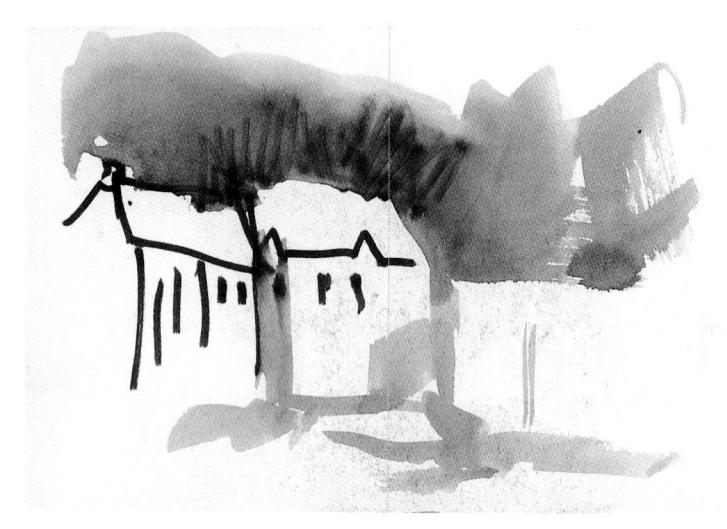

This very soft sketch of buildings was done with a felt tip pen. It is reduced to three major tones: very light, midtone in the washes and a hint of dark areas where there is some crosshatching. It is a very quick note to capture the tonal values for reference later in the studio.

Take your sketchbook everywhere with you as you never know when a subject might present itself. I was waiting with friends for a Christmas carol service to begin when the verger came to light the candles. I made a quick sketch with my fountain pen, and it may one day jog my memory of a happy occasion and prompt me to return to do a painting.

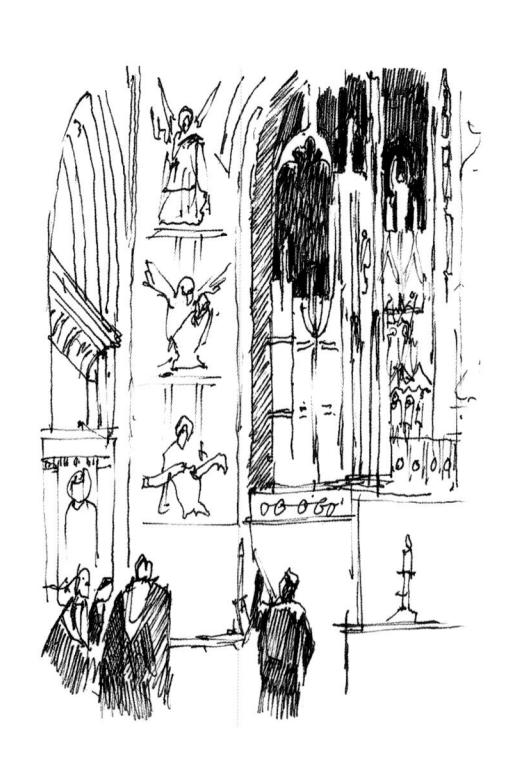

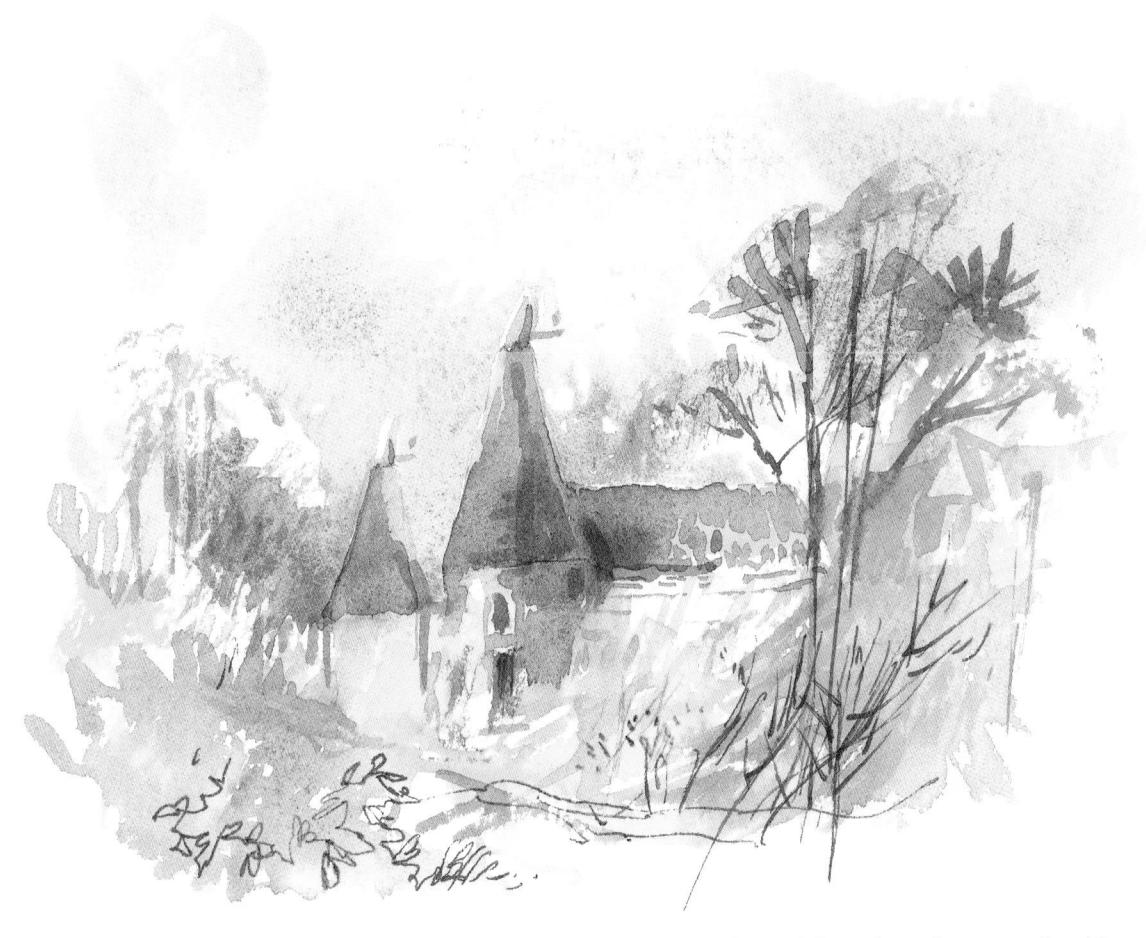

When you feel sufficiently confident you can go straight in with paint and then draw shapes and put in a bit of stress with pen and ink. This is a quite static topographical piece done with the intention of collecting information about the architecture and landscape rather than expressing emotion.

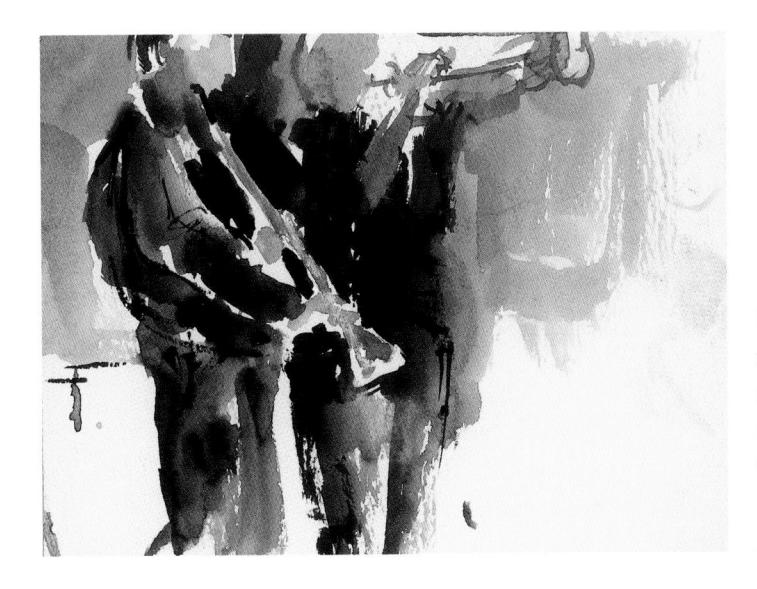

I made this sketch using just a brush and colour as I tried to capture musicians who were constantly in motion. My first simple marks were the hands of the clarinet player because they gave clues as to the angle of his head and the clarinet.

SIMPLE FIGURES

Many people anticipate that figures will be difficult to do, but if you want to introduce them into your paintings to add narrative, scale or perhaps bright splashes of colour there are easy ways to do this. At their simplest, they may be no

more than a few lines that will allow the viewer's imagination to fill in the rest. If you have more time and confidence, you can add in more detail so that your figures start to gain identities.

An adult's head is between a seventh and an eighth of the total height, and the navel is about halfway up. Individuals can vary quite a lot from this, but by understanding average proportions you will be able to spot where the differences occur.

In this simple figure drawing, the arms and body are drawn with one continuous line, starting inside the elbow on the right. Try some studies like this, looking as much at the figure as you do at the drawing to keep the coordination between what your eye is seeing and your hand is doing.

Capture some simple figures looking at the relationship between three basic points: the head and how it is joined to the body by the angle of the neck, and the angles of the arms. Your figures can be simpler, reduced to just a circle and two lines.

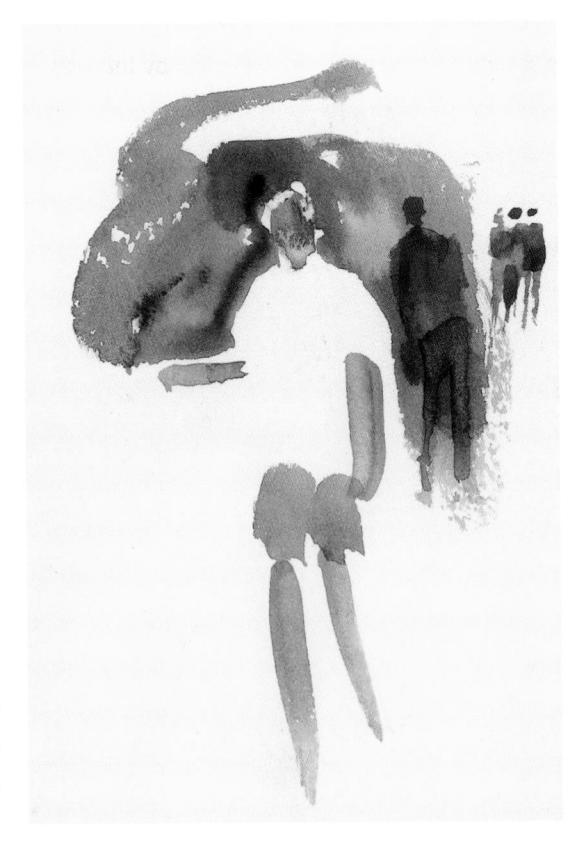

Next, start establishing a figure in space by painting in some tone behind it. Include as much detail as you feel is valuable to the painting. Note the group of figures in the background: figures are not always seen in isolation but are sometimes grouped into blocks of tone.

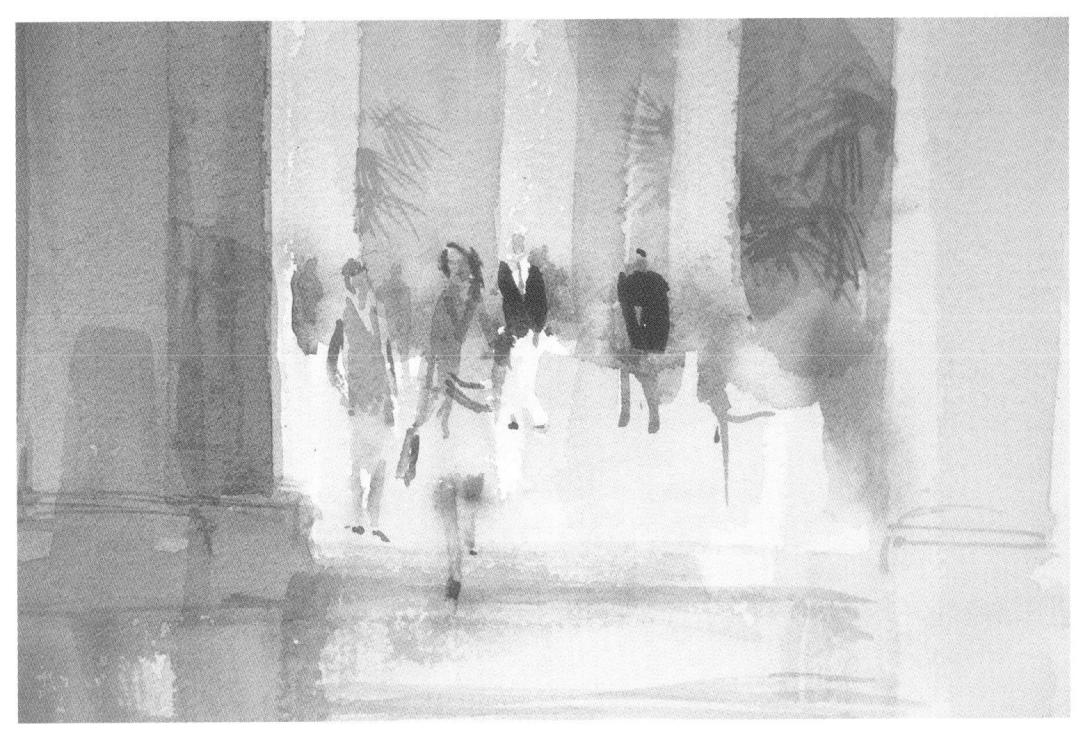

Figures in Monte Catini (detail)

Putting figures in a composition lets you place marks of bright colour or strong tone.

Here the figures are contributing high points of tone while not interrupting the spacious feel. Composed of three main tonal thrusts – light, medium and dark – they emphasize the vertical composition by the way they stand at the bottom of the pillars.

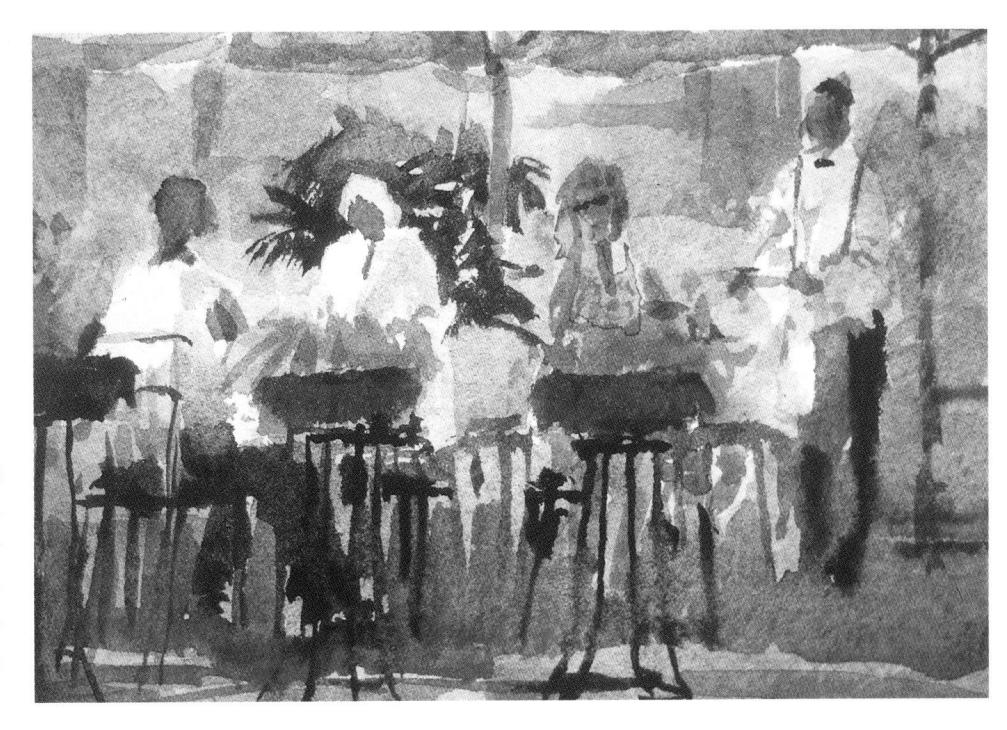

Relaxing in Syracuse (detail)
When you are drawing figures at rest you have much more time to put in detail and fill in their surroundings. Here I was able to note the waiter's bow tie and braces and the sunglasses on the woman taking her morning coffee.

PERSPECTIVE

Understanding some basic principles of perspective will give you the ability to introduce a three-dimensional feel to your compositions. The first and most crucial principle is that the horizon line is always at your eye level. All parallel lines running away from you towards the horizon will

appear to converge at a single point on the horizon, called the vanishing point (single-point perspective). Figures in your drawing will diminish as they recede but provided they are of similar height their heads will always be on the horizon line.

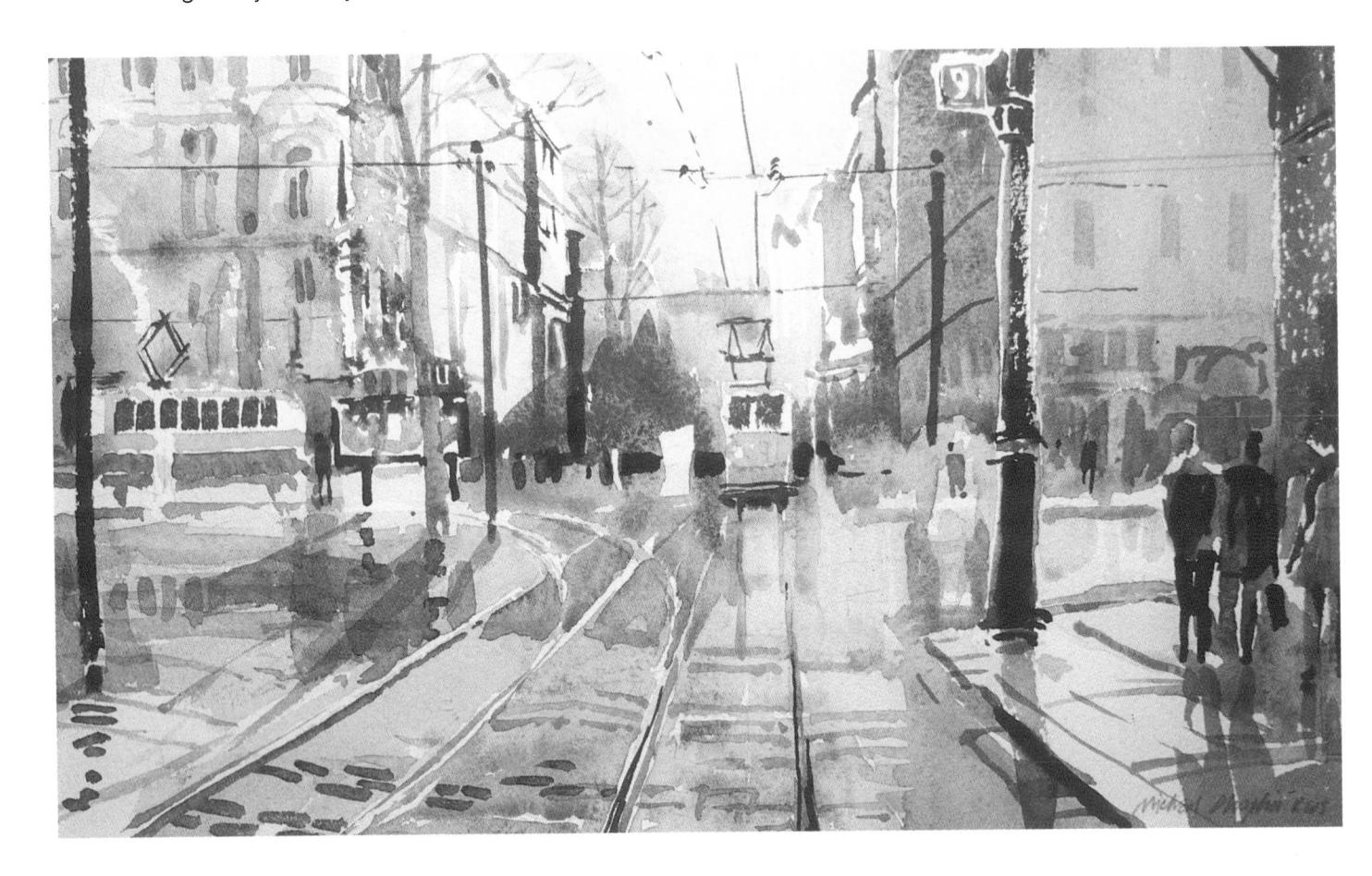

Trams in Prague 25×35.5 cm $(10 \times 14 \text{ in})$

From my position standing between the tracks, the vanishing point is directly ahead of me (marked by a spot on the tram). Notice how the tram tracks converge as they run towards that point. The figures in the composition all have their heads at that same horizontal line, whether they are near the foreground or in the far distance.

Where objects are obliquely placed rather than parallel to you, the sides converge at two vanishing points (two-point perspective). One or both of these may not always be

visible in the picture frame, but as long as you understand the principle that they too will converge, you will be able to show the angles in your picture.

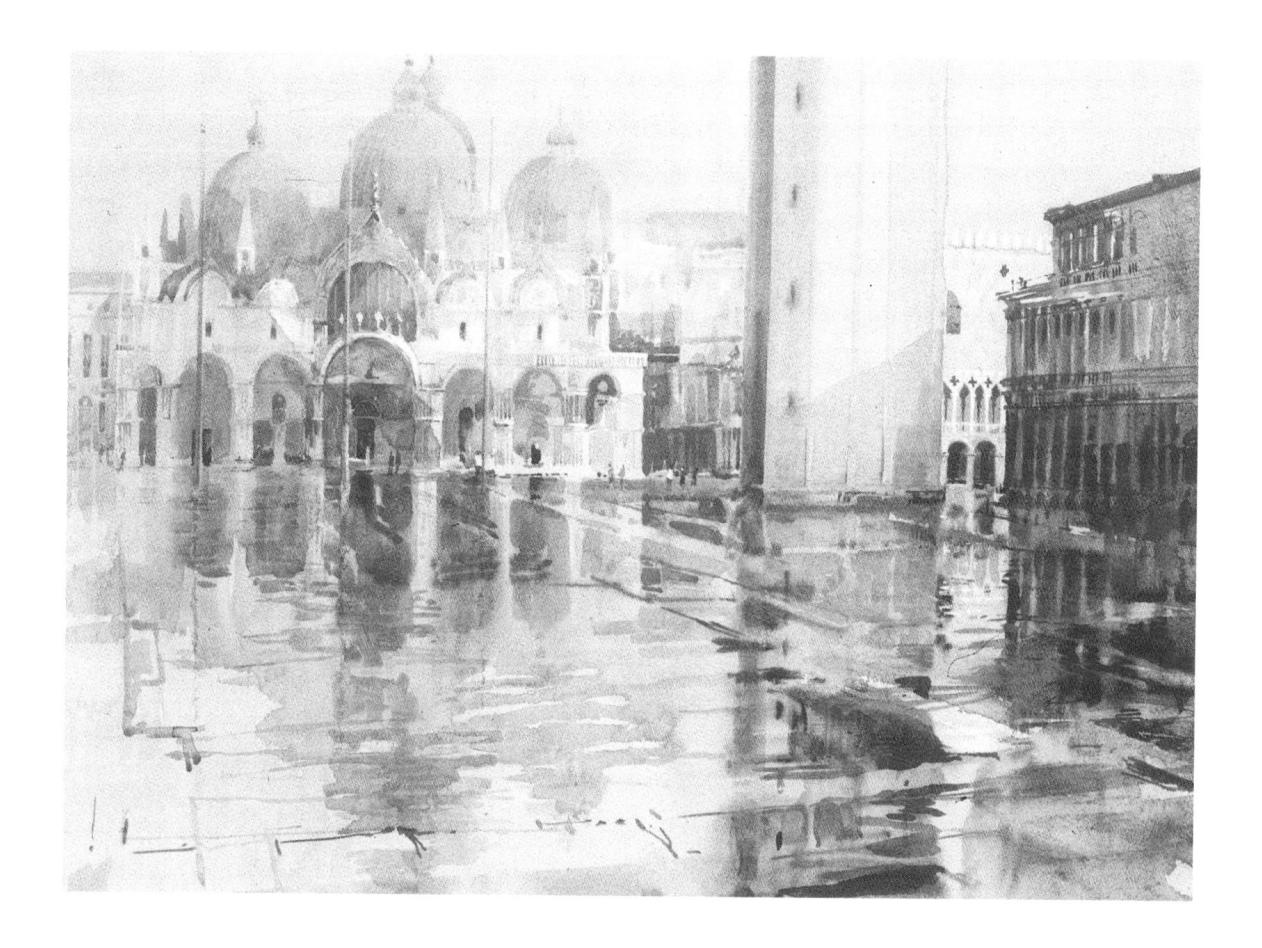

St Mark's Square in the Rain

51 × 61 cm (20 × 24 in)

The little figure on the diagram shows where I would be if I had walked directly forward from my vantage point – at the spot where the parallel lines ahead of me converge. The lines running horizontally in front of me converge at unseen points to the right and left of the frame. Over half this painting is purely about the two-point perspective of the inlaid marble marks on the ground.

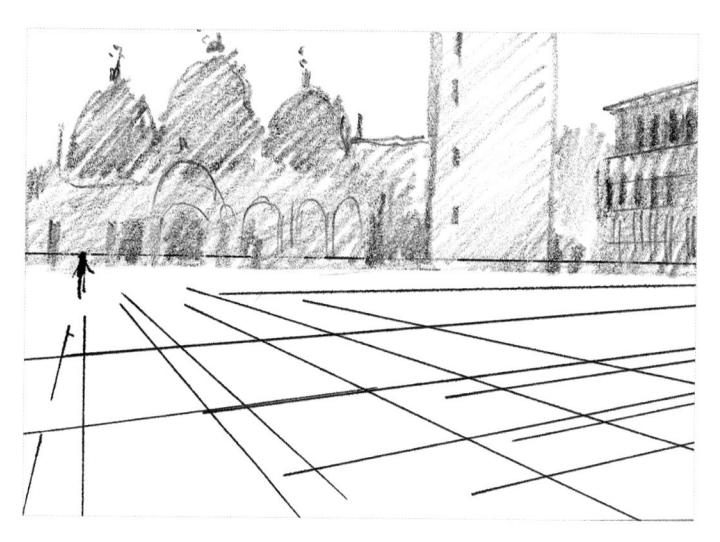

ESTABLISHING DEPTH

One of the most elusive things to achieve with watercolour is to give a feeling of depth to a scene. The key things to remember are that objects painted with hard edges, detailed linework and strong colours and tones will

advance into the foreground, while loose, soft-edged shapes with paler, cooler colours and tones will recede. With aerial perspective, distant parts of the landscape recede into increasingly pale blues and greys.

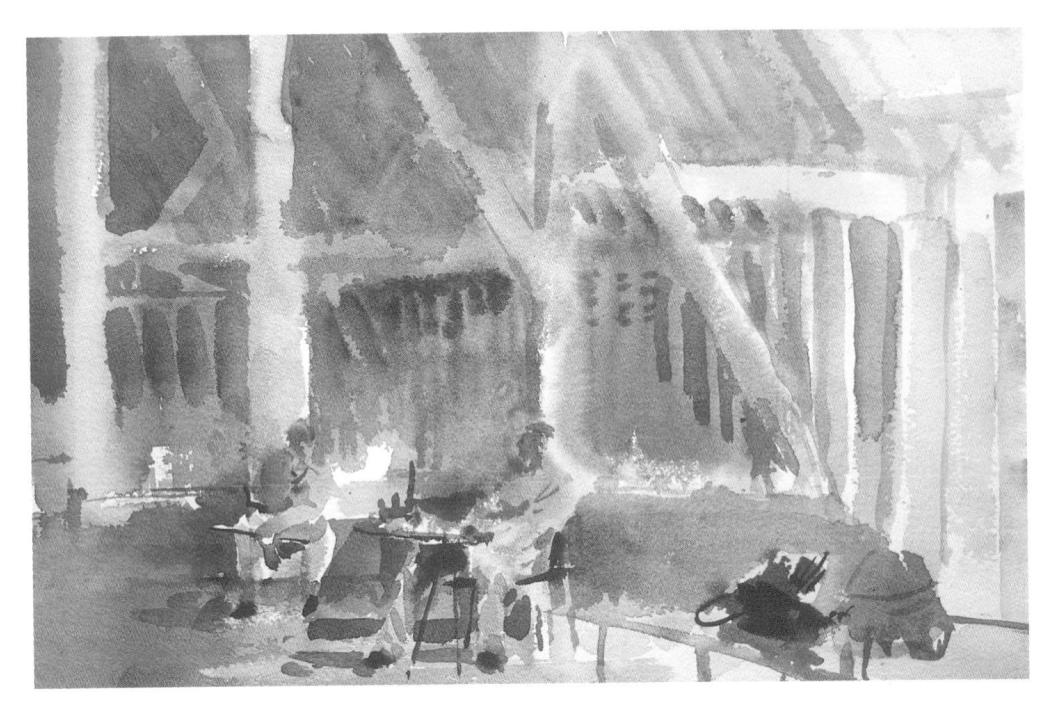

In this preliminary study for a picture of two students painting in a barn, depth is mainly limited to the foreground and middle distance. All the hard shapes, strong colours and extremes of tone are in the figures, bringing them forward. The rafters of the barn are painted loosely, wet-into-wet. There is just a hint of further distance through the door, with the recessive blue of the sky and cool green of the field.

In this sketch, the warm colours of the shop and the hard linework of the poles that support the blind establish it firmly in the foreground. The figures are painted with hard edges and dark tones, while in the figures in the middle distance the colours are more in the midtones and there are hardly any details. In the far distance, the foliage of the park is only hinted at with wet-into-wet washes.

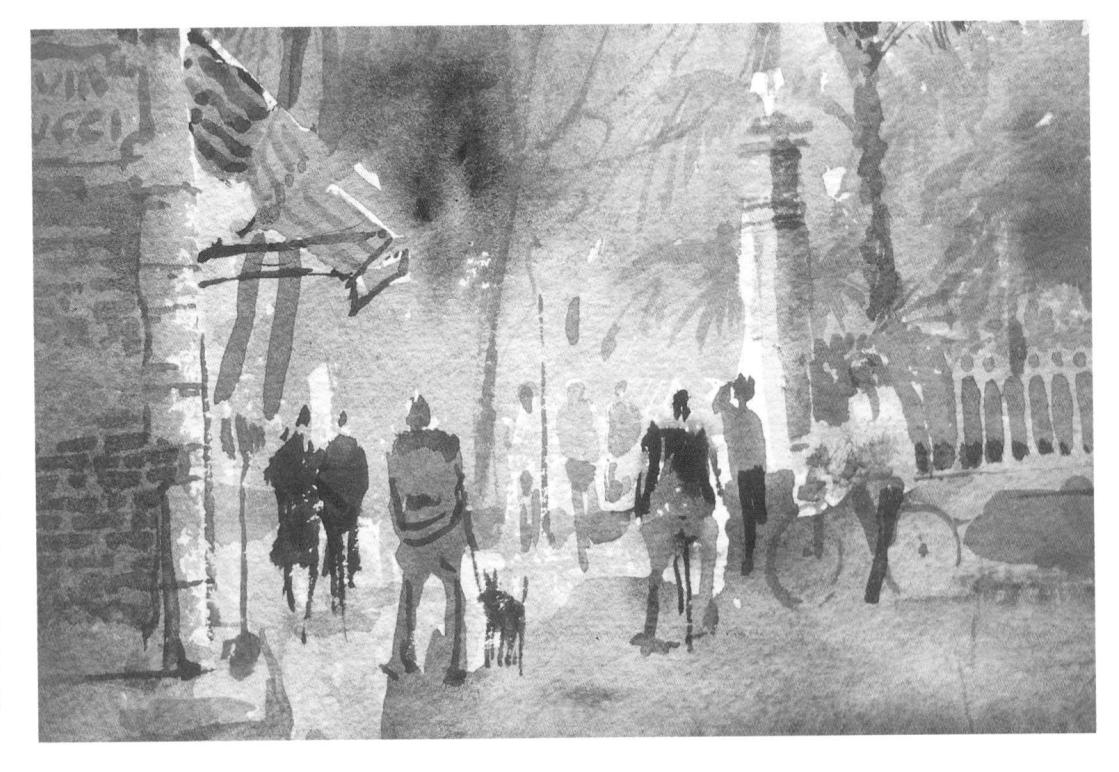

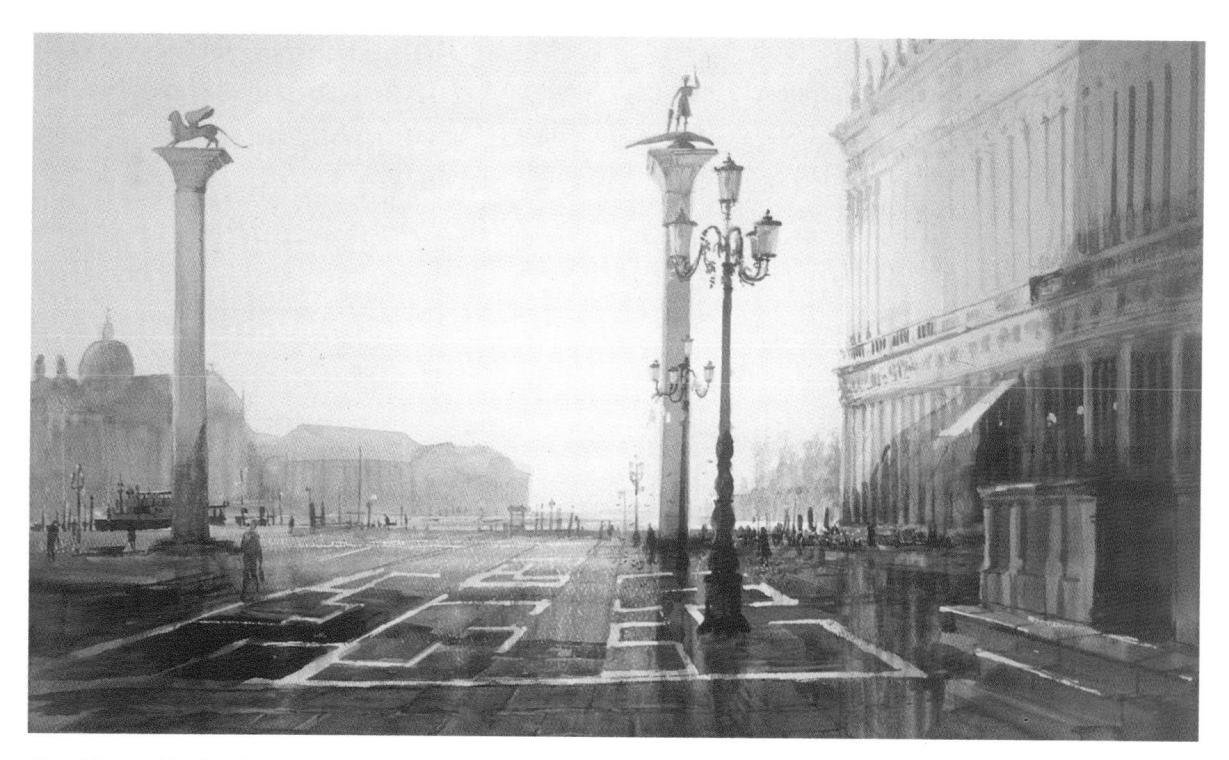

San Marco, Venice 38.4 cm \times 52 cm (15 \times 21 in)

I used very flat, light washes in the sky, allowing the white of the paper to make them transparent. The eye is pulled right into the picture by these washes, which contrast with the dark tones of the foreground. The single-point perspective of the white lines on the ground contributes to directing the eye.

Distance in this study is established by the use of aerial perspective. Making sketchbook notes of the underlying structure of tone and colour is crucial if you want to go on to make a finished painting from a scene such as this. I was looking across a lake in the yellowish light that occurs at the end of the day. It suffuses the painting with warm colour behind which is placed the cool blue of a distant mountain.

COMPOSITION

Composition starts at the moment you pick up a piece of paper and with watercolour it is all too easy for it to be a random choice. An oil painter defines size and proportion right from the outset by stretching a piece of canvas on

which to work, and your paintings will benefit from the same considered approach. Once you have decided the format of your painting, you then need to plan how you will lead the viewer's eye round the picture.

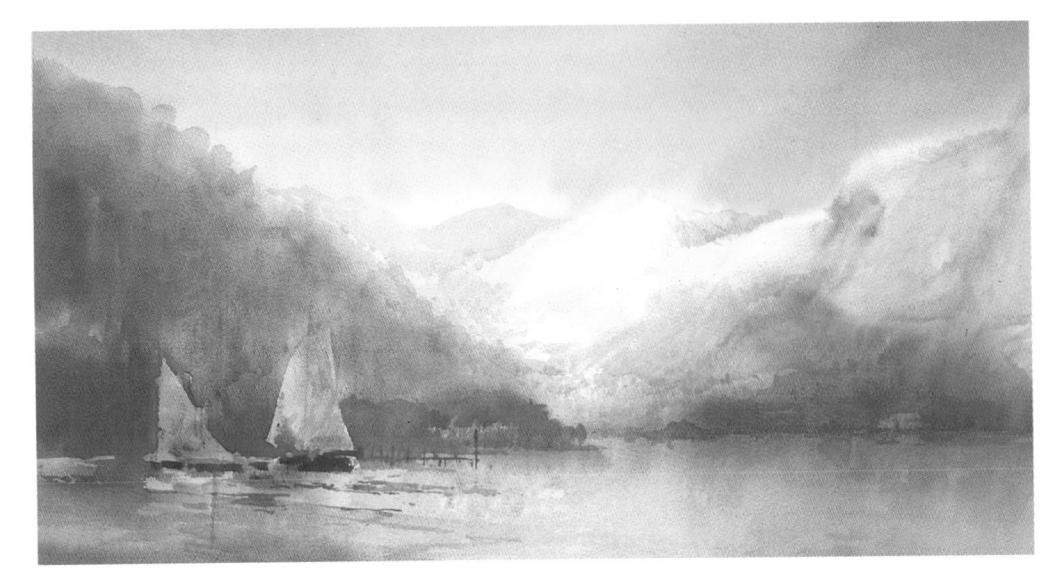

Borrowdale $40.6 \times 76.2 \ cm \ (16 \times 30 \ in)$ This painting is in a panoramic format to suit the landscape. The horizontals of the textures and water sit within a horizontal format and induce a feeling of tranquillity. To the left, the painting is about tone, while on the right the focus is on strong, soft colour, with soft orange-red providing unity throughout.

The verticality of the building demanded a vertical format, and the feeling is of excitement and dynamism. Placing the main point of focus in the centre risks the viewer's eye failing to wander round the rest of the picture, but here the imposing structure of Big Ben is balanced by a crane just to the side of it. Don't dismiss all industrial equipment as ugly; cranes can be useful in a painting to carry the linear elements of architecture into the sky.

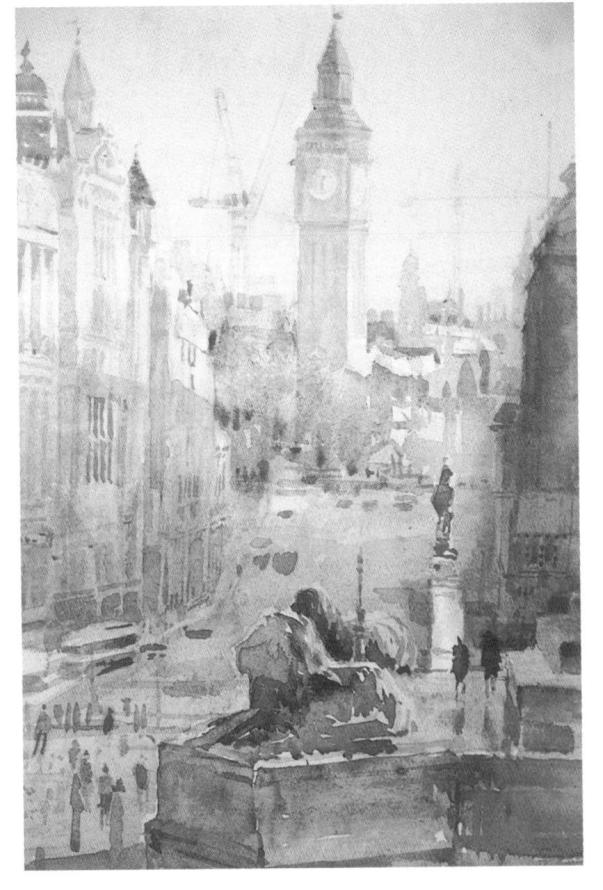

THE RULE OF THIRDS

Most of us have an instinctive understanding of aesthetic values; when I ask students to make a mark on a simple line, they invariably choose a spot about a third of the way

along it. Placing points of interest a third of the way in from the sides of your painting will make for an aesthetically pleasing composition.

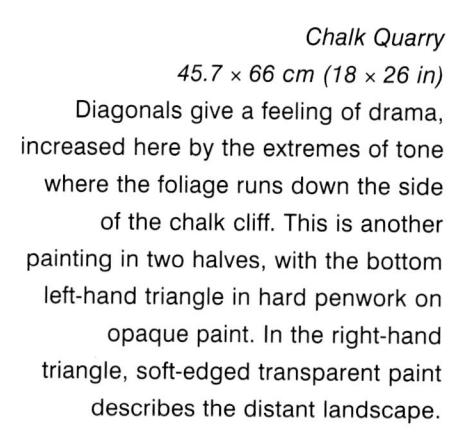

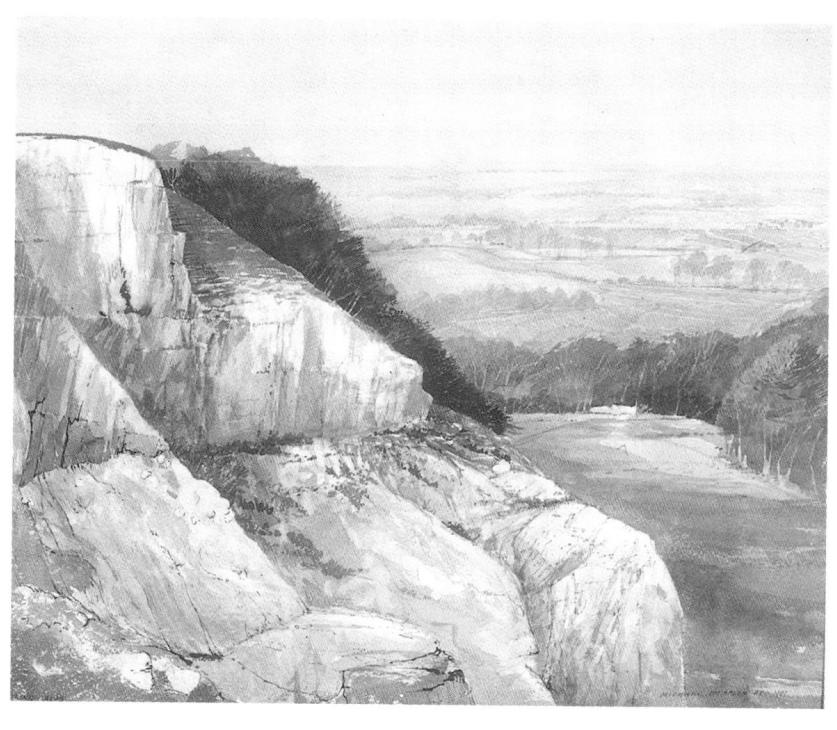

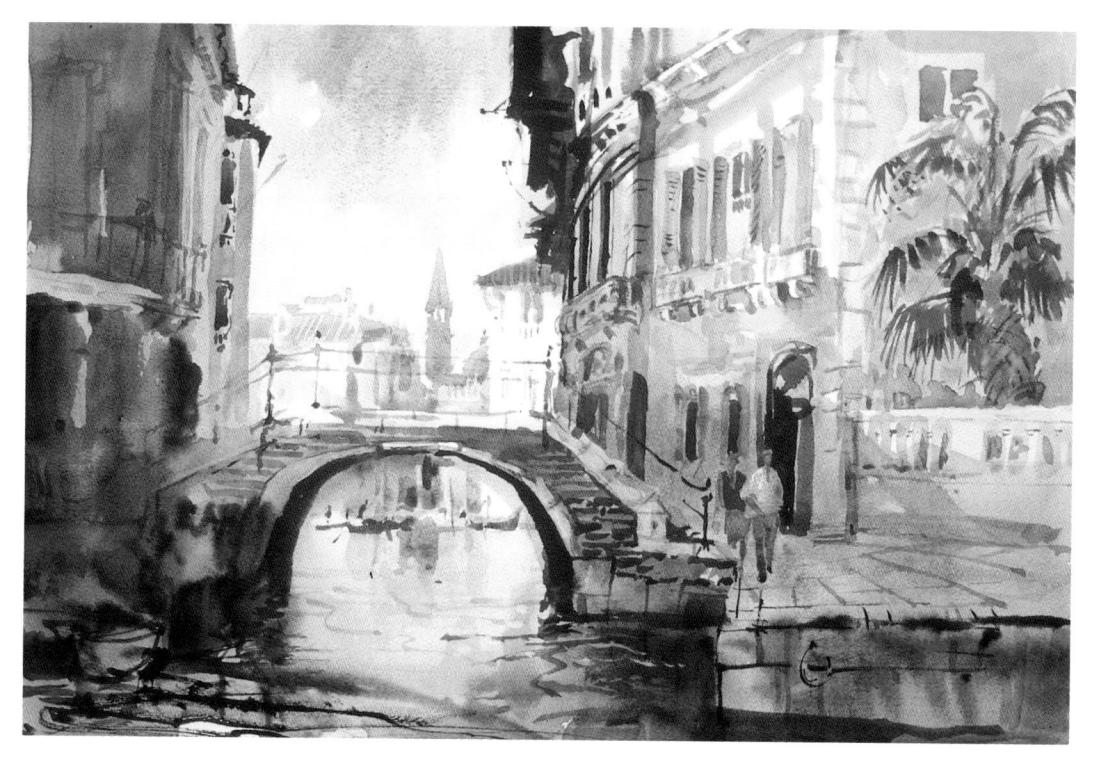

Bridge in Venice
30.4 × 38.1 cm (12 × 15 in)
Note how the bridge is
placed about one-third in
from the edge, making a
classical compositional
device that was much
used by the Old Masters.

STEP-BY-STEP: An Urban Scene

When you are travelling, keep a sketchbook at the ready so that you can enjoy the challenge of different architecture, landscapes and human activity. It is a good idea to spend the first day just walking around making little thumbnail sketches while you get the feel of the place; if you take your

paints out right from the start you will spend all your time in one location and perhaps miss better ones. Don't always think in terms of doing a final painting on the spot, for sketches perhaps backed up by some photographs will give you plenty to work with when you return home.

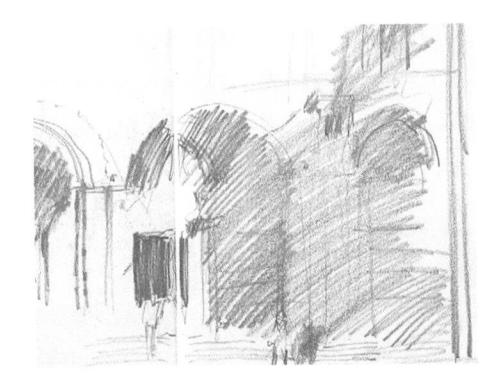

My initial idea here was simple – a sudden shaft of sunlight across the the cathedral square in Lucca, Italy, captured in my sketchbook with a soft 6B pencil. This tonal drawing is a very basic capture of a moment in time, its main function being to note the extremes of tone that give the feeling of drama.

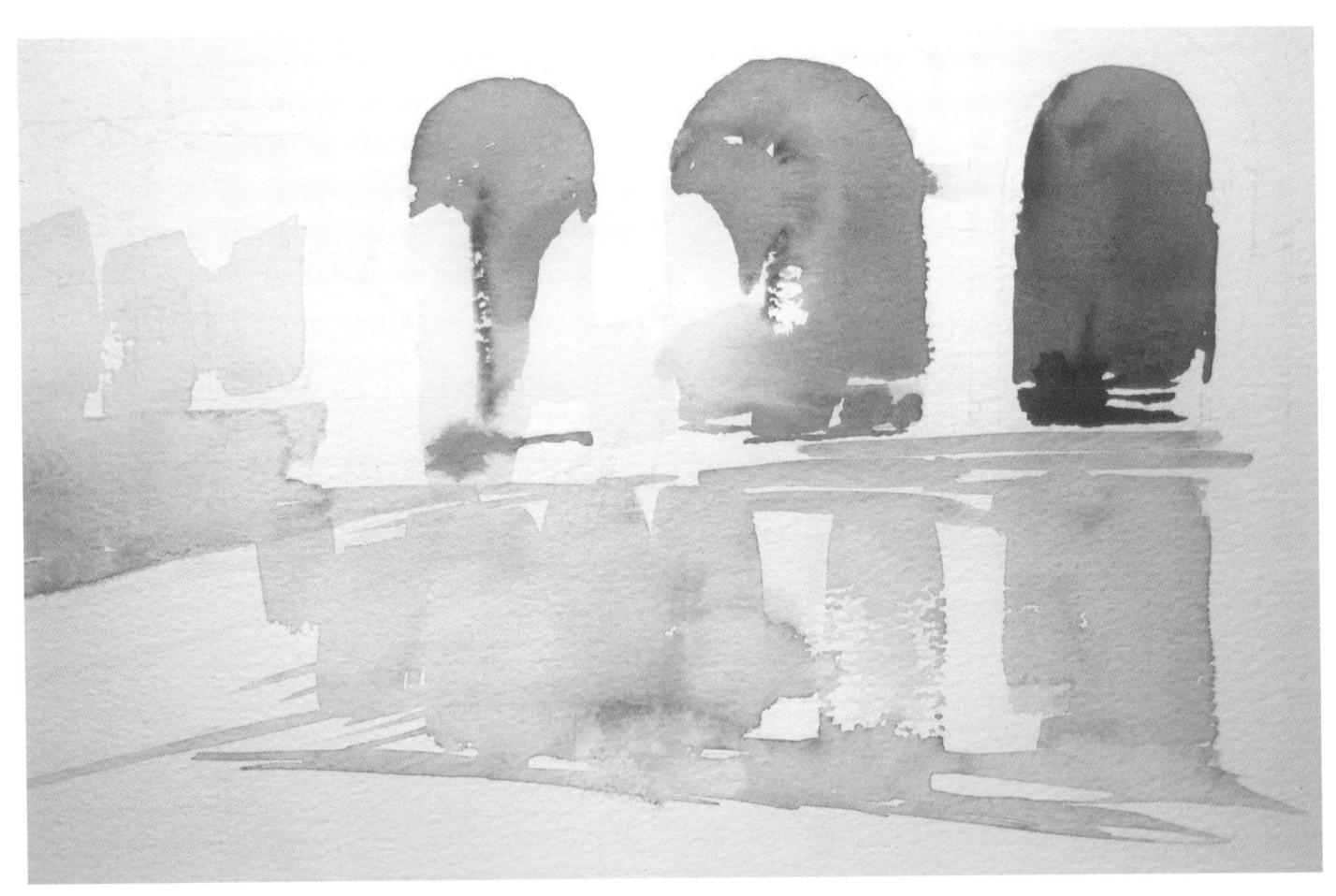

With the first washes I put in the three arches of the cathedral and the square to the left. Note the change from the warm washes in the foreground to cool washes towards the distant buildings. As I darkened the tone of the arches, I left some white space where the figures were to be put in.

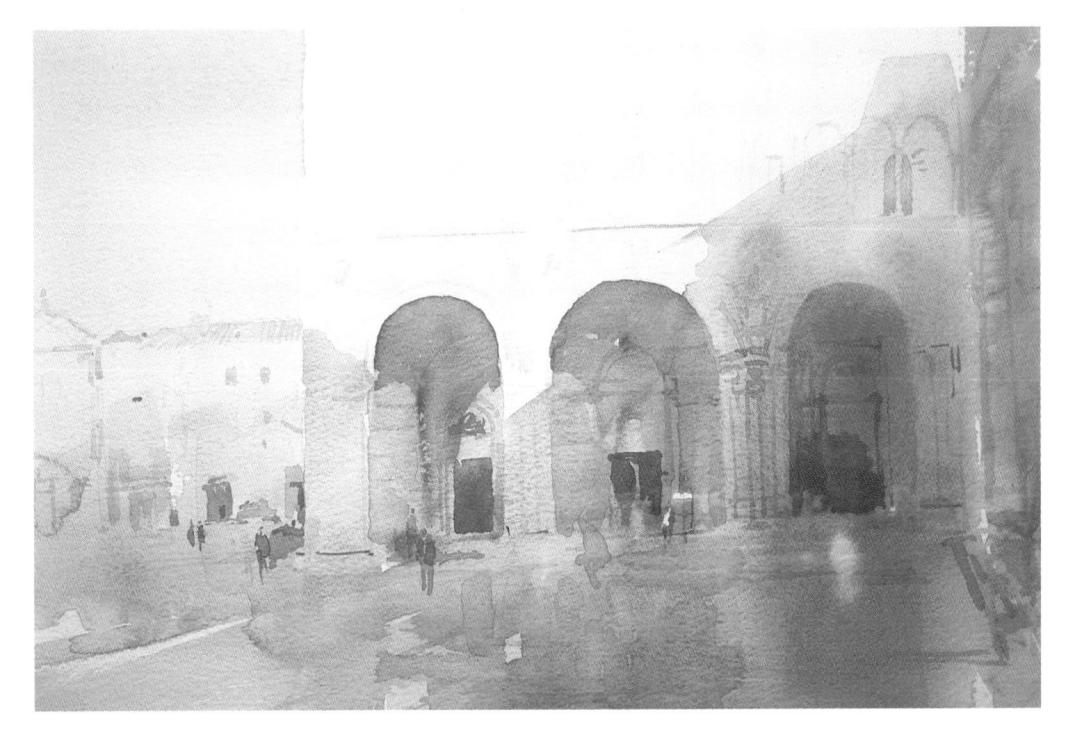

When the first washes were completely dry I laid the next washes quickly in order not to disturb them. A gradated sky wash, darker at the top to light at the bottom, defined the edge of the sunlit façade of the cathedral. I used Ultramarine, a warm blue, for the foreground and diagonal shadows, and lifted out one of the figures with a clean moist brush.

I strengthened the tones and colours as I worked on the foreground, which is unified with the background by the use of the same four colours in lighter washes. With brisk drawing using a small brush, I put in the final details of the figures and the row of arches across the top of the façade.

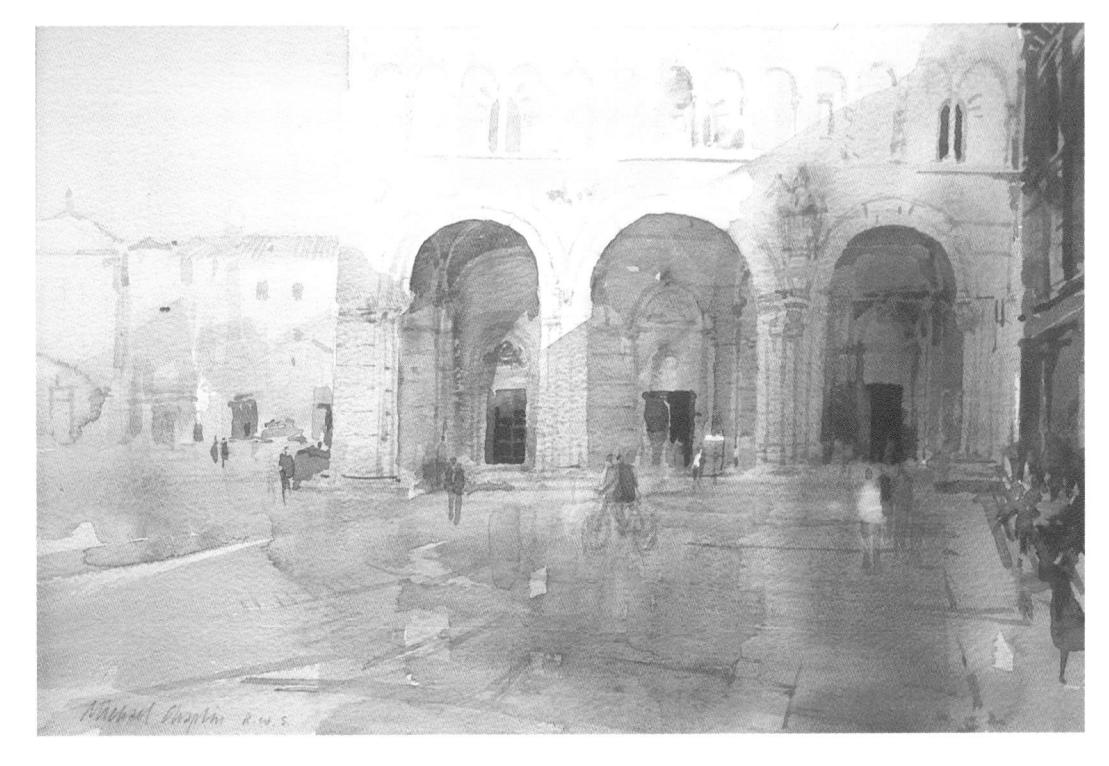

SKY AND WATER

The two main elements that our planet is composed of are sky and water, both of which are limitless sources of study for the artist. We can use skies to express movement, show the time of day and establish the overall colour of the picture. They also give us a chance to have fun with big washes of colour, put in wet-into-wet. Make studies of the sky whenever you can – you will always find something different to paint and they will act as useful reference.

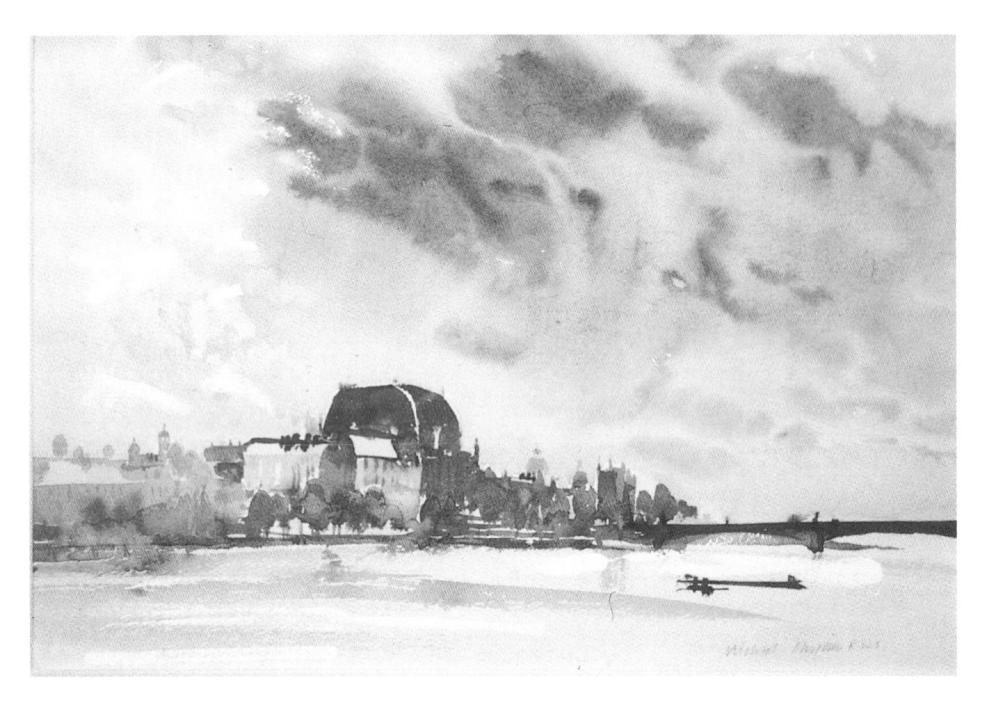

Prague Opera House 30.4 × 38.1 cm (12 × 15 in)

This contre-jour painting was done on blue-tinted paper. I covered four-fifths of the sky with a thin wash of Cerulean Blue, deadened slightly. To the left, the yellow tells us where the light is coming from. The clouds were painted with Burnt Sienna plus a little Violet. Note the perspective of the clouds from the top to the distance.

End of a Hot Day in Venice 30.4 × 38.1 cm (12 × 15 in)
Industrial effluence in Venice produces marvellous sunsets with an unusual yellow colour which dominates this painting. I used the complementary colours of yellow and violet to provide the subtle tones of the distant Santa Maria church in silhouette. For the sake of continuity I painted the foreground water from the same palette; as artists, we do not have to depict reality.

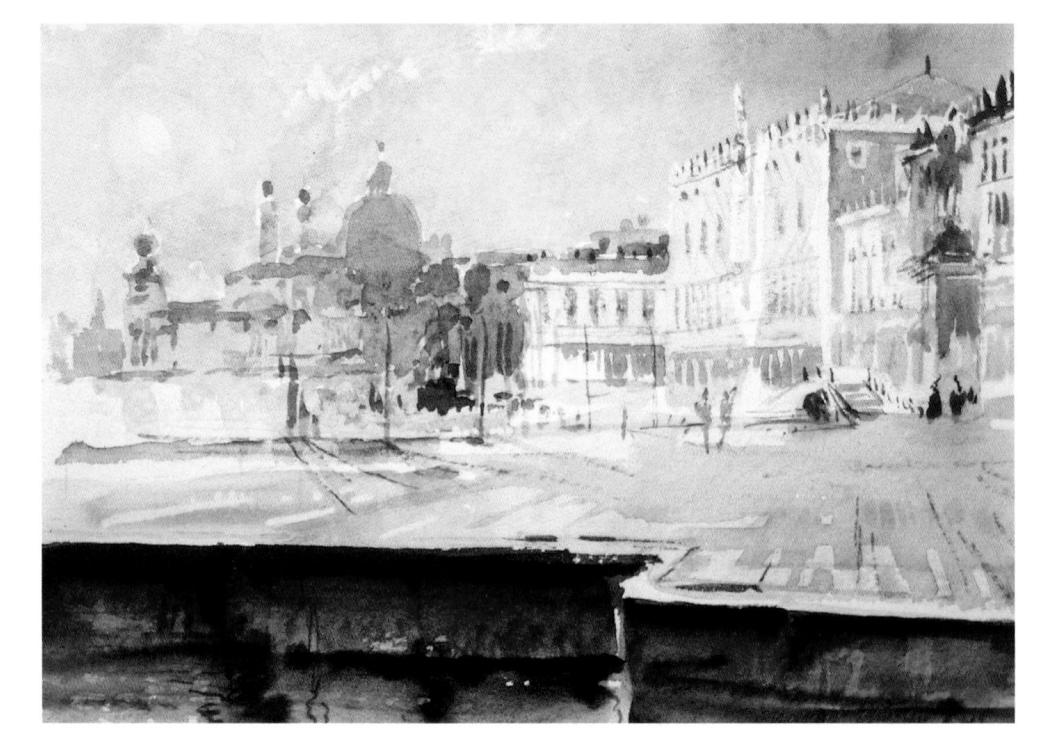

Water can give us intense foreground interest, with texture, movement and, above all, reflections. Those in the painting below may look complicated, but are just a looser treatment of the sky, house and trees they are reflecting. In

a flat calm lake, the reflections would be less distorted and would more closely resemble the reality. Express the nature of the water by the way you use your tools, from broad, sweeping brushstrokes to stabbing marks.

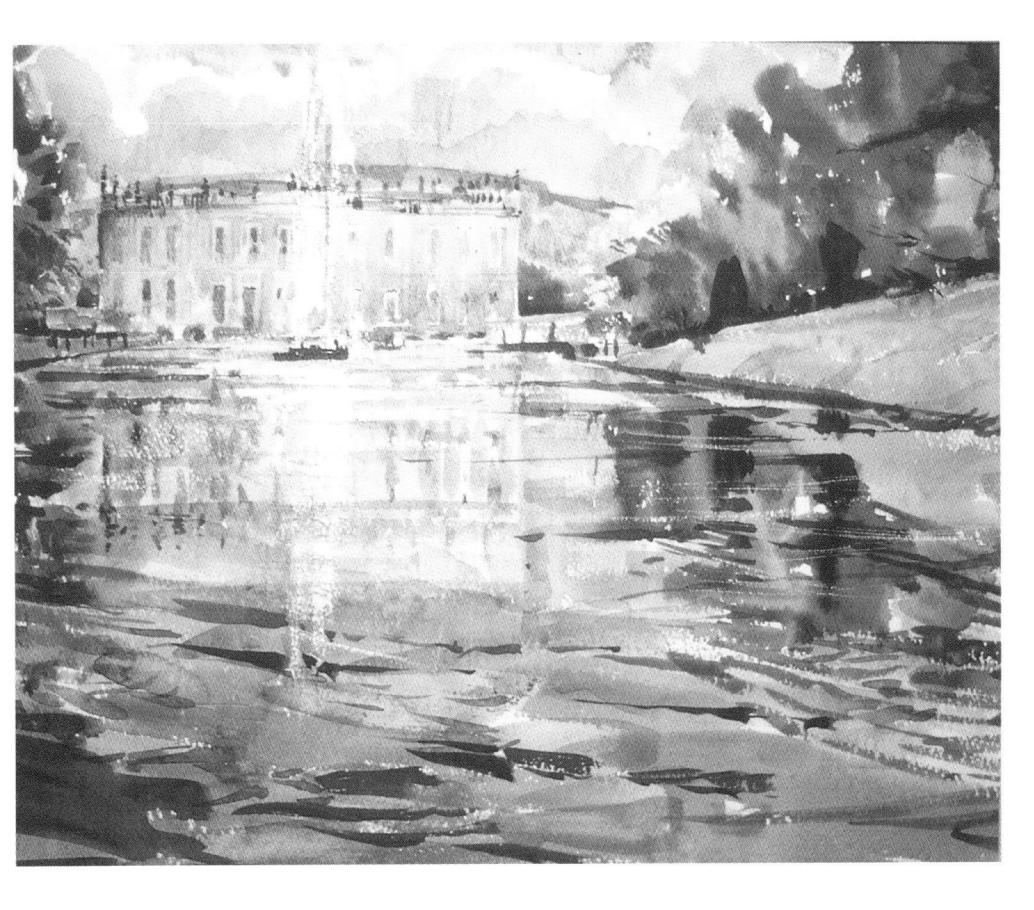

Chatsworth 35.5×40.5 cm $(14 \times 16$ in) This is a study of different surface qualities. All the water marks were painted at the same time as the objects they are reflecting, using the colour still on the brush, but with looser treatment and distortion caused by the wind-ruffled water. The hard, dark marks in the foreground water diminish as they recede into the distance, where lighter tones and softer edges are used.

These three techniques of painting water are all used in the painting above. The sample below shows hard reflected light on a choppy day; the one top right shows very soft delicate recession; bottom right are little sparkles of light which can be seen in the dark recesses of the reflection of the bank.

I used a 25 mm (1 in) flat brush like an italic nib to produce a thin line with a sideways movement and thick line with a downwards movement. I drew from side to side, twisting the brush as I moved down to make it present a flatter face to the paper and bring the waves further to the foreground.

I laid a midtone blue-grey wash and then made some very soft wet-into-wet marks to represent waves, stronger in the foreground.

Once the paint was dry I reinforced the ripples of the waves in the foreground with some tight brushwork with a No. 10 brush.

I laid a gradated wash from light to dark.

When it was bone dry I scratched little white wavelets into it with a point, broken at the top and coming down to more refined wave shapes at the bottom.

THE SEASONS

The changing seasons give you the chance to explore different palettes and textures. Spring is all about fresh, raw colours; summer is a time of dark, rich tones and strong shadows; autumn is about colour and texture and being

inventive in the way you paint it; and winter is about linear drawing. Set yourself object lessons in studying colour, tone, texture and line according to season, noticing how the qualities of light and shadow change through the year.

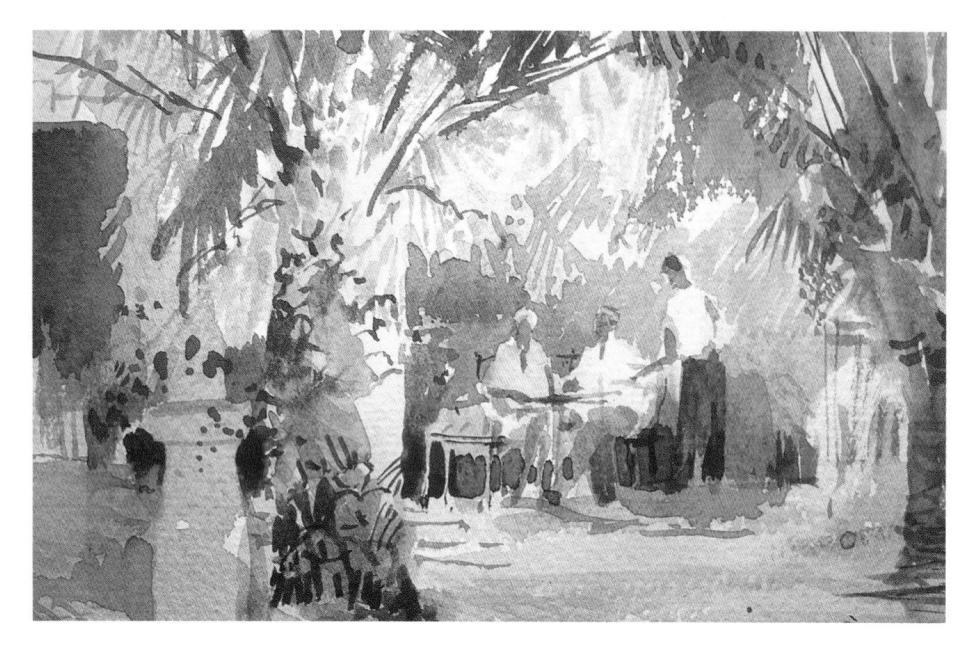

In this study of figures sitting in the bright spring light, new green growth on the palm tree is accentuated by the strong red of the flowers. Mix your greens from blue and yellow to obtain the pure acid greens that are seen only in spring and try painting straight on to the paper without preliminary drawing to capture their freshness and immediacy.

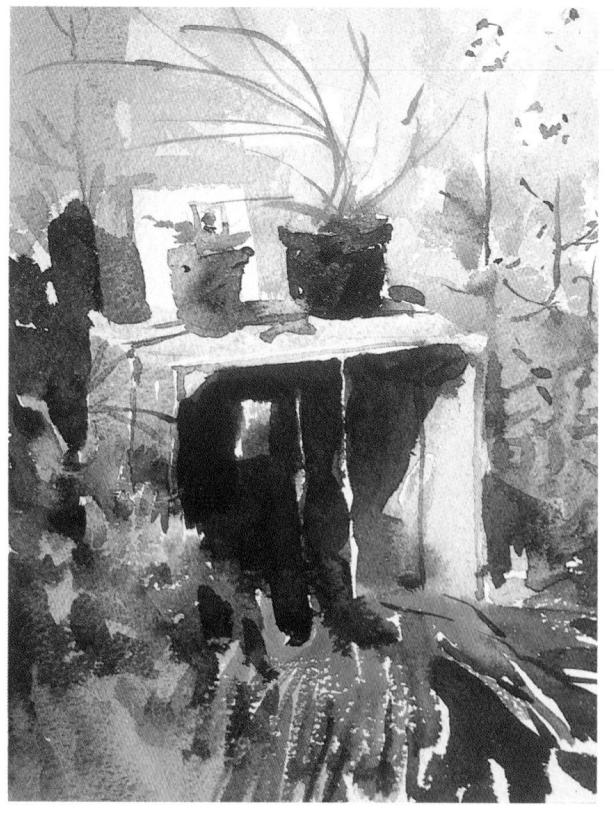

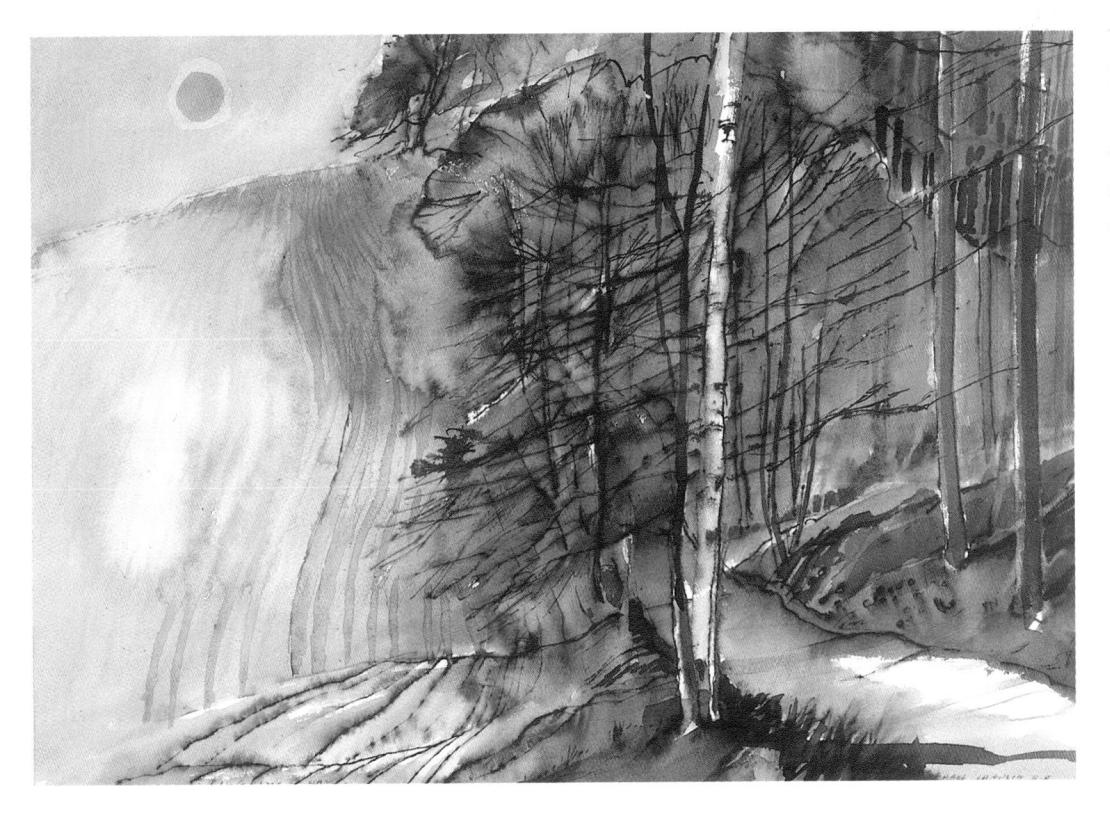

Typical autumn colours are hot oranges, yellows and browns. While the paint was still wet I drew into it with sticks, feathers and pens to catch all the interest in the linework that was emerging.

In winter, colour is generally much simpler and cooler in temperature. Contrast is greater, with dark linear rhythms more in evidence. Snow studies encourage you to work fast and fast watercolours tend to be the most successful ones. Don't assume that snow is white it contains a wonderful range of blues and purples within the shadows.

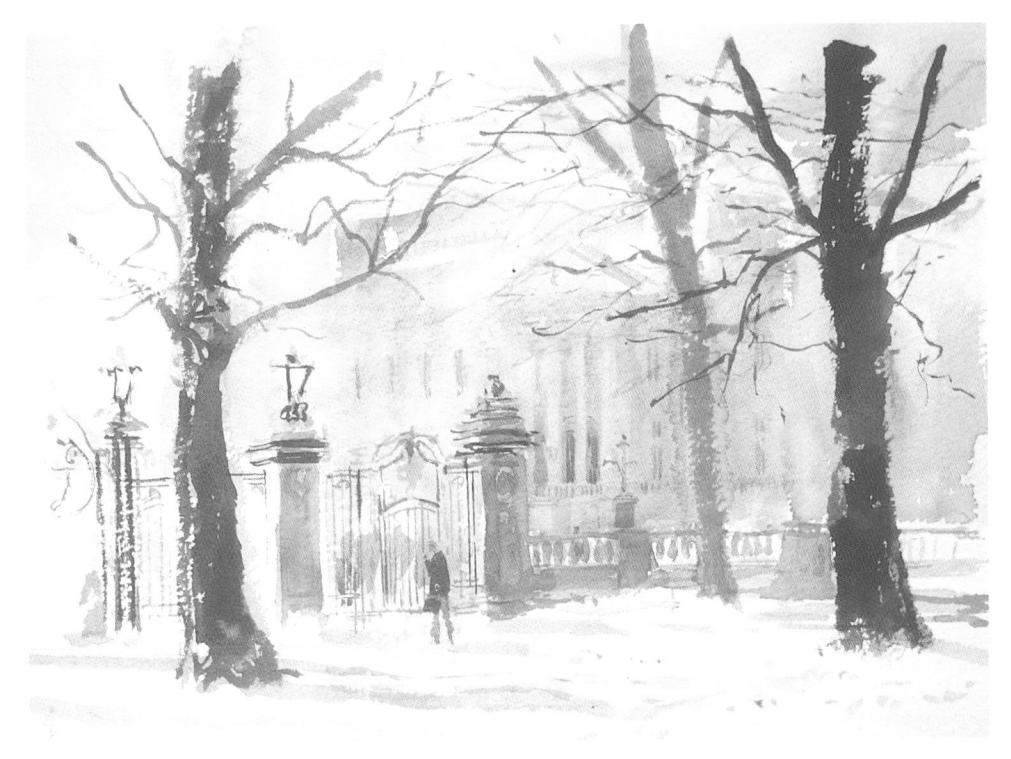

EXPLORING A LANDSCAPE: Tereglio, Tuscany

The sketches and paintings here show the value of exploring a scene in depth. Don't ever assume that because you have finished a painting you have also finished with the subject: you can reapproach it with different formats, sizes, materials and timescales.

In this pen and wash sketch my viewpoint across the valley to Tereglio gave me a composition of the town tucked against the hills behind it. The building on the bottom right emphasizes the plunging hillside.

The excitement of painting in watercolour is that we cannot dominate this medium, and to some extent it will do what it wants. Consequently, every painting may lead you on to other ideas about composition and format and whether you work loose or tight, fast or slowly.

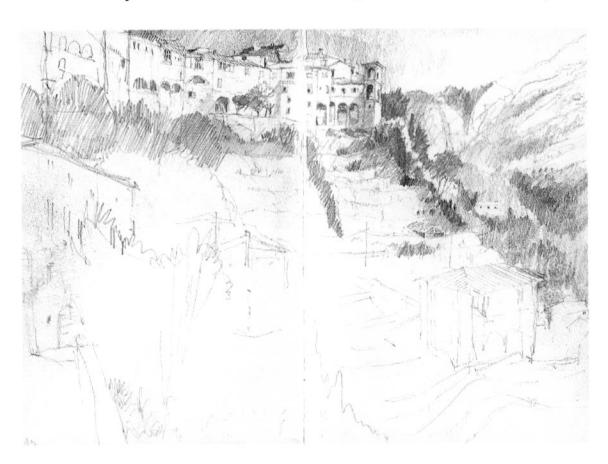

I then walked further down the hill and made a quick pencil sketch looking back up, from which viewpoint the buildings broke the skyline and added more drama.

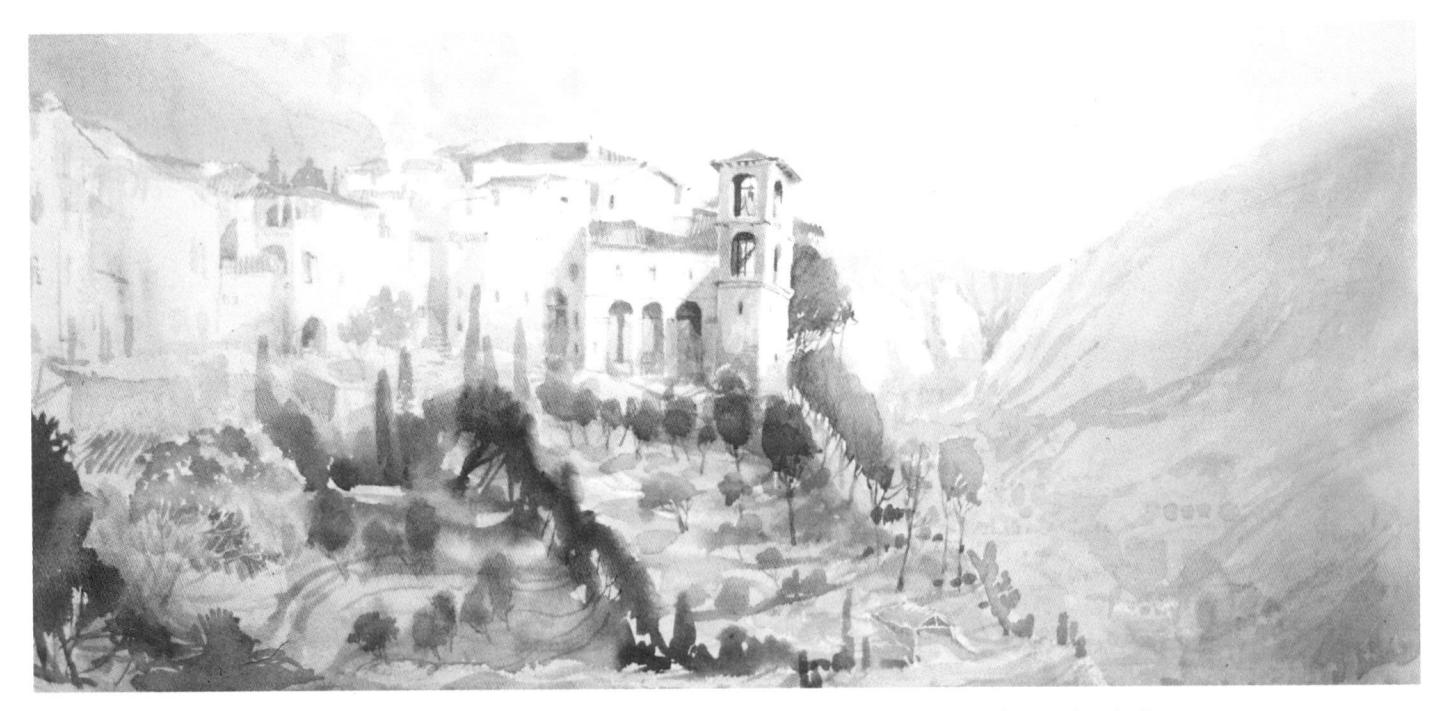

My first painted study was made from the pencil sketch. The double square panoramic format is similar to that which we would see if we looked across a wide valley, with loosely defined extremities. Placing the main point of interest centrally in the sketchbook risks translating to a painting with a too symmetrical composition; here the tonal composition moves from dark on the left to lighter on the right to avoid this.

I decided I wanted to explore
the viewpoint with the
buildings sitting against the
landscape, and this time I
moved the tower over to the
right. The diagonal at the
bottom righthand side,
although only lightly sketched
in, leads us to look at the
distant valley beyond.
The painting is loose on the
lefthand side, becoming tighter
across the page as it builds to
a crescendo of light, colour
and tone.

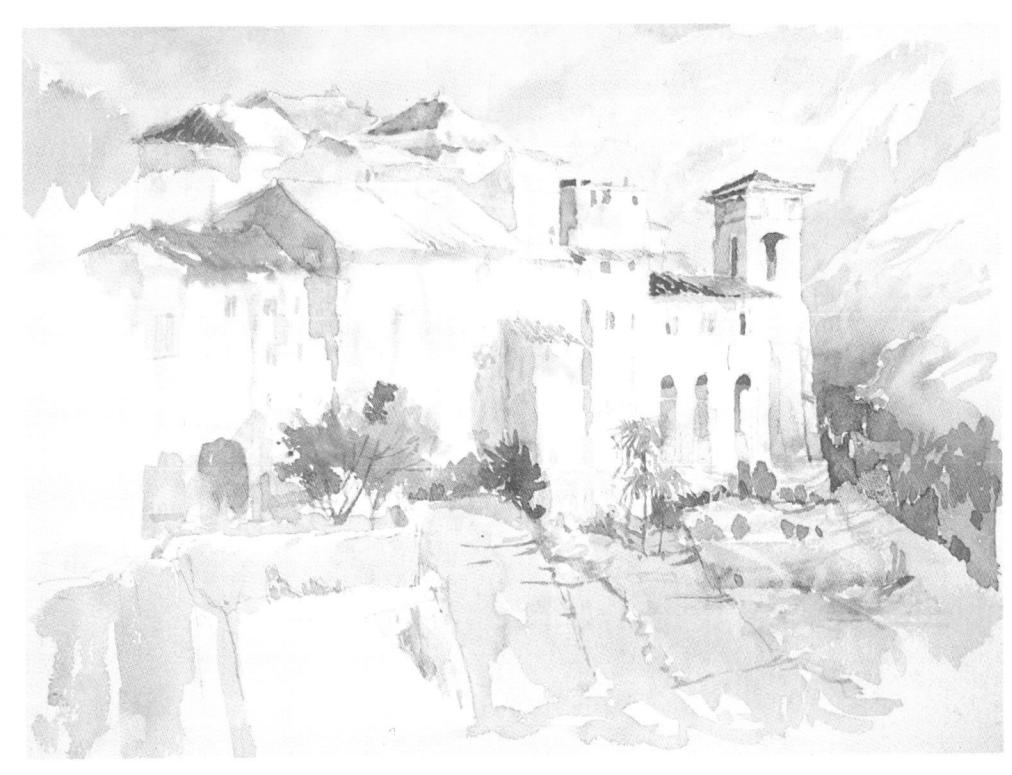

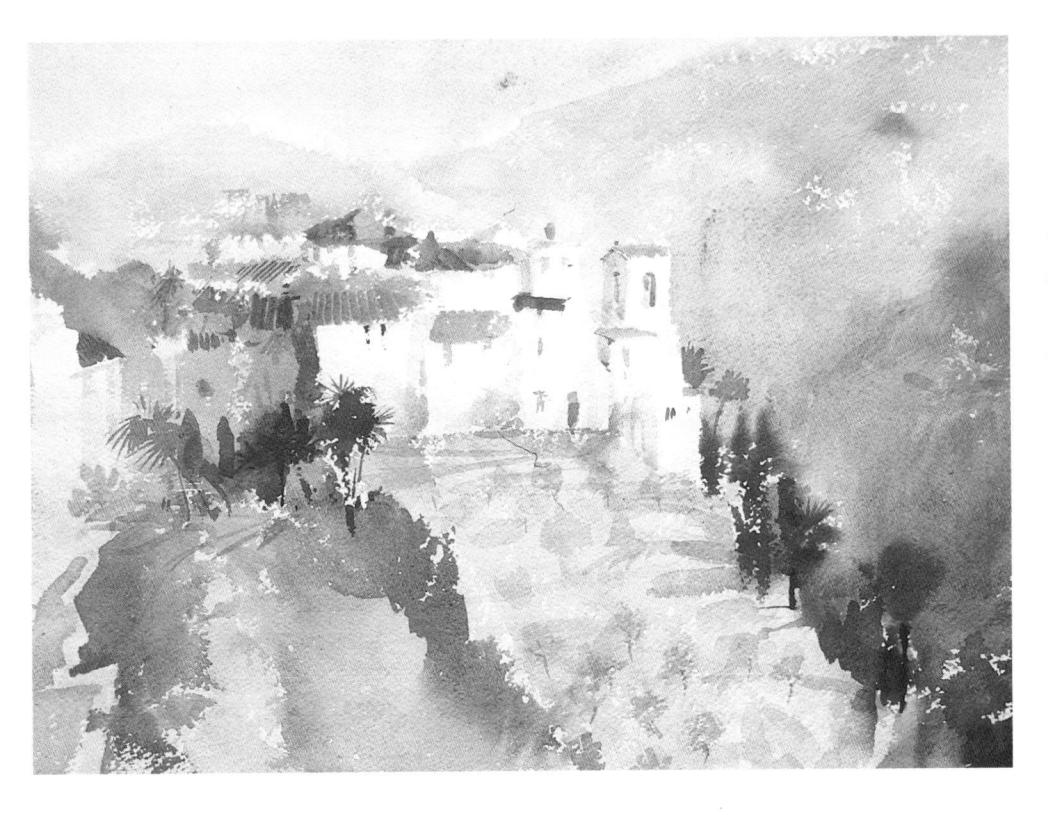

On my third attempt, painted quickly to investigate the balance between colour, tone and hard and soft edges, I established a diagonal movement across the page from top left to bottom right. The buildings have moved back to the middle but they are strongly balanced in terms of an asymmetrical composition by the way that the diagonal line introduces colour in the top left, hard-edged lights in the middle and soft-edged extremes of tone in the bottom right-hand corner.

EXPLORING A LANDSCAPE: Tereglio, Tuscany

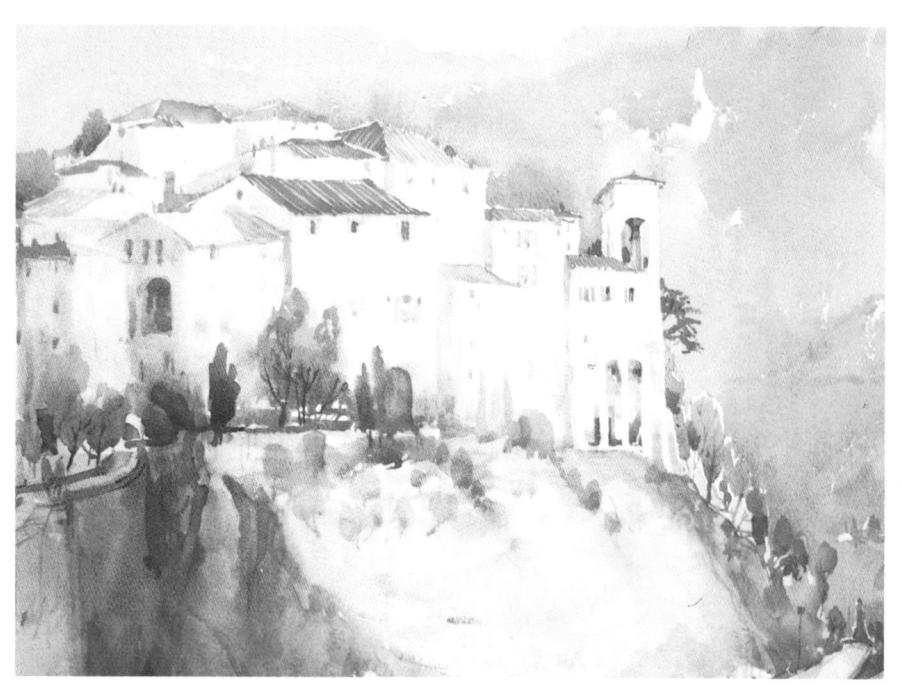

Happy with that strong diagonal movement, I began a more reflective painting of the composition in the style I used in the panoramic version. It has a calm softness rather than the vigour and excitement of the quick sketch, and I introduced an element of time and movement with the little wisp of smoke rising gently from the tower.

With watercolour paintings there is always the possibility of reassessing the composition with a couple of L-shaped mounts and cutting a mount to mask some of the painting if need be. In the end I decided I preferred this more intimate, very simple viewpoint.

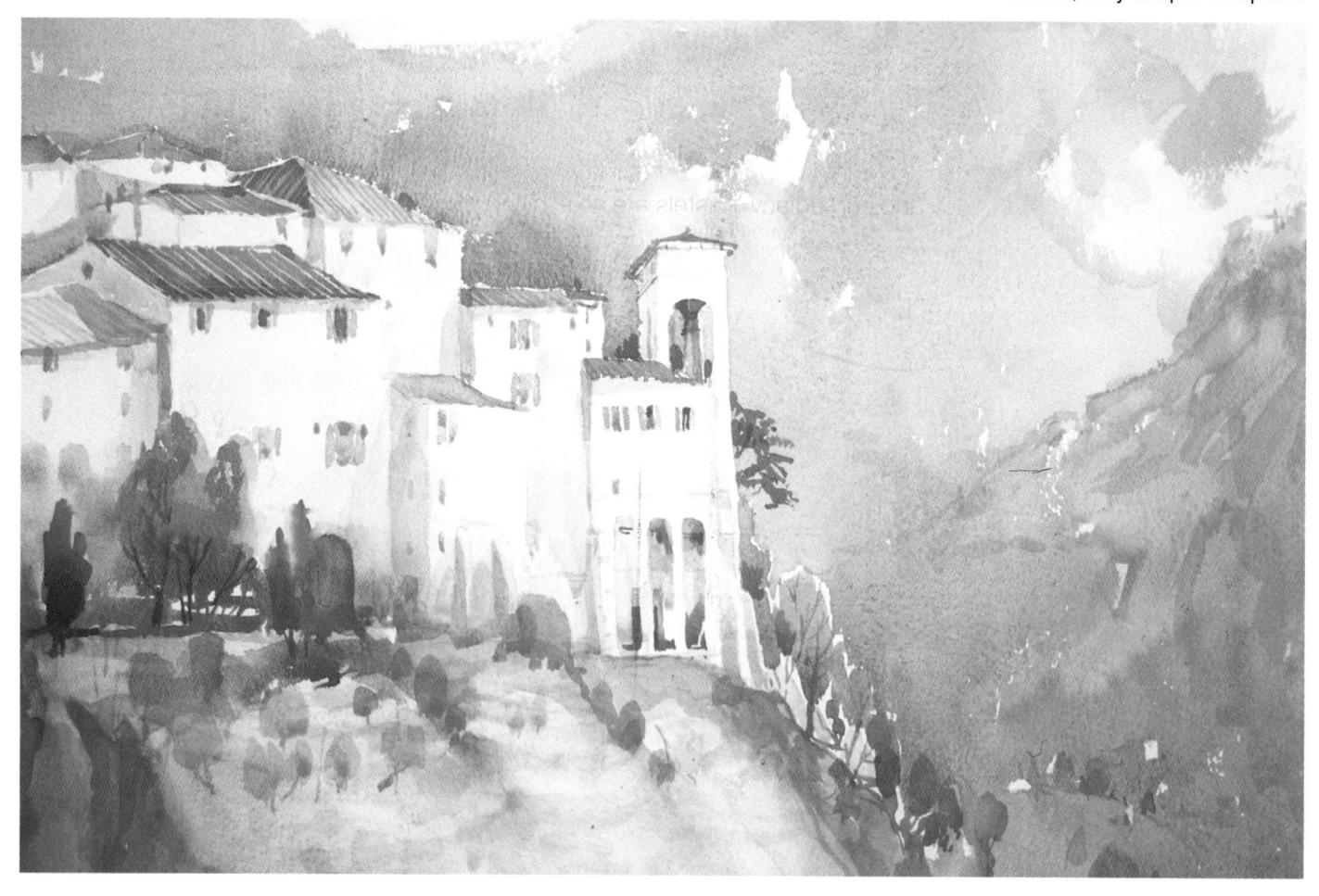

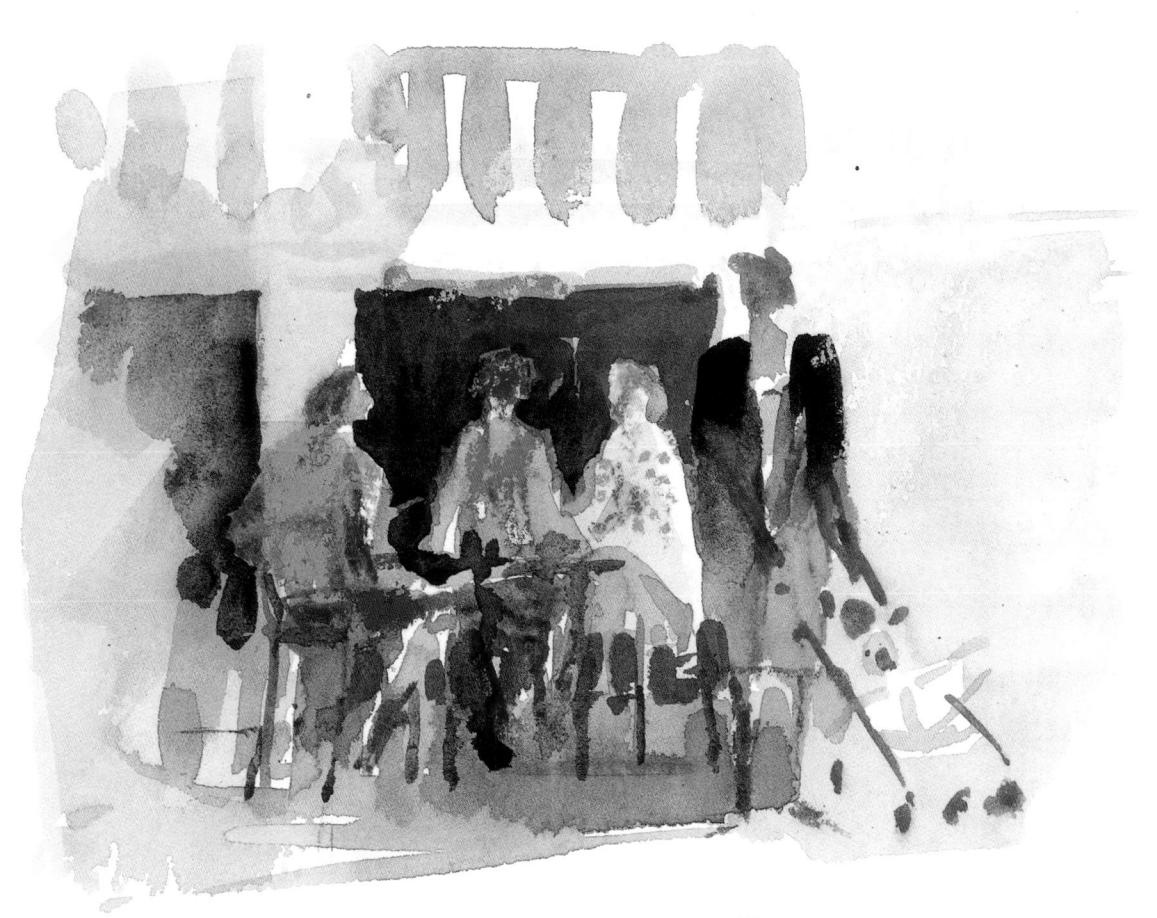

PASTELS

With their vibrancy and immediacy, pastels are an exciting medium to use. They also hark back thousands of years: Neolithic artists made their cave paintings using the same techniques of applying pure pigments to a surface that still hold good today. In more recent centuries, you can find them in Renaissance drawings by Leonardo da Vinci and in Edgar Degas' famous depictions of ballerinas at the end of the 19th century. They are the medium that many artists have reached for when they have wanted to express spontaneity and movement, with strong, pure colours.

Pastels are quite difficult to use, and their intense colours need careful handling. The grains of the pigment will always remain separate, so you cannot mix colours together as is possible with paint. Nor can you thin the colours down to make lighter tones. You can only make a pastel lighter or darker than it inherently is by scumbling one colour on top of another to make a mix that will be perceived by the eye as being a single colour. So, unlike watercolour where you can buy just a few pigments to begin with, with pastels you are faced with over 200 pigments to choose from – and each is available in five different tones.

Consequently, pastel can seem daunting for the beginner, and the aim in this book is to guide you through the early steps of mastering its use. It is a wonderfully direct and expressive medium that encourages you to work large and bold, and as such it may transform your work in other media too.

DRAWING TOOLS

Manufacturers offer pastels in about 200 colours, and since it is not possible for the artist to reduce the tone as is done with paint, each of the colours is available in five different tones from light to dark. In practice you will probably find three adequate, but this still leaves the beginner with a bewildering choice. Fortunately, useful starter sets are available, some of them including a brush, an eraser, some paper and a pencil sharpener. Starter sets are usually designed for a particular purpose, such as one for figures which has a range of flesh tones or a landscape selection with a choice of greens.

To make pastels, the pigment is mixed with binder in a vat. It is then extruded like spaghetti and chopped into short lumps or compressed into moulds, which produce much harder pastels. The latter are best for tight drawing with hard edges, while the soft ones are ideal for scumbling rich areas of colour. Hardest of all are pastel pencils, which have a wood casing.

Watercolour pastels and pencils are in effect watercolour paints, while oil pastels are compressed oil colour. They are a means of applying paint conveniently put into a drawing medium.

CHARCOAL

Charcoal is available in various grades, from hard to soft, and in thin wands or thick stumps. It is usually made from willow, but you can even draw with barbecue charcoal if it has not been treated with lighter fuel. It is messy to use but produces wonderfully rich velvety blacks.

The top zigzags are drawn with a compressed cake of hard pastel; the middle are soft pastel; the bottom are pastel pencil, which is the hardest of all. To the right of each, they have been rubbed out with a putty eraser. The zigzags have been smudged in three different ways, from left to right, with a soft dry brush, a finger and a stump.

These three marks are made with Sap Green in tones 1, 3 and 4.

If you decide to buy individual colours I recommend these for a basic set, plus black and white. It includes a warm and cool version of each colour. and you will need a light and dark tone of every one.

- 1. Cadmium Red
- 2. Alizarin Crimson
- 3. Cadmium Yellow
 - 4. Lemon Yellow
- 6. Hooker's Green 7. Cerulean Blue
 - 8. Cobalt Blue
- 9. French Ultramarine
 - 10. Burnt Carmine

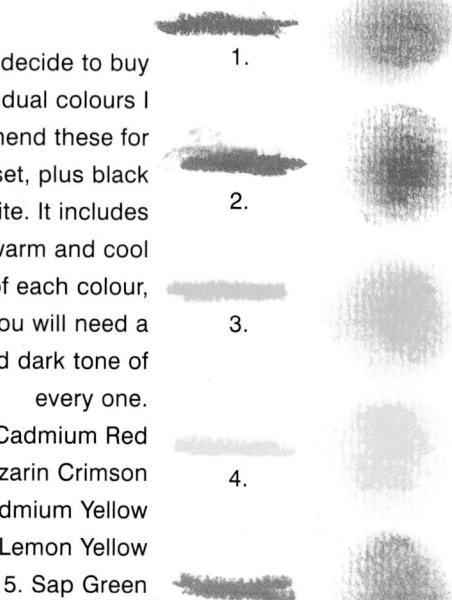

6.

10.

PAPER

To adhere to the surface, dry pastels need a paper with a rough texture. You will be able to apply up to four coats before a smooth chalky surface builds up, making it difficult to put more pastel down. Some artists draw on very fine carborundum paper of the kind used on car bodywork, which is strong enough to be used with wet pastels. If you

are working with dry pastels you can even draw on fine sandpaper. Be experimental, but also be aware that your work may not last as long as on art paper.

Because watercolour and oil pastels have gum and oil respectively in them they are quite sticky and can be used on smoother surfaces.

Artists drawing with pastel commonly work on midtoned paper, when all their marks become positive statements about light and dark tones. Many papers are available, offering a range of tones and colours. You can buy spiral-bound blocks with the drawing paper interleaved with waxy paper to prevent the pastel transferring to the back of the facing sheet.

EQUIPMENT AND WORKSPACE

Pastel is a messy medium, and if you will be using it in your house rather than a studio you will need to put down a dustsheet to protect your carpet. Wear a mask if you are making vigorous drawings with dry pastel and never blow dust off your work. I keep a vacuum cleaner beside me and when dust builds up on the surface of the drawing I run the hose close to it to suck up the dust. You may find a mini vacuum cleaner of the type used for computers a useful investment.

You will need a board to rest your paper on, and the problem of dust will be lessened if you tilt it upwards. If you are on a limited budget you can make do with a couple of bricks on a table, but buying a proper easel will allow you to angle your board a few degrees forward from the vertical, which will be a great help.

BLENDERS

You can blend pastels with your finger, cotton buds, a blending stump or a brush. Stumps, or torchons, are available in art shops, but you can make your own by rolling a strip of paper into a tight wad. A soft fan or blending brush is excellent for brushing soft powder across the paper to the exact spot you want it to be.

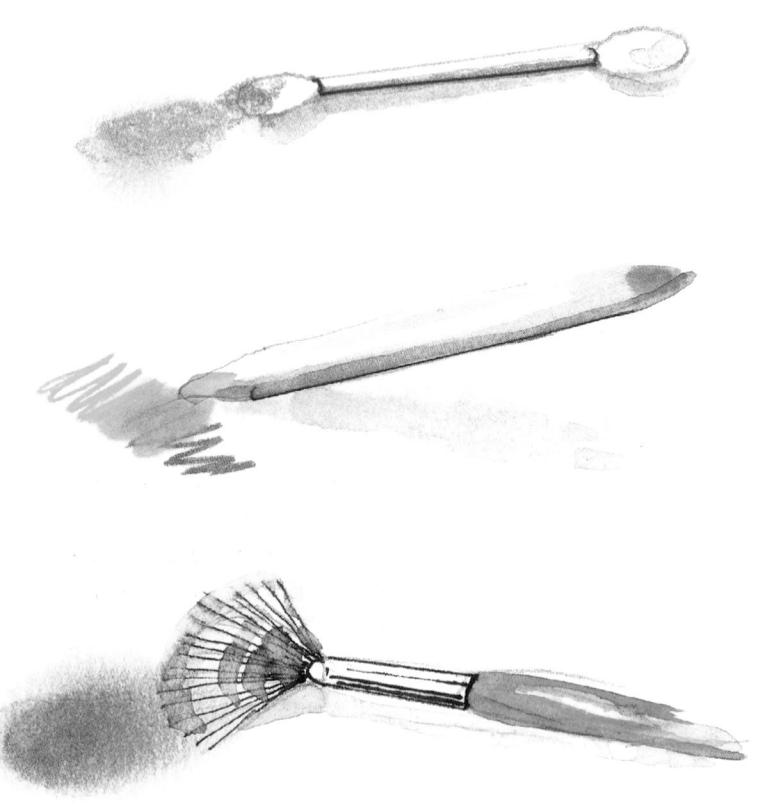

FIXATIVE

Fixatives are available in aerosols and in liquid form, for which you will need a diffuser. This is made of two tubes hinged at right angles. One tube goes in the fixative and you blow through the other, creating a vacuum which draws the fixative upwards to be dispersed in a fine spray when it encounters the air flow.

When you are fixing repeatedly and adding more coats of pastel you will clog up the paper if you apply too much fixative. Hold it 60 cm (2 ft) away and use just enough to stop the pastel falling off.

Fixative also allows you the creative use of dust. You can sandpaper a pastel stump above the paper to cover it with dust, then draw into it with a comb or other implement. You can even sprinkle dust down through paper doilies or stencils you have made yourself. You will obviously have to spray very gently to avoid spoiling your pattern.

If you are sketching on location with no fixative to hand, a can of hairspray will do the job. Don't use it for finished work as it may yellow or otherwise degrade the paper.

You can use an eraser as a drawing tool to put lights into darks but of course this must be done before you spray with fixative.

SHARPENERS

You will need a knife for sharpening stumps, and it will also be useful for scratching out pastel to reveal the paper or colour beneath. You can buy pencil sharpeners large enough for pastels, but hard, brittle pastel flakes when you try to sharpen it. Using sandpaper is the best option.

ORGANIZING YOUR WORKSPACE

It is best to have your own private workspace for any form of art so that you can leave your equipment and ongoing pictures out, ready for you to go straight to work even if you only have half an hour to spare. A window giving north light is the ideal, since you will not be troubled

by glare or by shadows moving across your paper. For drawing after dark, buy some daylight bulbs rather than using ordinary household bulbs, which have a pronounced yellow cast.

For keeping your paper clean and dry, a zipped folder from an art shop is practical and also spacesaving, since you can store it upright. However, with pastels it is essential to keep them safely away from children and pets, so a locked cupboard to keep knives, pastels and fixative safely stored is advisable.

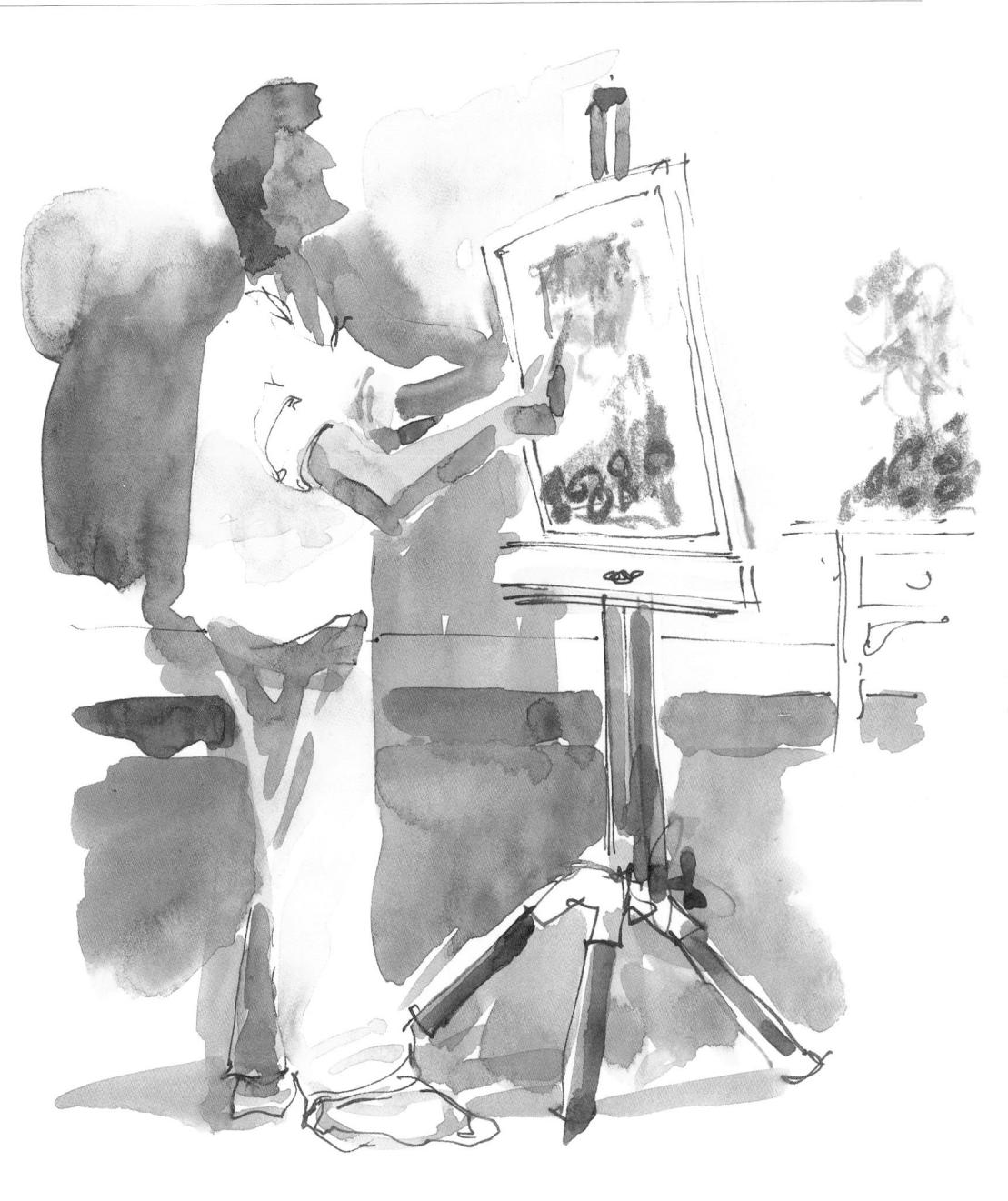

When you stand up for long drawing sessions, spread your feet so that your weight is evenly distributed. If you are right-handed, look past the left side of your board at your subject and vice versa. The artist here has his board leaning forward to shed dust, but it is set too low – try to have your eye in the centre of the paper.

BASIC MARKS

LINEAR MARKS

In the sampler of marks below I have worked light on dark. If you have previously drawn only dark marks on white paper you will probably find this quite an alien way of

thinking. However, it is a technique that is much used when working with pastel, so try practising these easy marks on midtoned paper to accustom yourself to it.

Hatching (a series of parallel lines to add tone).

Scumbling (working the pastel in circles).

Sharp, jabbing strokes.

Crosshatching, to deepen tone made by hatching.

Pivoting a short piece of pastel on the paper.

Sharp, jabbing marks.

Simple strokes with the point of a hard, sharp pastel.

Pastel smudged with a finger.

Marks made by rocking the flat end of a hard pastel.

Spots drawn with the end of a pastel.

Lines made by striking with the side of the pastel.

A simple full stroke of the width of the pastel.

I drew the vertical lines with a pastel then zigzagged with a stump, picking up colour.

I made the square with the edge of a pastel, then pulled the lines out from it with a stump.

Using orange pastel I drew staccato lines, giving a busy effect. I then took a blue pastel and made long, sweeping movements. On the left, the eye can easily distinguish betwen the two lines.

On the right, a third line has created a confusing jumble.

AREAS OF COLOUR

The marks below look simple, but they are very important because once you have done them successfully you will have covered all the basic ways of putting pastel down.

However, as you gain confidence with the medium I hope you will want to try experimental mark-making in order to build up your own personal vocabulary.

A simple mark pulled from the side of a short piece of pastel.

Here the mark has been smudged with a finger.

Drawn with the side of the pastel, with harder pressure on the left.

Red has been added, with harder pressure exerted on the right.

Here the red and blue have been smudged together with a finger.

This mark was made on rough paper so strong I could not press the pastel down.

Using the same paper, I smudged with my finger but some of the paper is still showing through the colour.

This time I wetted the pastel so it flooded over the paper, leaving no grain showing.

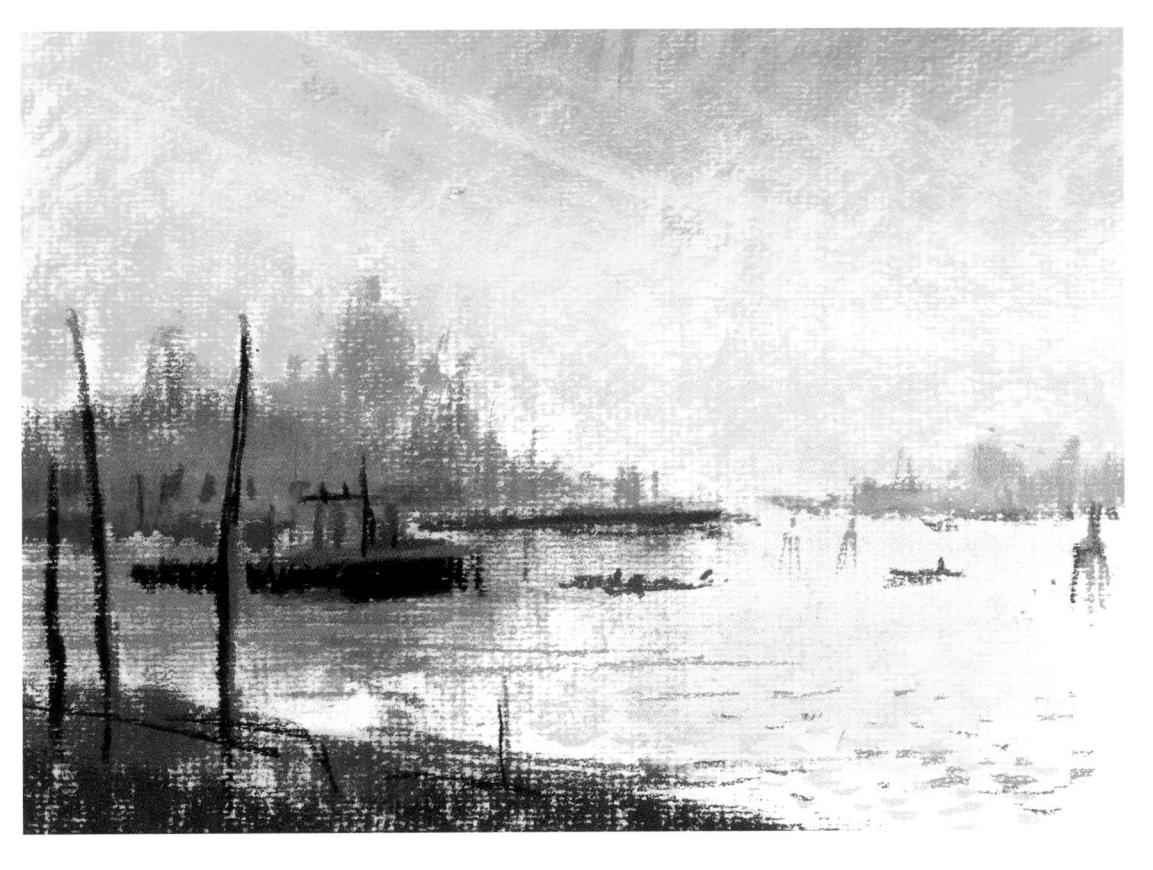

In this picture of the
Venice lagoon at
sunset, the colour at
the top of the sky
has been rubbed in,
whereas at the
horizon the sky is
slightly broken so the
eye travels into it.
Linear marks in the
foreground pull the
eye forward.

SKETCHBOOKS AND FORMAT

You will need sketchbooks for making notes, trying out your ideas and recording scenes you might want to make a finished drawing of later. Buy two, one square and one upright bound, to give you a wide choice of format, and try

to find ones with a variety of paper in them. If you cannot, clip loose sheets of paper to your board instead. Because your sketches are for your eyes only, they are a chance to enjoy being spontaneous and experimental.

A square sketchbook offers you a square or panoramic format. With an upright bound sketchbook you can work within a square, a portrait oblong or a landscape oblong.

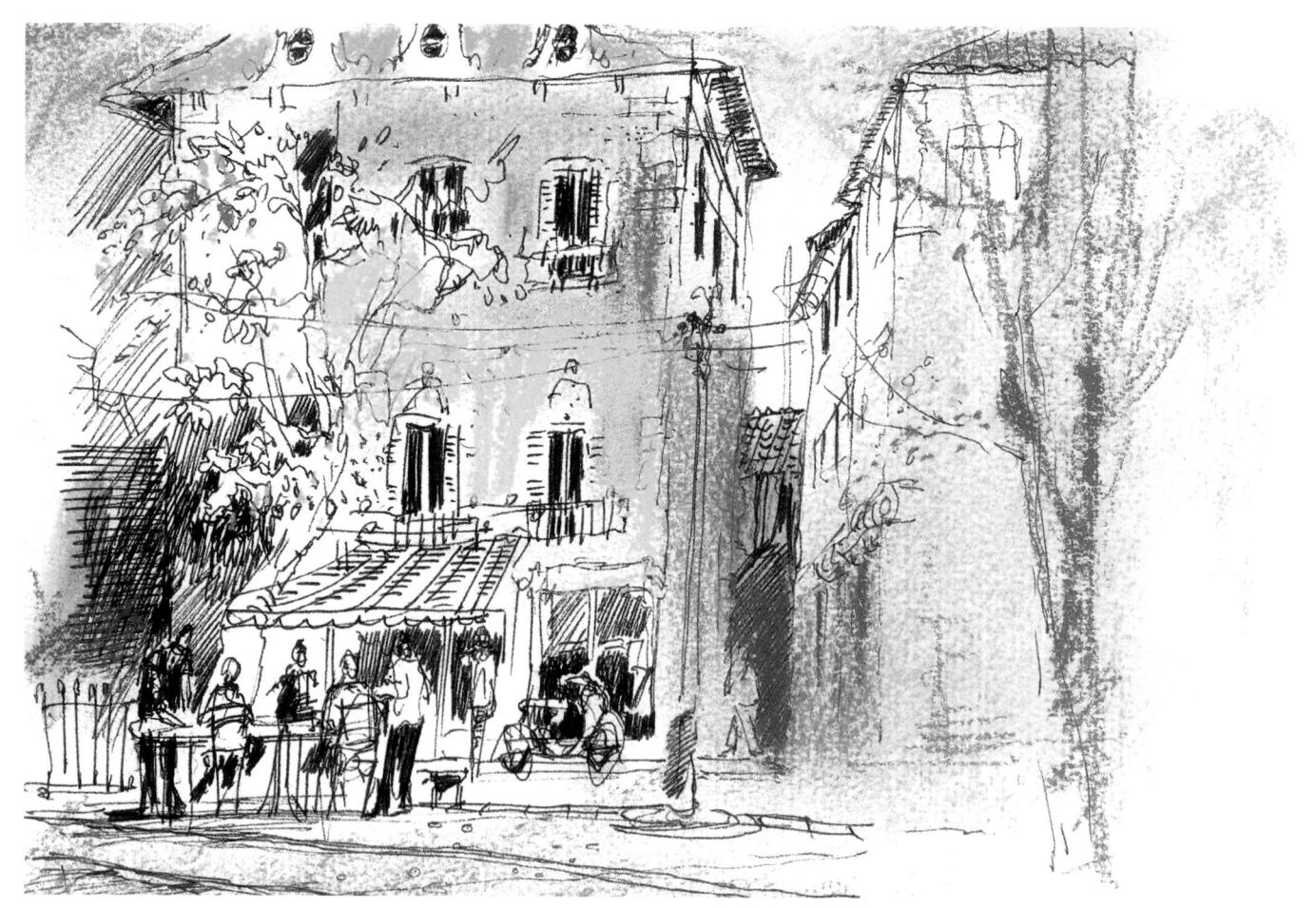

Pastel is a convenient way to carry colour, and here I have used it to make colour notes on a pen drawing. Do not feel you have to fit the paper manufacturer's format; I chose to end my sketch at the tree, giving me a format within which I often work.

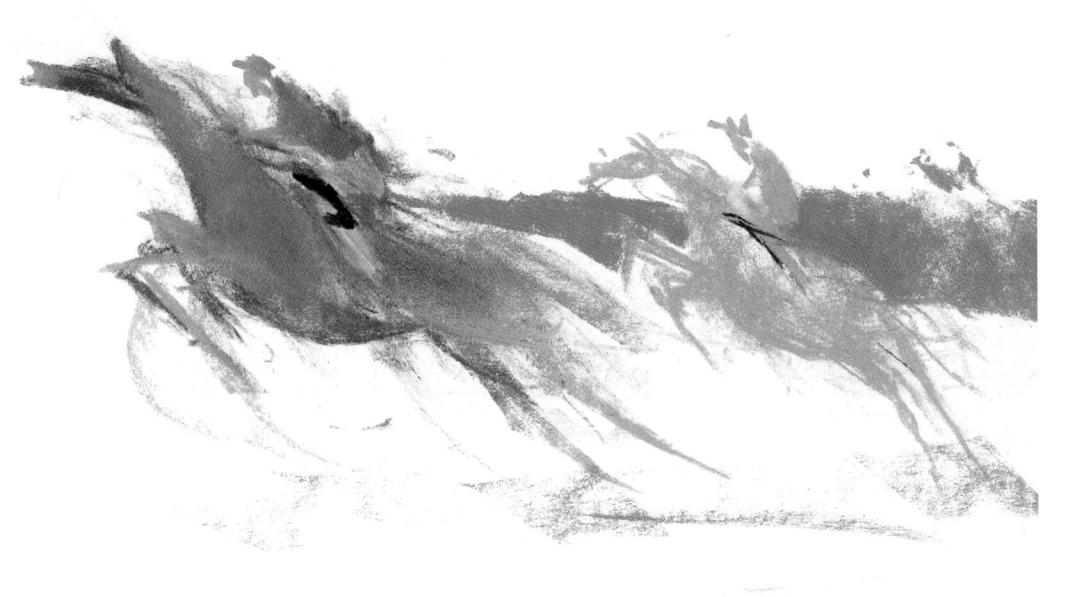

After I had been watching horse racing one day I realized that the flowing shapes I was making in my sketchbook resembled horses' legs. This sketch isn't intended to be accurate but to express the energy and fluidity of horses.

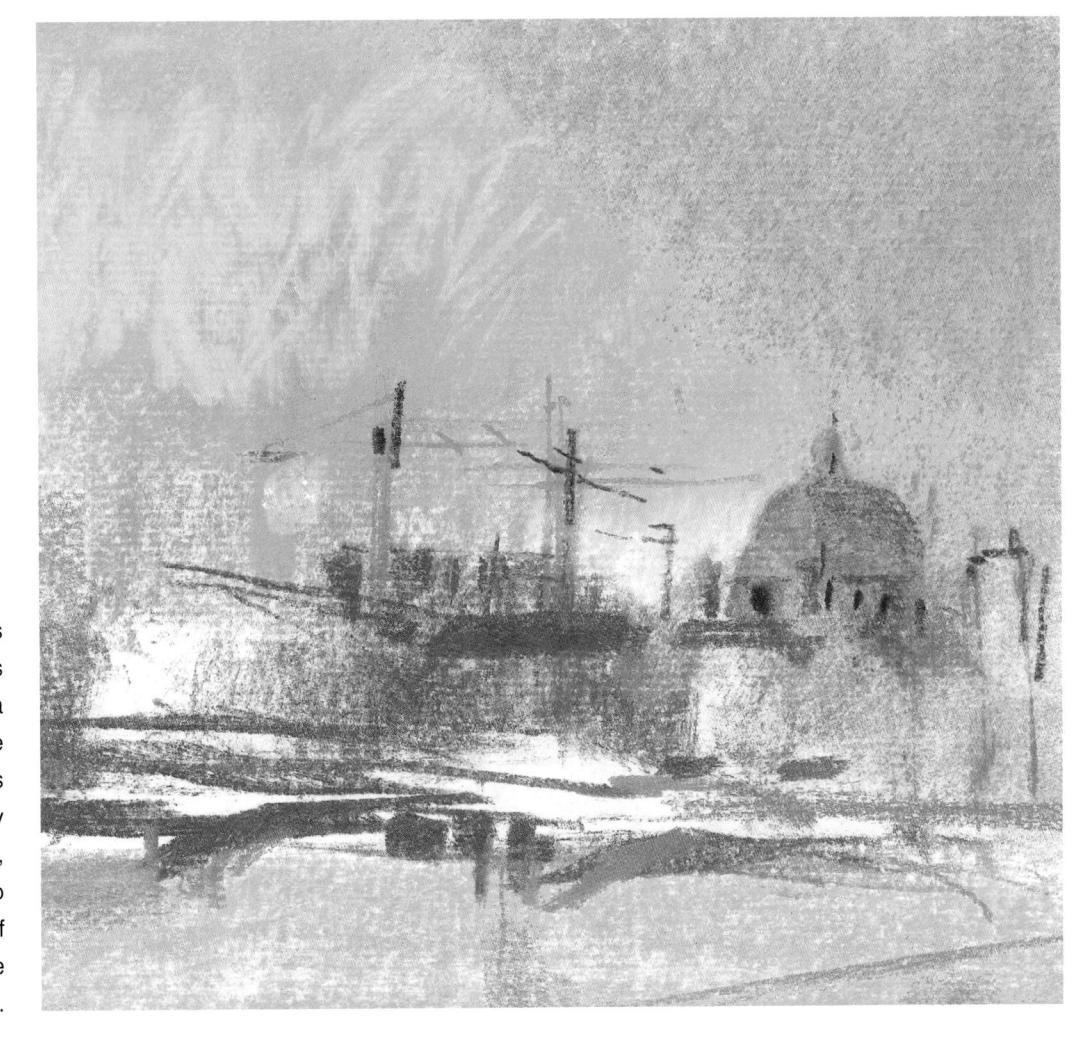

This sketch of St Paul's
Cathedral in London was
done on the spot but in a
more considered way than the
swift impression of the horses
shown above. I began by
scrubbing in pure, strong,
broad bands of colour to
establish the emotional feel of
the subject matter, adding the
drawing afterwards.

COLOUR

The colours you use in your pastels will to some extent be governed by the scene you are portraying but will also reflect your personal choice. However, colours also convey a psychological message that will affect the viewer's emotional response to your work. Reds, oranges and browns are described as warm, being associated with heat and fire, while blues and greys are cool, recessive colours that allow you to give a

The colour wheel contains the full spectrum of colours. as seen in a rainbow. Blue, red and yellow are primary colours and cannot be produced by mixing other colours. On the wheel they are separated by their secondary colours: red and blue make purple, blue and yellow make green, and red and yellow make orange. These are complementary to the primaries opposite them on the wheel.

Paint colours can be mixed in a palette, but with pastels you have to mix them on the paper instead. Always put the lighter colour down first as you cannot successfully pull a lighter colour over a darker one.

Green mixed by putting down yellow then pulling blue across the texture of.the paper.

Green made from blue and yellow blended with a finger; the result lacks liveliness.

Seen from a distance. these dots of yellow and blue give a fresh, vibrant green.

Complementary colours: green and red.

Complementary colours: orange and blue.

Complementary colours: purple and yellow.

Mixing complementary colours produces greys, and here I used purple and yellow for some of the recessive greys in this sketch of the Louvre, made on grey cardboard.

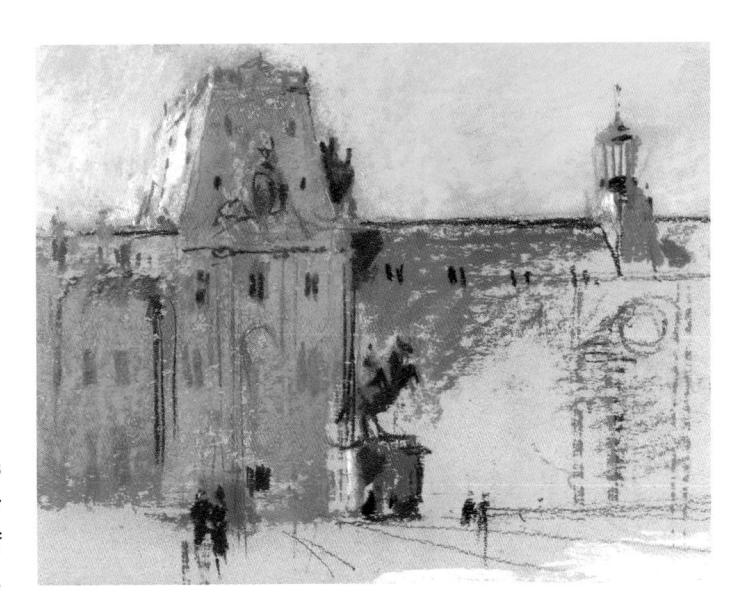

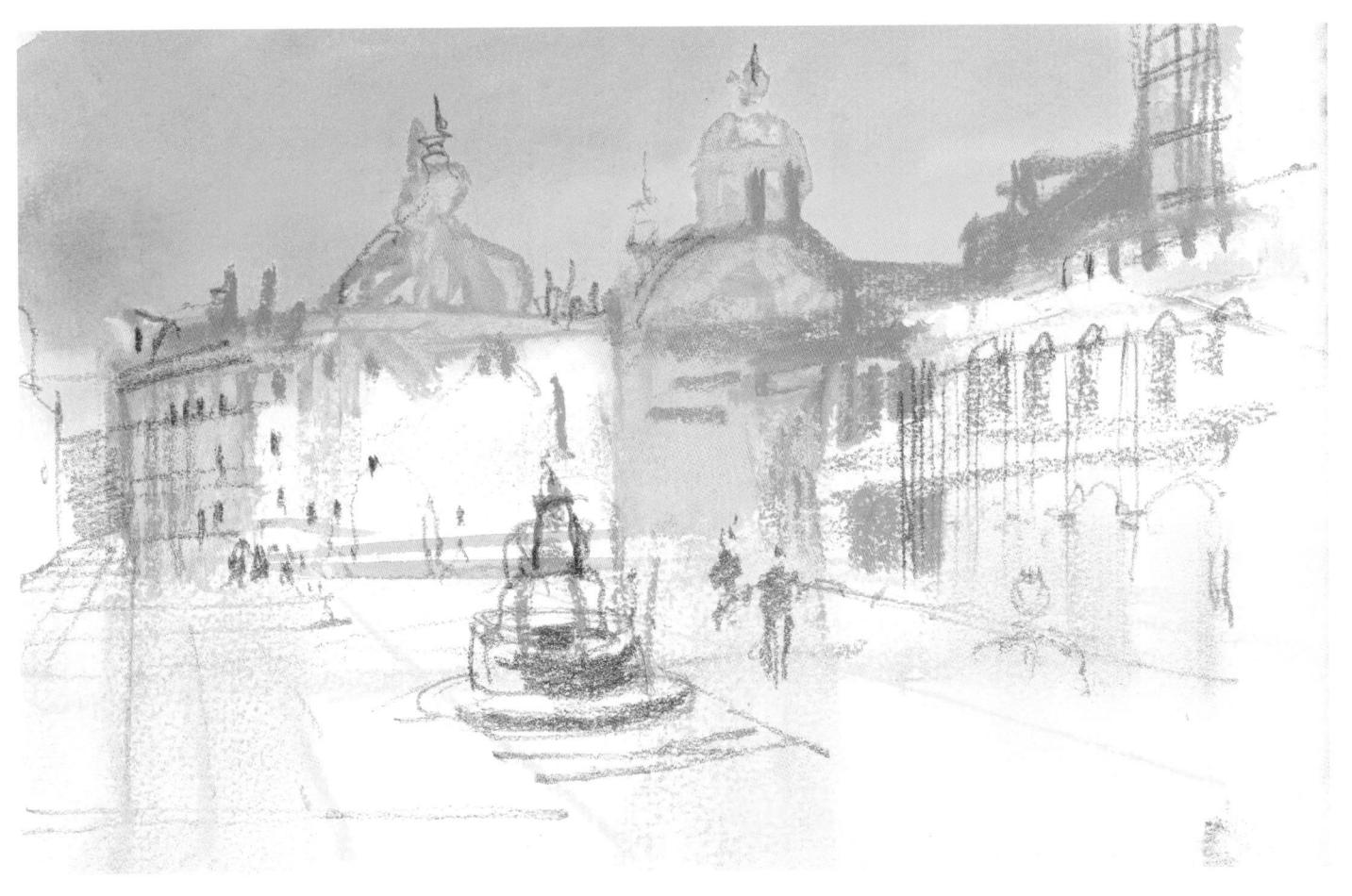

I drew this sketch with dry pastel but spread the colour out with water to make the soft, warm areas against the quite hard-edged blue areas. Warm colours advance, so they are normally found in the foreground, with blues receding behind them. However, because the blue here is hard-edged, with tonally dark lines in it, it comes forward from the warmer colour, which is tonally flat. Both colours are overridden by the dark charcoal of the fountain in the foreground.

TONE

By tone, we mean how light or dark objects are, governed by the amount of light falling upon them. We can use tone to show the form of an object and to set the mood of a picture; extremes of tone are dramatic, while close tones

give a gentle mood. Because we cannot alter the tone of pastels we have to buy each colour in a range of tones. Five are normally provided, though the set shown below has a sixth in the form of white.

Ivory Black

French Grey (Full)

French Grey (Mid)

French Grey (Light) French Grey (Pale)

Chinese White

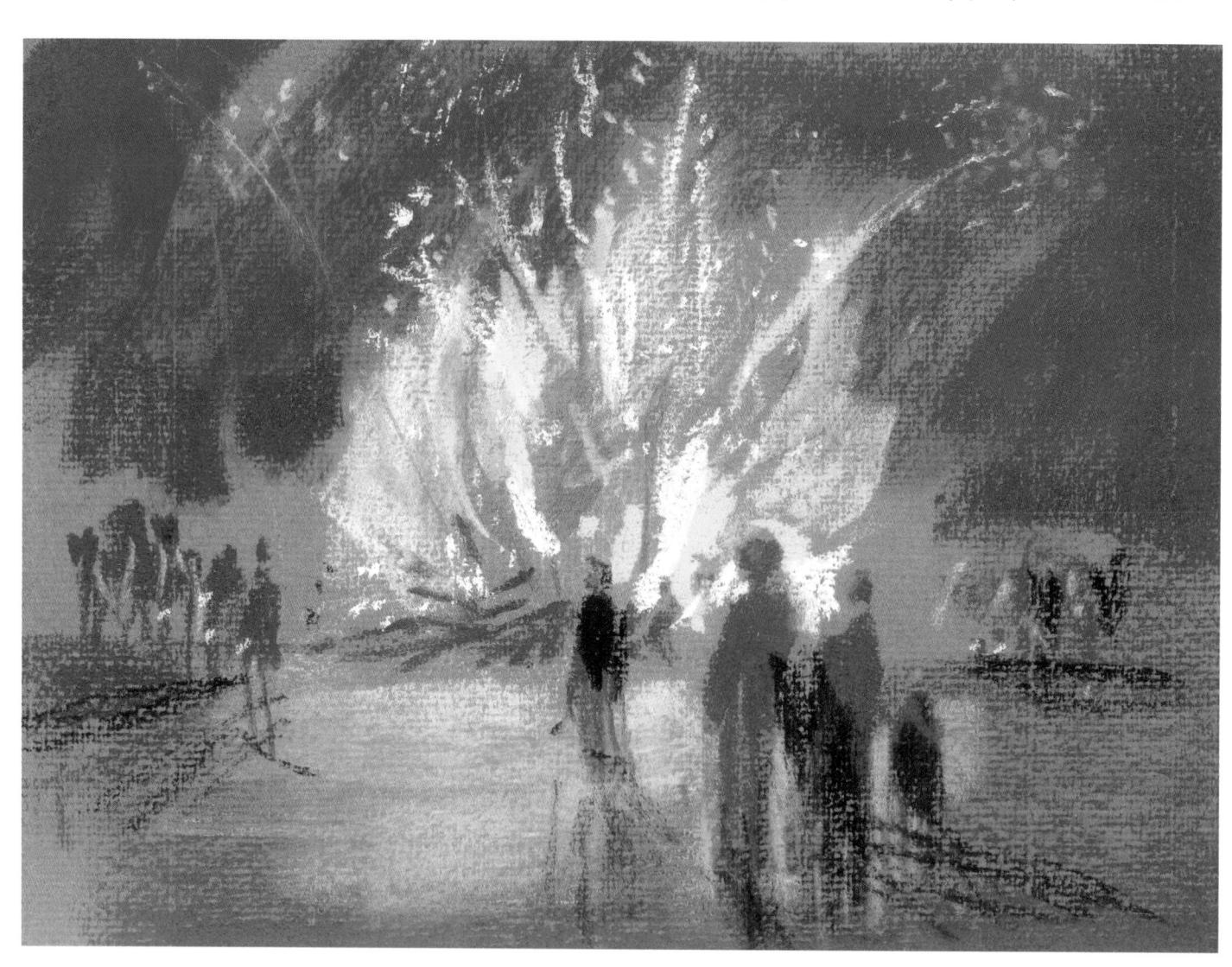

This bonfire scene relies on tone to present the main impact, and the colours have been considered as much for their tonal value as for their colour content. The dark shapes of the silhouetted figures emphasize the brilliance of the light from the bonfire, while the cold dark blue of the surrounding darkness contrasts with the hot red flames. I used a midtoned blue paper as a surface, against which the light colours of the fire showed up clearly and gained added drama.

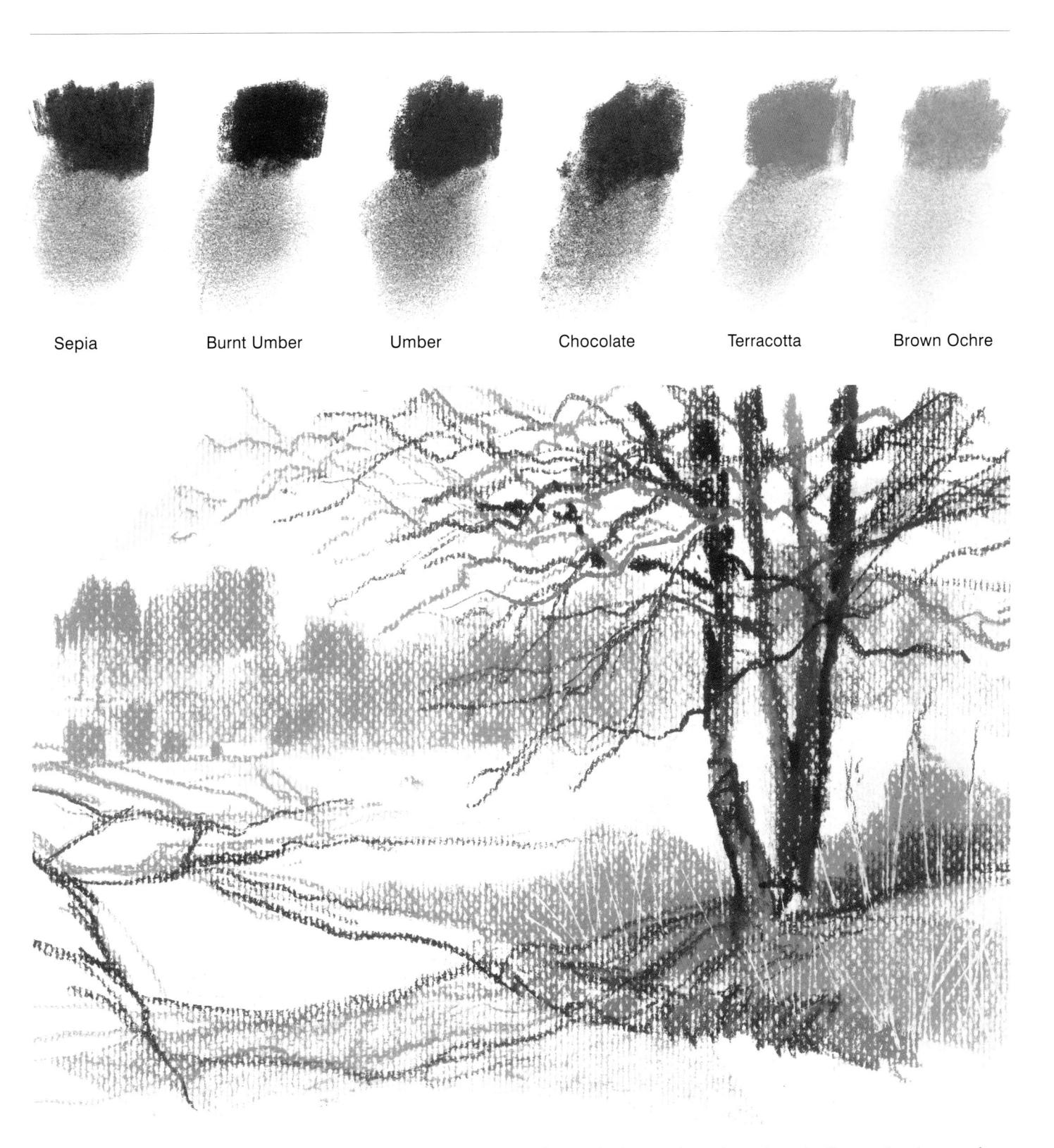

For this sketch I used a manufacturer's set of browns. The range of tones in the tree branches gives depth, creating layers of lines that the eye sees through. I created form in the tree trunks by drawing with different colours and tones. The tree was drawn dark on light, while in the grass below there are light marks on dark. These can be made by indenting the paper with a fingernail, a knitting needle or other point and then rubbing pastel flat on to the paper so that it does not dip into the lines.

DRY PASTELS AS A WET MEDIUM

Pastel is generally thought of as a drawing medium that is used dry. However, you can use it with water, crossing the boundary between drawing and painting.

Pastels can become quite hard over time, and if you try to use a set that has been stored for a while, be warned that you may find it more difficult to dissolve them in water.

After putting swatches of dry pastel down, I softened them with a brush dipped in clean water and pulled out pigment from each of the tones. I was able to achieve only limited distance and tonal range.

I dipped pastel in water to make a wet medium to draw with, rubbing until I had used all the available moist pastel. This method allowed me to spread and blend the colour over a much bigger area, with richer colour and texture.

Using rough paper, I put pink pastel down then worked watercolour over it, pulling the brush in different directions. The pastel dissolved to a soft pink glow.

After putting down pastel, I laid blue over the left-hand side in one stroke and dried it quickly with a hairdryer. The pastel has retained its characteristic marks.

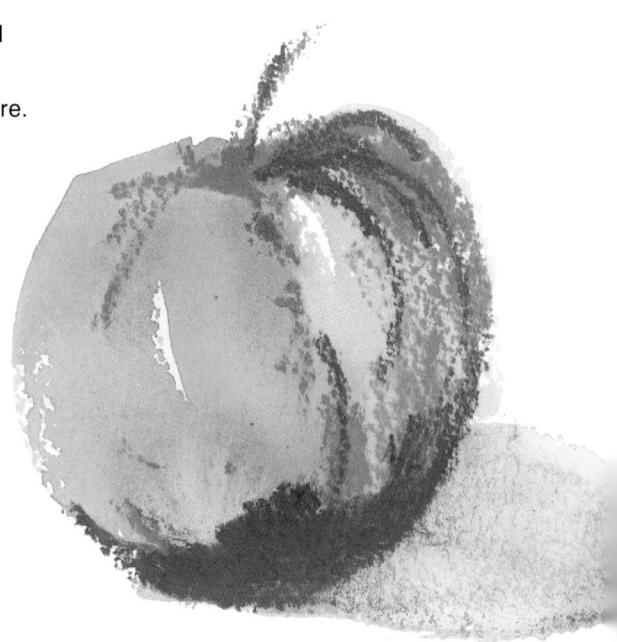

I created this apple by putting down an orange wash of watercolour then working into it with green pastel while it was still wet.

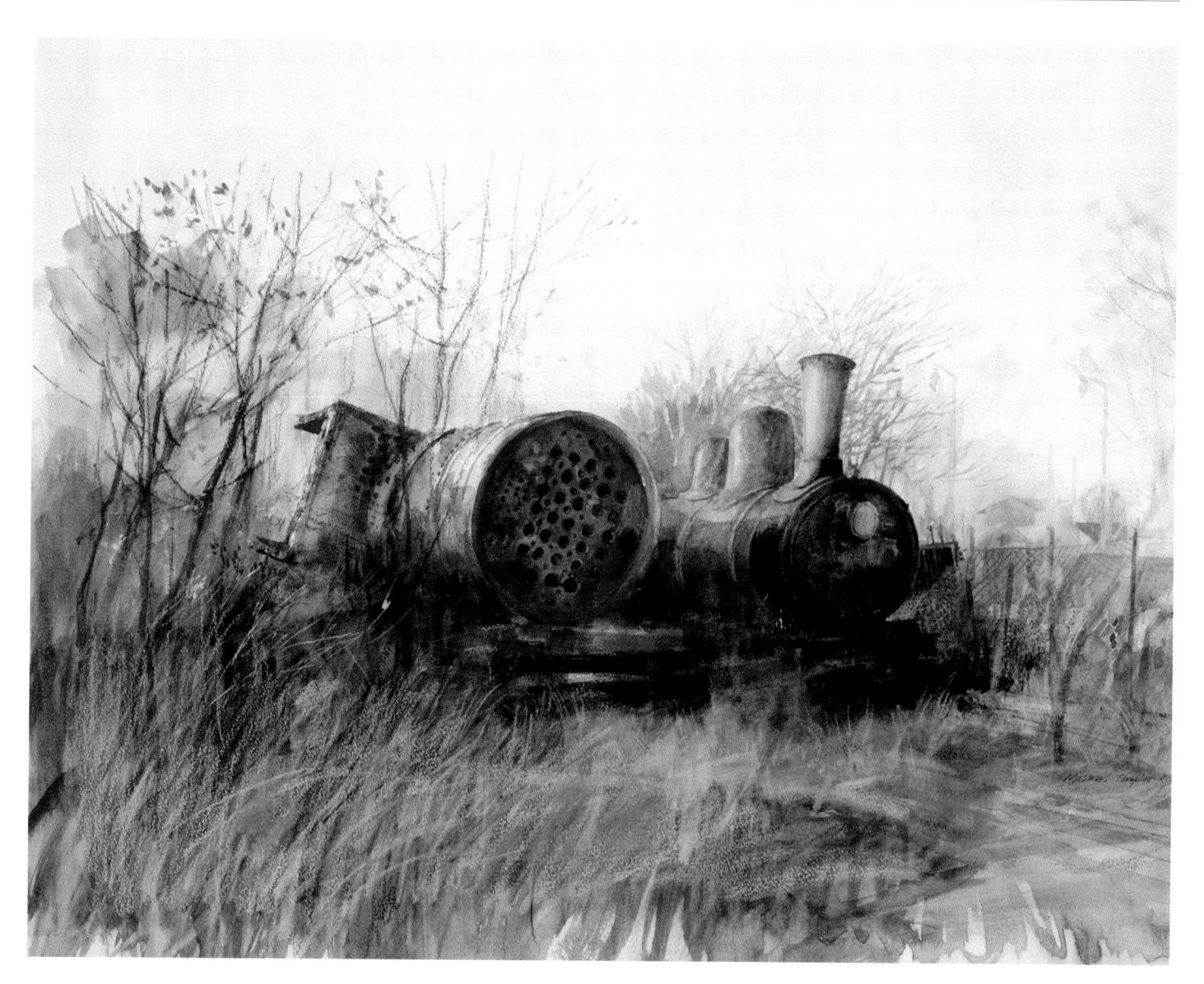

Pastels sit very comfortably with watercolour, and many watercolourists carry them for making notes. This picture is a mixture of watercolour and pastel drawing, some put in while the paint was wet and some added afterwards. Because I was drawing loosely on rough watercolour paper few of the lines are hard, so the pastel blends well with the soft qualities that are associated with watercolour. In the foreground grasses there are light marks on dark, added to give this area a lift.

To create a sense of space in the foliage, I drew some soft lines in wet paint and added harder ones when it was dry.

I built up light textures on dark with fluid marks, varying the pressure to make hard and soft lines that give depth.

RESISTS AND TEXTURES

RESISTS

Sometimes we need to reserve areas in a picture where the pigment cannot reach the paper. This can be done by laying a physical resist such as a paper mask on the paper or by relying on the antipathy between two different media. For example, most graphite pencils have a slight oiliness to them, and if you make a drawing first with a 6B pencil and then pull the side of a dry pastel across it you will find that where the grain of the paper has been filled by the soft, greasy graphite the pastel has been unable to adhere to it.

Another way of creating a resist is to use masking fluid, primarily used by watercolourists. It is removed by rubbing, and it is quite easy to take it off by mistake when you rub pastel over it. To avoid this, sandpaper pastel over the drawing then use fixative or water to fix the pastel dust.

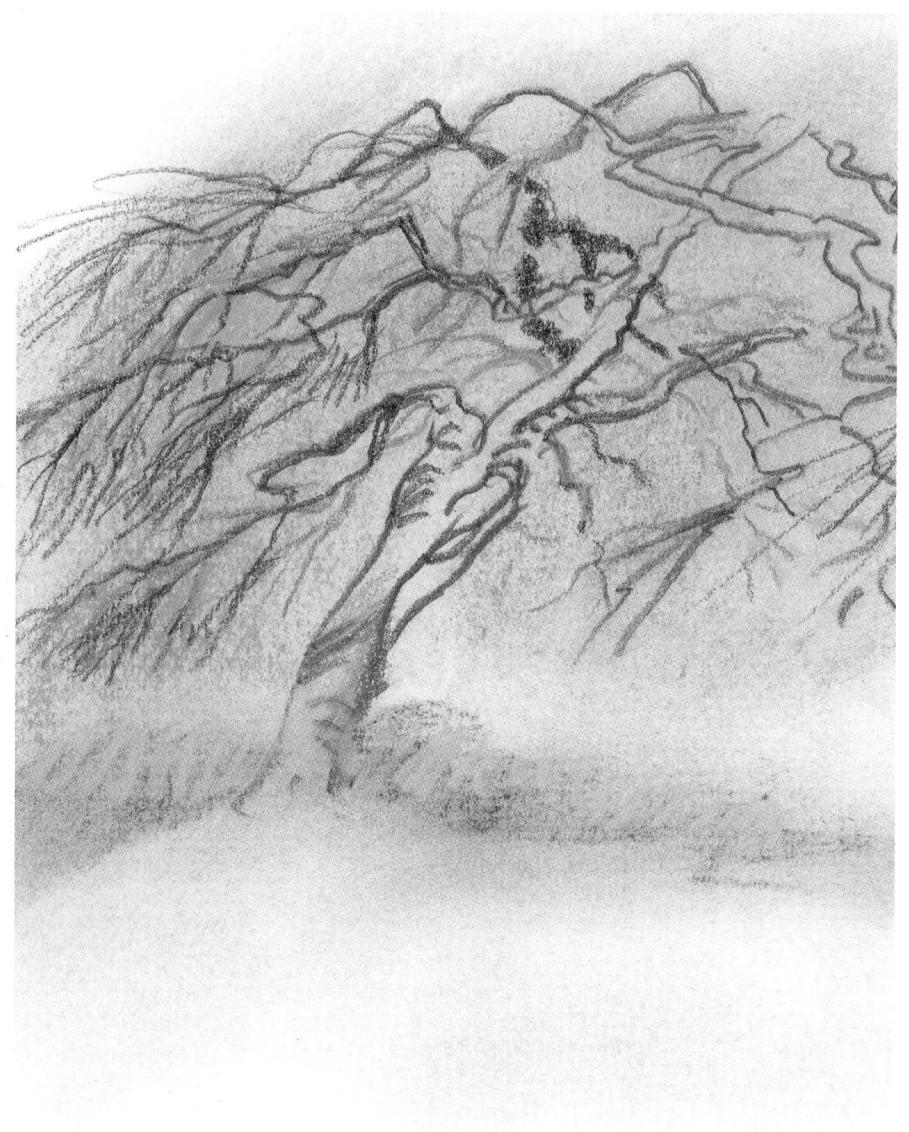

I drew this tree with 6B pencil then pulled the sides of blue and yellow pastels across it. The linear work with the pencil has remained intact, with the pastel creating a haze of colour around it.

These white shapes were created by cutting shapes in low-tack tape with a scalpel. I lifted them off after rubbing over the area with pastel and fixing it.
TEXTURES

Pastel used on rough paper will give you exciting textures, but you can capitalize on this further by using watercolour texture paste, available from art shops in tubes or jars. It is a white or clear paste which you can spread on the paper with a spatula and work into while it is wet. Experiment with various textures, perhaps disturbing it with a stick or corrugated paper or pressing fabric such as muslin into it. When it hardens, leaving a raised texture which prevents the pigment reaching the surface of the paper, rub dry pastel into it with your finger.

I used a mixture of watercolour and pastel in this sketch of a building with shuttered windows. I used texture paste to give the feeling of rough masonry, rubbing dry powdered pastel into it with my finger when it had hardened.

Masking fluid creates hard-edged whites and because of the accuracy with which you can apply it, using an old brush, it is useful for reserving fine lines.

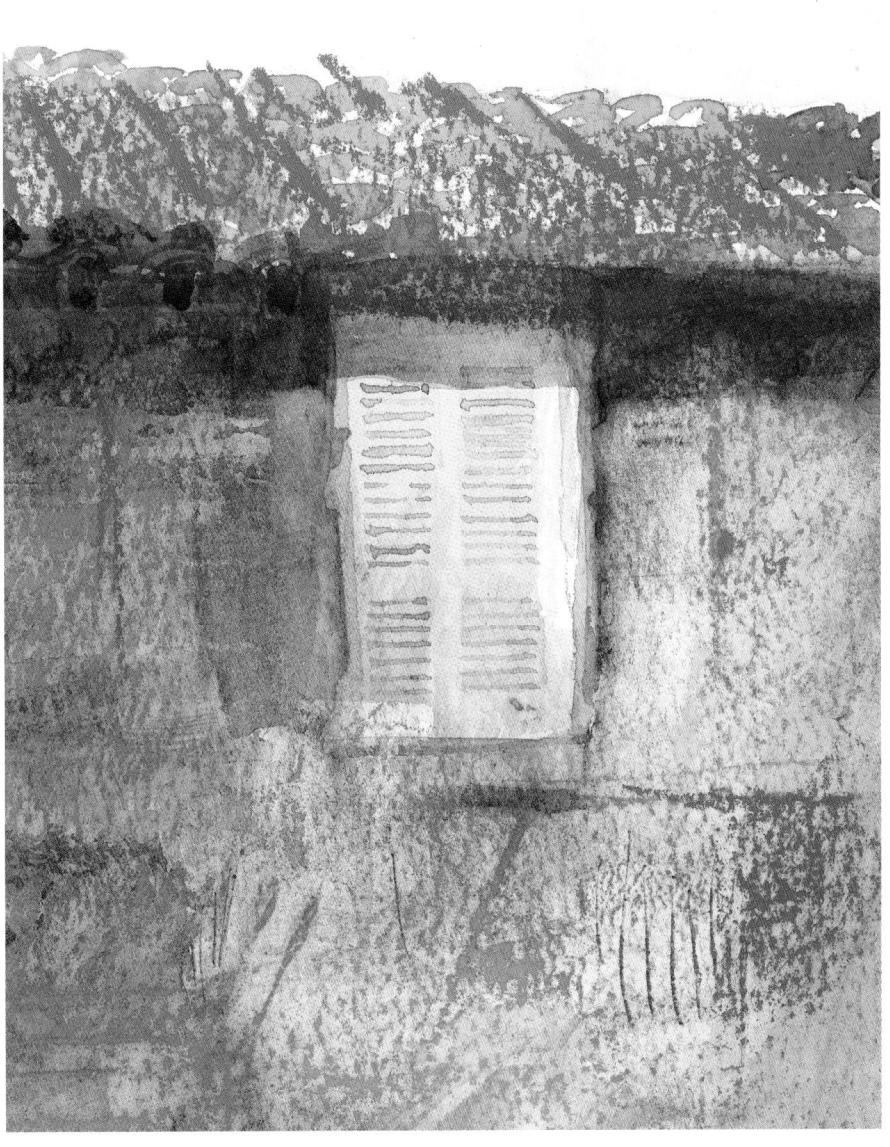

Making rubbings by laying paper over various items and rubbing pastel on top will make you aware of textures. Even something as mundane as a car tyre will help to train your eye.

ORGANIC SHAPES

Nature presents us with a much bigger choice of visual experiences than we could ever invent, and by going outdoors to work you will find many shapes and colours that are worth investigation. I structure my working time to allow me time to learn, which is a never-ending process for an artist. Setting daily tasks as I do such as making a linear study, a colour study, a tonal study, an exterior scene and so forth will give a point to the work you do that day and help to focus your mind on what you are trying to achieve in every sketch. Allow yourself plenty of variety by choosing different subjects or techniques each day.

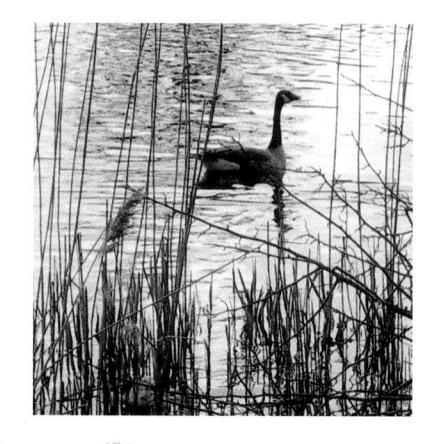

I took a photograph of this scene because I liked the contrast of the hard vertical reeds with the soft horizontals of the water ripples. The goose provided a touch of narrative.

The photograph makes the subject matter look complicated, but tackled as a flat linear pattern it is easily transcribed into soft horizontal marks drawn softly and slowly and darker vertical marks put in with jabbing strokes.

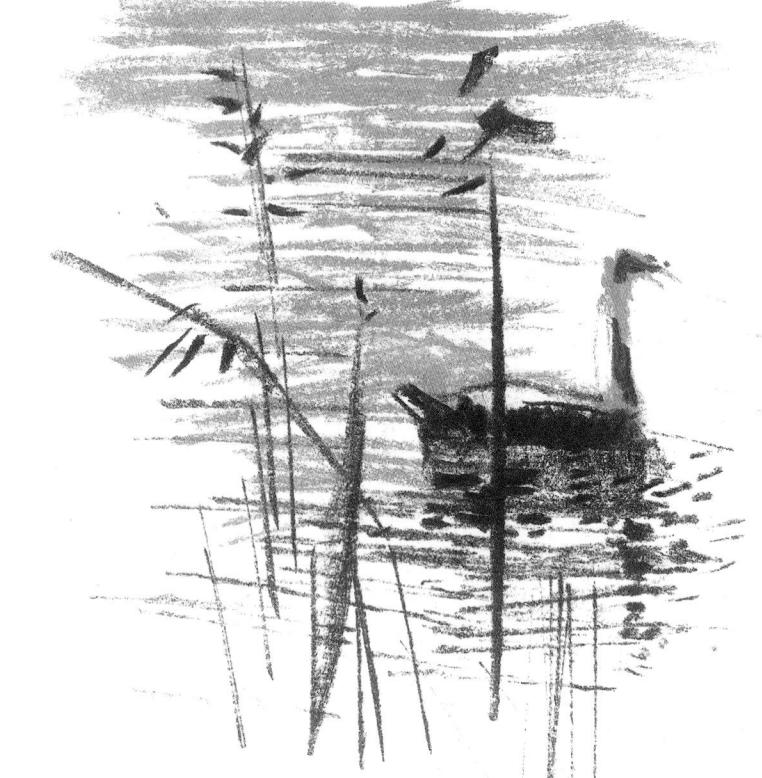

FLOWERS

I continued to build up tone in the water and added variation to the angles of the reeds. The goose is a very simple shape with a tall neck and an indication of a small head. Curving lines in the water in front of it show that it is in motion.

You can find a huge variety of texture, colour and form in floral subjects, from the fresh crispness of a bluebell to the sagging, browning petals of an overblown rose. For an artist, decaying plant matter is just as worthy of study as the most perfect bloom.

The extremes of tone make this a dramatic study of a lily that almost verges on the abstract. Working with a close tonal range would have evoked a very different, softer feel.

CHANGING SCALE

For small, intimate studies done indoors, keep a box of objects that appeal to you. Collect them for specific aesthetic reasons – for example, shells chosen for their colour, shape or repetitive linework. Art can happen on a tabletop, so there is no need to look for grand subjects.

Out of doors, you will find many of the same textures and rhythms within the landscape. Working on a larger scale will give you the chance for strong, gestural marks.

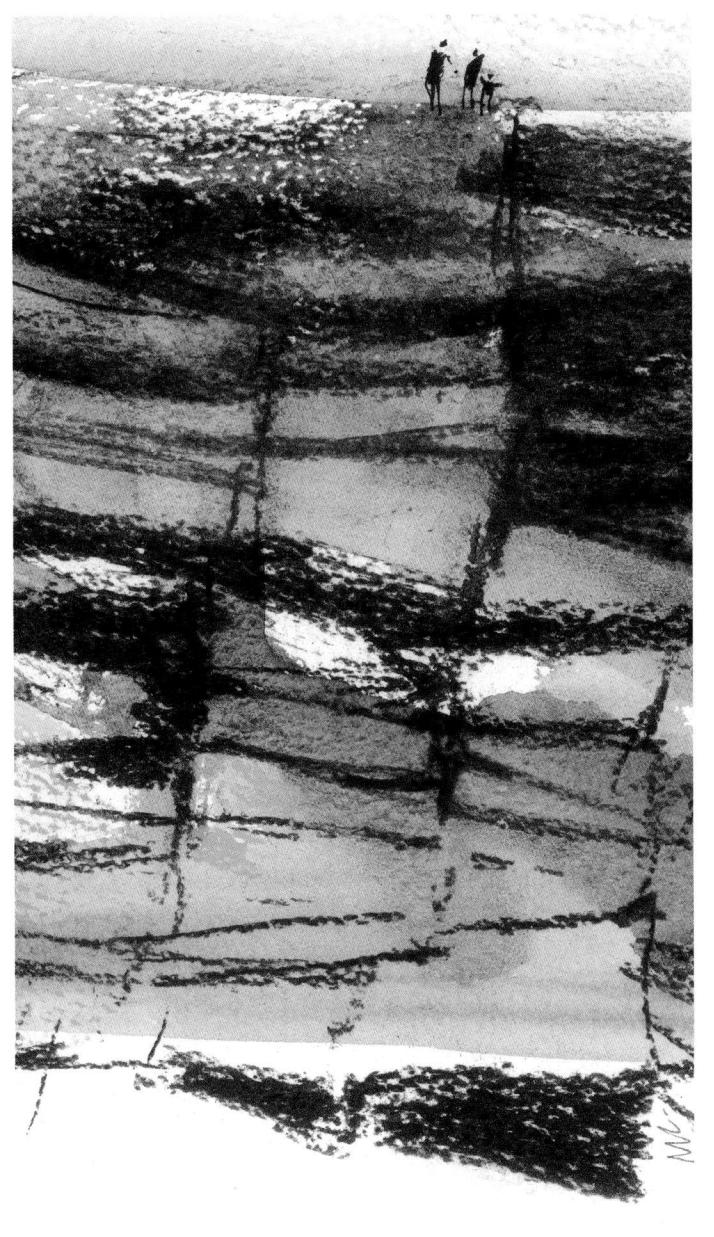

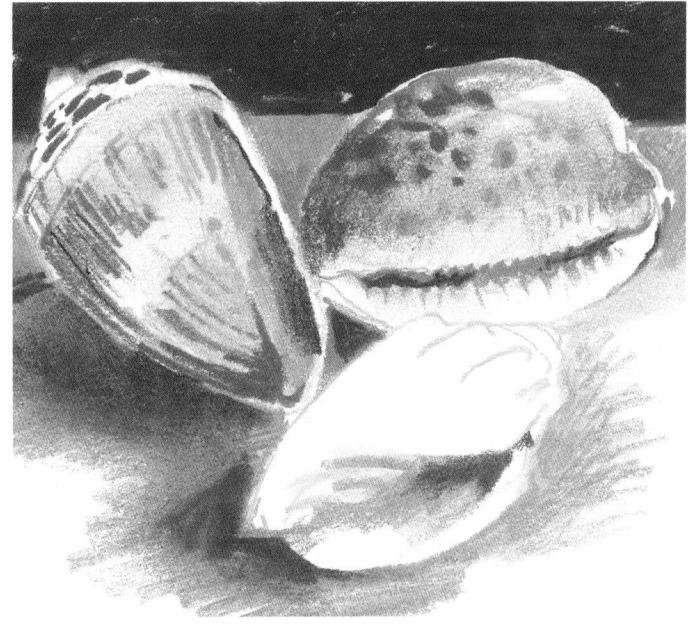

Because this drawing of three shells at various stages of completion is an objective study of colour, I needed to be very precise about the pigments I chose in order to achieve accuracy.

Umber

Burnt Carmine

Terracotta Dark

Terracotta Light

French Grey

Spectrum Blue

I felt the abstract qualities of stratified rocks were best expressed by using charcoal on rough paper to give a strong, dynamic piece. I put down pastel over the charcoal, dissolving it in places to vary the texture. The same strata would be found in even a small piece of rock from the same landscape, and without the simple figures at the top of the cliff the viewer would have no indication as to scale.

MANMADE SHAPES

While most people would regard manmade objects such as cranes, cooling towers and pylons as blots on the landscape, for the artist they present the opportunity to manipulate large areas of strong colour or tone and

balance them against the elegance of linear rhythms. If you study industrial scenes with an eye to making a composition from them, you will be surprised by how aesthetically interesting they often are.

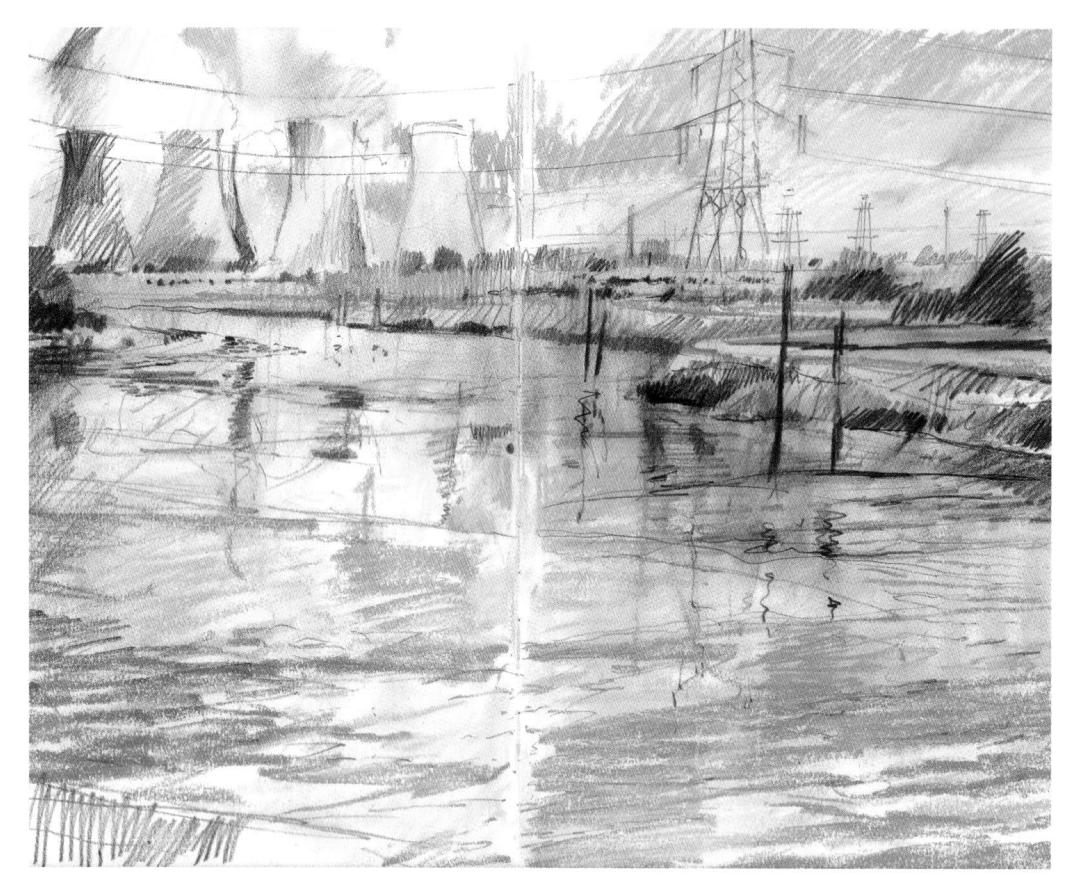

These power station cooling towers, seen across a wide river, made strong, dramatic shapes. I drew them with pencil and quickly applied pastel. Placing the towers at the top meant that the bulk of the composition is about the largely empty space of the water, with the reflection of the towers supplying interest in the middle distance. Done across both pages of my sketchbook, this large study is full of interest in texture, colour, line and tone.

The dramatic linear quality of the pylons is enhanced by the dark bulk of the bushes and the darkening sky behind.

The electricity cables running across the top of the picture push the tonal masses of the towers back into the distance.

I am intrigued by lines seen against the sky on building sites. The lozenges of browns and blues make an interesting design in themselves.

This detail from a painting of a container port shows the cranes that lift containers from lorries below, with little figures indicating their huge scale. After laying watercolour washes, I drew with pastel and charcoal to translate the vigour of the objects into the method of drawing them.

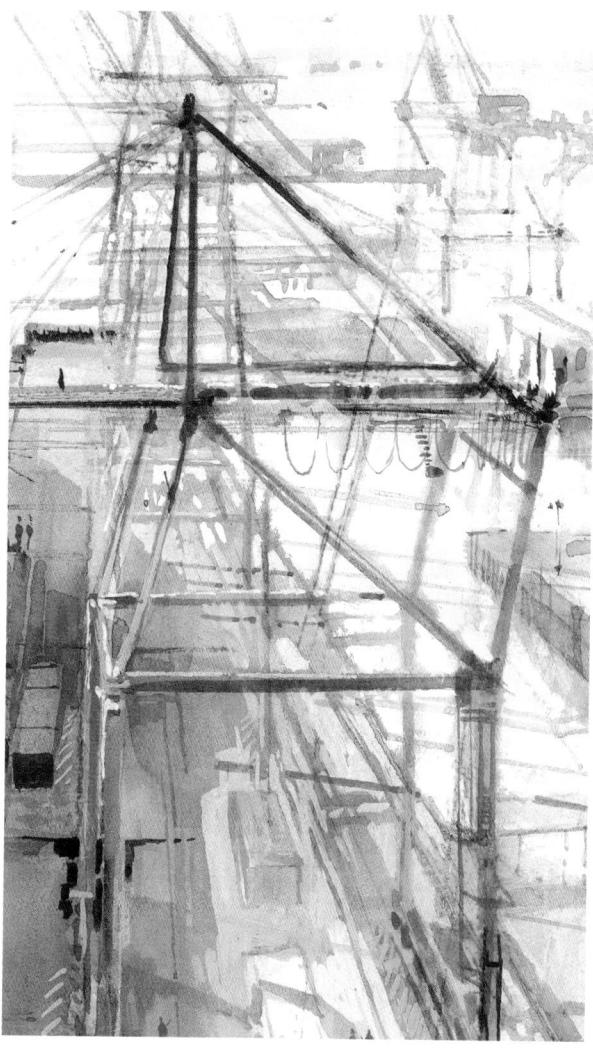

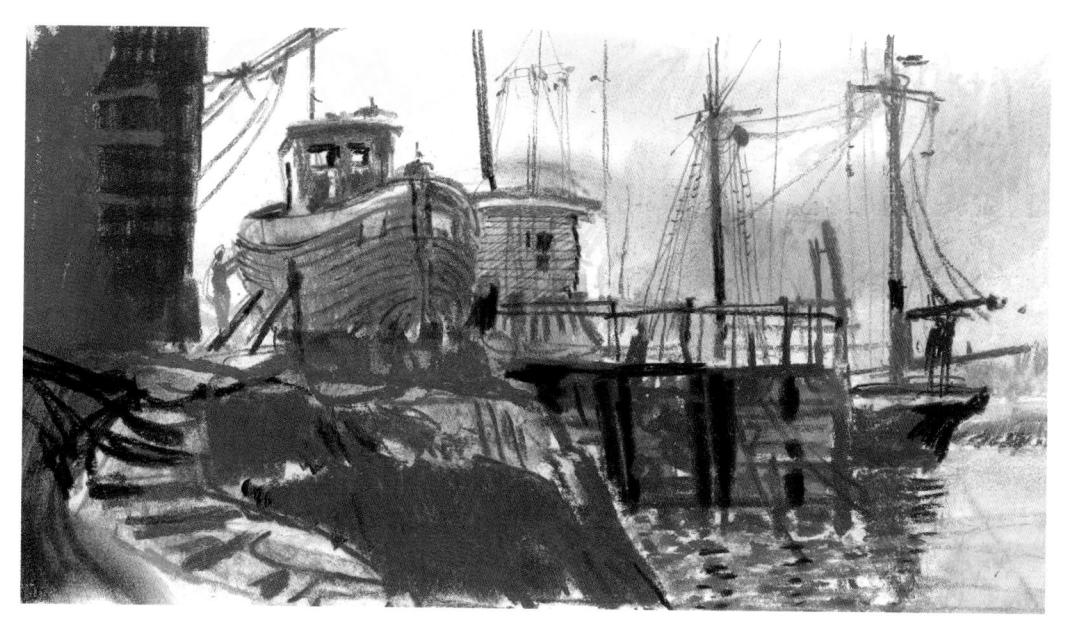

I often include pastels in my travelling kit, and when I came upon this scene of boats pulled up in a little creek I instinctively reached for them because I wanted the composition to be about full-strength tone, full-strength colour and plenty of linear interest. It is done entirely in pastel, some smudged and some hard-edged.

PERSPECTIVE

LINEAR PERSPECTIVE

A basic understanding of perspective will help you to give a three-dimensional feel to your pictures. The most important things to remember are that, rather than being a fixed point, the horizon line will always be on your eye level and that all objects will diminish in size as they recede from the foreground towards the horizon.

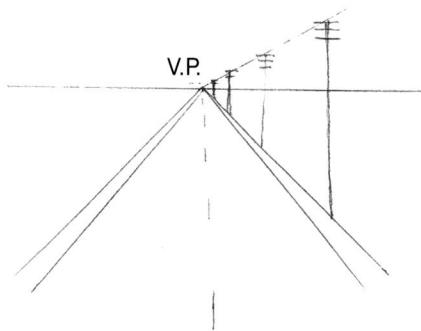

and meet at the vanishing point.

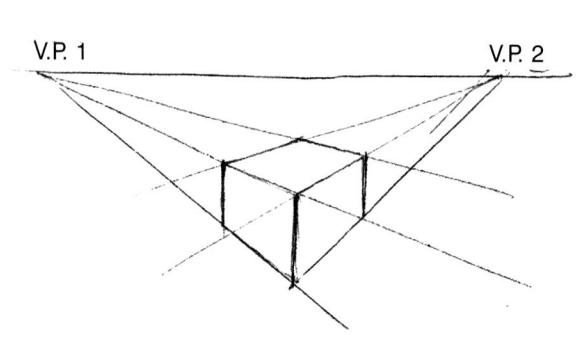

When an object is set obliquely rather than parallel to you, two-point perspective comes into play. Lines extended from the sides of the object converge at two vanishing points.

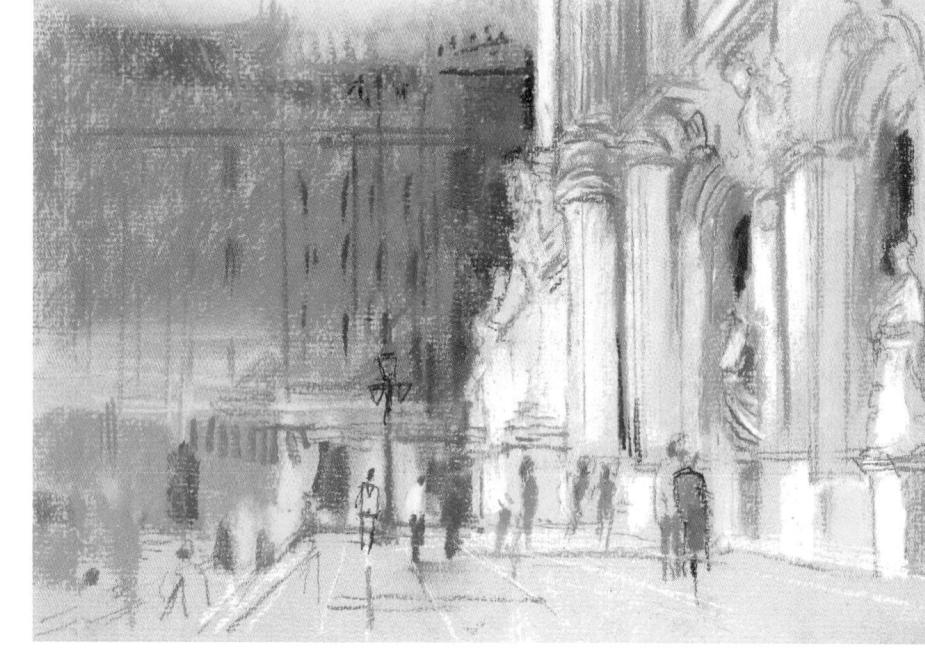

This sketch of the opera house in Paris is a loose study in single-point perspective.

The little linear figure to the left of the lamp post represents my position if I were to walk directly forwards from my sketching point.

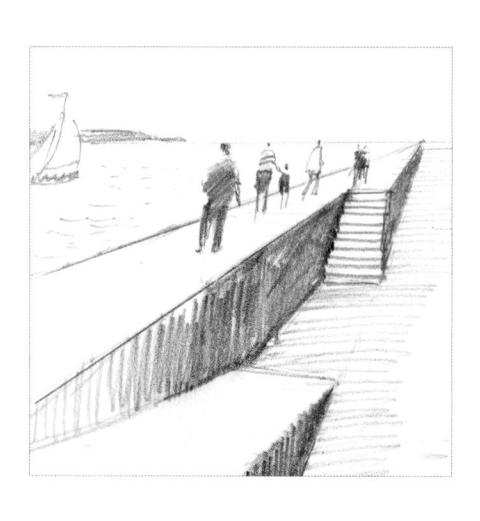

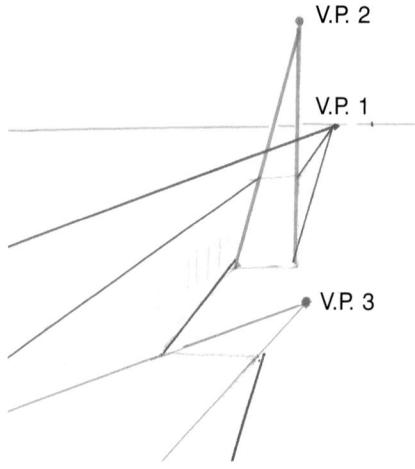

In this drawing the lines of the flat surfaces obey the rules of single-point perspective. If a plane is rising in front of you the vanishing point will be above the horizon; if it is going down away from you the vanishing point will be below it.

AERIAL PERSPECTIVE

Atmospheric conditions make objects lose their strength of tone and colour as they recede from us until eventually they are little more than pale, hazy outlines. Edges and details soften and colours become cooler. Remember that aerial perspective also affects the sky; overhead, it is dark blue, becoming lighter towards the horizon.

Dark tones in the foreground recede through mid to light tones in the distance. When colour is introduced, the perspective is reinforced by the progression from warm colours in the foreground to cool blues and greys in the far distance.

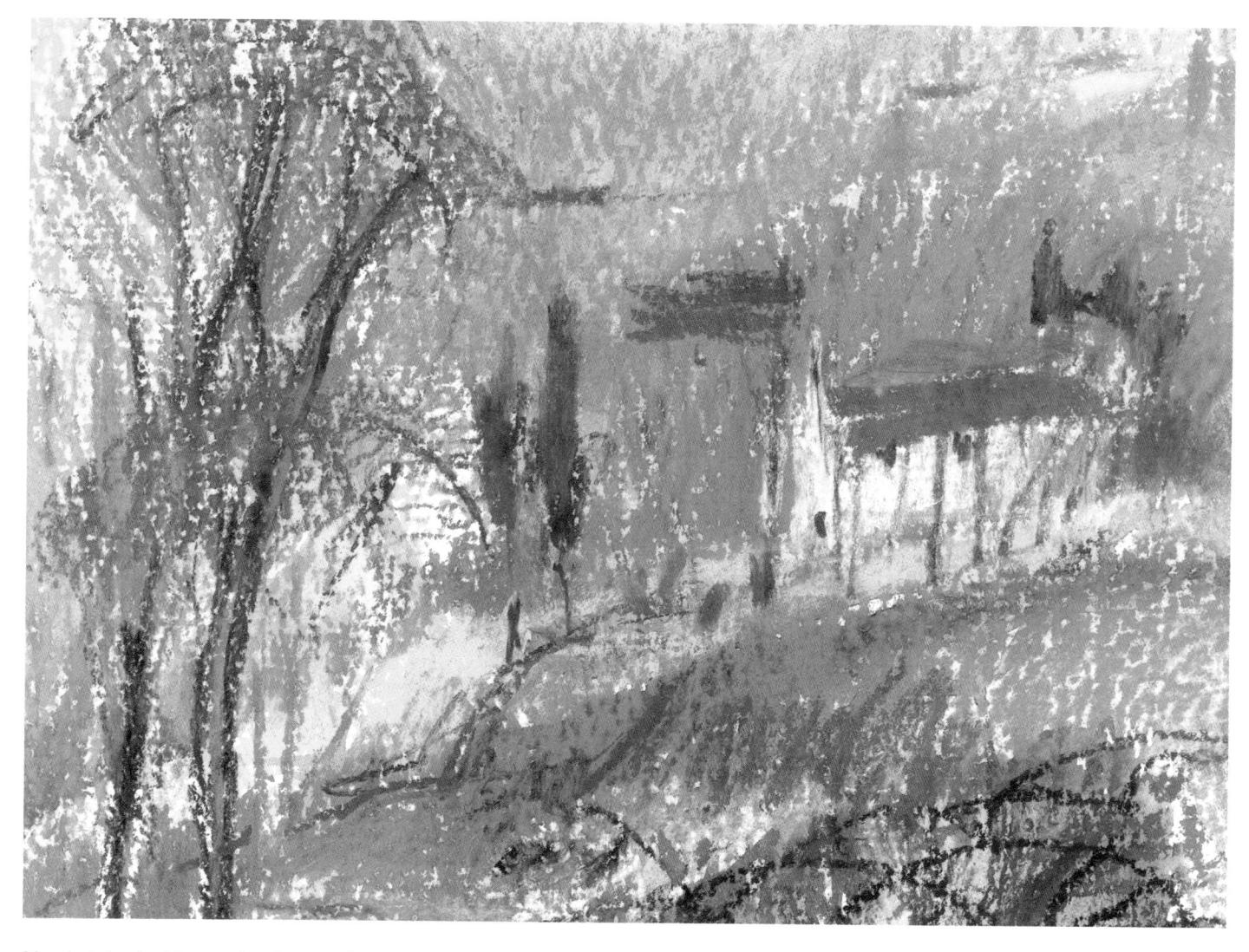

My sketch of a Tuscan landscape demonstrates the use of aerial perspective in a composition. The strong tones, warm colours and defined details are in the foreground, while the distance is little more than diffused cool blues.

SIMPLE LANDSCAPES

The two landscapes shown here are quite similar in that they are both concerned with the seaside and people at leisure in that setting. However, they have very different horizon lines and the view of the cliffs is therefore from

different angles. When you are making a study of a landscape your first choice is whether to put the horizon line high or low in the composition; avoid placing it in the middle as this tends to split the composition into halves.

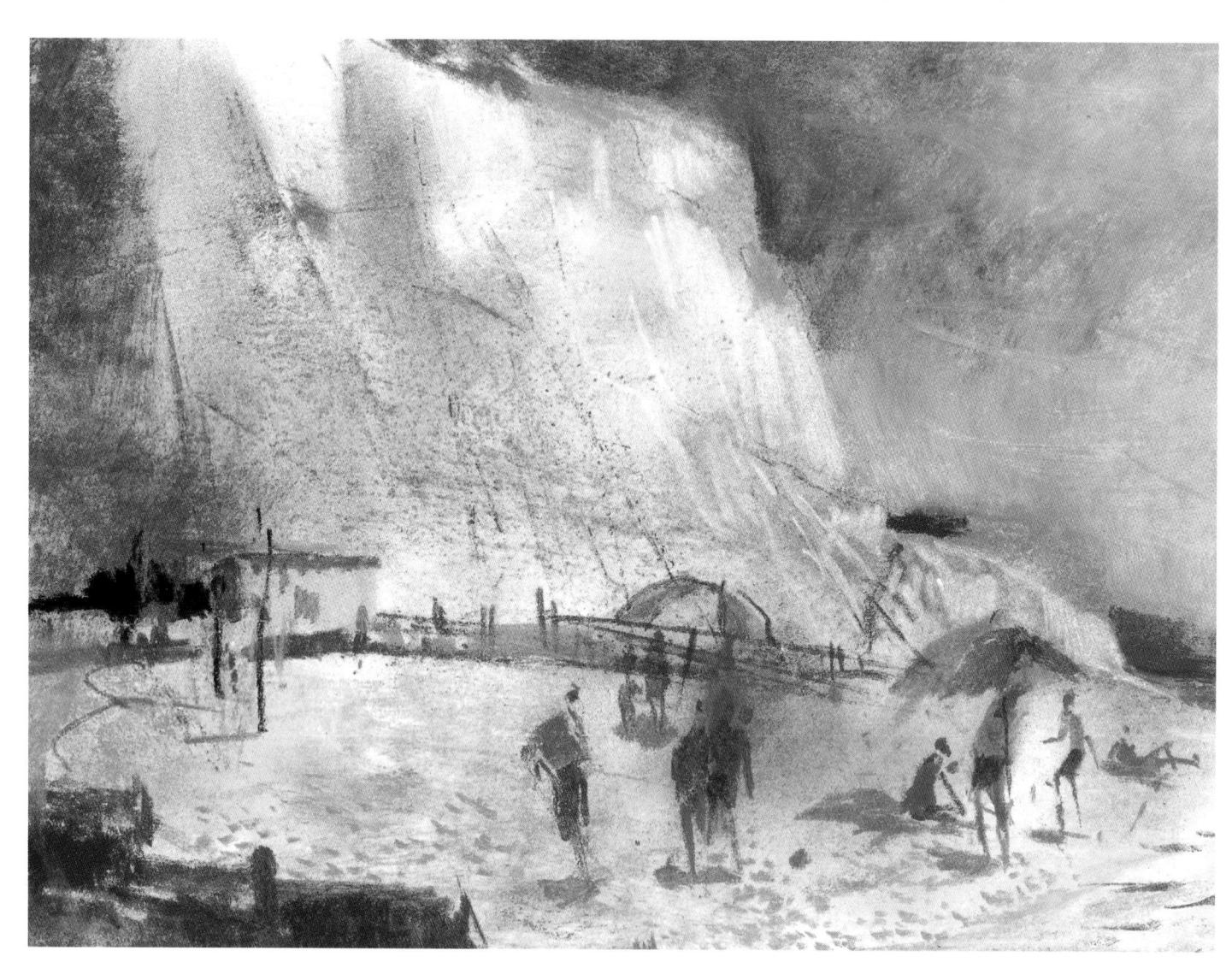

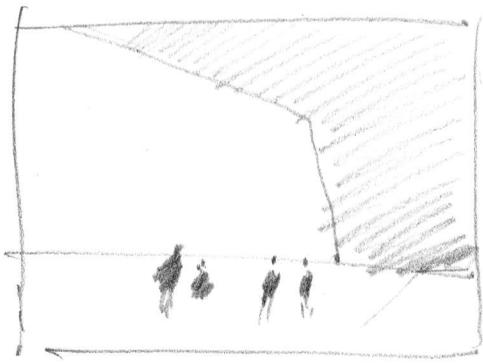

I wanted this drawing to be principally about the drama of the dark blue sky with the white cliff in sharp relief against it, so I placed the horizon very low to make a strong sculptural composition. The figures are on the same plane as the viewer, making us very aware of the vertiginous nature of the cliff that rears above them.

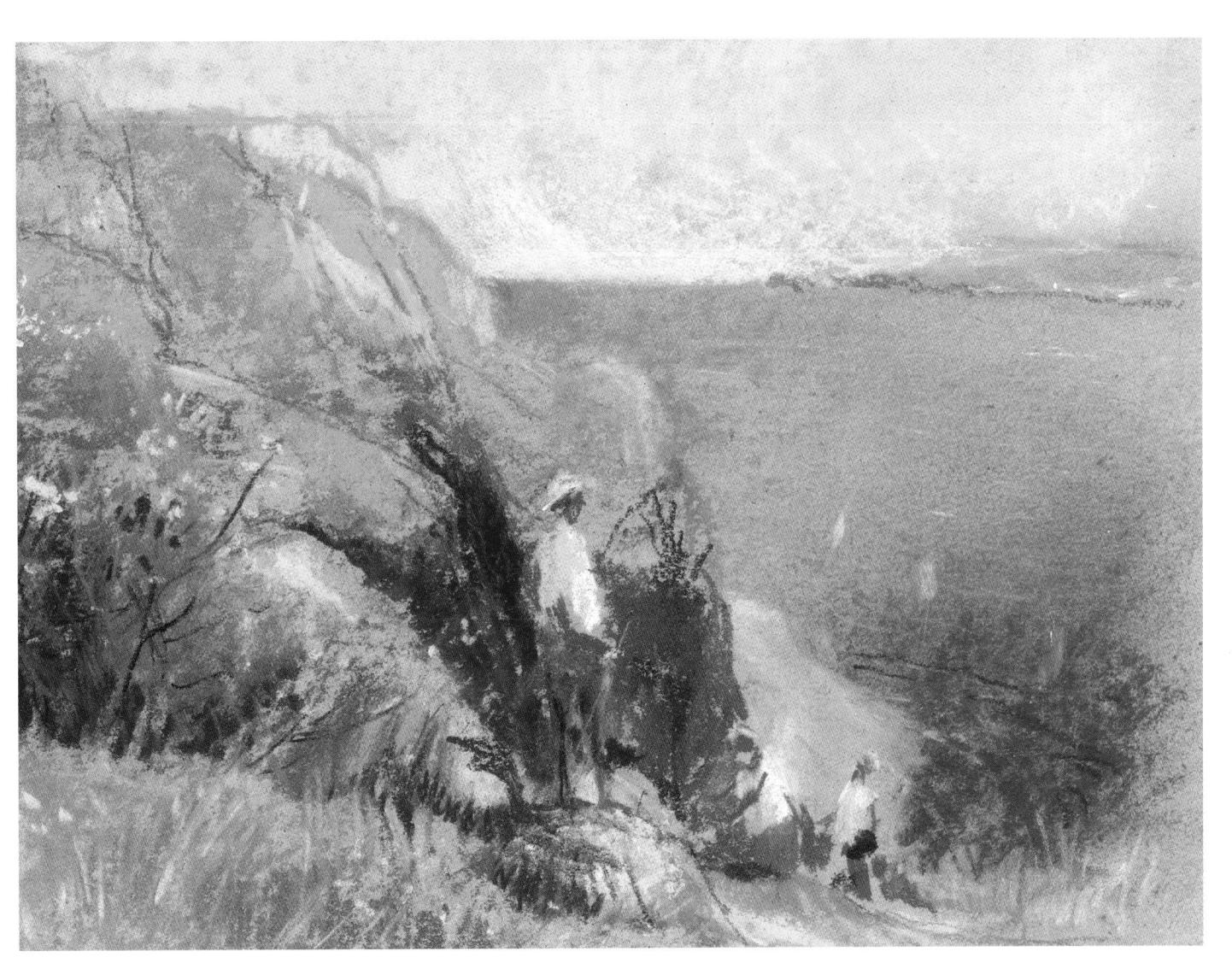

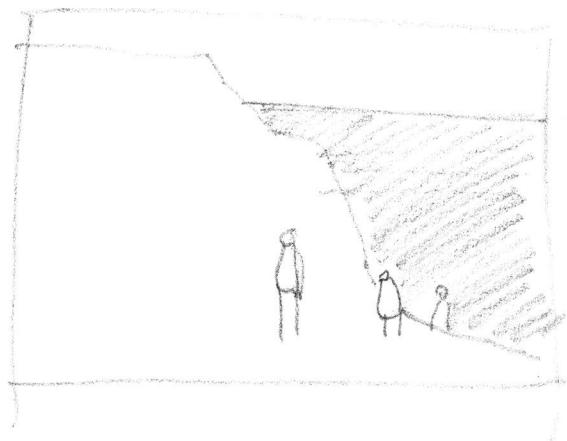

Here my viewpoint is from high up on the cliffs and the horizon line has moved up with me. Three-quarters of the picture is of the cliffs and sea below and the figures are spread out in a diagonal composition.

Although in narrative terms they are more static than the figures playing on the beach, they are compositionally more dynamic.

STILL LIFE

Still life subjects are the only chance the artist has to take complete control over composition, shape, colour and tone. You can choose your subject matter from everyday domestic details such as pots and pans or perhaps make

a still life with a narrative theme such as wellington boots, a rod, a creel and some fish – evidence of a good day out. Choose objects that have something in common and use them to explore ways of showing form and surface.

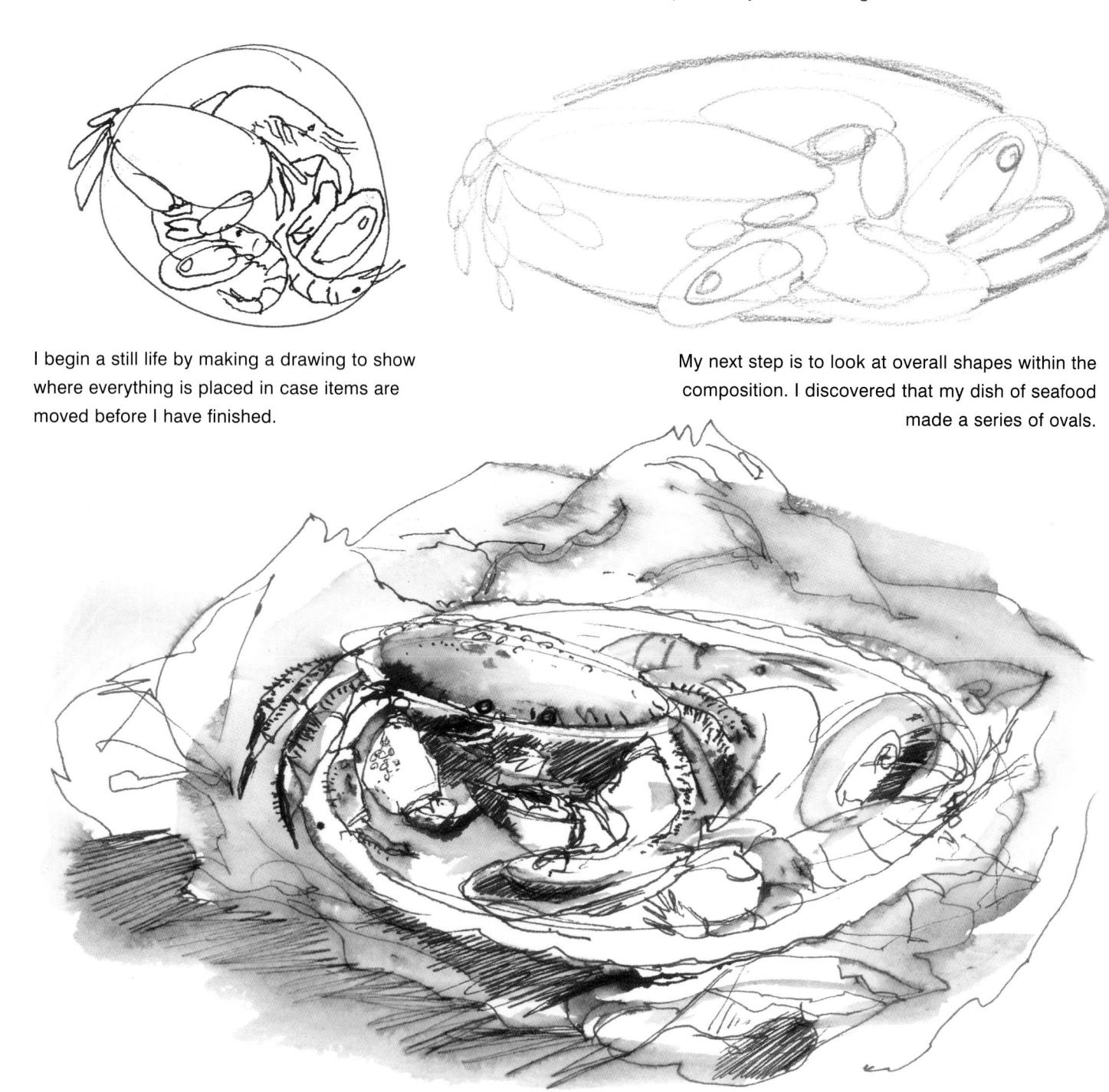

Making a preliminary drawing with line and tone introduces you to some of the details of the drawing. In doing this pen and wash sketch I discovered I particularly liked the hairy legs of the crab and the softness of the supermarket carrier bag.

When you draw a still life, give yourself a time limit and see what results you can achieve over that period. I like the drawing below in all its stages, from its loose impressionist beginning to the final rich, illustrative state. If you lay masks

over the page and look at each section in isolation you will be surprised by how different they are. How worked up you choose to make your own drawings is purely a matter of what suits your temperament.

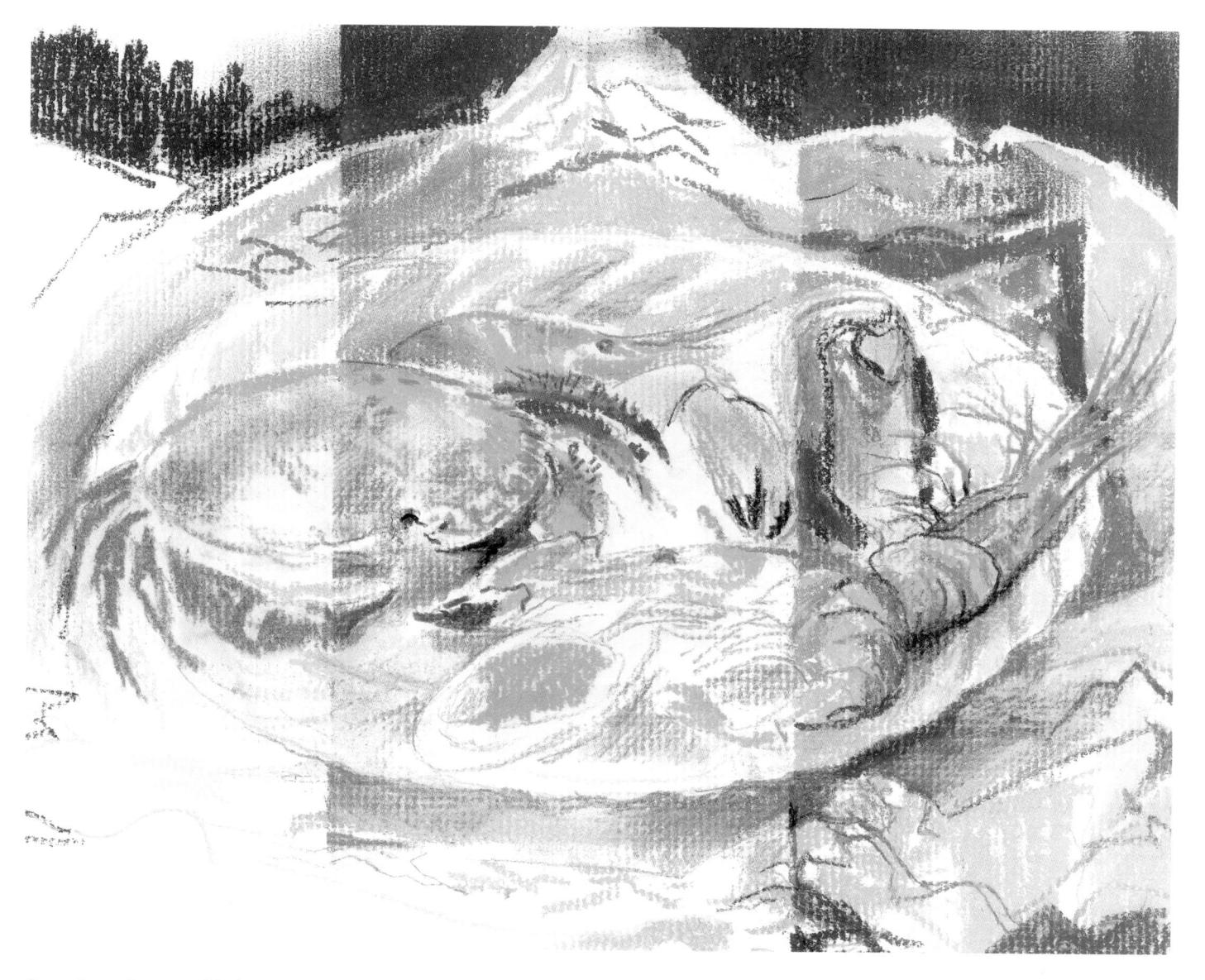

Once I was happy with the composition, I chose a lightly textured off-white paper to draw on. The illustration shows the three different stages of my working process. I laid in the whole drawing in the style seen in the left-hand side, establishing very loose linework and rubbing in broad areas of tone to identify the colours I would use. I then covered up the left-hand side of the paper and worked the drawing up further with more detailed tone and colour. The final stage shows what I felt to be the completed work.

FIGURES

Adding small figures to a picture will give some scale and narrative and it is not difficult to do; just a few lines and splashes of colour are sufficient to allow the viewer's imagination to put in the rest. Life drawing, however, is one

of the most challenging areas for an artist and because mistakes show up so clearly it is the best learning experience you can have. Enrolling at a life drawing class at a local college will prove immensely rewarding.

A broad mass of tone with an indication of legs is enough to describe a group of people in the distance. The foreground figures are captured with minimal mark-making and are anchored to the ground with their cast shadow.

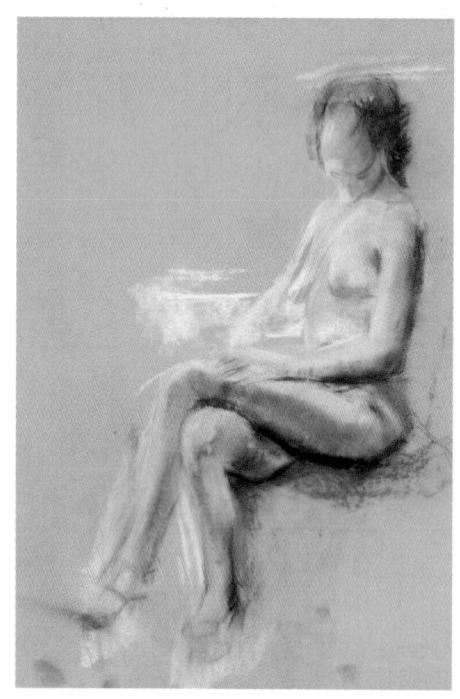

In this drawing, light and dark areas are put in against a midtone. Here the colour is used mainly as tone to show the form of the model.

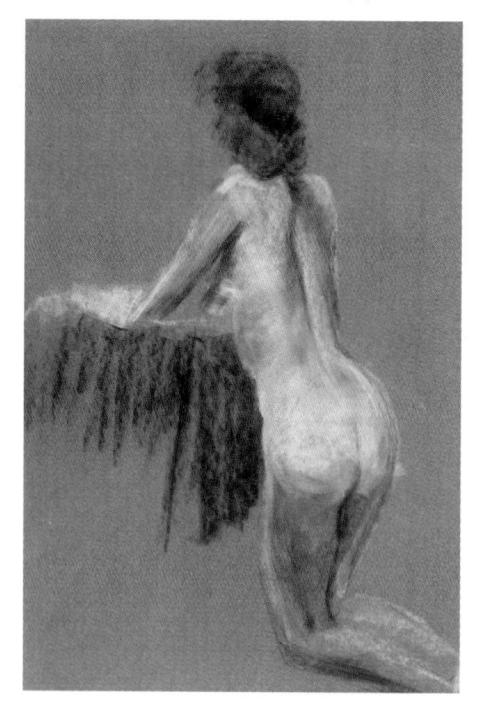

Most of the figure is lighter than the paper, while a lot of the browns are exactly the same tone. The figure is established here by the use of colour.

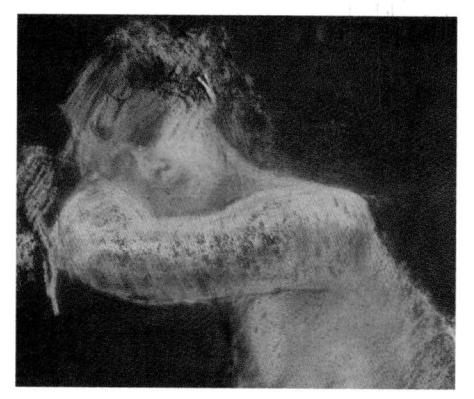

Nearly all the marks here are lighter than
the background paper, including the
subtle recessive shadows on the
underside of the arm. The strength of
colour and dispersal of tones in these
three drawings by Gaynor Lloyd are in
fact very similar, demonstrating how
much pastel is affected by the surface
it is used on. They show an artist
studying the relationship of tones within
the body without being deflected by the
tone of the background.

When you are travelling, you will find it especially enjoyable to include figures in your pictures to capture the feel of the local life. Whether they are shopping at market, fishing, farming or enjoying leisure activities, the figures will bring

atmosphere and vivacity to your drawings. If you feel self-conscious about people looking over your shoulder to see what you are doing, you can position yourself unobtrusively against a wall to work unnoticed.

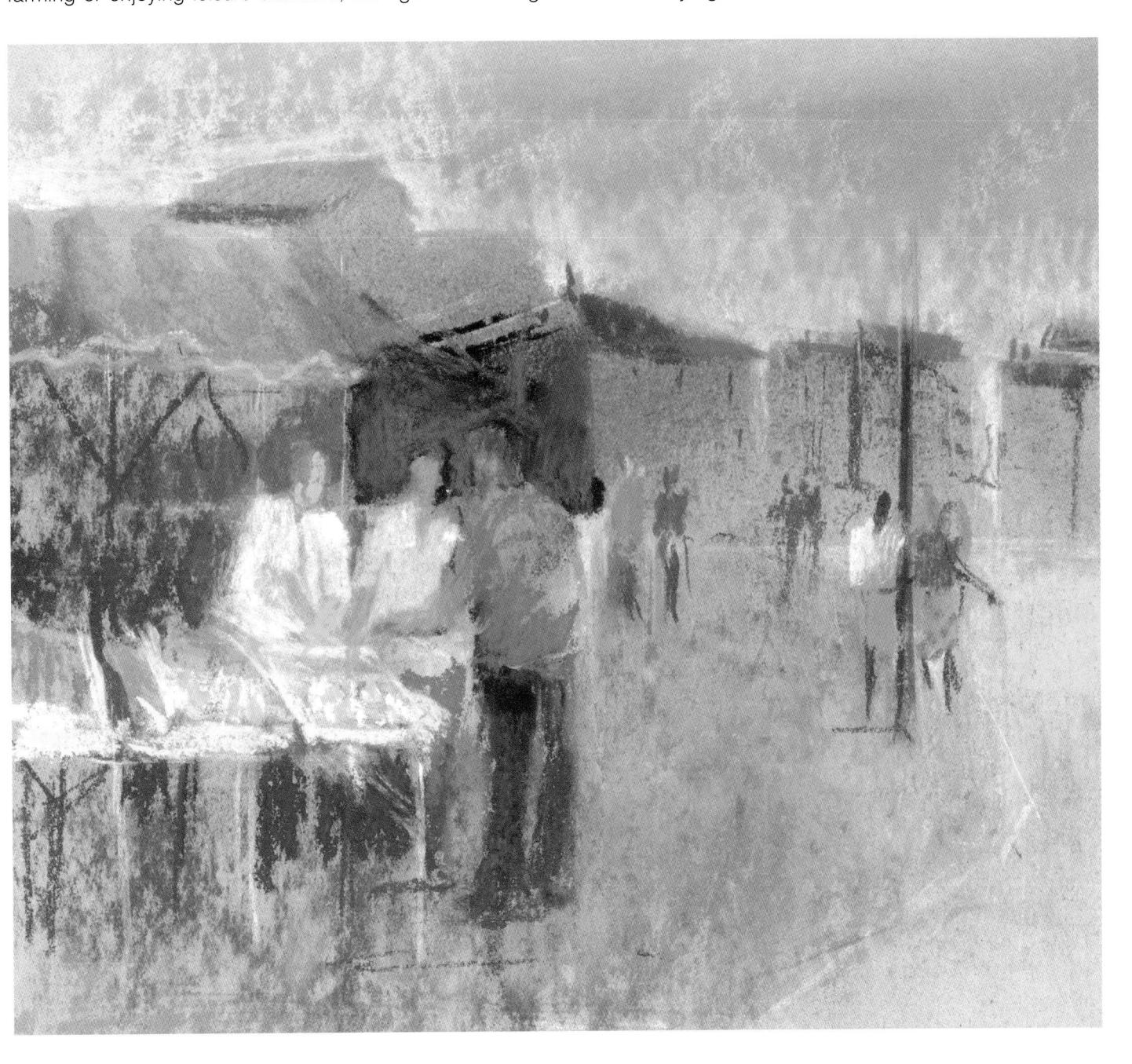

This market stall scene in a little Tuscan town gave me the opportunity to have some fun with narrative and to use strong colours in a variety of cools and warms, lights and darks. It is done on untreated cardboard taken from a boarded envelope.

ARCHITECTURE

Architecture has already been created by design, so it has specific structures, angles and mass. It usually has hard edges and often bright colours and strong tones, but if you treat all the objects in front of you as the same weight there

is a danger that they will cancel each other out. Instead, you need to give some thought to how you will treat foreground buildings to differentiate them from less important or more distant structures.

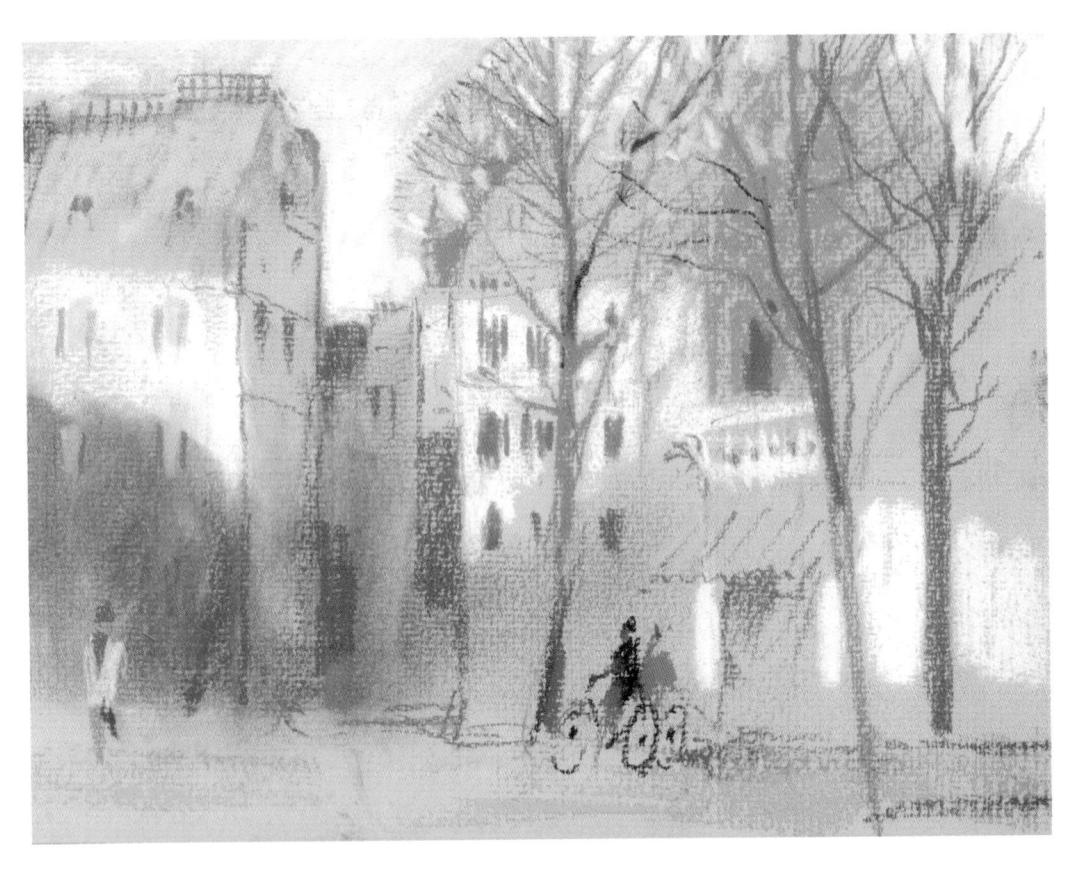

The building on the left is lightly defined and given soft edges in order to make the building in the centre with hard shutters and darker windows come forward. The two cyclists have the strongest colours, bringing them into the foreground. Note how the colours are echoed in the building above them.

The soft blue of the roof on the lefthand building is a recessive colour, and the windows are barely indicated. The viewer's eye understands them as windows that are too distant to see detail.

The two cyclists were quickly put in with just a few strokes of colour but they nevertheless play an important part in adding narrative and establishing foreground.

INTERIORS

When you enter a building, allow some time for your eyes to adjust to the dimmer light. This is particularly important on a bright sunny day, when it may take as long as ten minutes before you can fully interpret all the tones. The light sources inside a building can be quite complicated, so you need to take careful note of where shadows fall.

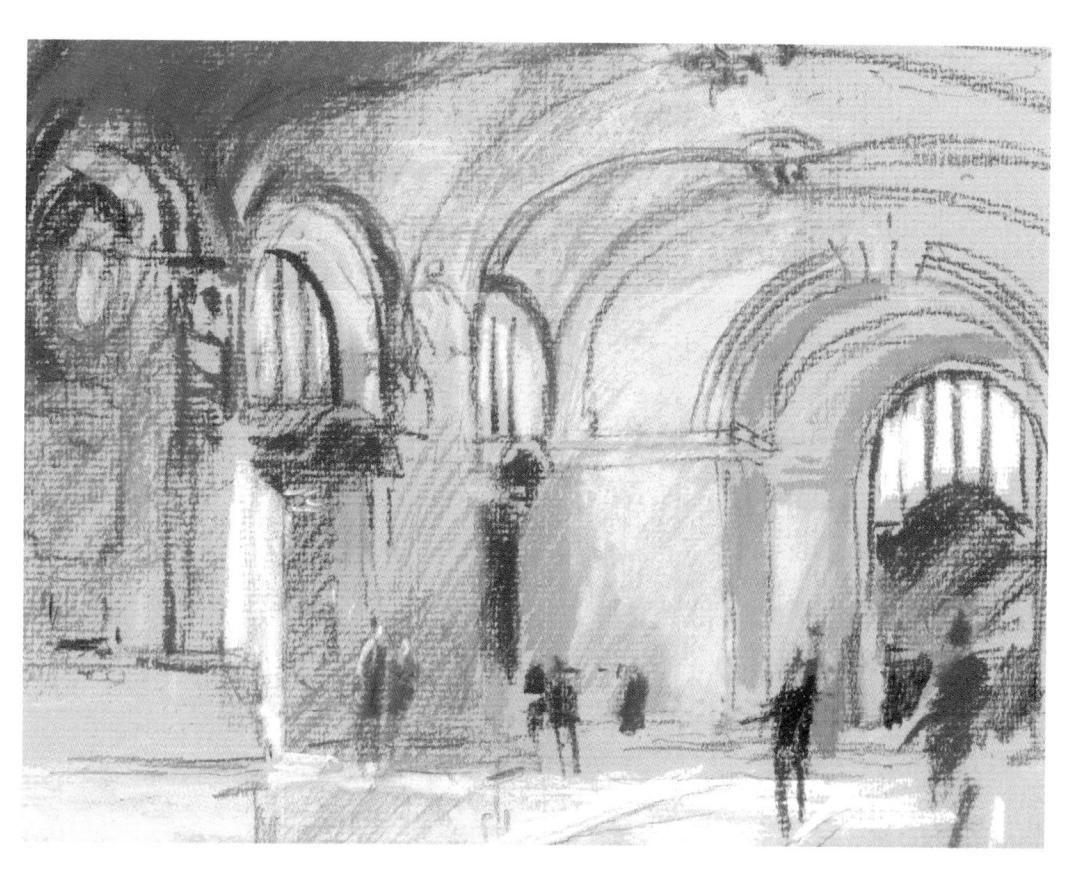

In this interior of the opera house in Paris, light is flooding in from the doorway on the left, catching the figures as they walk in. There is another light source on the right, coming through the window straight ahead of us.

The lefthand side of the picture is mainly about colour as tone, with the little halo of light catching the figures from behind and making them stand out against blue shadows.

The cold, hard light from the window, done with simple white chalk, throws all the tone in front of it into high drama. There is hardly any colour in this side of the picture.

WATERCOLOUR PENCILS

Watercolour pencils do not need fixing, so they are very convenient if you want to go out with minimal drawing equipment. However, you cannot obtain quite such strong colours from them. When you use dry pastels you are

putting pigment full strength on paper, but with watercolour pencils the intention is to wet them to soften the edges of your drawing and at that point you will lose some of the power of colour and tone.

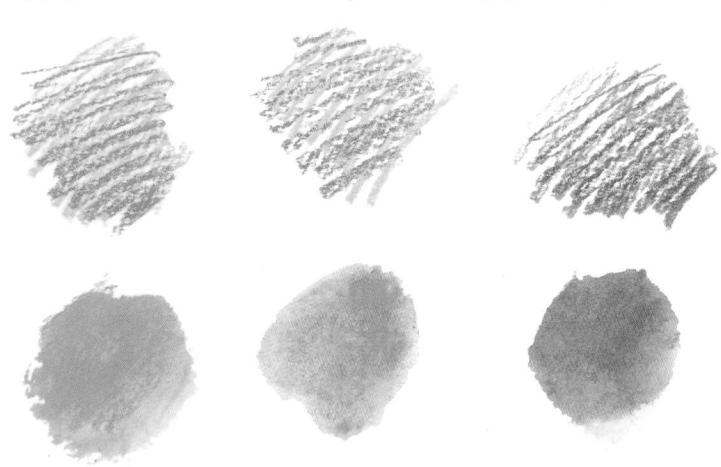

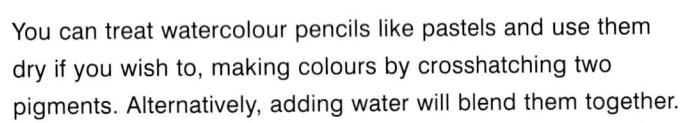

I scraped dust off the end of three pencils, then sprayed it with a fine mist of water to dissolve it.

After laying down clean water I worked pencils into it so that they dissolved at the tip, giving maximum colour.

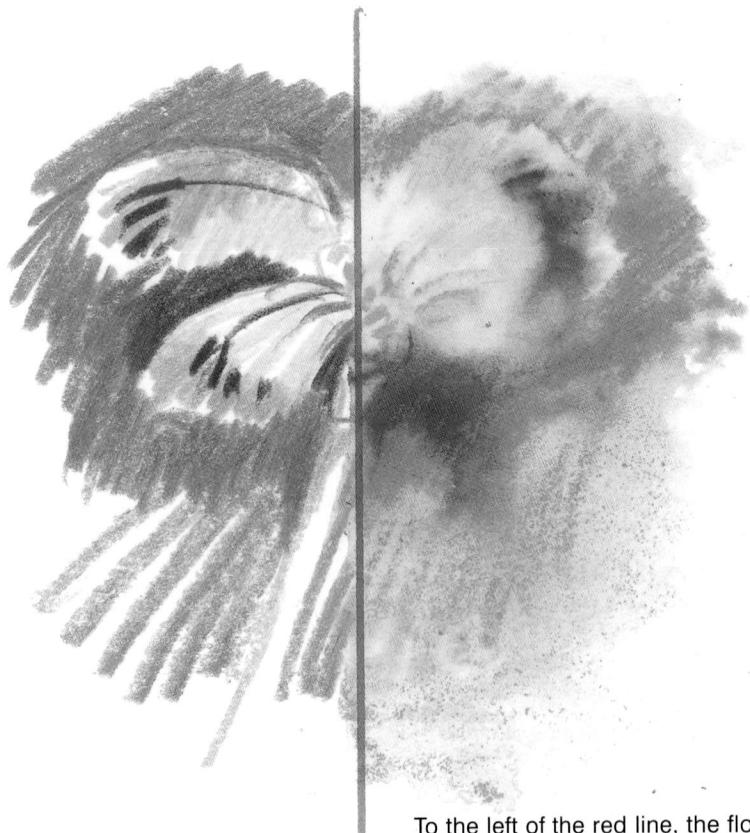

I wetted the paper, scrubbed in a little swatch of blue and then pushed it around with my finger to see how much of it would stay precise and how much would dissolve.

All the primary colours plus green stay crisp and bright while dry but are muddy when dissolved. Wetting two primary colours will give a pure secondary colour.

To the left of the red line, the flower is as it was drawn. I covered that side and sprayed the righthand side with a lot of water which took five minutes to dry, allowing the drawing to dissolve.

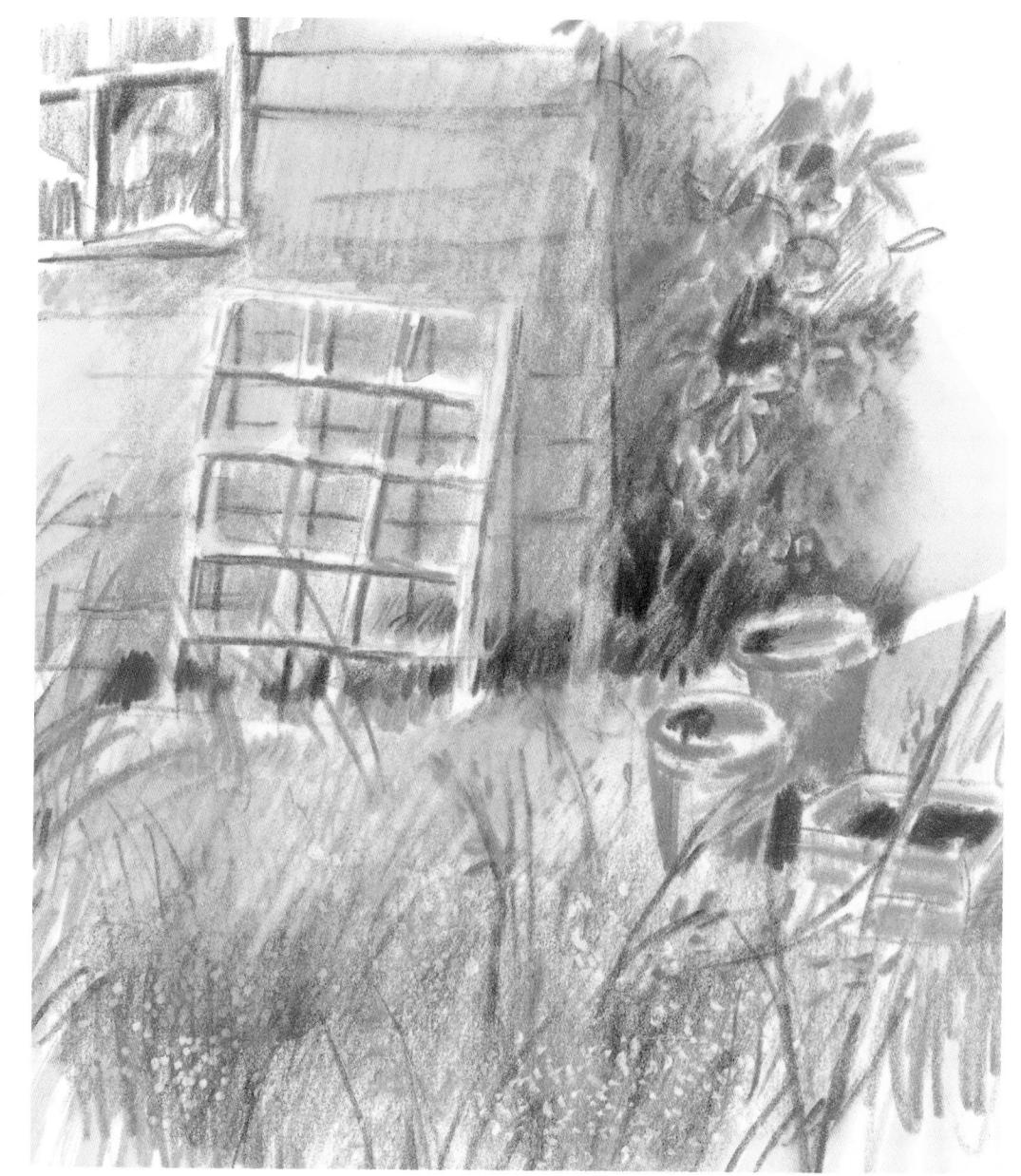

This drawing shows a little wild patch of my garden with the remains of some forgetme-nots in the foreground. Some of the drawing remains hard, while elsewhere I worked a loose wash of reds. As watercolour pencil is quite a transparent medium you cannot lay light colours over darker ones, so I reverted to a pastel technique of jabbing indentations in the paper, pulling the colour over it and leaving it dry. Wetting it would have caused it to flood into the indentations.

The forget-me-nots were created by indenting the paper with light marks, midtones and dark blues, giving the impression of numerous tiny flowers. I could then pull a darker tone over the flat of the paper.

WATERCOLOUR PASTELS

Where watercolour pencils are encased in wood in the same way as everyday graphic pencils, watercolour pastels come in chunky lengths like pieces of chalk. Consequently, you would not choose them for the precise work for which

the pencils are ideal but for strong, fluid drawing you will find them very rewarding. Which you prefer will depend upon your temperament and also upon what you are trying to describe in your work.

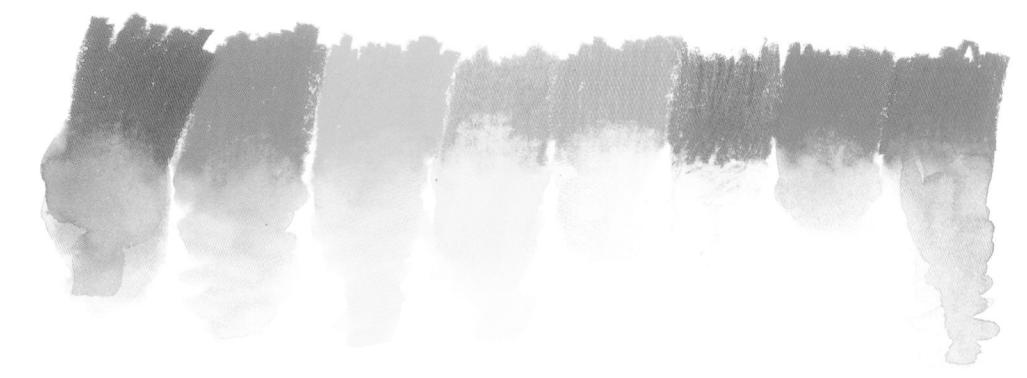

The colours of the spectrum are shown here at full strength and pulled down to pale tones with clean water.

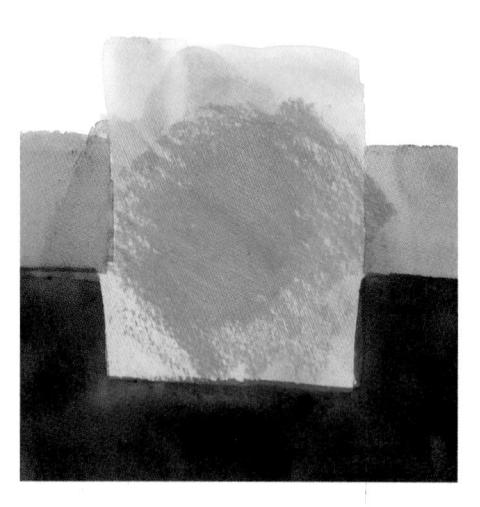

My first step towards drawing the bowl on the facing page was to lay down a swatch of watercolour and destroy it with water. I tried it against white, a midtone and a dark tone to see how it looked against each.

Next I had a look at the bowl. The effect of putting the dark tone against it was to give it a hard edge that contrasted with its soft decoration. It also made it a light mark as compared to the upper part, where it is a dark mark against light.

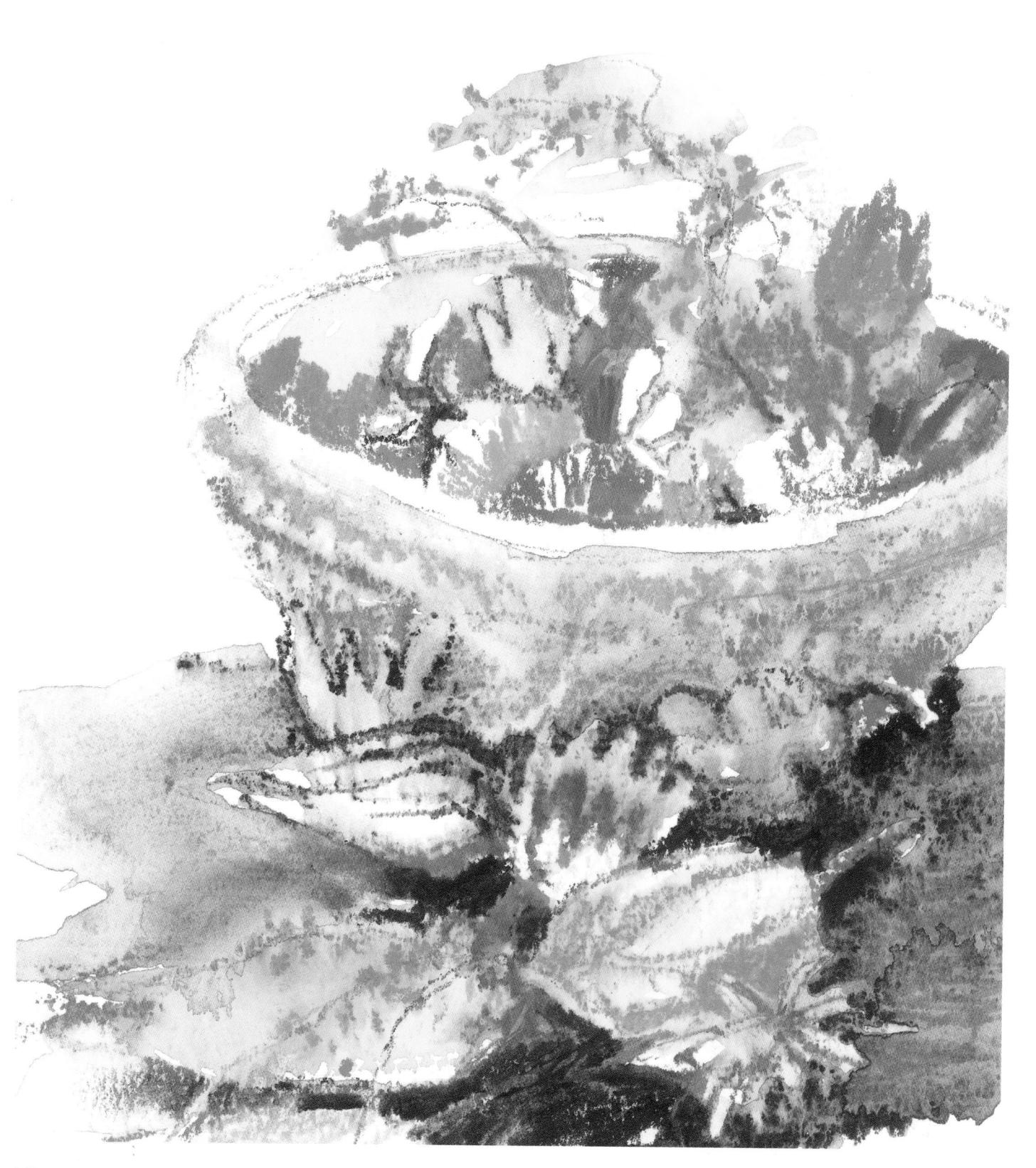

I filled the bowl with potpourri, which has particularly interesting shapes and colours for an artist, then set to work. In some areas I wetted the paper before applying paint, while in others I drew on dry paper and destroyed the line with a wet brush.

OIL PASTELS

Unless they are using them to make an underdrawing for an oil painting on canvas, artists generally draw with oil pastels onto paper. However, it is necessary to prime the paper first to prevent the oil spreading out from the colour over a matter of time. A thin wash of acrylic primer, available from art shops, will suffice for this. Clean your brushes with distilled turpentine, and make sure you keep them separate from your watercolour brushes.

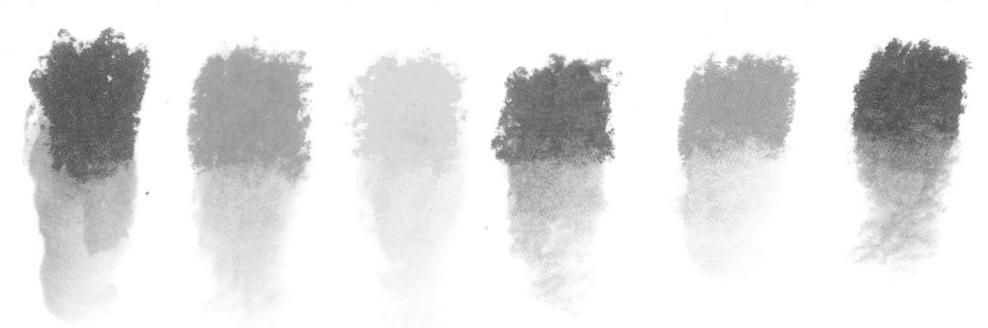

Oil pastels are brilliant in colour when used full strength and you can reduce them to lustrous transparent washes by thinning them with pure turpentine (not distilled turpentine, which may damage your paper).

Oil pastels act as a resist for watercolour. The first marks I made in this sketch were the colours of the women's clothes, which remained unchanged when I laid dark watercolour washes over the top of them.

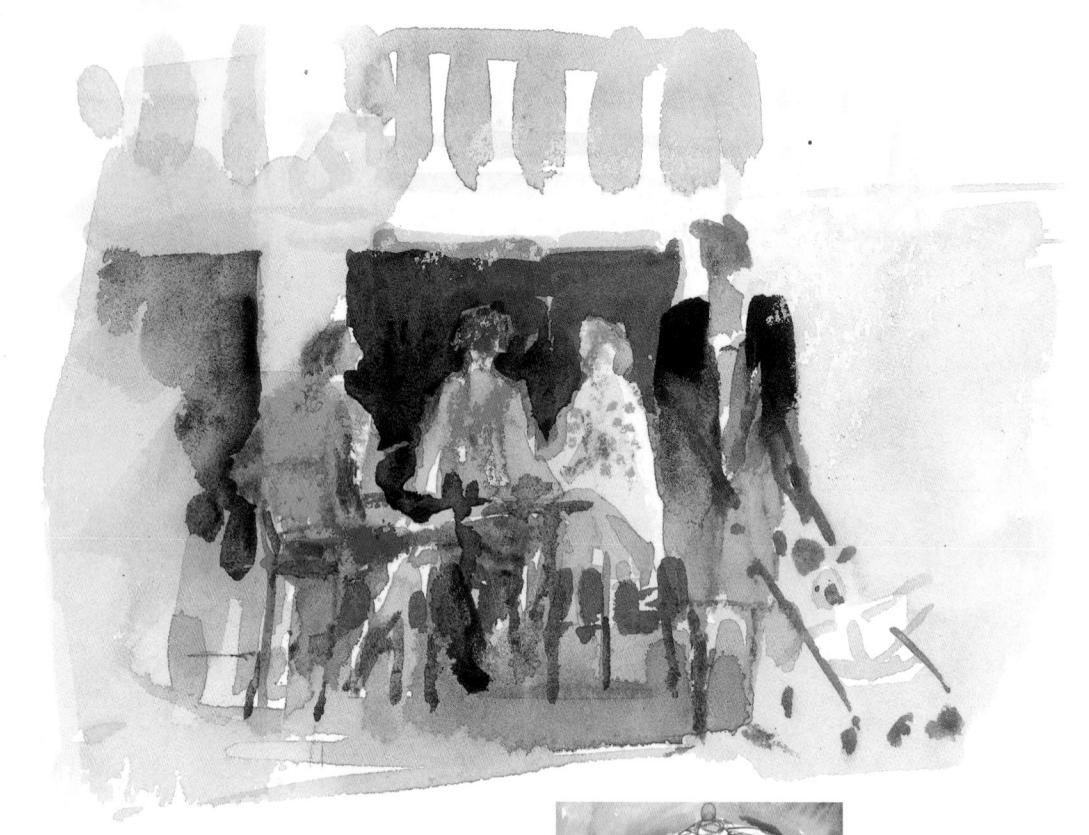

The strong, vibrant colours of oil pastels are ideal for a decorative piece such as this. I drew the pastels directly on to the primed paper and then dissolved and spread them with a brush loaded with turpentine.

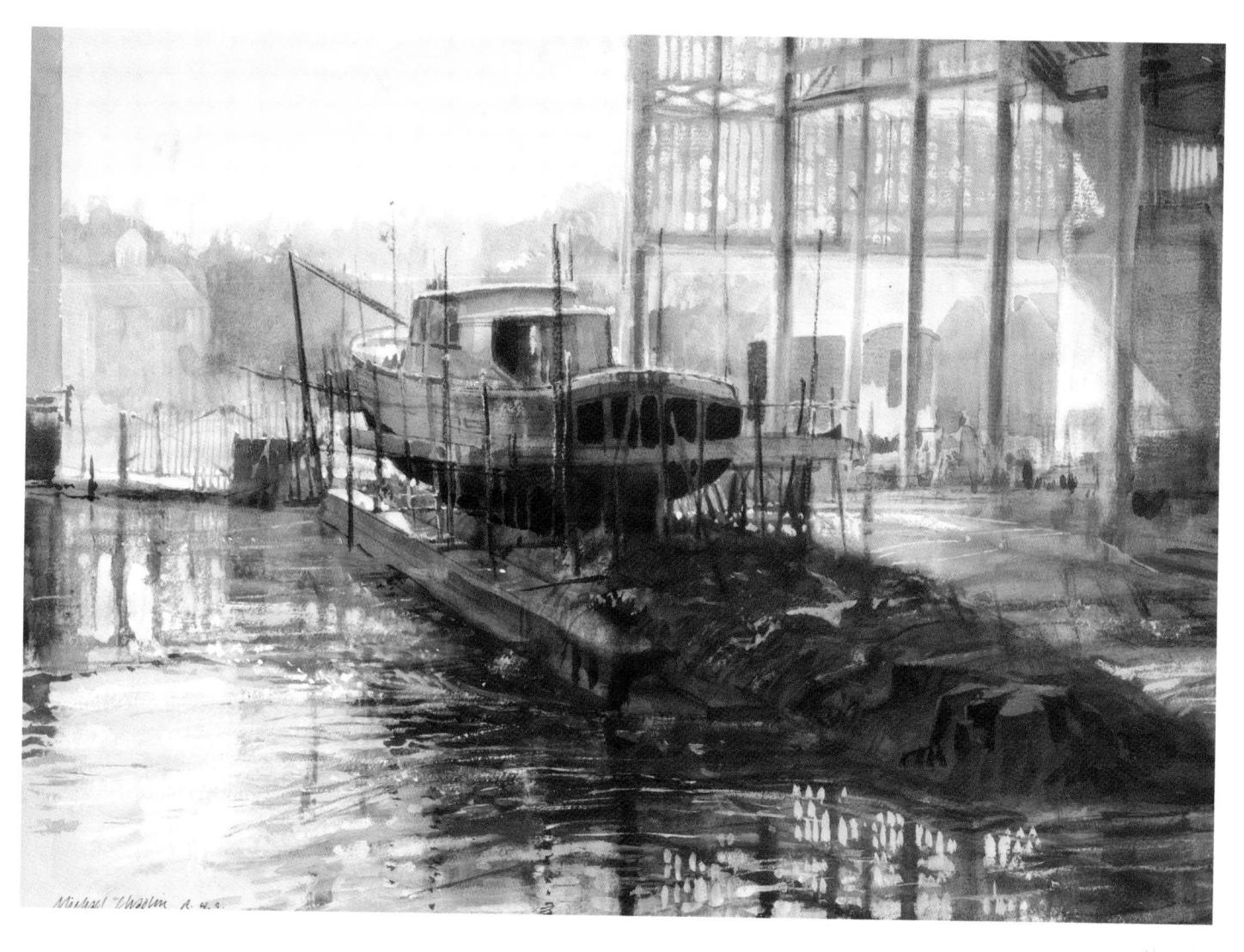

In this tonally dramatic picture painted contre jour (against the light), oil pastel has been used both as a resist for watercolour and on top of it.

The sparkly lights in the wet foreground were made by using oil pastel to lay light marks over dark ones, which is not possible with watercolour alone.

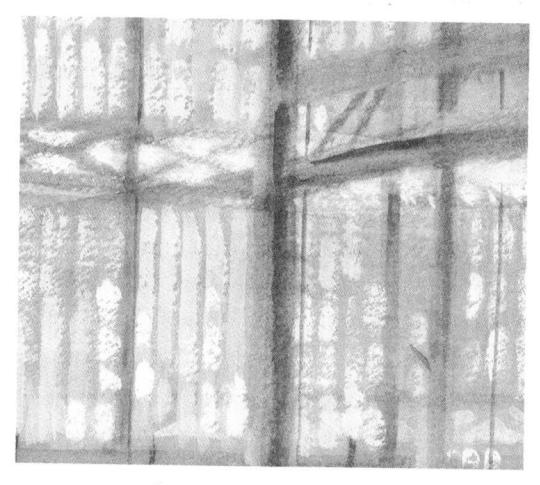

This detail shows the soft-edged marks I made with the oil pastel at the top of the painting.

I then laid watercolour washes over the top.

CHARCOAL

Although charcoal crumbly and dusty, it is capable of the most delicate work as well as tonally powerful drawings. It is and undeniably messy doesn't appeal to everyone, but do try it out. Even if you decide you don't like it, you will have learnt more about mark-making just by using it. You will find this particularly valuable if you are prone to drawing very tightly, for it will encourage you to make bold gestural marks which you can then translate to another medium.

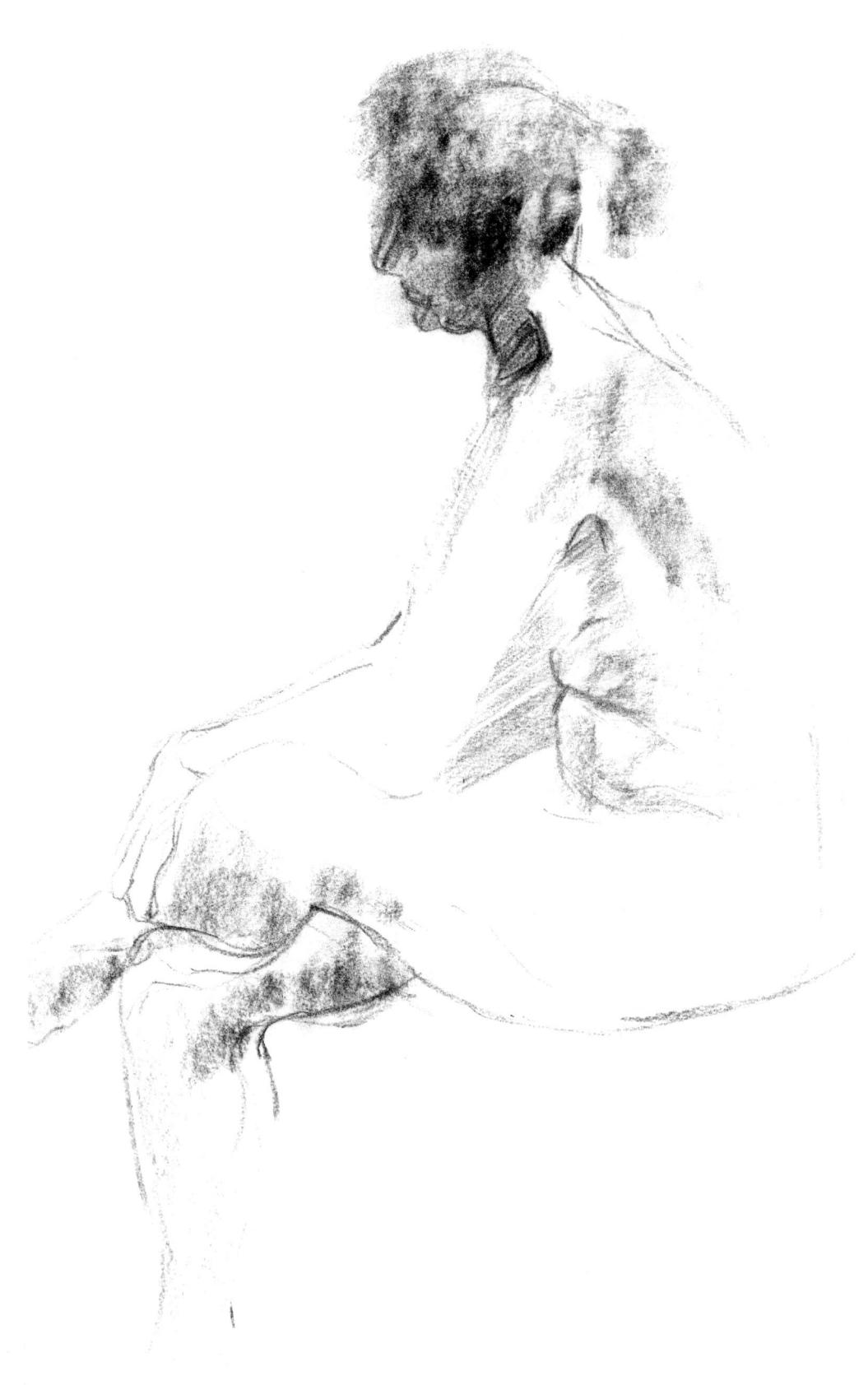

In this life drawing Gaynor
Lloyd has described the
form of the model by the
changing weight of the line,
which varies from thick to
thin. The sparse, soft lines
up the back develop into the
more fully described head
with its shadowed,
half-hidden features.

CHARCOAL WITH WATERCOLOUR

Perhaps surprisingly, charcoal works very well with watercolour washes, which tend to be associated with delicacy and translucency. The charcoal gives a tough drawing and when you begin laying the washes over it they pick up a lot of granular quality that produces lovely textured areas of paint.

Watercolour over charcoal gave me gritty washes that were just right for the gritty subject matter of an old steam train boiler.

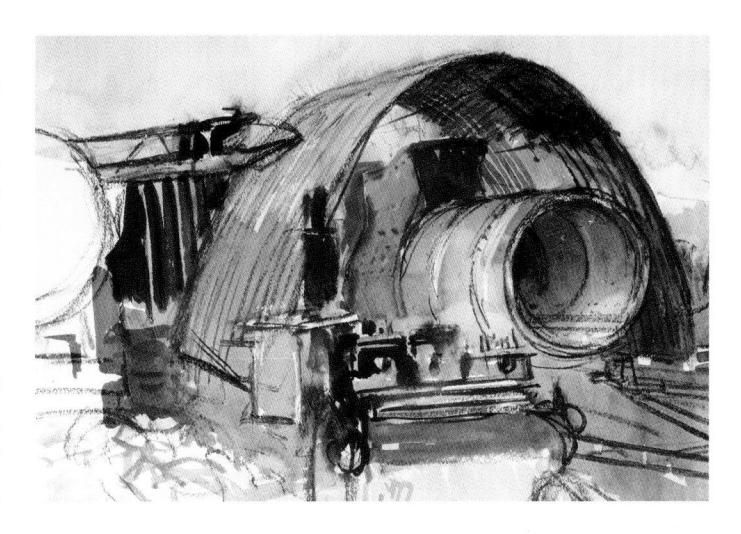

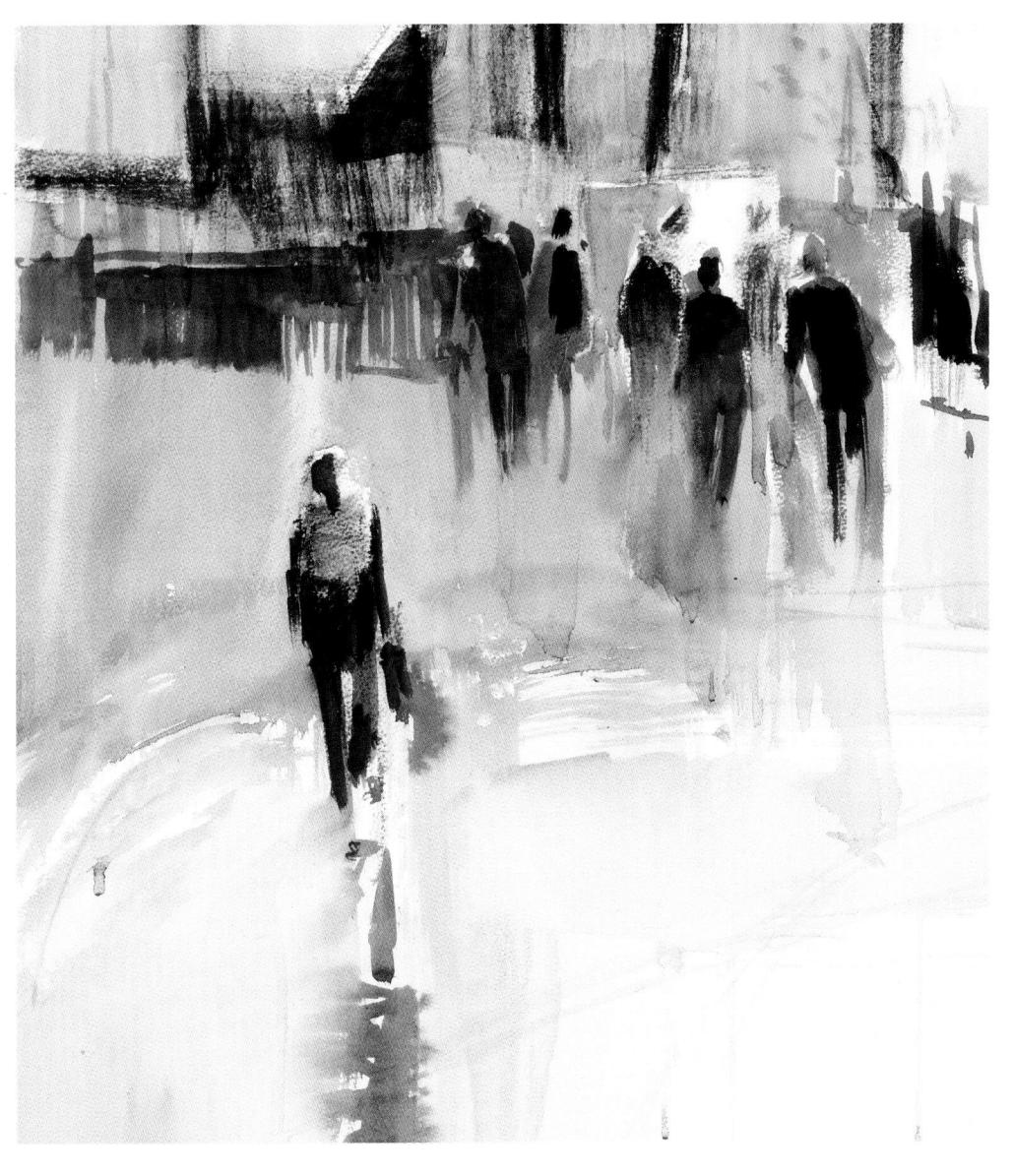

Sitting in a car park on a wet and windy day, I made quick charcoal notes about the people queuing at the ticket machine and washed some paint over the top. This sketch sums up the briskness of the scene and gives a feel of the weather conditions.

A MIXED MEDIA PIECE

In these drawings of Venice I enjoyed pushing pastels to their extremes, using them together with watercolour pencils and charcoal. While the subject matter was a visual delight, the pleasure of painting and drawing is partly about experiencing the handling of materials and the richness of design, colour and texture for their own sake. As an artist, you can become intrigued by these challenges even when you are tackling the most mundane objects.

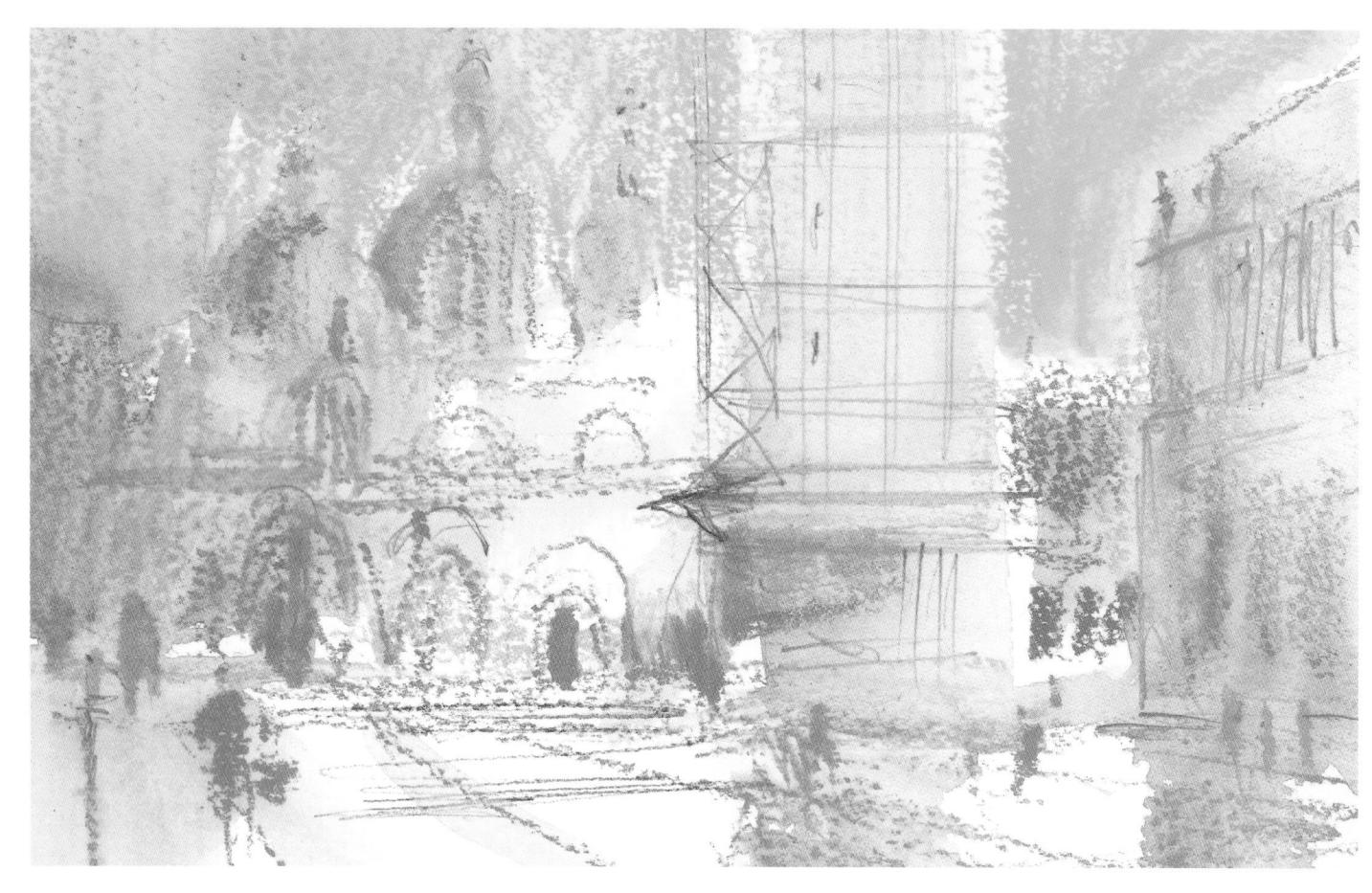

As preparation for a drawing of the Basilica in Venice I made an initial drawing on wet white paper in my sketchbook. My aim was to explore all the aspects of the light falling on the Basilica and the shadows thrown by the bell tower on the wet foreground, as well as the balance of the hard delineation of the scaffolding against the crumbly façade of the Basilica.

Back in the studio, I explored how I might use colour and texture, hard and soft lines and extremes of tone to regenerate the excitement! felt when I was on location.

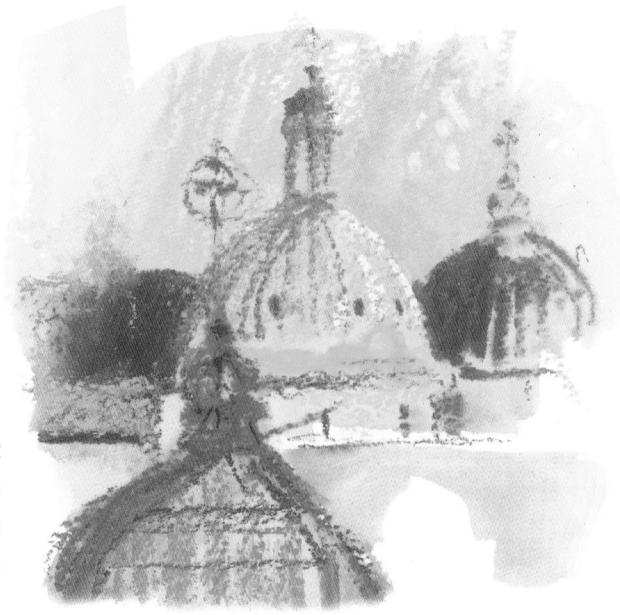

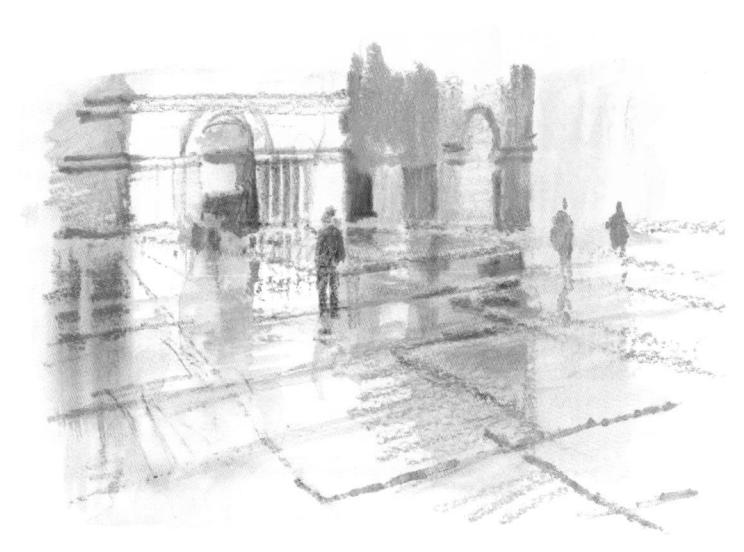

Next I began to examine the two-point perspective in the foreground and how I could make that surface echo the buildings behind. I solved this by drawing the top of the buildings shown here with quite hard pastel pencil and then using clean water on a soft brush to pull some of those tones down into the foreground. I exaggerated the perspective a little to add excitement.

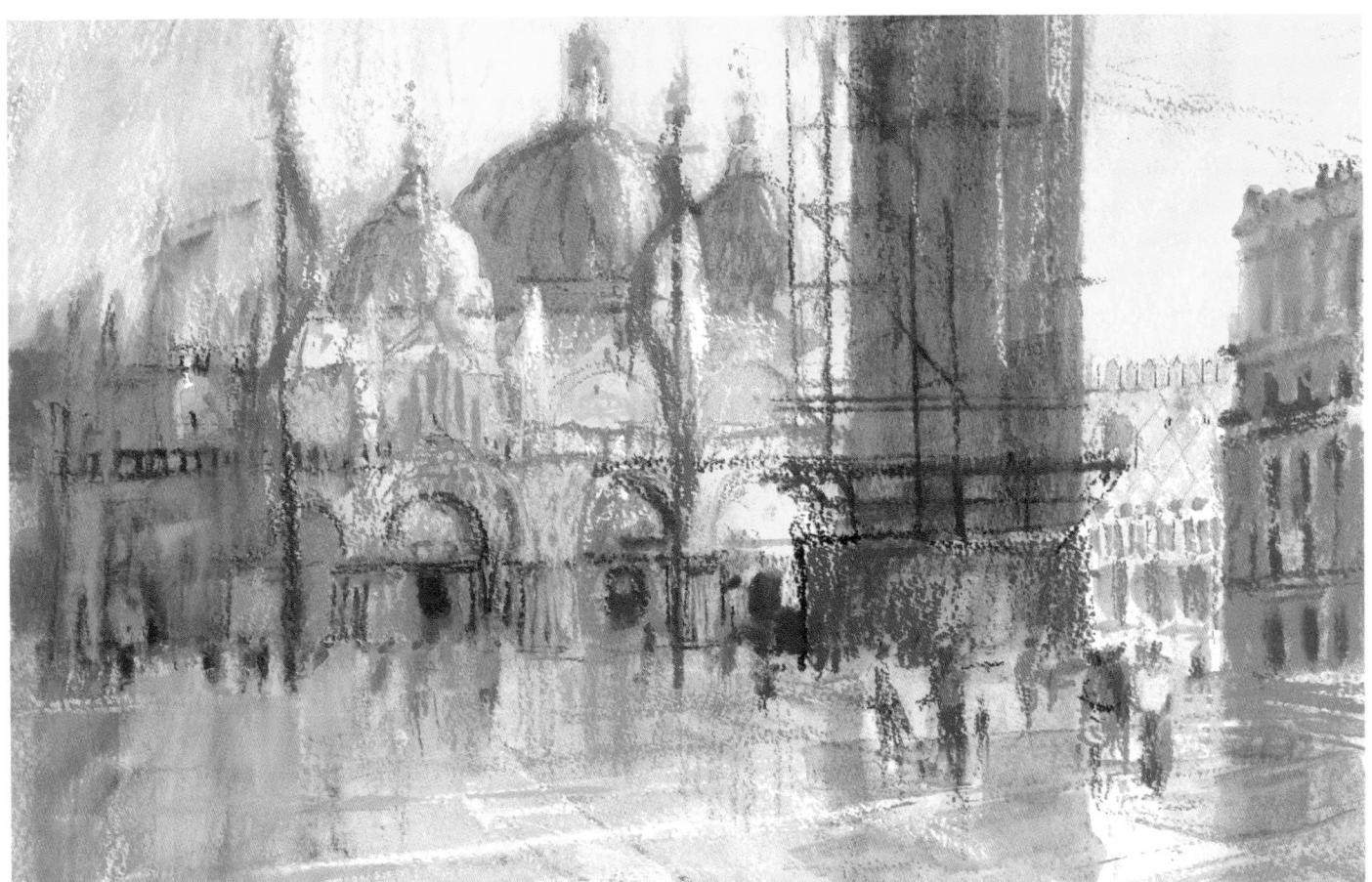

The Basilica, Venice 28×38 cm $(11 \times 15$ in)

This final piece shows the accumulation of all the decisions made as a result of doing the preliminary studies. I have introduced the red banners that hang from the flagpoles in front of the Basilica and the figures are now established as little points of colour, some light on dark and others dark on light. They are harder-edged in the foreground and softer-edged and more muted in colour as they recede in the picture plane, contributing to the three-dimensional effect given by the single-point perspective.

A MIXED MEDIA PIECE

This detail shows the brilliant colour of which pastel is capable and the vigorously textured effects you can obtain in linear and tonal work. The latter make it especially suited to describing the mass and surface of architecture such as the Basilica.

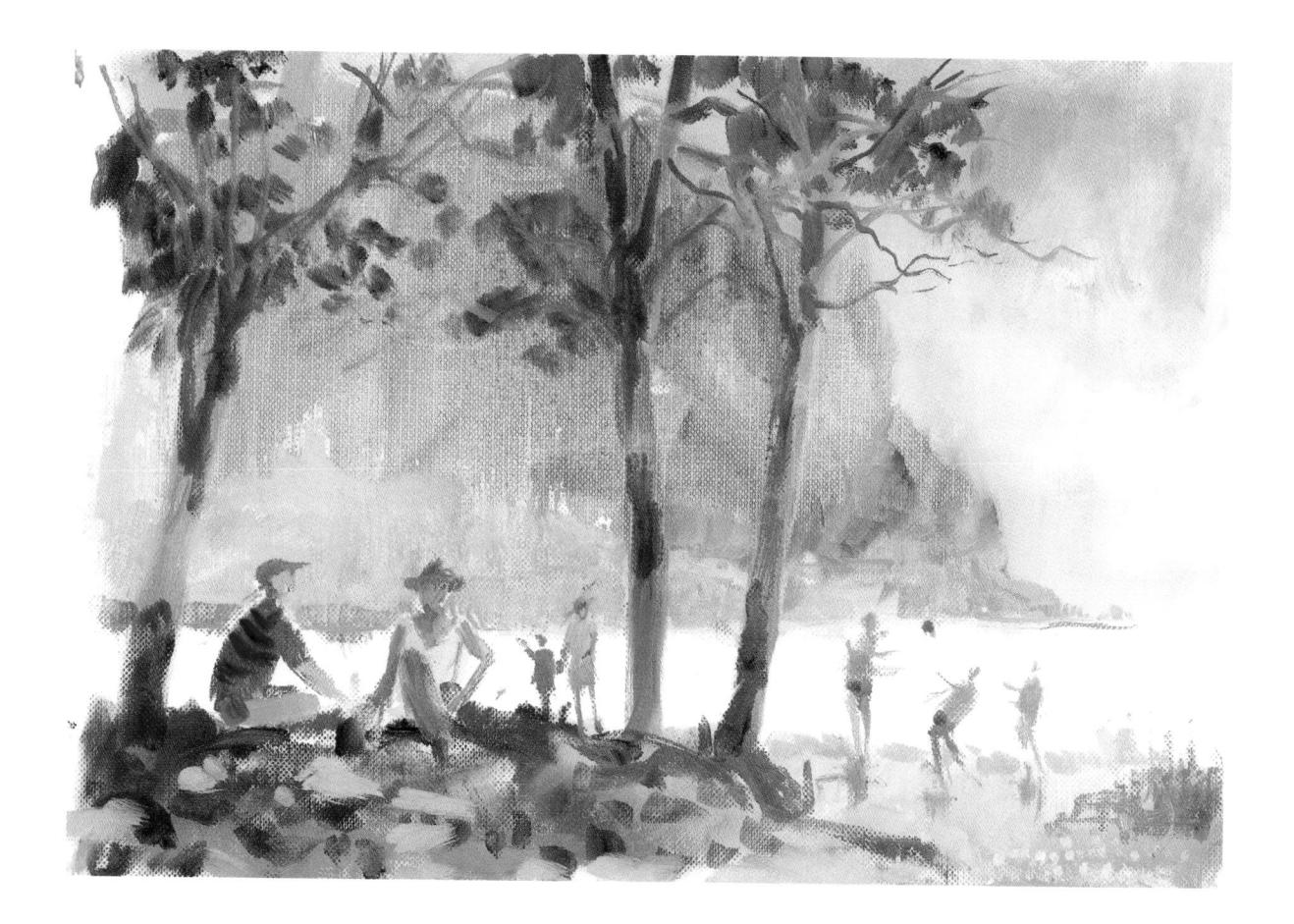

OILS

Oil painting is probably the most durable form of painting there is; indeed, it often remains in better condition than the surface it is on, such as damp, crumbling church walls. It is also extremely liberating, for the work is no longer limited to the size of paper that is produced by a manufacturer; measurements are dictated only by the imagination and energy of the painter.

So the idea of painting in oils is exciting, but it is also challenging. Setting yourself up with the right equipment seems a more complicated and expensive task than acquiring a box of watercolours or pastels. More importantly, oil painting seems to carry a greater weight of history, from the Old Masters to the Impressionists and beyond. As an amateur, it is easy to feel that it is the province of 'real' artists.

However, remember that the Impressionists themselves cocked a snook at history and threw aside the high degree of finish that was previously considered essential. Oil pigments are capable of being worked from the thinnest, most delicate glazes up to the heaviest impastos that are almost sculptural in their relief, and you will be able to find a manner of using them that suits your own capability and temperament – so take pleasure in the excitement of putting paint down and your confidence will grow with practice. The explanations of materials and techniques in the following pages demystify the process of oil painting and will set you on your way to your own explorations of this wonderful medium.

BRUSHES AND PAINTS

BRUSHES

Brushes for oil painting tend to be quite stiff bristle, usually hog, though you can use synthetic fibres or a mixture of the two. Most have long handles because oil paintings tend to be quite large scale, in which case you will need to stand

up and position yourself far enough away from the work to see what it looks like overall. For detail or fine linework you will want to move in closer, when you will use a short-handled sable brush.

Sable rigger

holding the brush at the end, or drawn along the length of the sable bristles.

Filbert

Filberts fall between flat and round brushes. They have a curved tip that allows you plenty of control.

Bristle stencil brush

Use to scrub on paint. Because the bristles are very short and hard, small lines remain visible. Alternatively, stab the brush repeatedly on the paper to make stippled marks.

PAINTS

Paints all come from the same pigments and it is the binder used with them that determines the medium. In the case of oil paints this is linseed oil. They are available in artists' quality and, more cheaply, students' quality. As the difference between them is quite subtle, I recommend starting out with students' colours so that you won't worry about the cost of experimentation.

Oil paints are thinned with more linseed oil or, for thin glazes or a matt finish, pure turpentine - not turps substitute, which is for cleaning brushes only. If you don't like the smell of turpentine, you can now buy an odourless substitute called Sansodor.

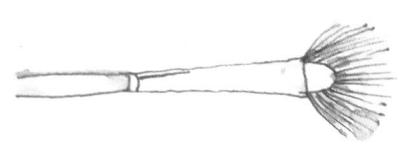

Fan or blending brush

Hold the brush very lightly and draw back and forth across the paint to blur the edges where colours meet.

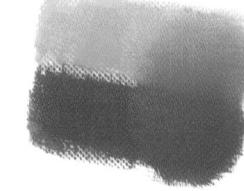

Flat brush

As with an italic pen, pull sideways for a thin mark or downwards for a thick one.

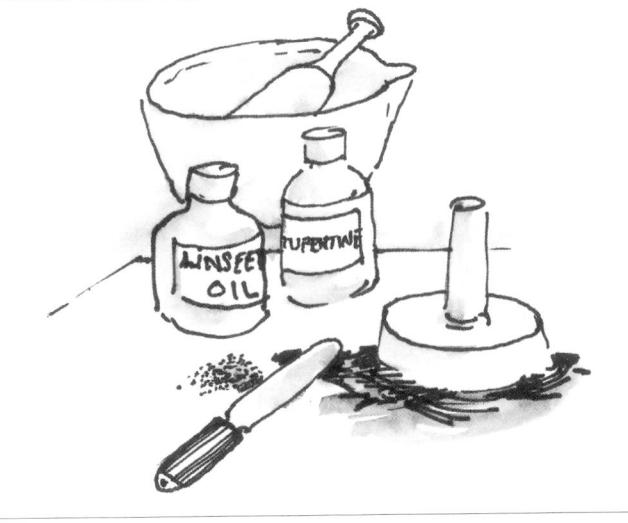

SUPPORTS

The first traditional supports for oil paints were wood and vellum, with fabrics being a later arrival. Any surface will take paint, but the ones you are most likely to encounter are hessian, canvas, linen, cotton, muslin and MDF board, with the latter being particularly popular.

STRETCHING

Fabrics are stretched on wooden bars, which you can buy in pairs from art shops in various lengths, along with triangular wedges. The longer ones have a slot for a centre bar for extra support. Stretch the fabric round to the back of the frame, staple it to the wood and then knock two wedges into each corner to stretch the fabric taut.

Hessian

Fine linen

Coarse linen

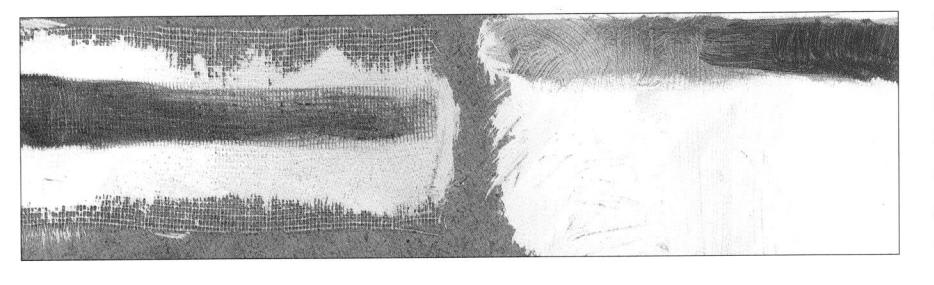

PRIMING

Art shops sell ready primed canvas, board and textured paper, but other than these you will need to prime all surfaces yourself to prevent the paint sinking into them. The easiest means of doing this is to buy acrylic primer. Begin by laying a thin coat, diluted half and half with water. When that is dry, lay full-strength coats, waiting for each to dry, until the surface will not absorb any more. The number of coats you will need depends on the porosity of the surface, so just continue until the support is no longer visible.

You can lay the primer smoothly or scumble it to give a textured surface that will go through to the paint. You can also add a cool or warm tint, using acrylic paint.

Fine cotton

Cotton muslin

Primed textured paper

Here I have glued muslin to MDF with primer. On the left, the muslin shows through the primer and will be reflected in the paint quality. On the right, I have added extra coats. Some of this area is smooth, to give a surface on which I can paint accurate lines, while some is scumbled to give texture.

A TRAVEL KIT

While pigments themselves are not flammable the solvents needed for their use as oil paints are, so you may find that you are not allowed to take them on aeroplanes. If you are travelling by air and don't want to risk confiscation of your art materials, the safest choice is the artisan paints made by Winsor & Newton, which are oil paints that you

can thin with water. These are of course equally useful at home if you want to avoid using turpentine.

For a neat travelling kit, you can buy pochade boxes in various sizes. They open up to reveal a little flap that acts an easel, behind which you can store your supports. I stock mine with pieces of ready-primed MDF board.

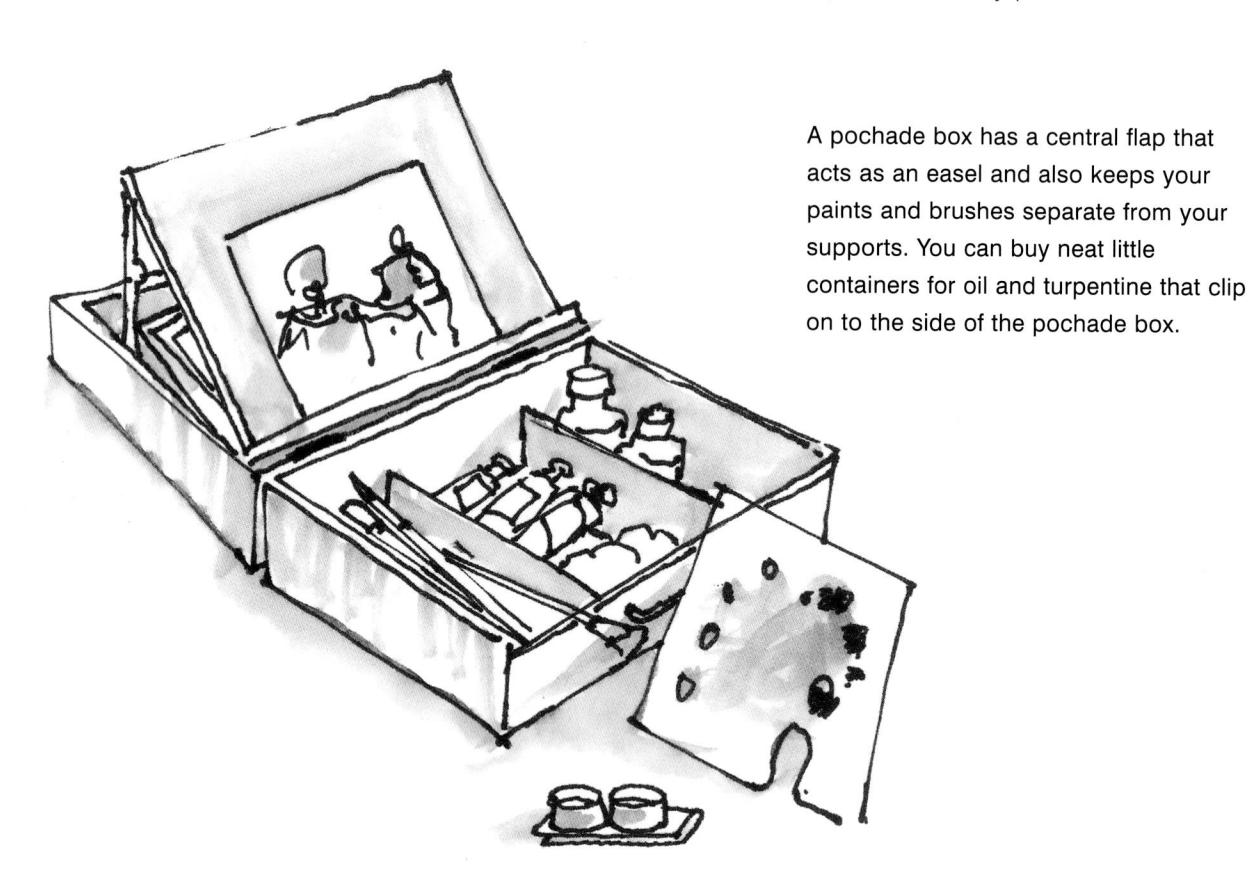

Oil paintings take a long time to dry, so you will often need to transport them while they are still wet. To do this, get four little pieces of dowel from a do-it-yourself shop, hammer a nail into each end and then cut off the head of the nail with pliers. Pin a dowel into each corner of the painting, then put another canvas on top so that the two are held safely apart from each other, face-to-face. You can sometimes buy these dowels from art shops, but it is very easy to make them yourself.

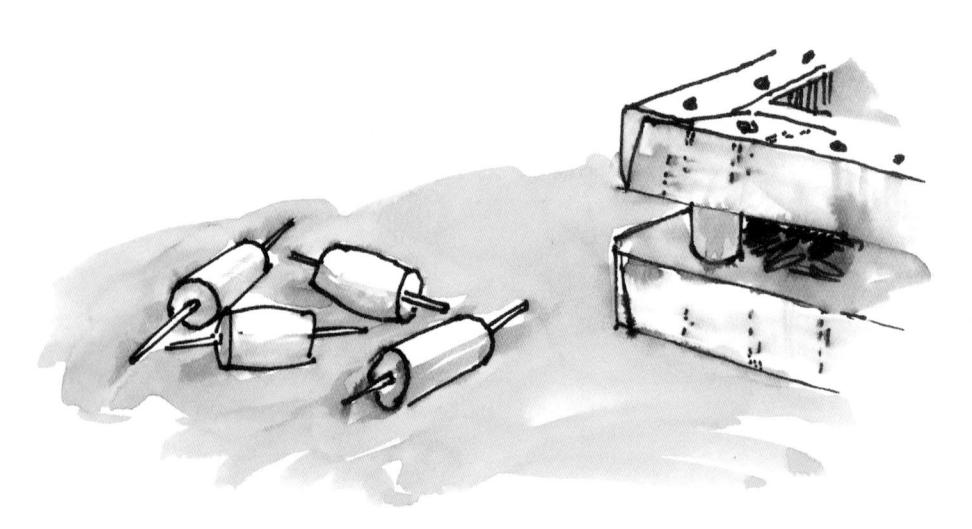

A STUDIO SET-UP

Oil paints are not forgiving if you trample them into the carpet, so you will need to find a permanent painting space where you can lay dustsheet, plastic or cardboard on the floor. Because you will be using oil and turpentine, this

must be somewhere there is good ventilation. Ideally, it should have north light so that glare and shadows are not a problem on sunny days. For working after dark, buy some daylight bulbs which mimic natural light.

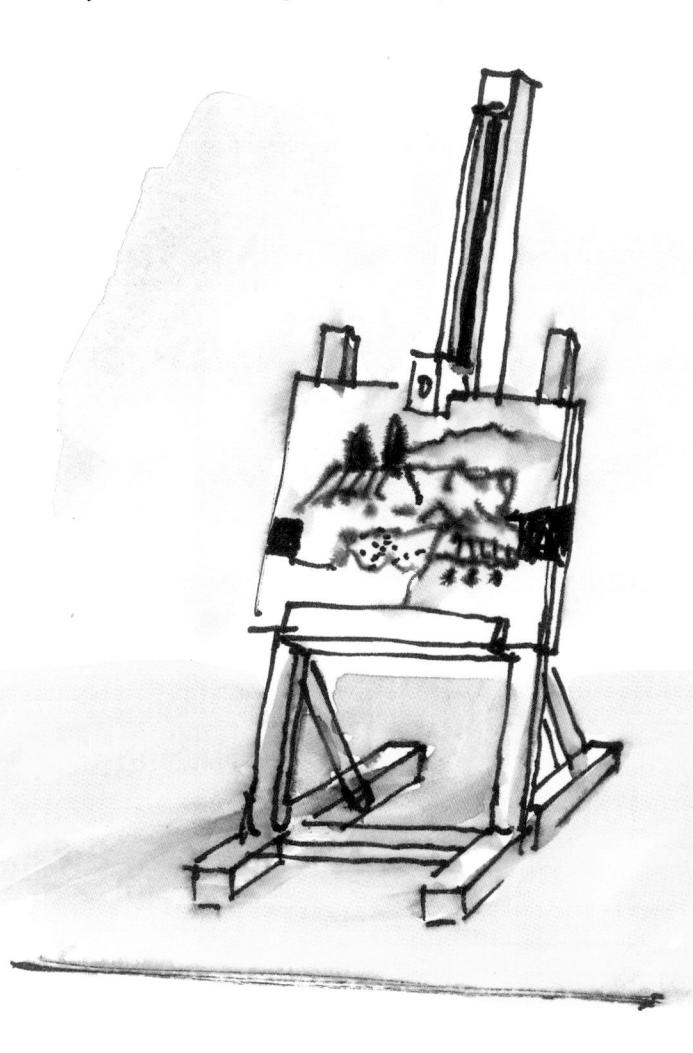

You will need an easel, either on a stand or a tabletop model. The latter are considerably cheaper and will be adequate for most purposes. If you are showing people your paintings with a view to selling them, putting them on easels is a good way to display them rather than stacking them on the floor.

Paint kettles for cleaning brushes are available from do-it-yourself stores and art shops. The latter supply more sophisticated models with a mesh basket on which you rub your brushes so that all the old paint drops through into the bottom of the kettle. They often have a handle like a big spring which you can wedge your brushes into.

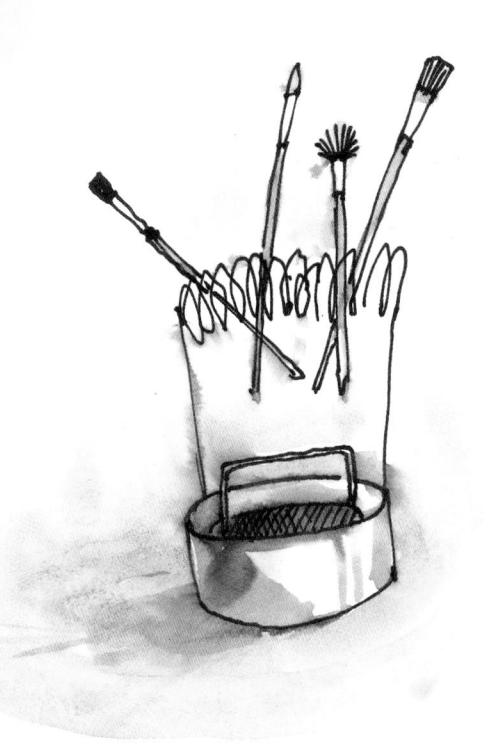

PALETTE LAYOUT AND BASIC MARKS

You will need some sort of palette to keep your paints on. Square or rounded wooden palettes with thumbholes are available from art shops, but if you are on a budget you can make do with a piece of wood or even plastic on a table top. On your palette you will need the colours of the spectrum, usually in both a warm and cool version, plus the earth colours (browns), black and white. Titanium White is opaque, while Flake White is more transparent.

How you lay out your palette is a matter of personal choice. One convention often used for landscape painting is to have dark cool colours one end, light colours in the middle and dark warm colours the other end, with the earth colours separate. Shown below is the layout I prefer.

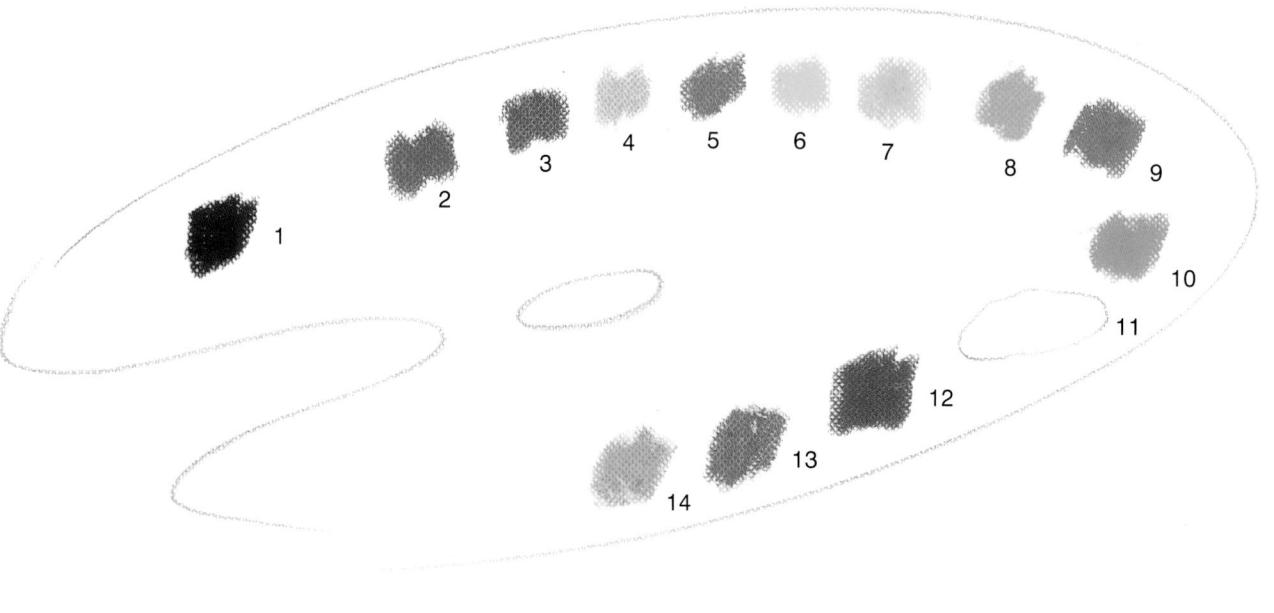

- 1. Black
- 2. Ultramarine Viole
- 3. Ultramarine
- 4. Light Cobalt
- 5. Phthalo Green
- 6. Lemon Yellow
- 0. E0111011 10110W
- 7. Cadmium Yellow
- 8. Cadmium Orang€9. Alizarin Crimson
- 0. 7 m2am 0m100
- 10. Cadmium Red
- 11. White
- 12. Burnt Umber
- 13. Raw Umber
- 14. Terracotta

Here dark and light blue are scumbled together. They are not blended, but the viewer's eye perceives them as a single tone with a textural finish.

The same two blues have been blended together by very light use of a blending brush to give a smooth effect. The dark blue has been laid at the top then pulled out and diluted with linseed oil. This way of changing tone from dark to light gives transparent colour.

Using a palette knife to ladle the paint on gives a thick impasto surface.

A darker colour has been laid on top of a lighter base by scumbling (working the brush with a rotary motion). Lighter tones have been scratched out with the end of the brush handle, a technique known as *sgraffito*.

Dark blue has been scumbled over the top of light ochre to leave small light marks showing through.

Light green has been scumbled over the top of dark green so the dark marks show through.

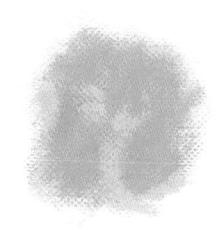

These two colours are exactly the same tone so the colours shimmer in relation to each other.

Removing paint is just as valid a way of mark-making as putting paint down. Shown below are three methods of achieving this. Together with the other techniques of markmaking shown on these pages, they cover nearly all the marks you will encounter in painting.

Paint has been lifted off by laying a sheet of kitchen towel over it and then drawing on the back with a fingernail to blot it off.

A cotton bud can be used as an absorbent pad to lift out colour by drawing into it. If it doesn't come off easily, soak the cotton bud in oil or turpentine.

Here paint has been lifted off by simply twisting a piece of rag into it.

Using glazes

The above illustration shows how you can use cool and warm glazes (transparent layers of paint) to make an area appear remote or intimate respectively. Use glazes with discretion, as they can produce a muddy effect unless you are laying just one pure colour over another. The paint beneath must be absolutely dry.

SKETCHBOOKS

You will need sketchbooks in two different formats, and although unprimed cartridge paper will suffice for drawing and temporary oil sketches a pad with primed paper is necessary for permanent oil studies. The advantage of

unprimed paper is that the paint dries more quickly, but as it sinks into the paper the quality is poor and oil seeps through the fibre. For more considered sketches I buy books with heavy handmade paper and prime it myself.

One page of a horizontal panoramic sketchbook gives you a wide landscape format or a portrait format if you turn it sideways.

Working across both pages gains you a format of almost four squares, ideal for expanses of landscape.

A square sketchbook is also useful.

Squaring up

When you want to translate a sketchbook composition into a finished painting it is essential to retain the same format. This is done by squaring up.

This pen and wash sketch of a harbour has been squared up by drawing centrally placed horizontal and vertical lines and then drawing diagonals from corner to corner and from the horizontal to the vertical points. The diagonals cross at the middle point of the whole picture and at the middle of each rectangle created by the horizontal and vertical lines.

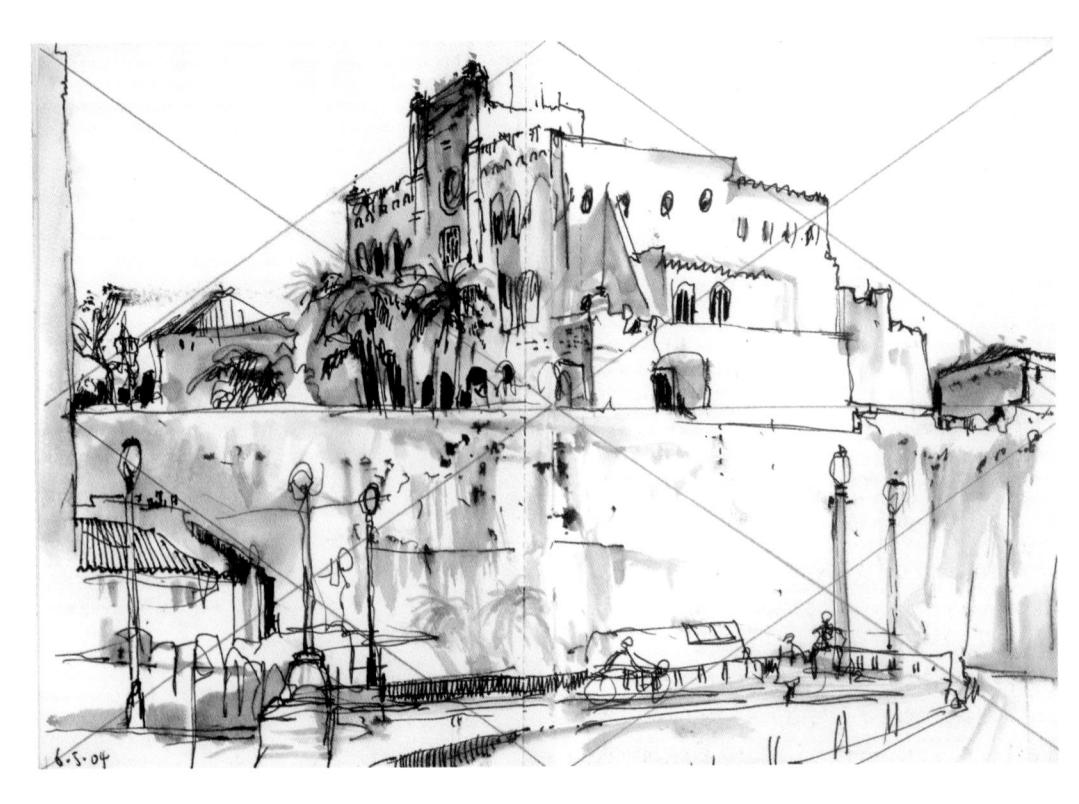

Put your sketchbook in the bottom lefthand corner of your support. Lay a ruler across it up to the righthand corner and draw a line. Any lines drawn from the side or bottom of the paper to meet on the diagonal will give you the same format.

Referring to your original sketch, you can transfer the elements within it to your support. The two lamp posts pass exactly through the middle of the bottom quadrants, while the top of the harbour wall is exactly on the central horizontal line.

Here I have begun laying in the first loose washes of colour. You can see that the delicate squaring up lines, drawn with a very soft pencil, are already beginning to disappear beneath the paint.

SKETCHBOOK STUDIES

Take a sketchbook with you wherever you go so that you are constantly recording the world around you, building up a visual vocabulary at the same time as you practise your skills. Your sketches may be linear notes or may perhaps contain colour too. Even in monochrome sketches it is always worth putting in the tonal values so that you can see how the light is affecting all the elements of the scene.

My little pen sketch of some figures sitting under a canopy at a Mediterranean café took less than five minutes to do, with some water brushed on to give tone.

This is a vignette with no attempt at choosing a composition.

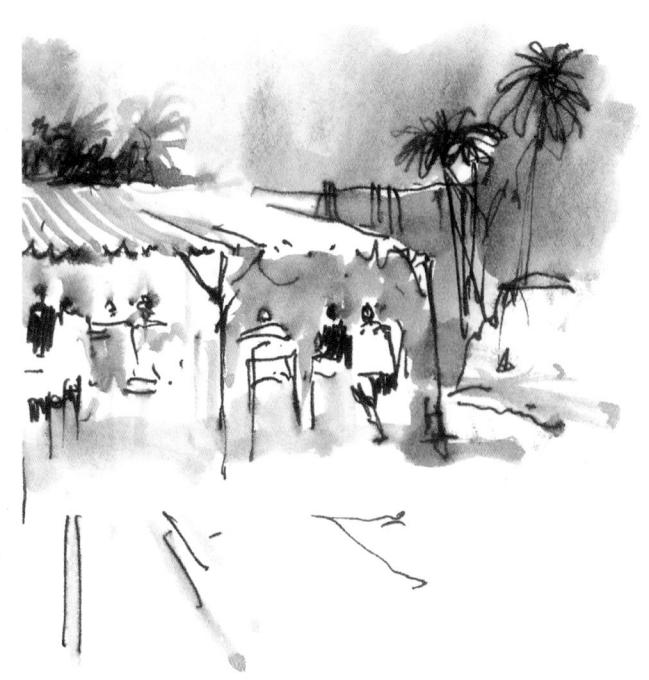

I followed up the pen sketch with a loose colour study, giving more thought to the composition and putting in the cars. If I wish to make a finished painting I now have all the information I need to do so.

There's no need to look for a specific view before you get out your sketchbook; I had fun sketching this little pottery figure in a garden.
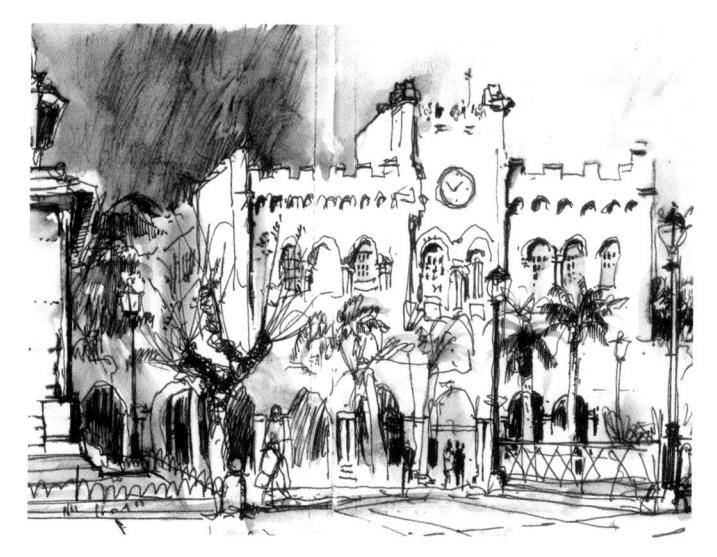

This is a more finished sketch of a police station in a Minorcan town. It occupies two pages of the sketchbook and I have put much more thought as to where objects are placed within that shape.

From the drawing above I have begun a small painting of the police station. Note how at this very early stage the colours are already recurring in different areas of the painting to provide unity and dark tones have been put in from which to judge the level of the midtones.

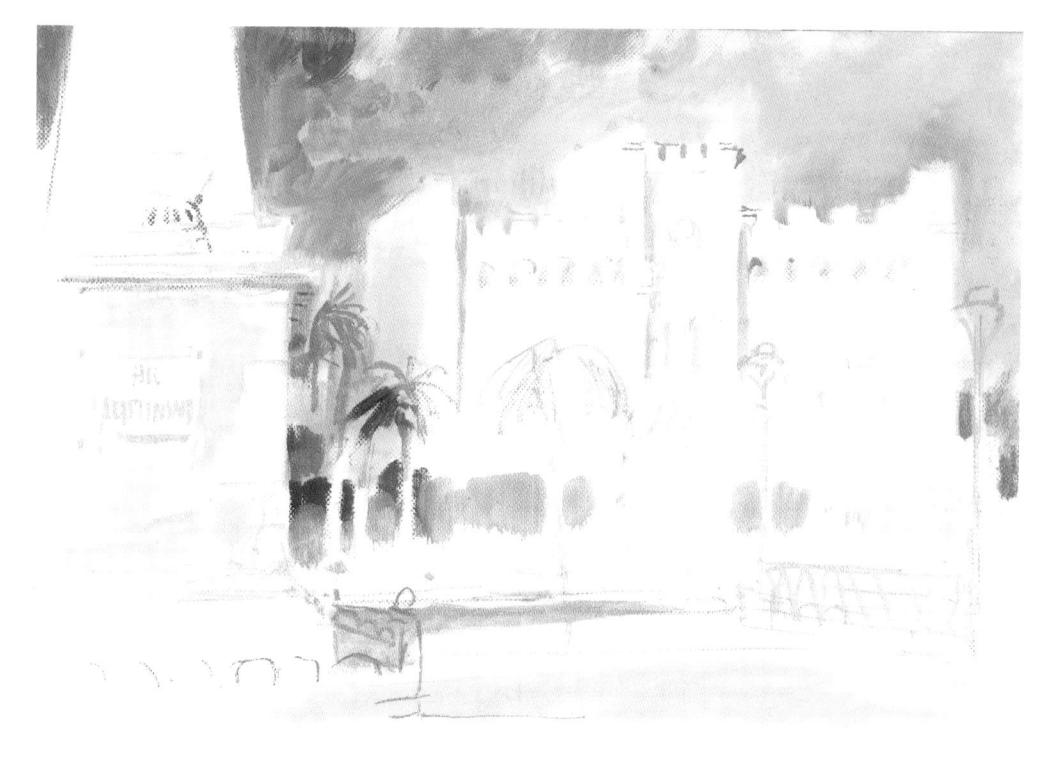

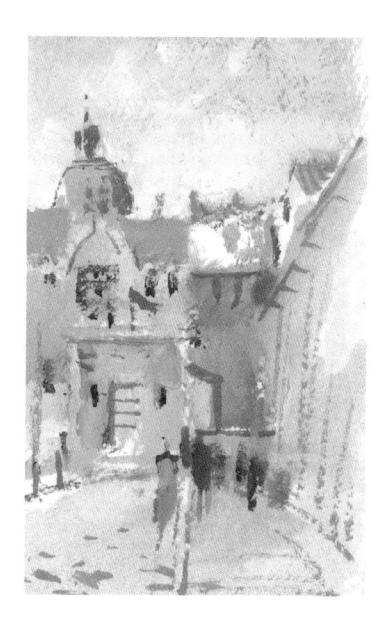

This sketch of the customs house in the same Minorcan town was a brief essay into colour. I used unprimed paper so that the sketch dried within 15 minutes in the hot climate and I could shut my sketchpad and go on my way.

TONE

Tone represents shades from dark to light. In the case of black to white the intermediate tones are a series of greys, and their relationship to each other in terms of which are light and which are dark is easy to discern. With colour, tones become a little more complicated, since strong colours can be confused with dark tones.

Extremes of tone are dramatic, but very close-toned paintings are also interesting as the relationships become about pure colours side by side.

Because the blue and red are strong, pure colours they stand out from the other colours in the panel.

Seen in monochrome, the colours are very similar tonally. The darkest are the muted green and brown.

The strong colours shown above range from light to

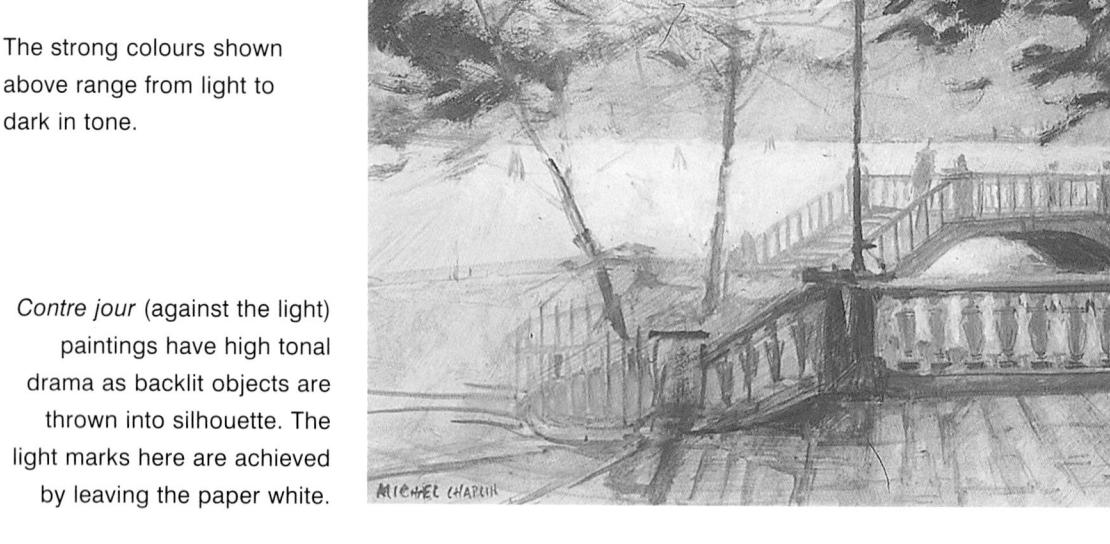

This oil study is of some brilliant light on a patch of grass. In comparison to the monochrome sketch on the facing page, the light areas were painted by using light marks on dark so that they become the main focus of attention.

It is not possible to determine a tone until it is seen against another one. Against white paper the tone of this apple looks too dark; by putting a strong dark tone next to it I have made it appear lighter. Putting in the darkest tones at the start of a painting allows you to judge the level of the midtones.

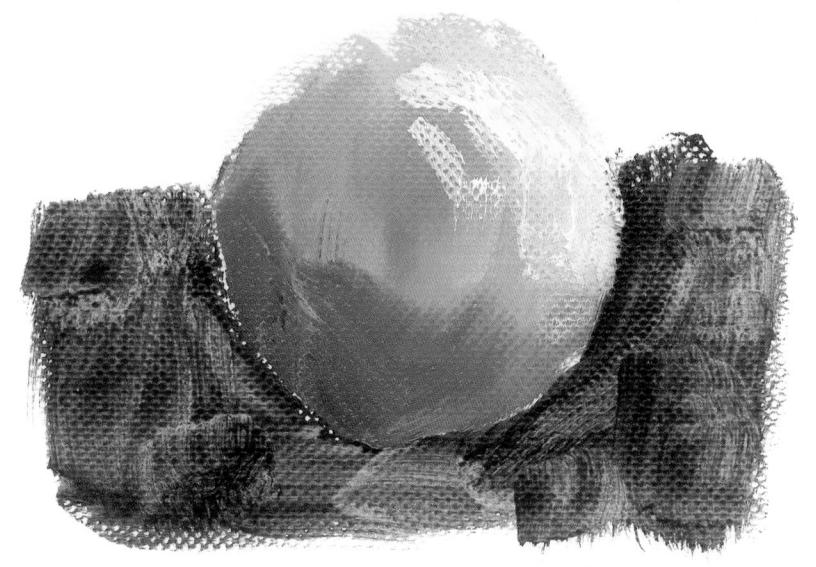

COLOUR

The three primary colours – blue, red and yellow – cannot be mixed from other colours. However, mixed with each other they produce what are called the secondary colours: blue and red make purple, red and yellow make orange, and blue and yellow make green. The colour wheel shown here is made up of the spectrum of colours seen in a rainbow, with the secondary colours between the primaries from which they are made. The colours that face each other across the wheel are opposite, or complementary, to each other. The dark brown in the centre of the wheel is what results if all the primaries are mixed together.

Blue and yellow have been physically mixed together to make green.

When blue and yellow are put down together in small patches, the eye reads them as green from a distance of about 1.8 m (6 ft).

Blue mixed with yellow can never produce a dark-toned green. One way to achieve this is to mix black and yellow.

This little painting, done on the spot, is about using simple colours. It has a freshness that comes from the colour being laid down in one go and then being left alone.

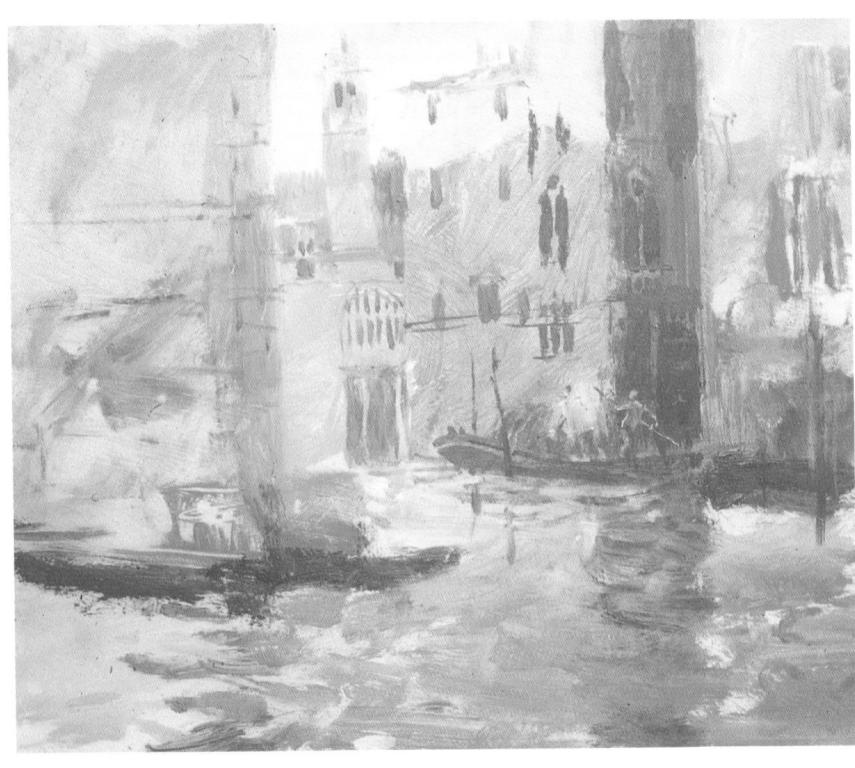

MIXING GREYS

Rather than diluting black, artists tend to make subtle greys by mixing opposite colours. These can either be warm greys or cool, recessive greys that give a sense of distance.

Grey mixed from yellow and violet.

Greyish-black mixed from green and red.

Grey mixed from orange and blue.

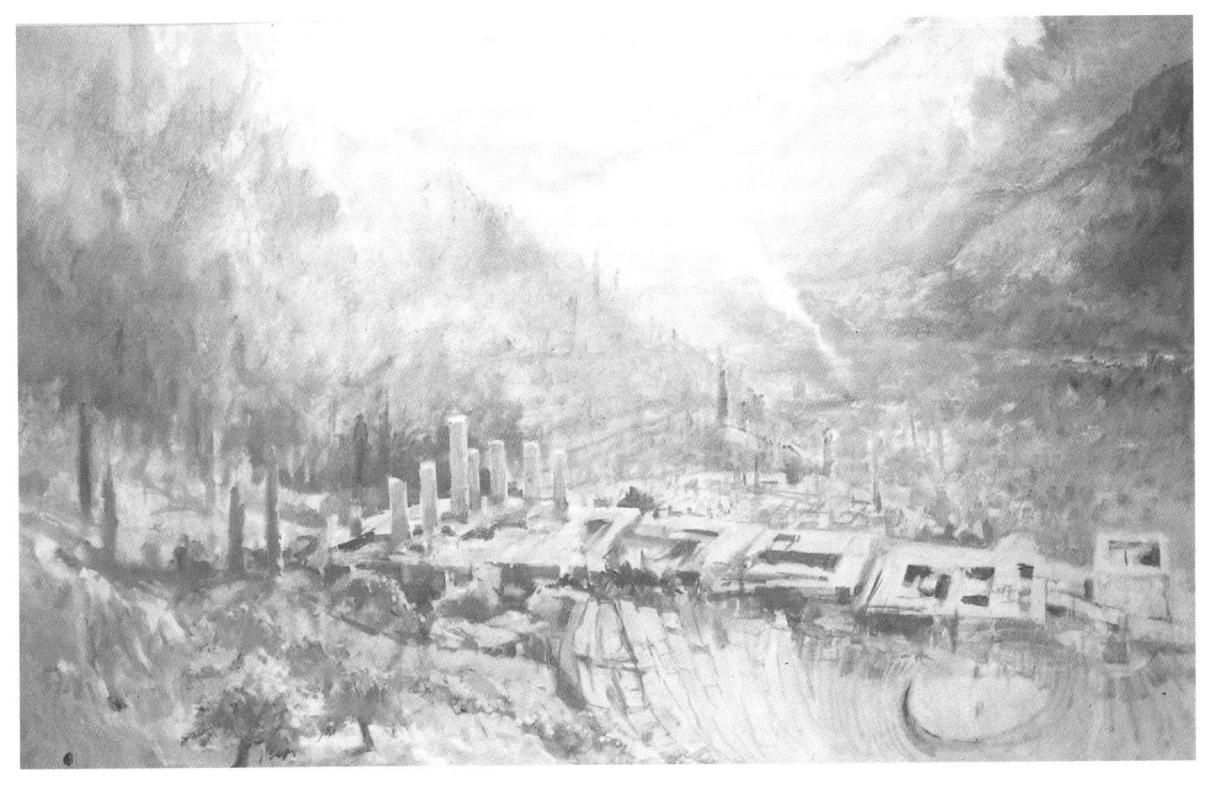

Delphi from the Amphitheatre 101.5 × 152.5 cm (40 × 60 in)

The thrust of this painting is the mixing of opposite colours to produce a very close-toned work. Light is shown by painting some areas of pure colour and some subtle greys made by mixing yellows and purples.

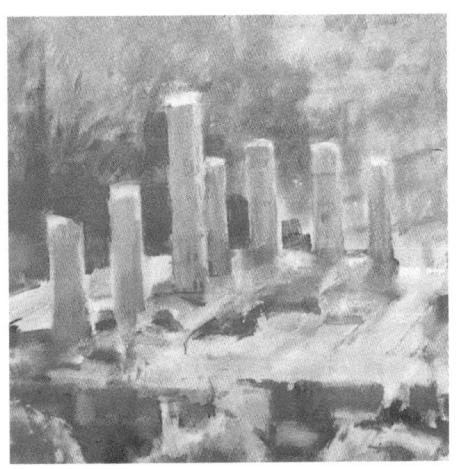

The pillars are painted by laying glazes of light violet over ochre. The viewer sees through one colour to its opposite, so the effect is translucent grey.

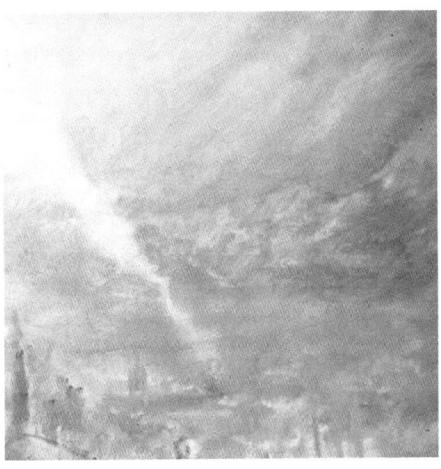

In the far-distant mountains, I laid down ochre paint then scumbled violet blue over the top to give an opaque grey.

PERSPECTIVE

SINGLE-POINT PERSPECTIVE

Perspective affects the way we see the world and we need to employ it in our paintings to give a three-dimensional appearance to a two-dimensional piece of board or canvas. While dealing with perspective can be challenging, particularly where architecture is concerned, a few basic rules will help you through the early stages of learning.

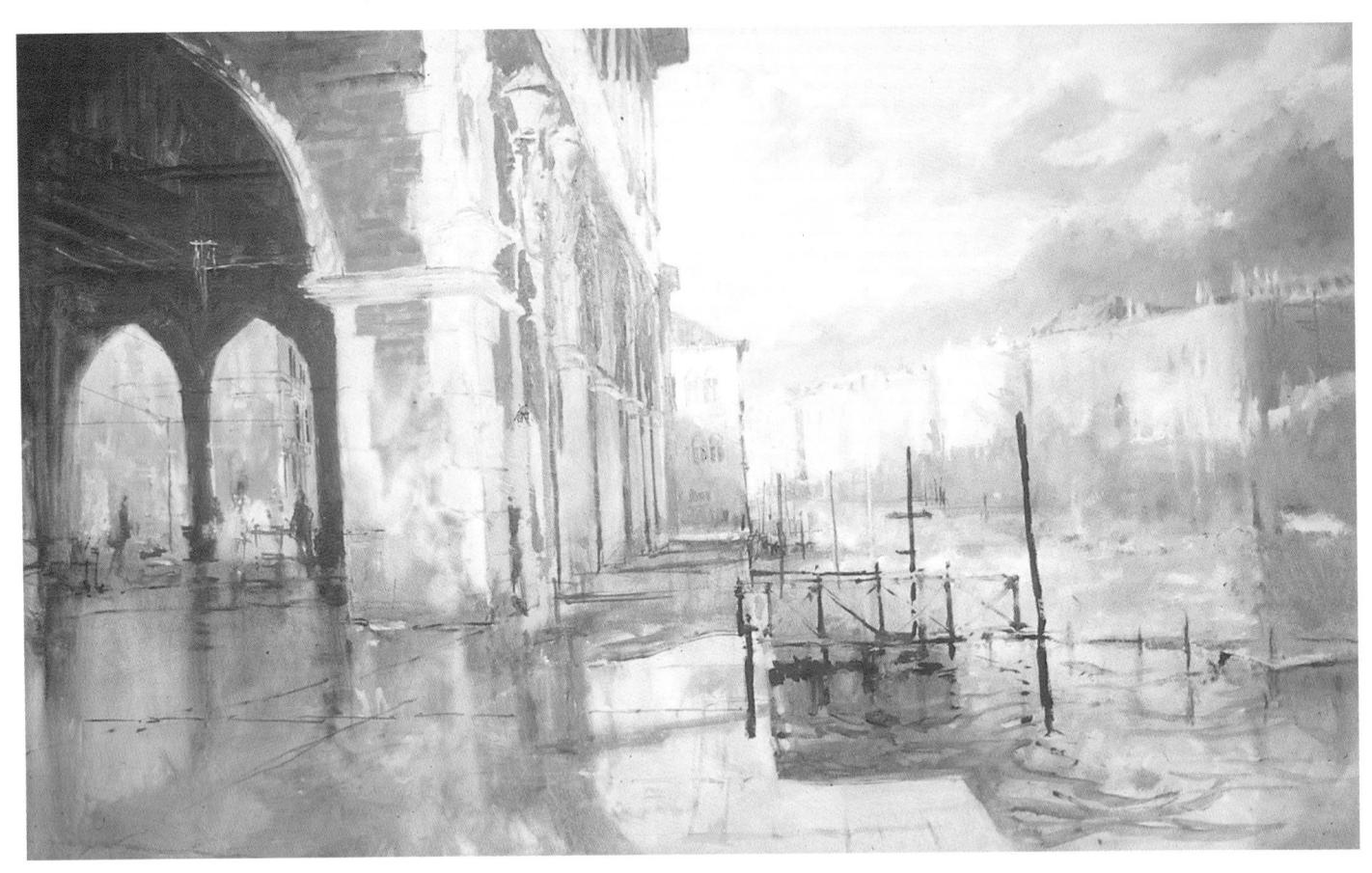

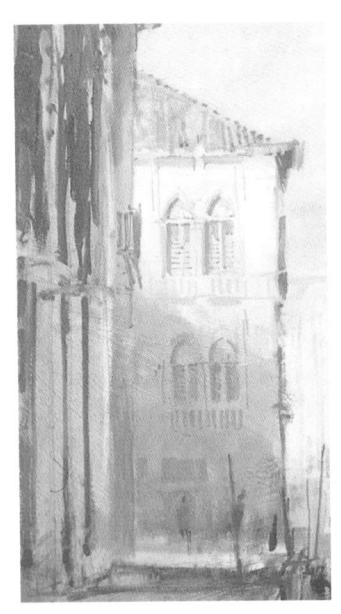

The Fish Market in Venice 101.5×152.5 cm $(40 \times 60 \text{ in})$ The single-point perspective in this painting leads to the distant building with the light shining on it. My viewpoint was from directly opposite the figure wearing a red shirt.

The overhang of the roof on the right of the distant building creates a little dark triangle that gives volume to the building and leads the eye back down to the vanishing point.

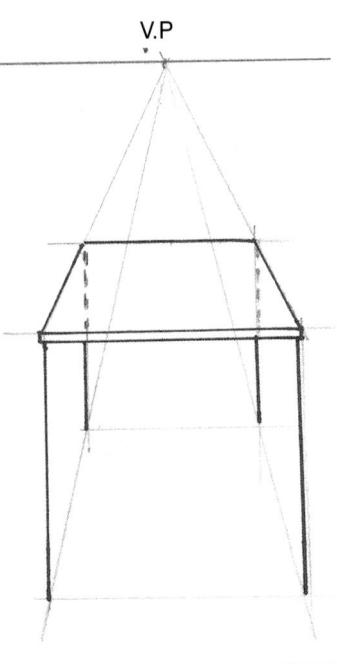

In single-point (or one-point) perspective, parallel lines running directly away from you will converge towards a vanishing point on the horizon. The horizon is always at your eye level.

TWO-POINT PERSPECTIVE

When an object is set obliquely to you, there are two vanishing points. They may not necessarily appear in the frame, but you must understand where they would fall.

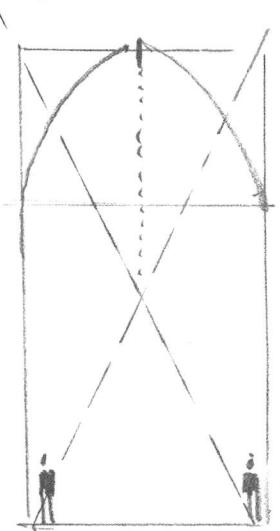

To draw an arch, place it within a rectangle. Draw diagonals in the rectangle. They will cross in the centre, and projecting a line up to the top of the rectangle from that point will give you the spot where the centre of the arch is.

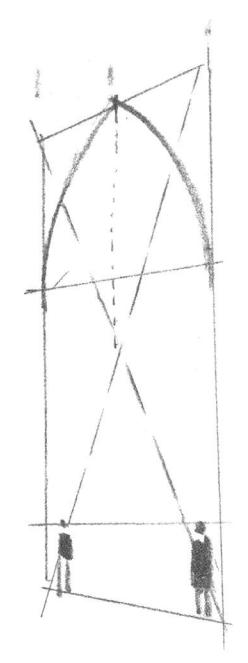

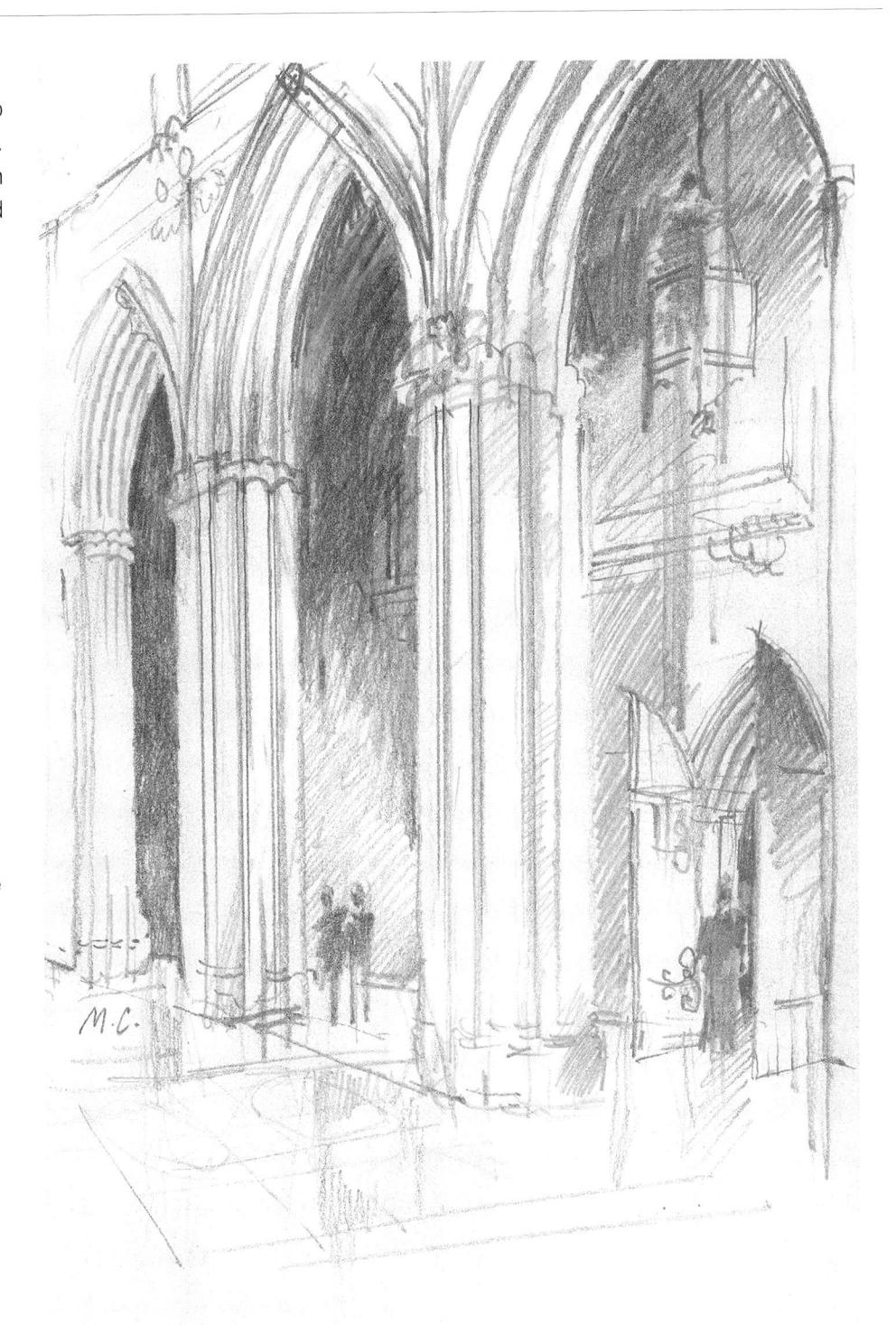

Once the arch is seen in perspective, its highest point is no longer in the centre. Using the same method of drawing diagonals, you will find it about a third of the way along.

Looking at the arches from an angle of about 45 degrees, each one is diminishing about one-third in size as they recede. Note how the lefthand rising side of the arch is a shallow curve seen against the much shorter and tighter curve on the right.

ESTABLISHING SPACE

Linear perspective is not the only way to establish space; you can also use your handling of line, tone and colour. Hard edges, dark tones and warm colours come forward in a painting, while soft edges, pale tones and cool colours

recede. As detail becomes less clear the viewer assumes it to be further away, equating it to what is less clearly visible in real life. Likewise, as we look towards a distant view we see aerial perspective causing pale tones of cool blue.

When we look at this block of vertical lines they all seem to be occupying a slightly different place in space. This is achieved by the strength of tone and line and the temperature of the colour.

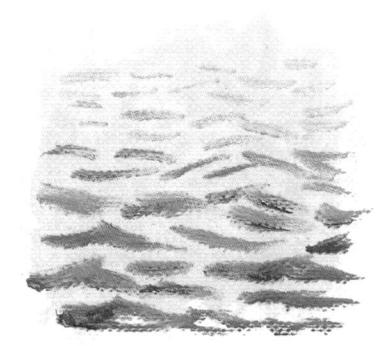

As this water was painted on midtone blue paper the overall tone has not altered. However, the foreground waves are defined with hard edges and dark tone. At the back they are just insignificant little dashes.

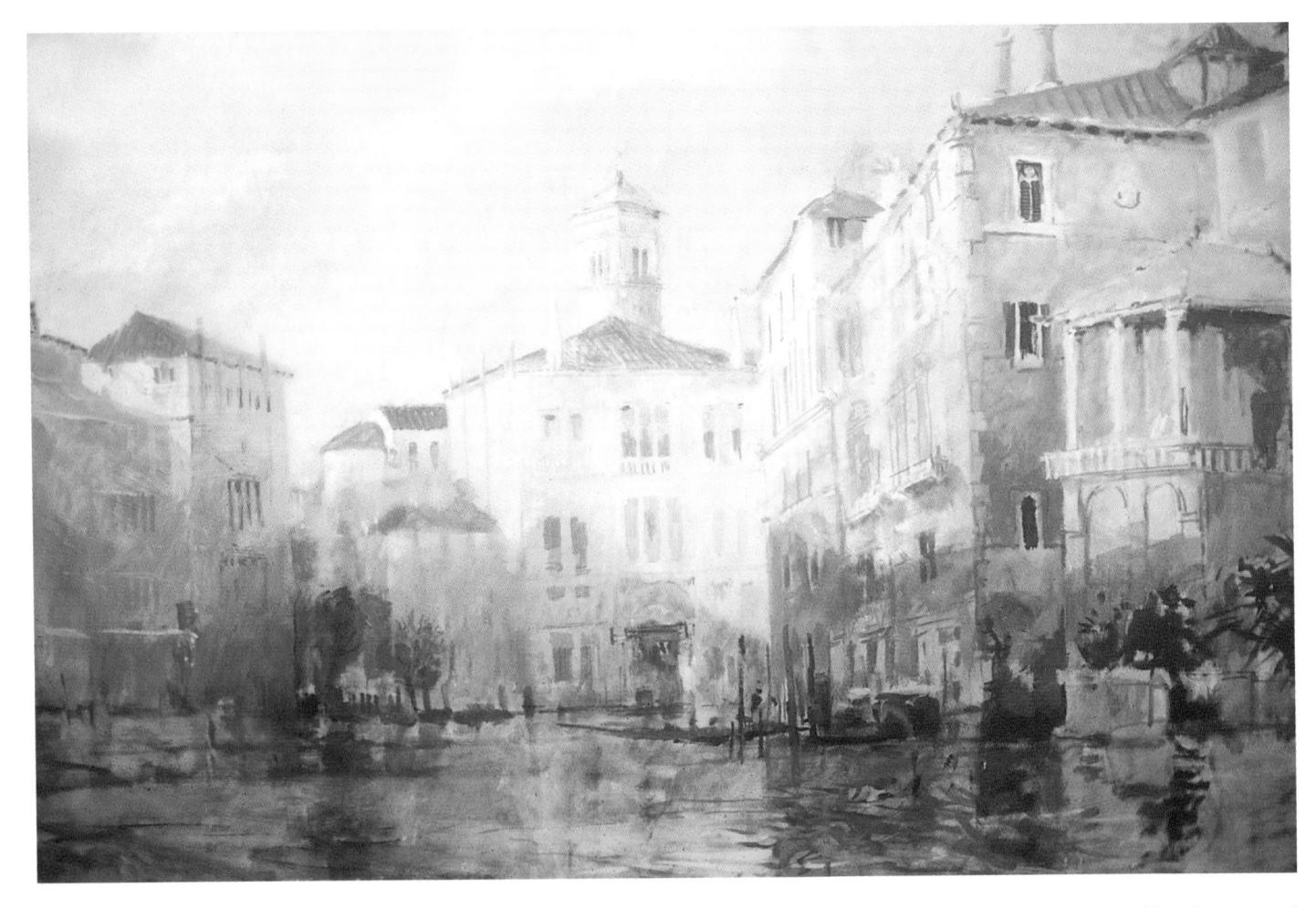

The Palazzo Balbi in Evening Light 101.5×152.5 cm $(40 \times 60$ in)

In this painting you can see the effects of using tone to create distance. The foreground is dark in tone, while the buildings in the middle distance are midtone and the Palazzo in the distance is lighter, even in the colour of the roof.

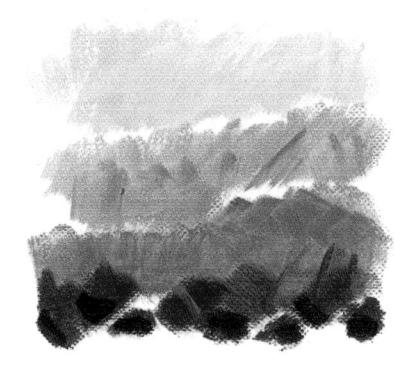

This series of stripes illustrates the phenomenon of aerial perspective. The eye reads that the pale-toned cool blue stripe is the furthest away.

In this detail taken from *View from a Window* by Pierre Bonnard, warm roofs are set against a cool blue distant landscape – a very simple device that gives a feeling of peace and light.

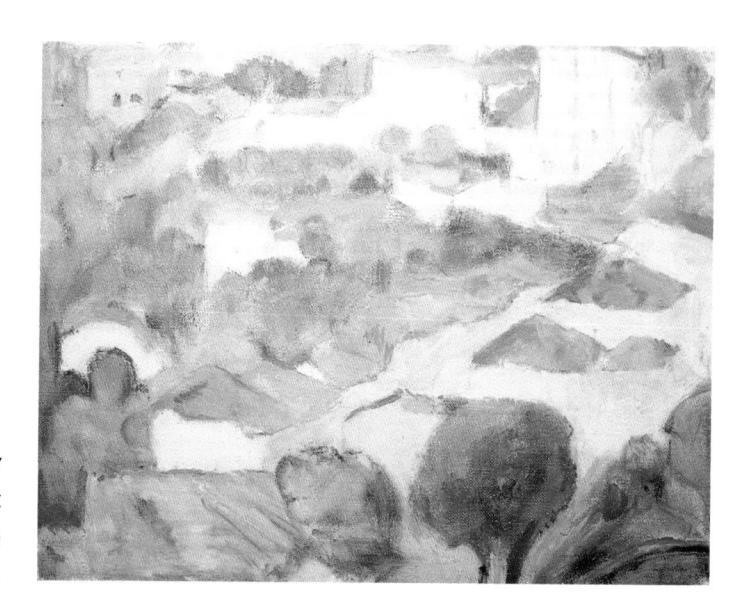

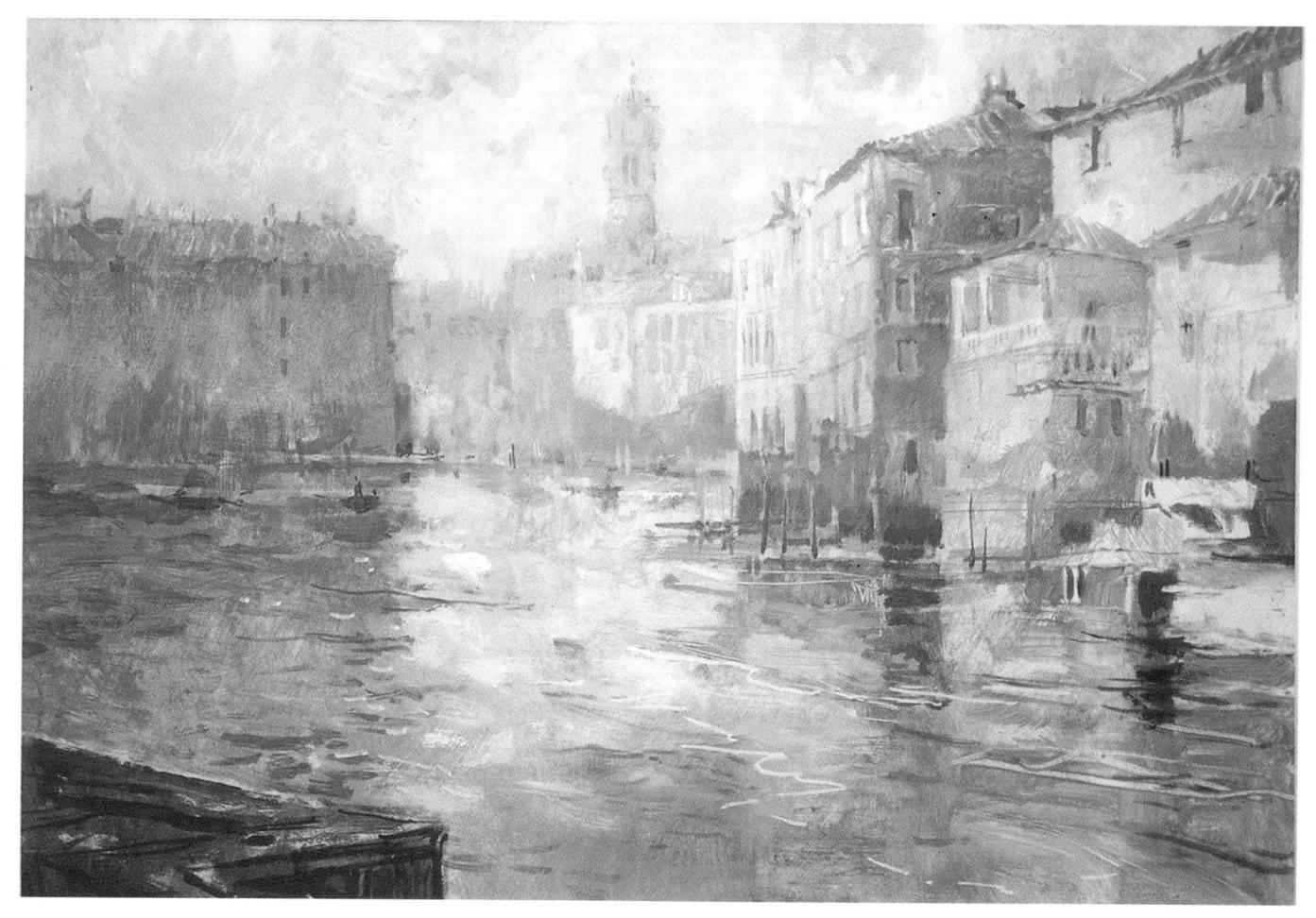

Palazzo Balbi, Afternoon Sun 30.5×51 cm $(12 \times 20 \text{ in})$

In this second view of the Palazzo Balbi in Venice, the dark jetty just in front of our feet brings the foreground even further forward.

AN URBAN LANDSCAPE

Novice painters tend to put in all the detail at an early stage of a painting and then find it difficult to change it if the work starts to go off track. This project shows you how to embark on a large, complicated painting by working from the

general to the specific, so that the structure of the painting is well established at the outset. Investigating your subject by laying in simple areas of colour and tone first makes the work far less daunting to tackle.

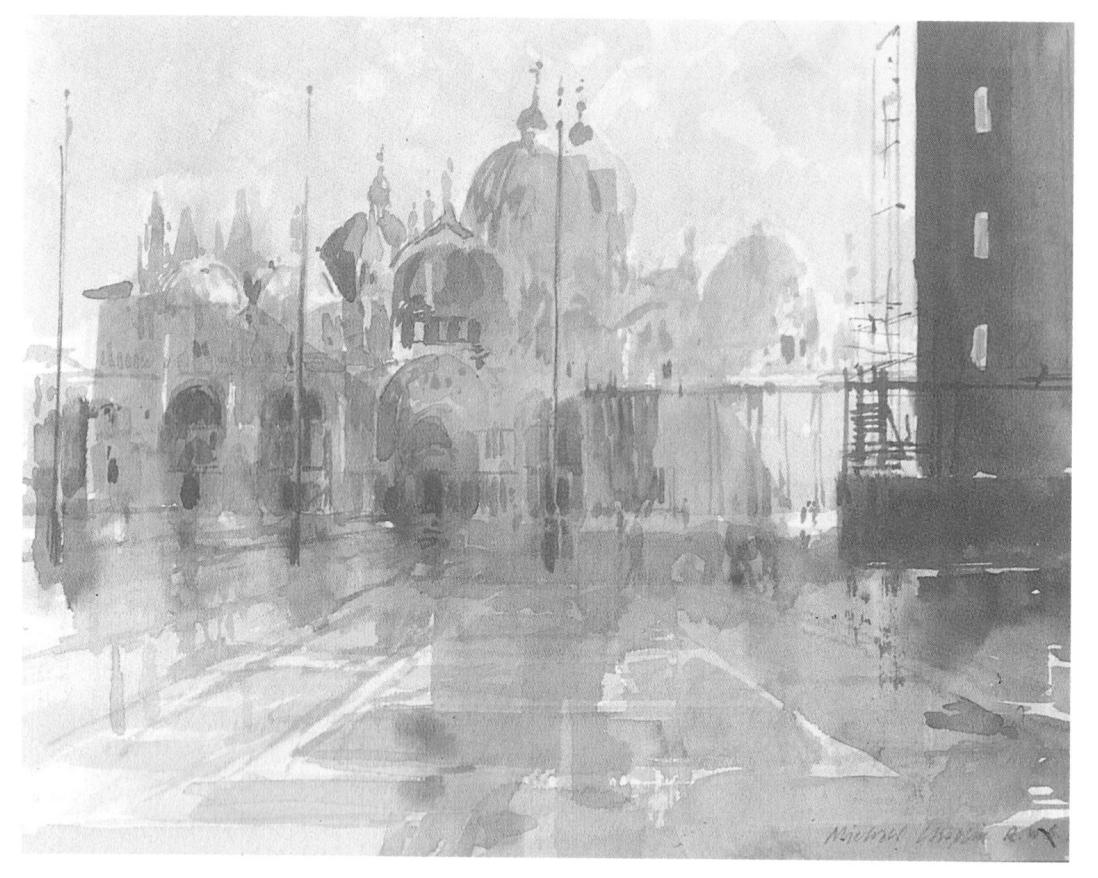

First of all I made a quick watercolour study of this well-known and much-painted view of the Basilica in Venice. My aim was just to get the feel of where the light was coming from and where the main areas of architecture were going to be in the composition. The vanishing point is almost halfway up the picture.

In this oil study I moved the horizon line down to divide the picture into thirds horizontally. I also changed my line of vision slightly to bring the whole of the campanile into the picture and included a little bar of the building on the right. This viewpoint divided the picture into thirds vertically – a classic compositional device.

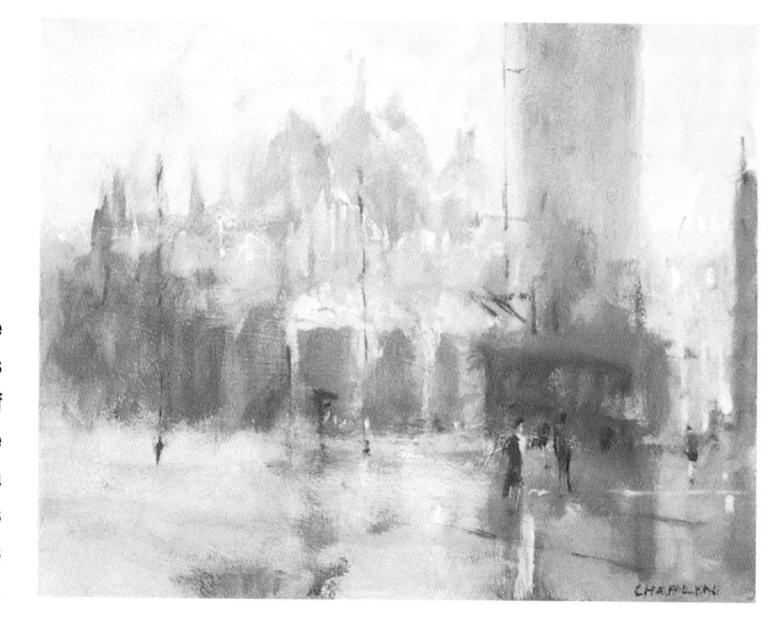

Having established the angle of light and the composition, I began work on the painting by laying in the first areas of tone. Putting in the darkest tone, in this case the building on the right, allowed me to make informed decisions about the level of the midtones. Some of the blue of the sky and the warm colours were to survive right through to completion of the painting.

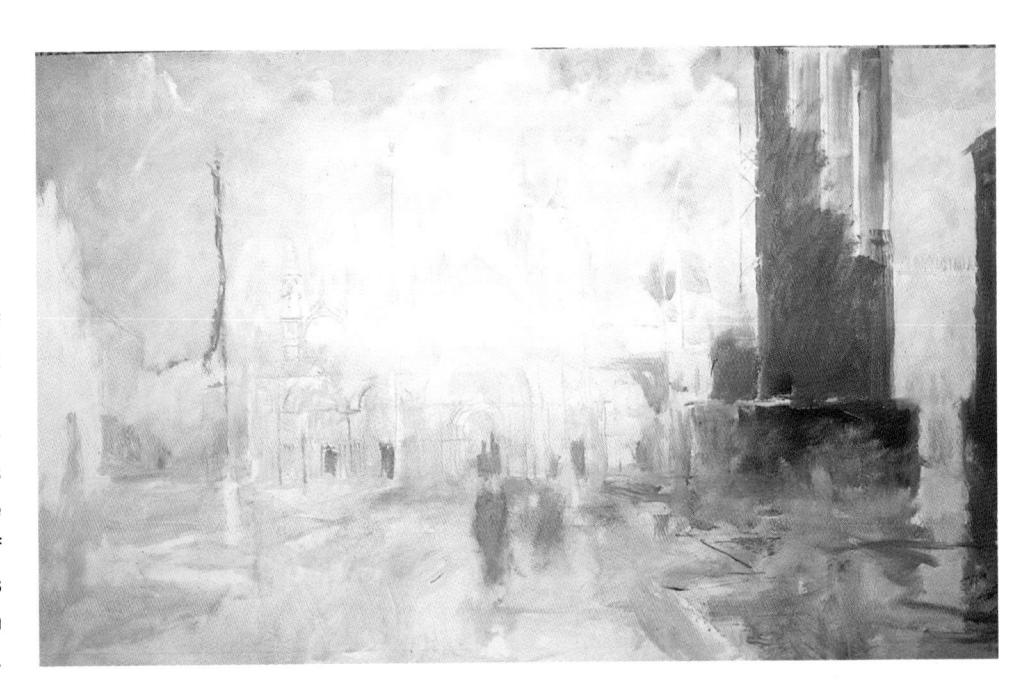

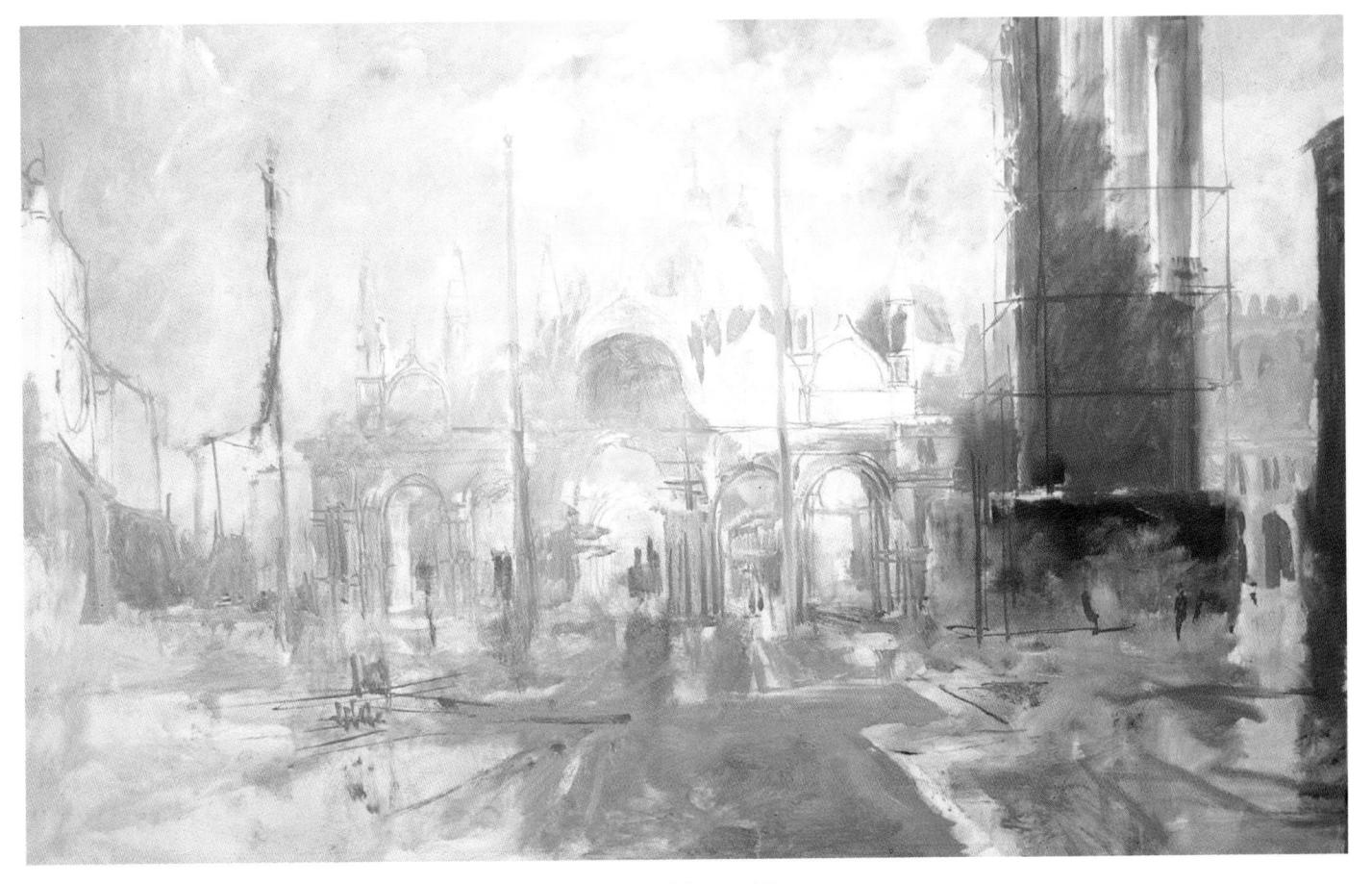

Once I was happy with the areas of darkest tone I began to build up midtone areas. I painted in shadowy areas of the Basilica and brushed warm colour into the foreground to give the feeling of recession from warm back to cool.

AN URBAN LANDSCAPE

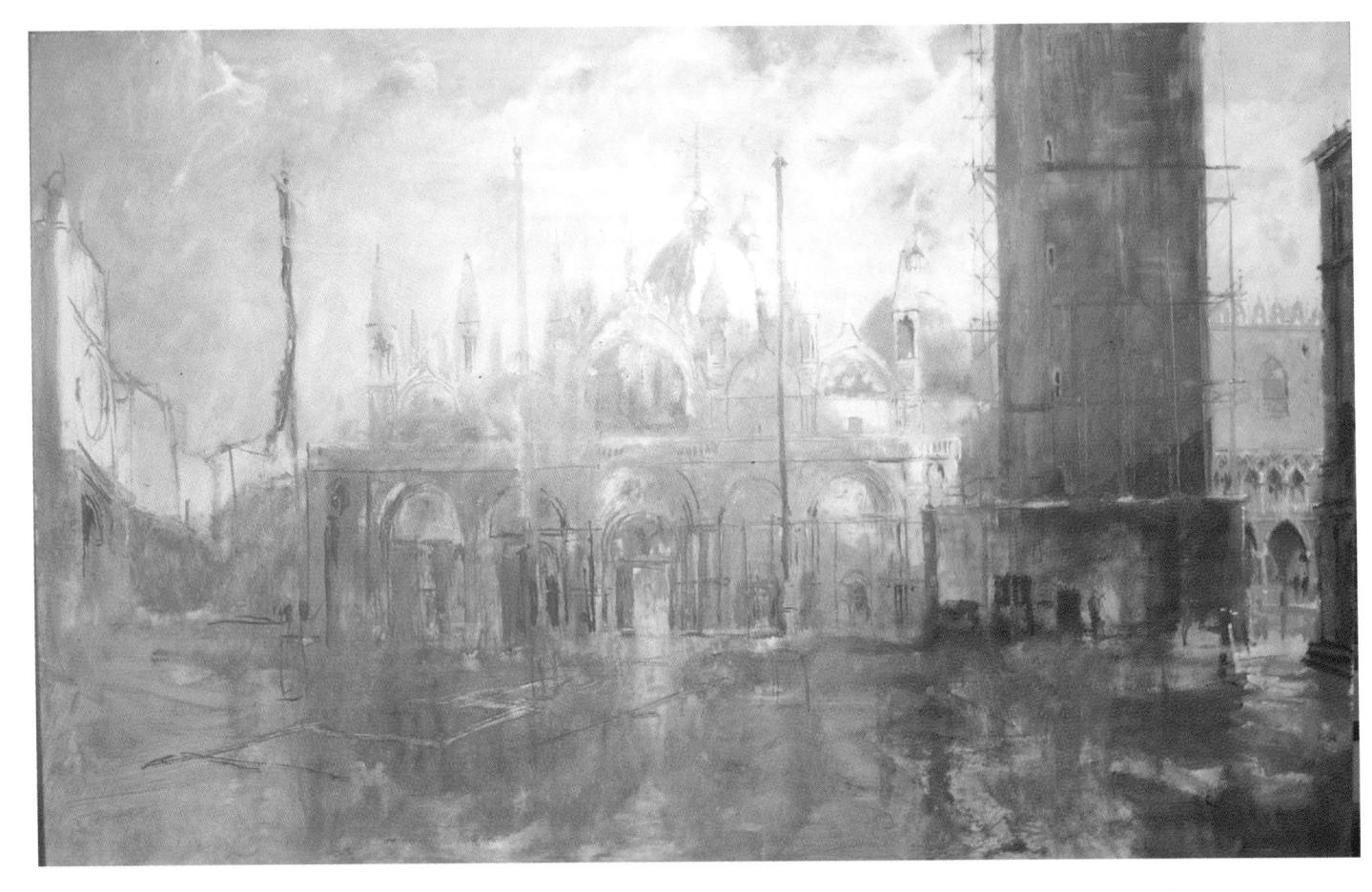

I began to accumulate some figures and firmed up the perspective in the foreground. I reworked over some of the transparent first washes to build up strong, solid colour, especially in the foreground. As I did so I identified the areas that were to be very tight and finished and those that were to remain loose and diffuse.

At the foot of the tower, figures are scurrying through into the shaft of light shining between the buildings. They are very sketchily laid in because they are only figures on the periphery of the scene and are not an important part of the painting.

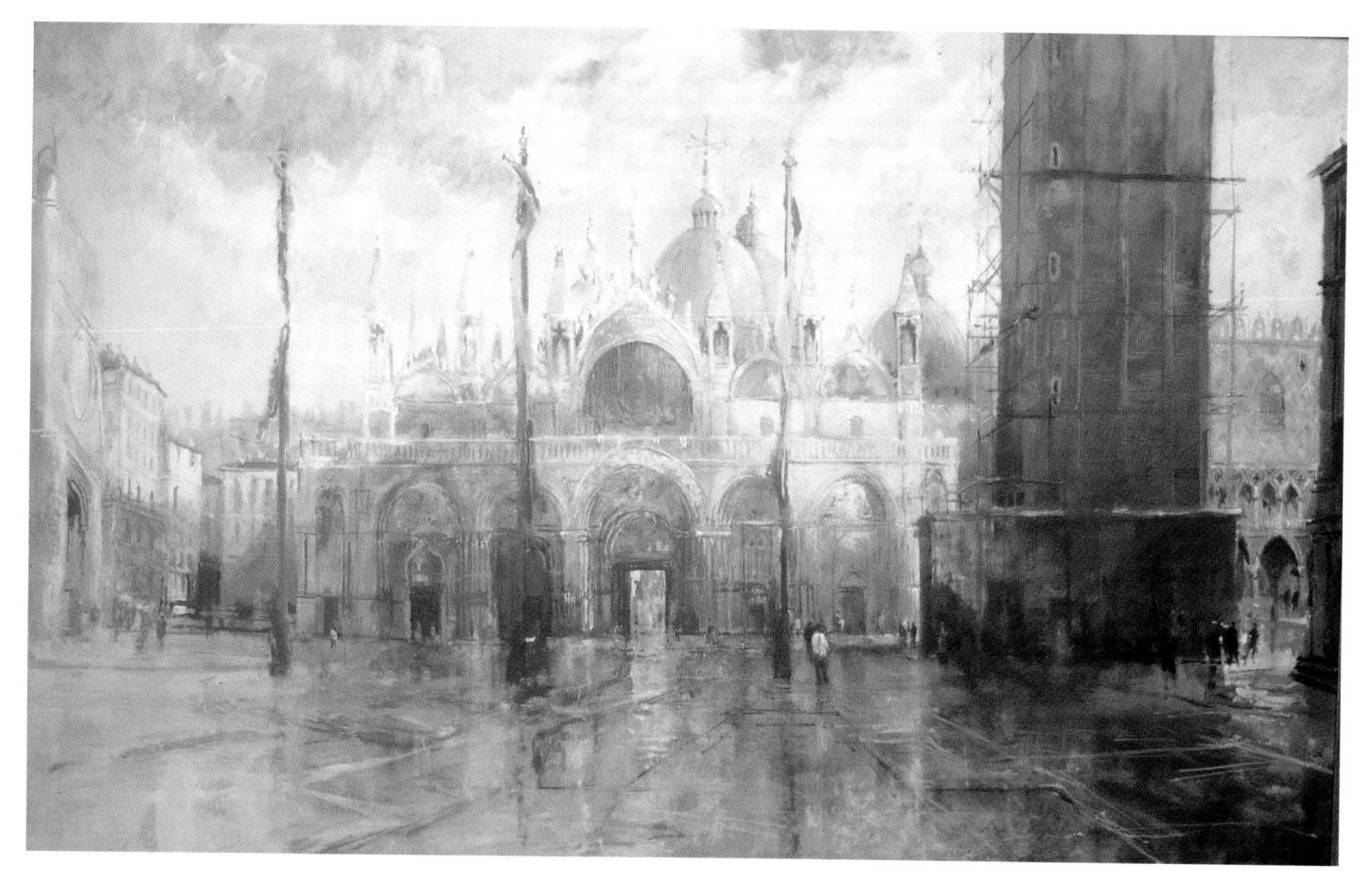

St Mark's Square, Venice 38 × 42 cm (15 × 21 in)

I finished the painting by putting in all the architectural detail and defining the flagpoles. I adjusted some of the darks to make them lighter and vice versa, particularly in the foreground, where I put in opaque white to make it less heavy.

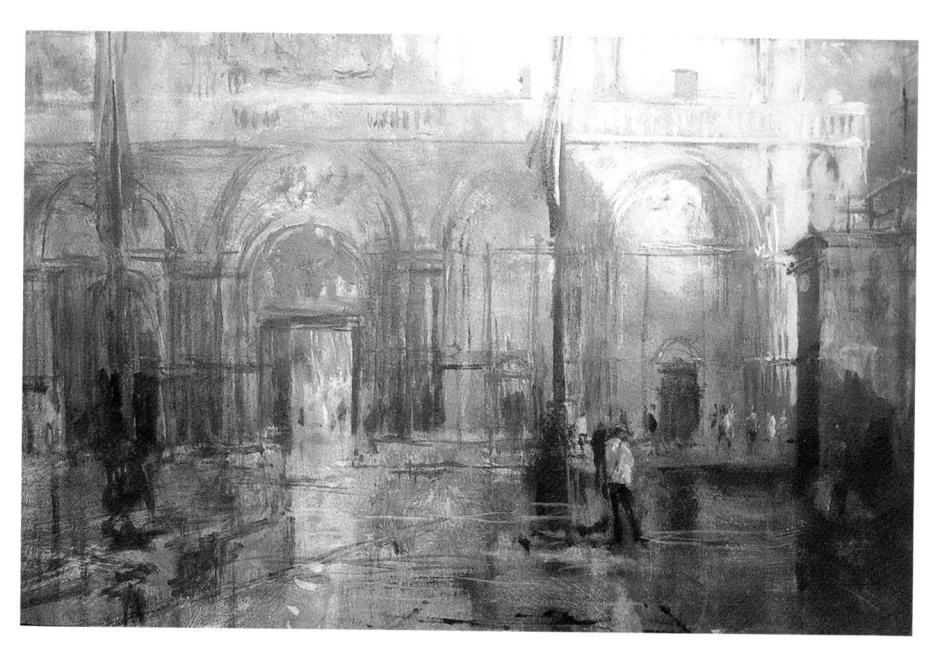

These figures are painted in enough detail for them to be identifiable as tourists, one carrying a camera with visible strap round his neck. This high degree of detail is set against the sumptuous texture of the light as it floods out of the Basilica door and is reflected in the wet foreground. The whole painting is about balancing hard and soft edges, high detail and soft recessive areas.

STILL LIFE

A still life can be as simple or as complex as you choose to make it, and the objects it is composed of can come from nature, industry or your own domestic life. Some of the most delightful still lifes are just a simple arrangement of food, either on a table prepared for a meal or in the kitchen waiting to be cooked; fruit and vegetables provide a range of surfaces and colours for you to explore. With still life you have complete control over the objects and how they are placed, and if you want to do a floral study you can make it one of an ornate vase carrying lush, complex blooms or just a couple of daisies in a plain little jug.

This is an exploratory sketch of a little vase of flowers, placed centrally but with darker and stronger tones and colours on the left to make a more interesting diagonal composition. The drawing was done with a biro, which is a quick and friendly medium for sketching. I then brushed on some colour to see how things were placed.

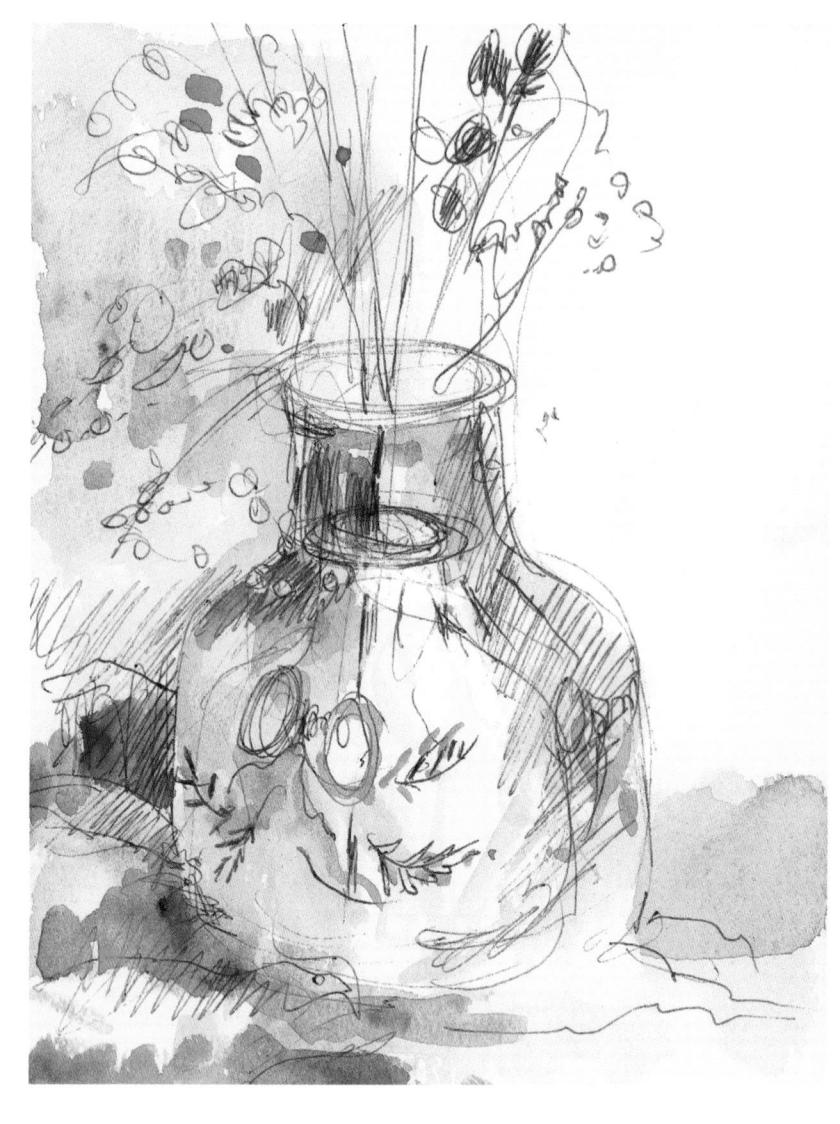

The overall shape the vase makes is a rectangular composition, but I decided to go for one that more closely approaches a square. I started with loose washes of colour that mainly established the edges present within the painting.

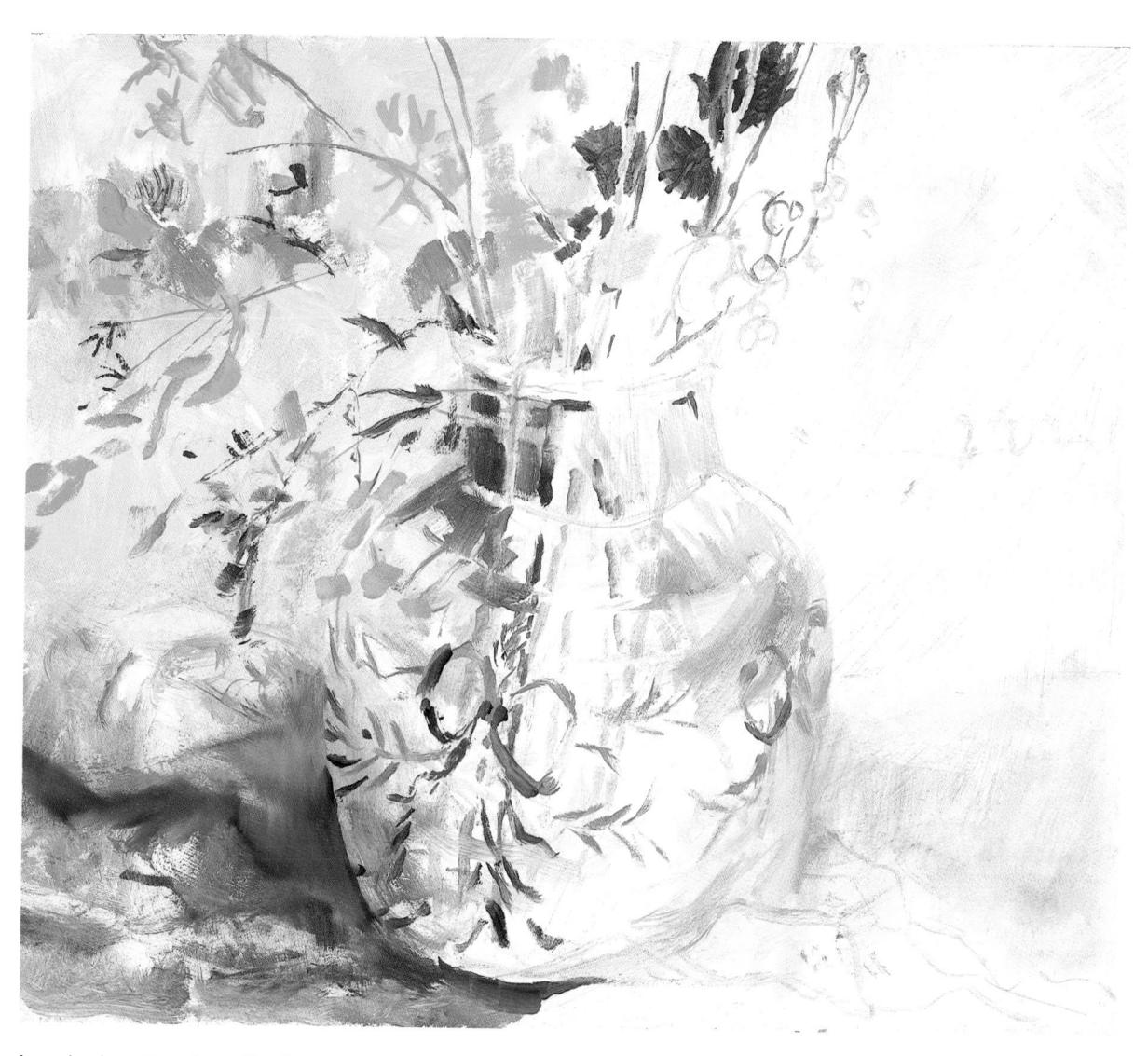

I worked up the strength of the colour throughout and increased the drawing. Only a loose and impressionistic painting, this still life could be worked up still further or left as it is in the form of a less finished picture.

The lights have been worked up to make the glass look transparent, while the blue on the left becomes a reduced tone.

The rim of the vase shows what an extreme tonal range you can encounter even in something as clear as glass.

FIGURES

Figures give scale and narrative to a scene and you will often want to include them in your pictures. Unless they are playing a major role you need to show very little detail; as long as you can sketch a recognizable posture the viewer's imagination will do the rest for you. Stand in front of a mirror and watch how any movement you make with one part of your body will cause an opposite reaction in another.

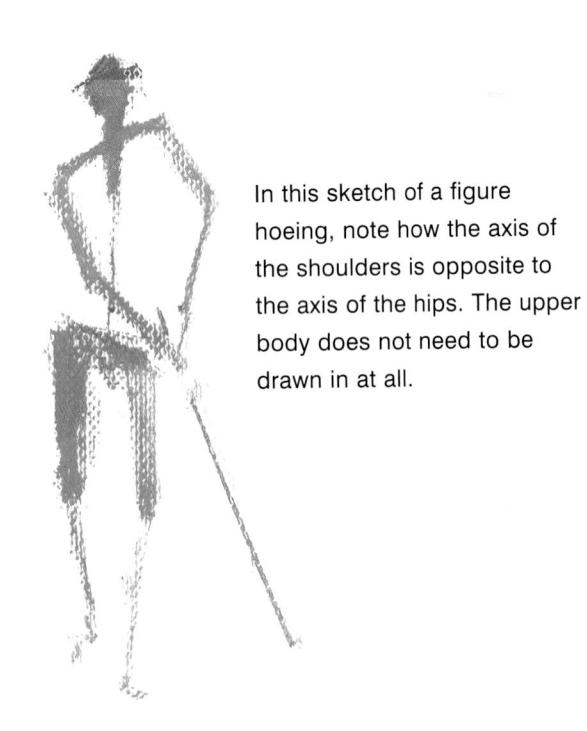

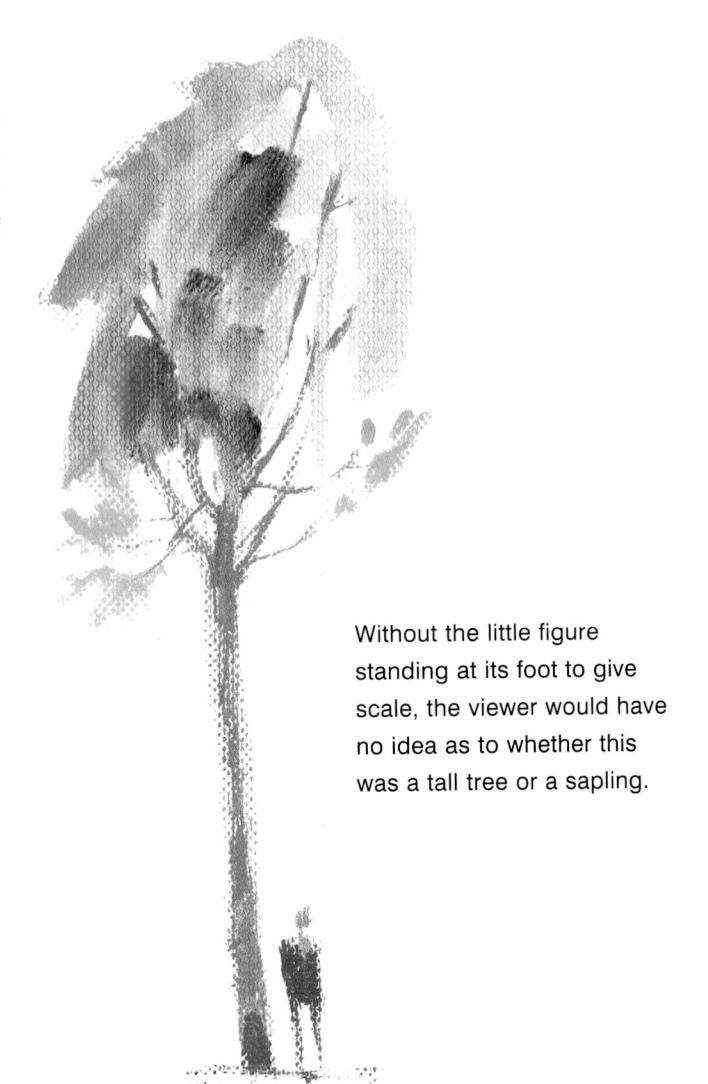

I drew these marathon runners without taking my pen off the paper, keeping it constantly moving. This continuous line drawing does not try to capture any detail, only the essence of figures running.

EXTERIOR AND INTERIOR FIGURES

Your figures may be populating a large urban space in an impersonal fashion or perhaps occupying an intimate corner of a restaurant or café. Keep your sketchbook

constantly with you and make notes of the narratives you can glean from people's interreaction.

Make sure that figures standing in groups make an interesting shape as a single entity. Look for small figures seen beyond large ones to give variety of size and strength of tone.

In this intimate café scene the light is coming from behind the figure in the red dress and catching on the shoulder of the figure with its back to us. The profusion of plants adds vigour to the painting.

FIGURES

LIFE DRAWING

If you feel you would like to embark on more stringent drawing of the human form, sign up for a local life drawing class. Life drawing has always been the acknowledged way of training an artist's eye, brain and hand and as a means of learning how to subtly model with line, tone and colour it cannot be beaten.

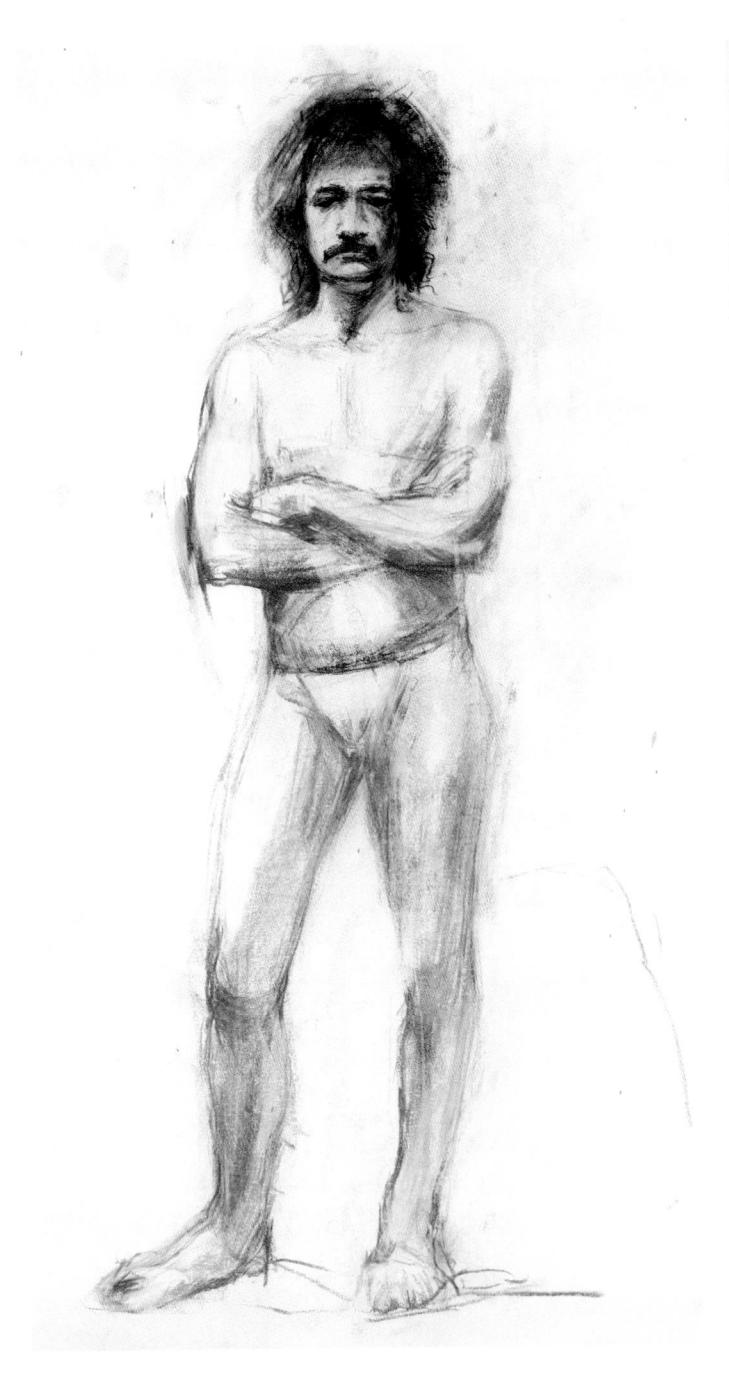

This detailed drawing by Gaynor Lloyd is concerned with establishing the form of the figure. Note the subtle relationship between the angle of the hips and shoulders and how the weight is thrown on one leg.

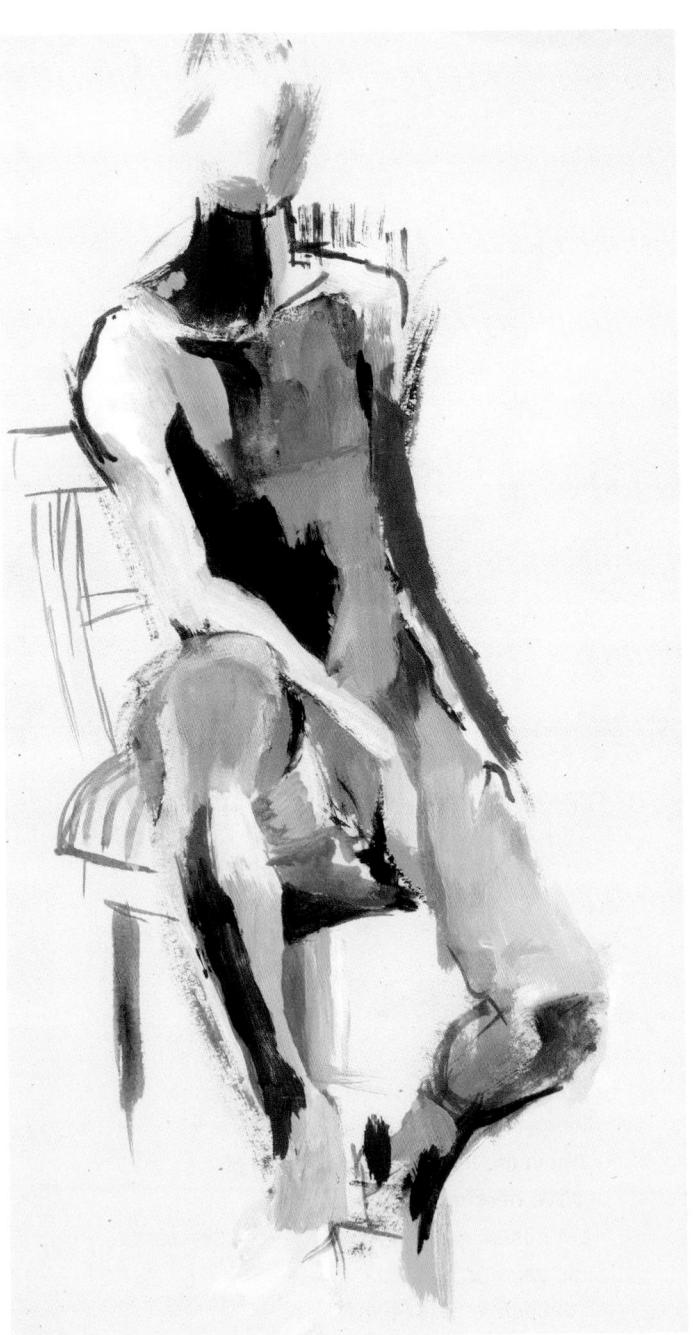

Here Gaynor Lloyd's drawing examines where the main areas of tone lie but handles them in a loose way. They hint at very strong light sources coming in from several angles to describe extremely complex forms.

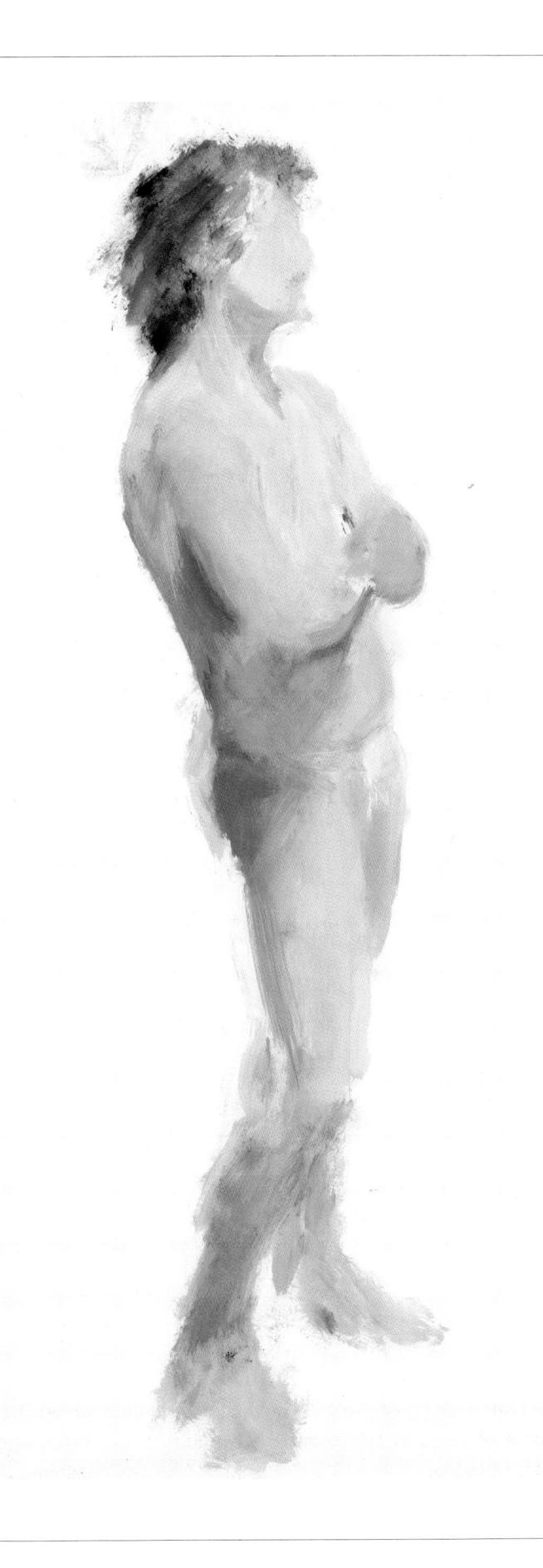

Again the tonal areas have been examined but this time the artist has used colour. Note the subtle recession in the thrust-forward leg created by the blues changing from warm to cool as the shin tilts back.

A BEACH LANDSCAPE

The seaside is an ideal place to sketch people at rest and at play and to set them in the context of a landscape. If you take oil paints to the beach, you will need to make sure that you keep them clear of sand or you risk ruined tubes of paint. Watercolour sketches that can be translated to oils back in the studio are a better choice if you will be working near people kicking up dry sand.

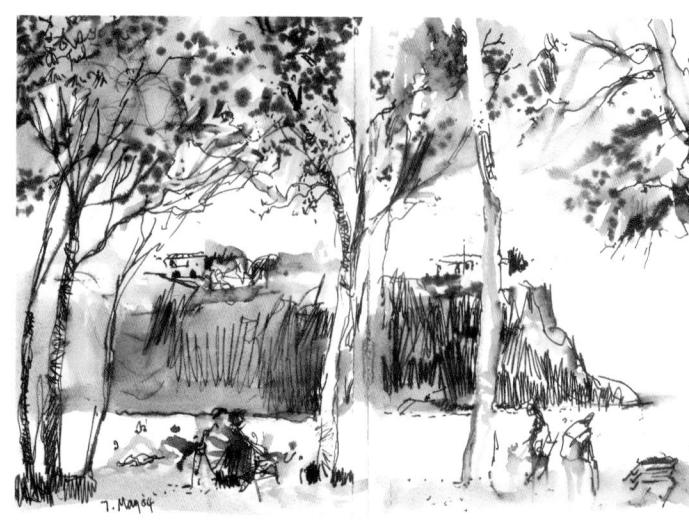

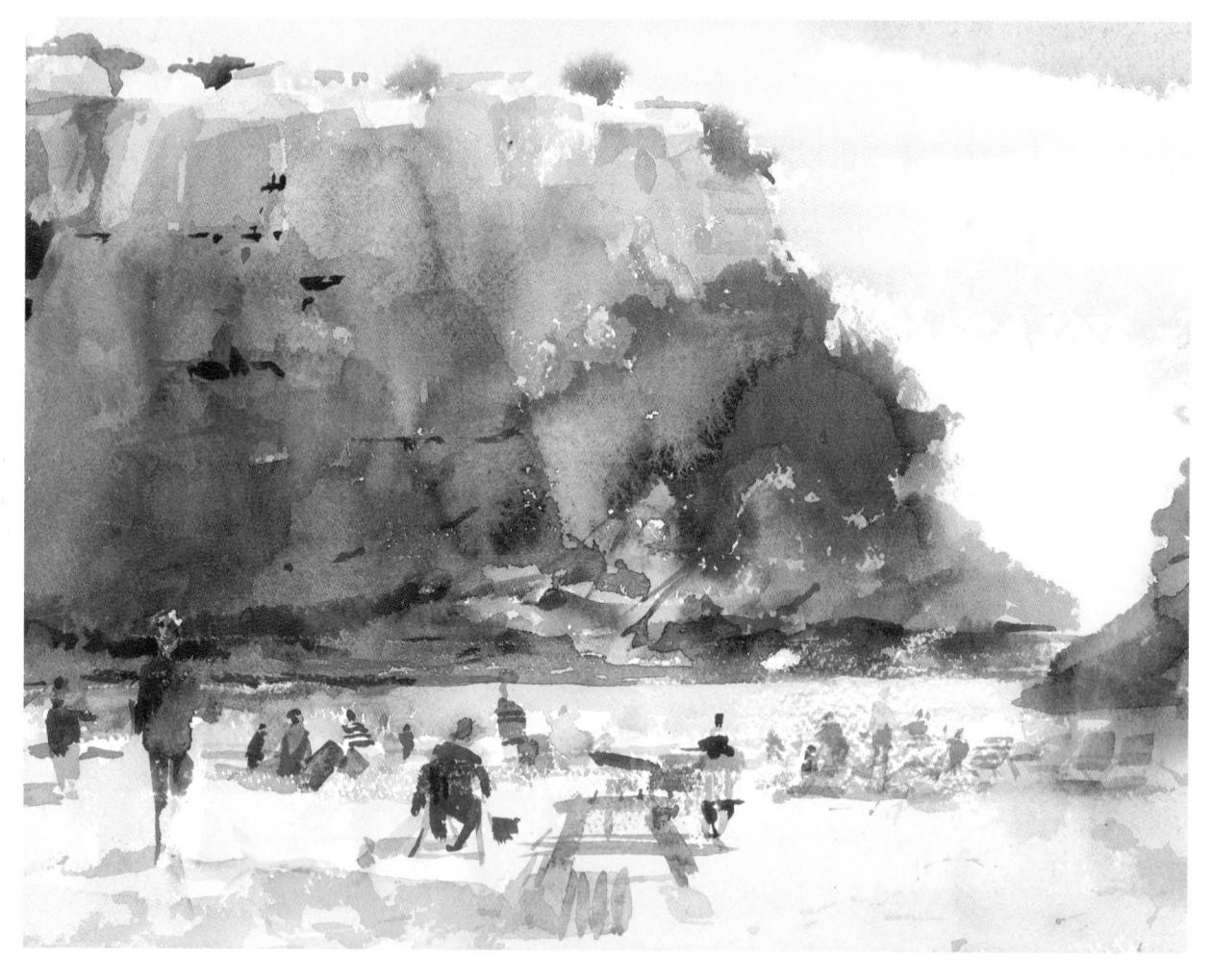

To try out some colour ideas I used watercolour pigments for speed. The light on the sea was achieved by reserving white paper, a necessary technique with watercolour but one I thought I might also use with oils later.

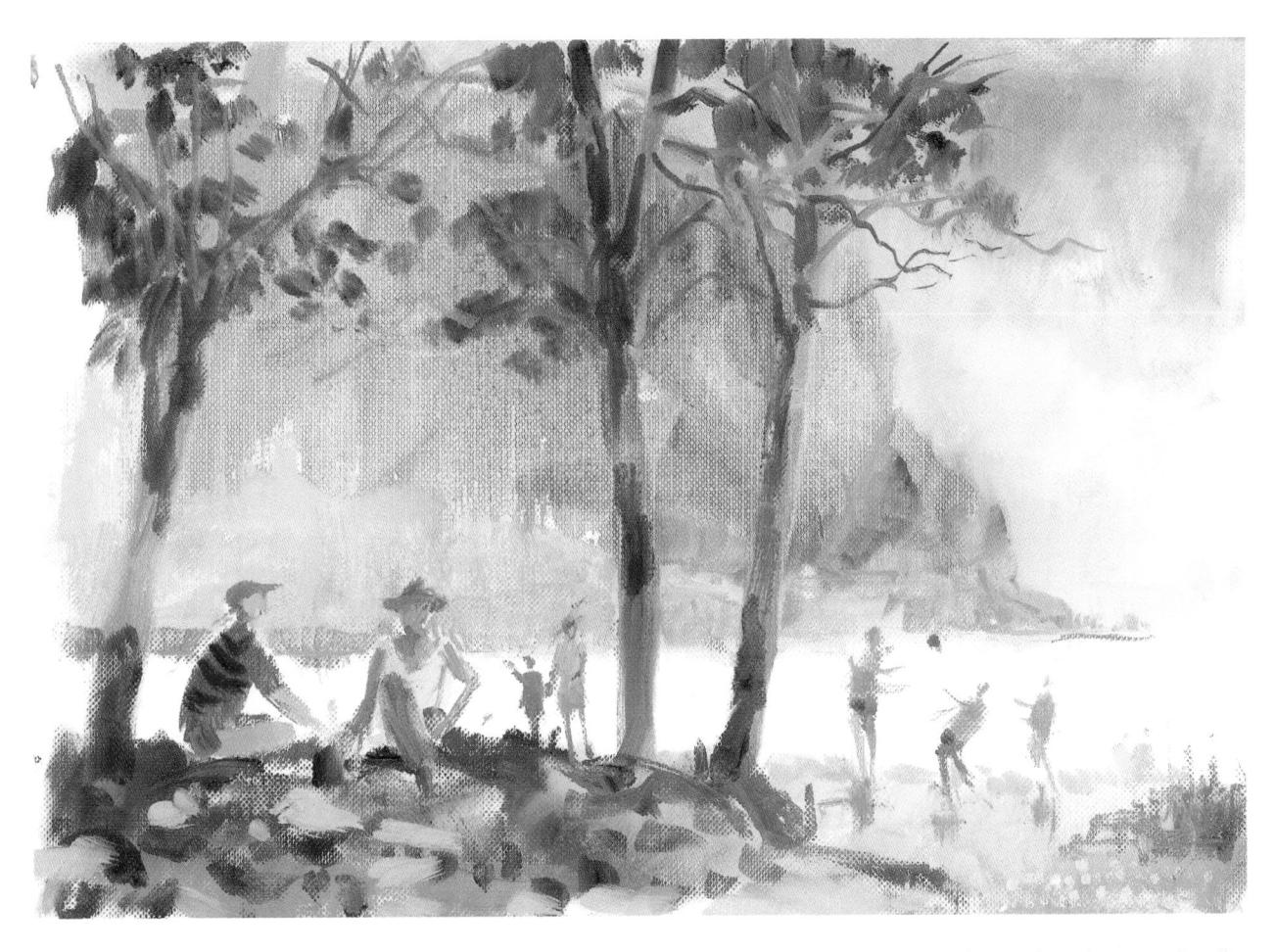

I liked the exuberance of the colour, so back in the studio I decided to paint my beach scene in oils.

The relaxed figures having a picnic are in strong contrast to the smaller but more vigorous figures seen in the distance. In the background, the colours change from warm to cool as they traverse from left to right. This is echoed in the figures by using predominantly warm colour in the picnickers and much cooler blues and even grey skin tones in the background figures. The trees act as a framing device, bringing the seated figures further into the foreground.

The handling of the trees is done with the same vigour as that of the figures, in keeping with the feel of the scene.

The figures with the ball are sketched in very lightly, allowing the viewer to gather information just from their postures.

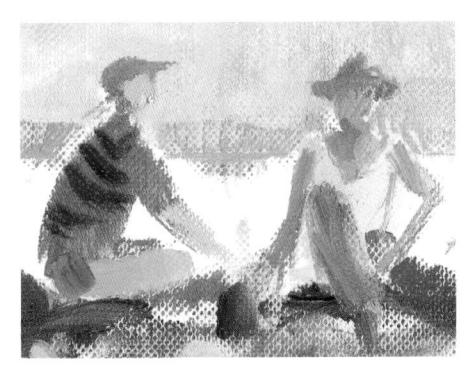

The seated figures are much more closely observed; note the subtle changes of colour on the woman's arms.

LIGHT AND WEATHER

As artists, we can derive a lot of visual stimulation from what nature throws at us. Howling autumn winds and lashing rain give the chance to capture the movement of stormtossed trees and exciting reflections, so don't feel that if the weather is bad there is no aesthetic point to going out. Misty mornings and hazy sunsets offer a different challenge in the handling of diffuse effects, while bright sunshine calls for vibrant colour.

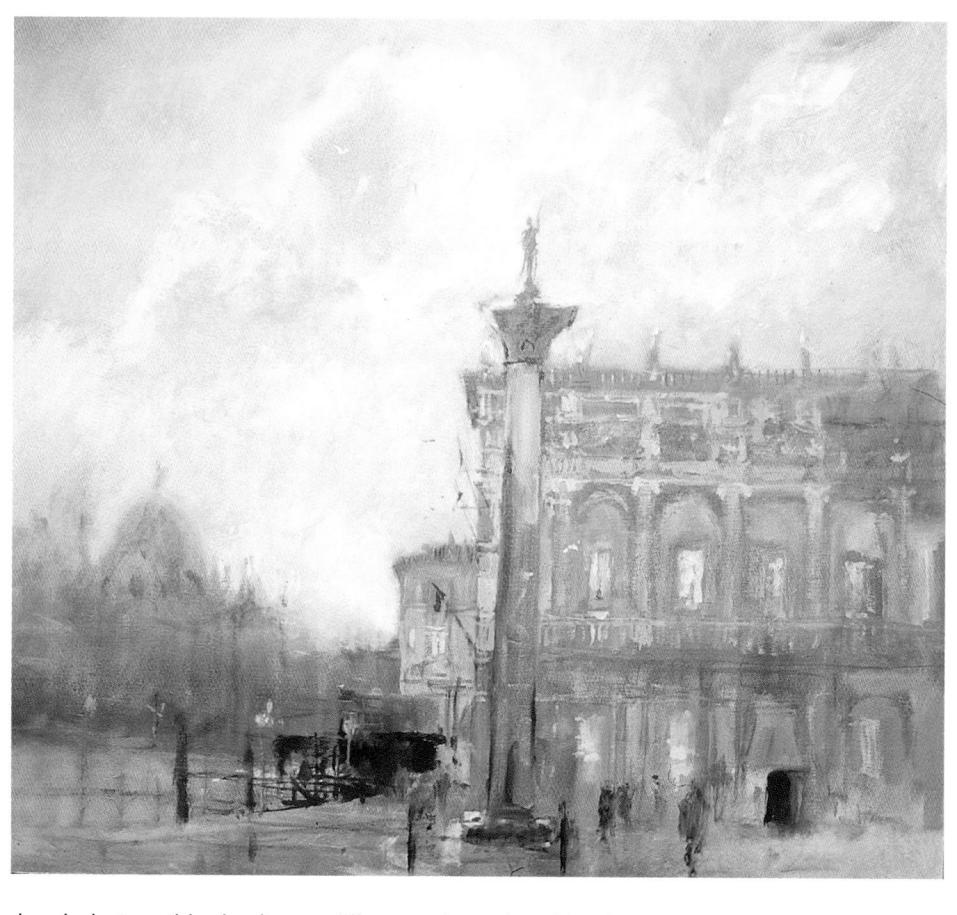

St Theodore Atop His Arch, St Mark's Square 35.5 × 46 cm (14 × 18 in)

The light in Venice can be very harsh, but on this day it was diffuse and pearly, with a lot of reflected light coming from the water. The emphasis of that softness is heightened by the hard lines in the foreground and the stark colour on the overhang of the building.

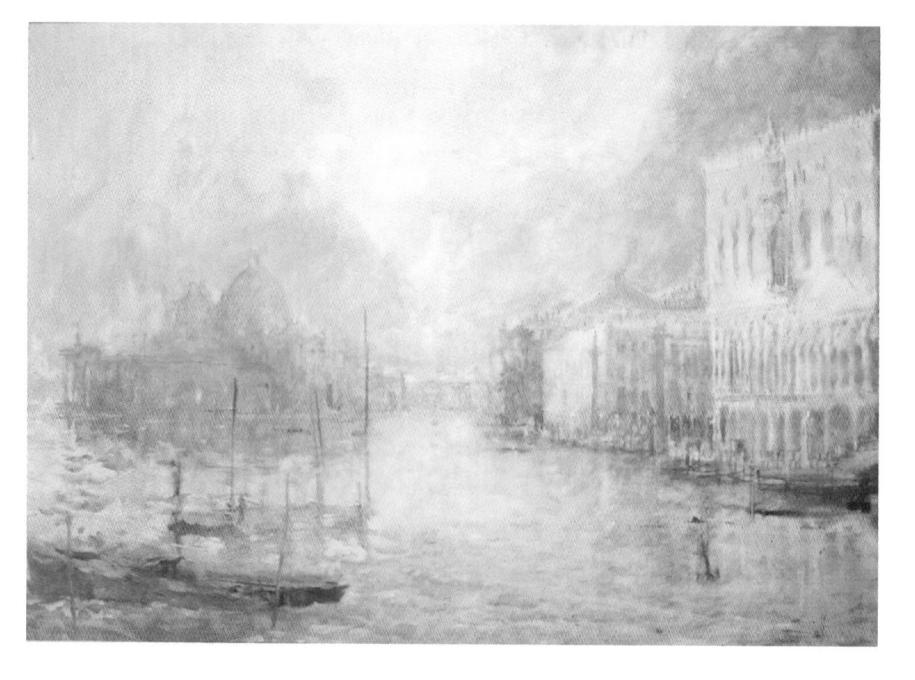

Looking West up the Grand Canal 76×117 cm $(30 \times 46$ cm)

The approach to the atmospherics in this picture is similar to that above but the colour is much more close-toned and muted, giving a more gentle, restful feel. There is very little middle distance in the painting and the stimulus comes from reading it sideways from one tone and colour to the next rather than looking at very obvious recession.

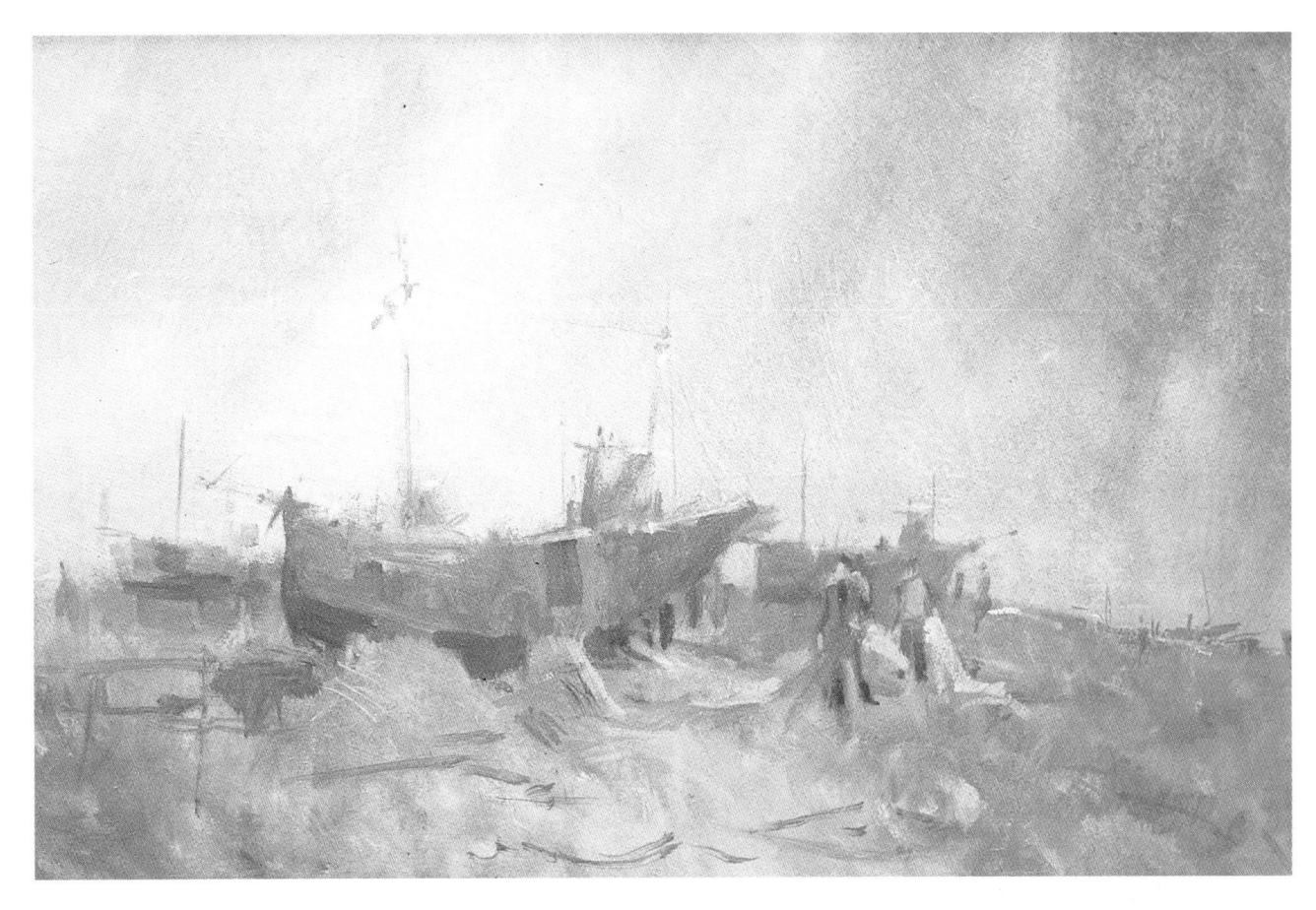

Drying Out the Nets 30.5×41 cm $(12 \times 16 \text{ in})$

After a hard day working at sea the fishermen have pulled up their boat on the shingled beach and are drying their nets while a storm threatens from the east. Storms provide tonal drama and a sense of movement in the sky.

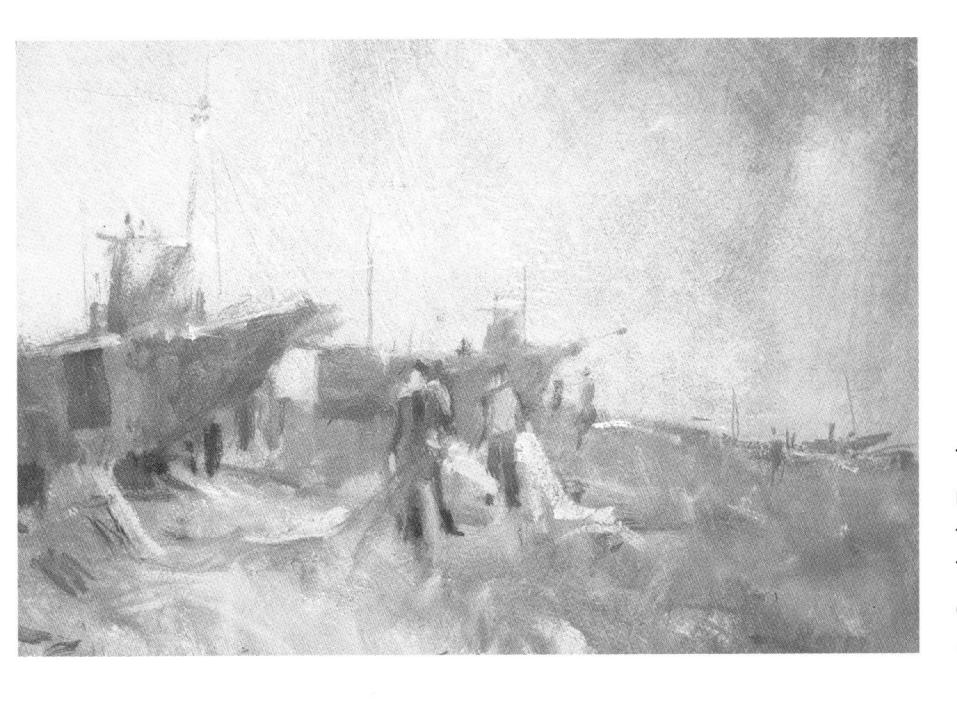

The stormy marks in the sky were rubbed out with a rag to make them very soft and recessive.

They direct the eye to the high drama of the dark figure and the light catching the wet nets.

THE SEASONS

The changing seasons call for different handling of colour and light and for different equipment on outings too. A hat and an umbrella to shield your eyes from glare on hot sunny days is essential, while in winter you will benefit from a handwarmer if you are attempting anything more than the quickest sketch.

Spring Growth in Syracuse
35.5 × 38 cm (14 × 15 in)
The fresh colours of spring in a square in Syracuse are captured by the pastel shades of the stuccoed café and by Chrome Green used almost straight from the tube.

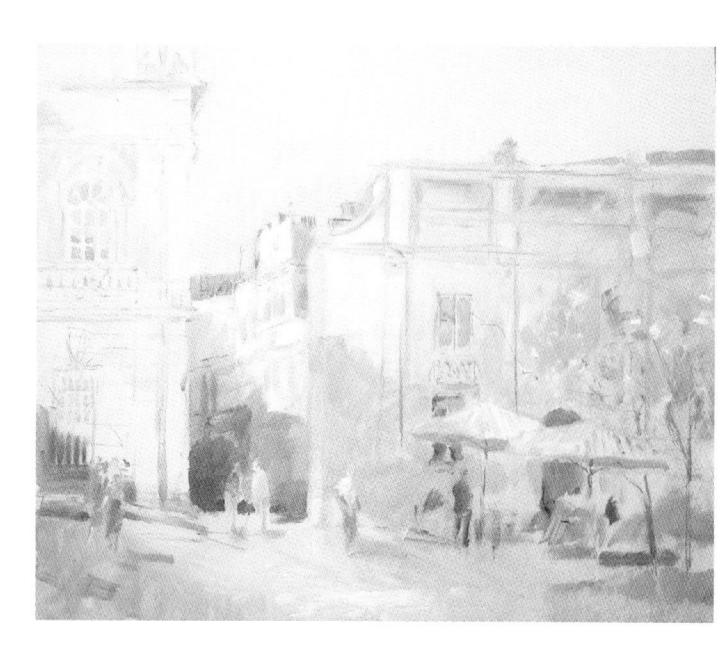

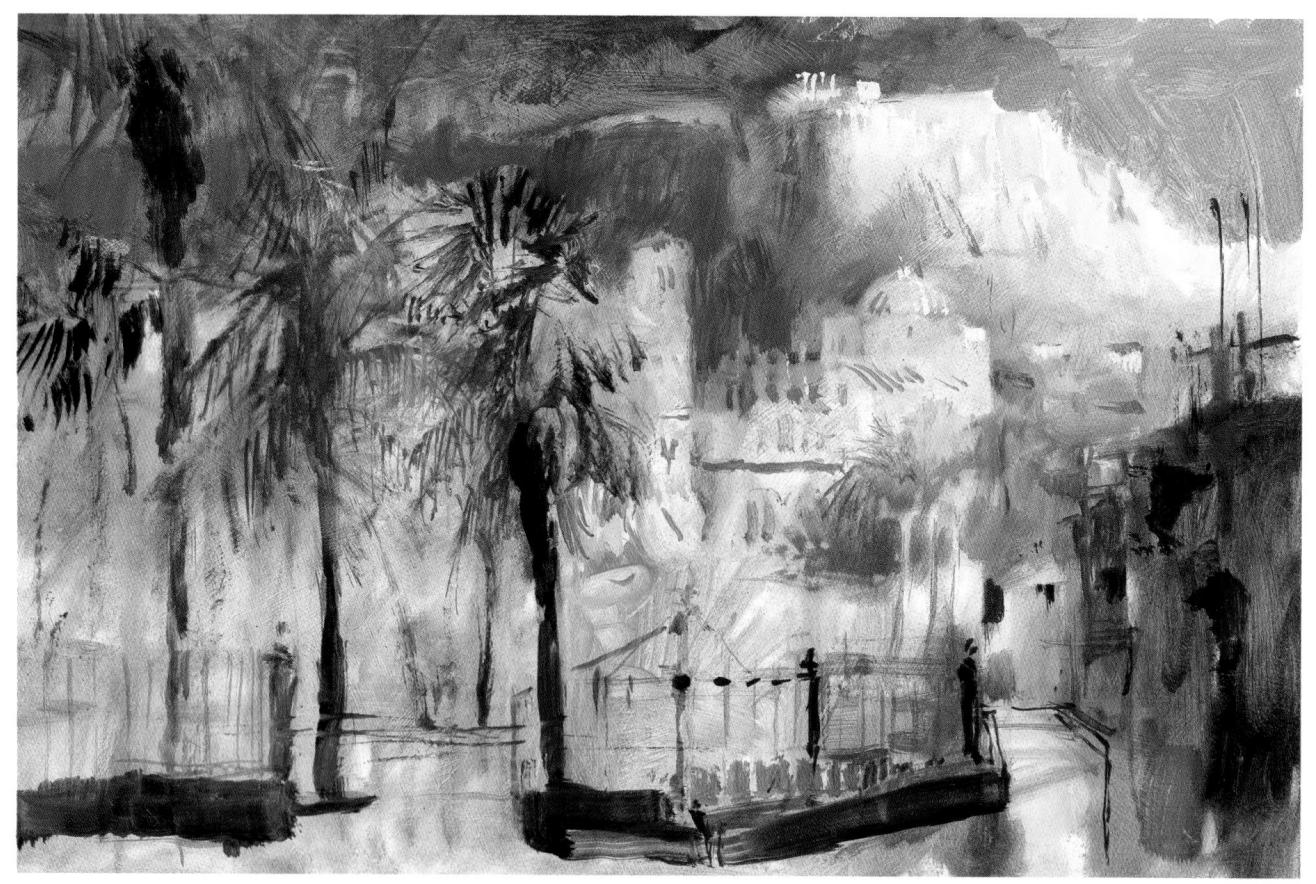

The Acropolis, Early Morning 25.5 \times 35.5 cm (10 \times 14 in) The glowing light of the rising summer sun can present dramatic compositions. Here the brightly lit face of the Acropolis disappears into purply shadows in flat tones that contrast with the textural busyness of the palm trees.

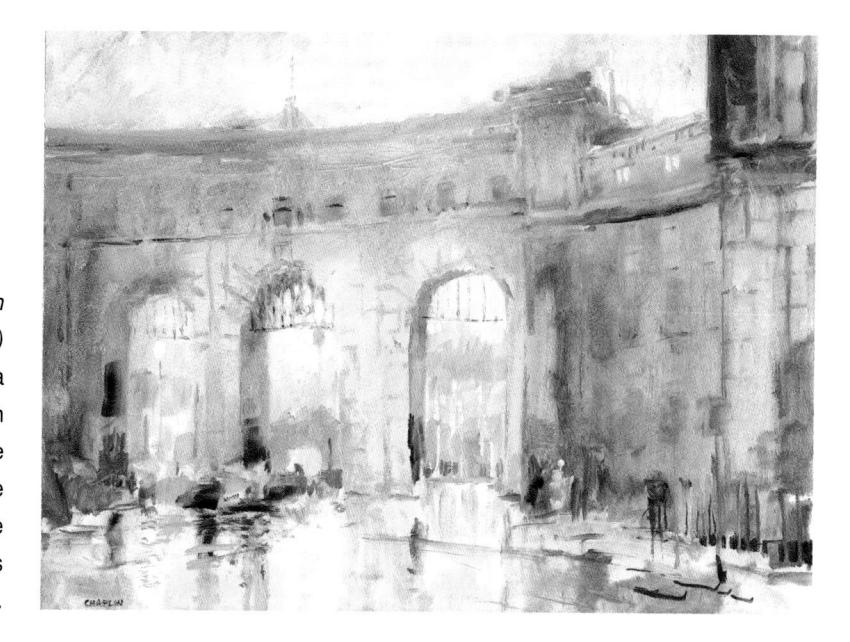

Admiralty Arch in the Rain, London 35.5 × 45 cm (14 × 18 in)
The Admiralty Arch seen at twilight on a rainy day conjures up the atmosphere of an autumnal city. Rain always presents the most interesting foregrounds and the little colour notes in the reflections bring the vertical composition right down to meet us at the bottom of the painting.

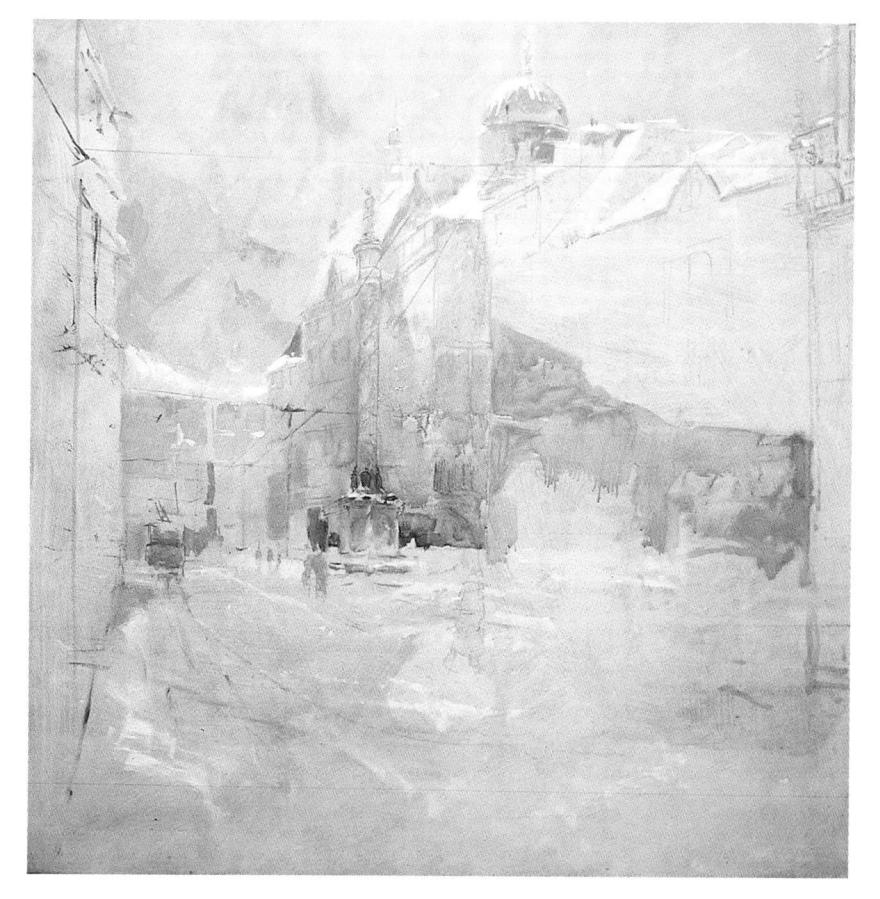

Trams in the Snow, Switzerland 122 \times 122 cm (48 \times 48 in) For this chilly Swiss scene I added a slight blue tint to the primer to enhance the coldness of the snow against the warmer colour of the sky.

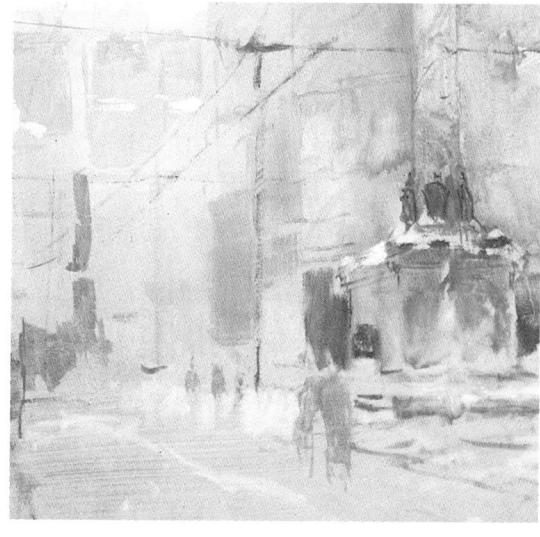

Much of the colour in the painting was provided by the cool blue underpainting. The figures, though barely described, speak of people huddled up against the cold and struggling to keep their footing.

USING PHOTOGRAPHS

Taking photographs is a good way of recording information, but you should never copy directly from them and you will tend to do this if you have them next to you. If you are using one for detail, put it at the far end of the studio so that you have to walk over to see it. Take little bits of information and make them your own as you walk back so that your painting

will be an interpretation rather than a copy. Pin up photographs taken for tone and colour at a distance where you can see just big slabs of tone and high points of colour.

Use your camera with a specific purpose. One day might be devoted to photographing linear subjects, for example. Look at the range of subjects shown here.

Looking for linear subjects, I was pleased to find these shadows from a pergola making soft, curved lines across a seat and hard geometric lines on the path.

This photograph is all about colour, with the reflection of a red boat among floating mussel shells in the water outside a café in Minorca.

I took this photograph through the wing of a swan. I was looking for subtlety of design in nature and found an image about soft texture too.

Using a photograph or a postcard, you can trace off an area to reduce a complex scene to simple tones. Put two sheets of tracing paper over it to cut out the midtones. Tracing off the dark areas will help you to decide how to lay your first washes of light and dark tones.

I laid a white strip across this colourful photograph to see how dark the tones were. The sea and sky are often thought to be much lighter than they really are.

LOOKING FOR RHYTHMS

Looking for rhythms in your subject and translating them to your painting can bring unity to your compositions and can also arouse an emotional response in the viewer. Rhythms arise through the repetition of certain elements, the

echoing shapes of objects or the spaces between them, and the recurrence of line, colour and tone in balance with each other. Employing an overall directional movement is another way to give rhythm to your work.

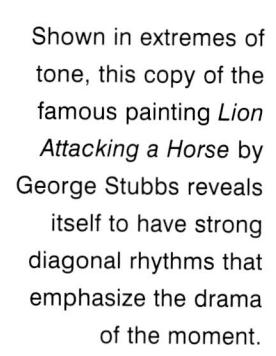

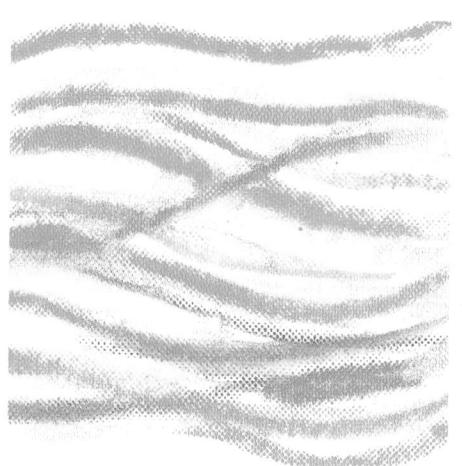

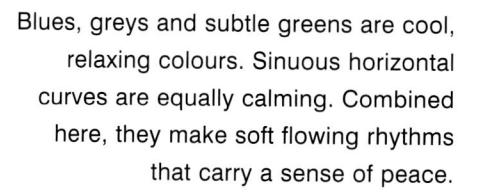

Zigzag, staccato lines express agitation and restlessness. When they are drawn in hot reds and high tones of other warm colours, the rhythms become increasingly jarring and anxious.

MANMADE SHAPES

There is often the temptation to think that the natural world must offer the most beautiful subject matter, but as artists we look at texture, light, line and colour and these can be equally interesting on an old rusting piece of machinery or a modernistic building rising above a cramped and noisy street. Including manmade objects in your painting inevitably adds a touch of interesting narrative, for even if figures cannot be seen we know they have been present.

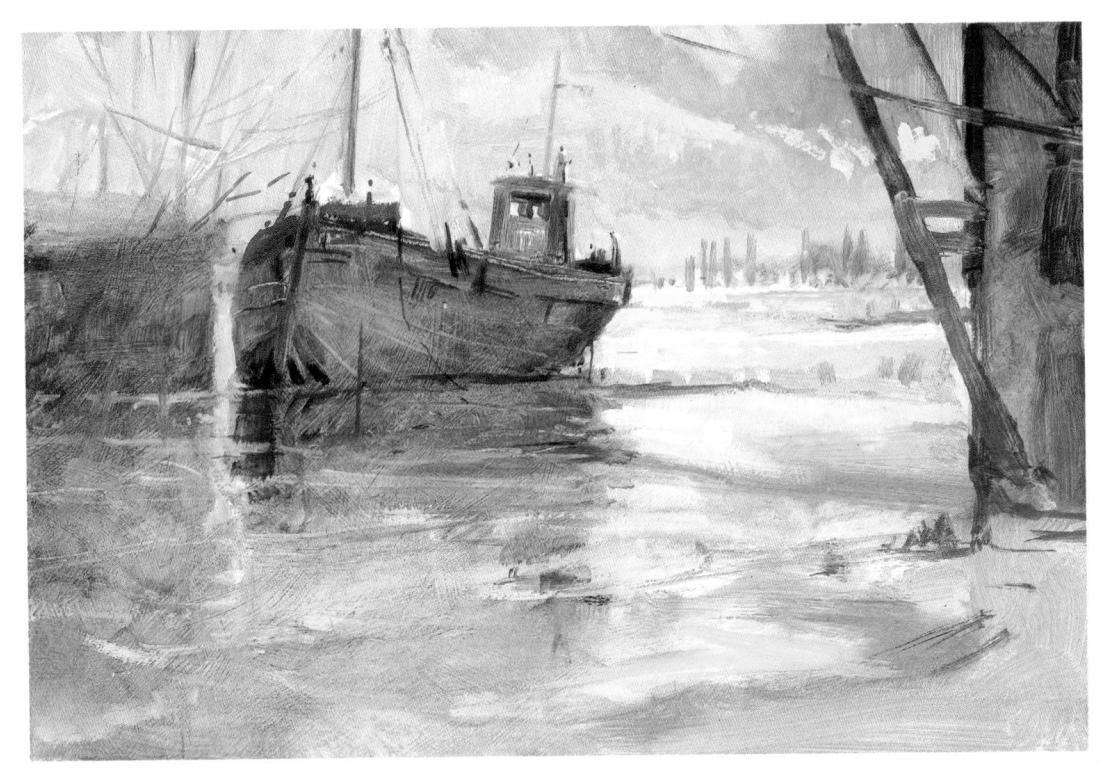

This moored wooden boat gave me an opportunity to explore warm brown and violet reflections in the water, the brushstrokes expressing the movement of the current on which it was floating.

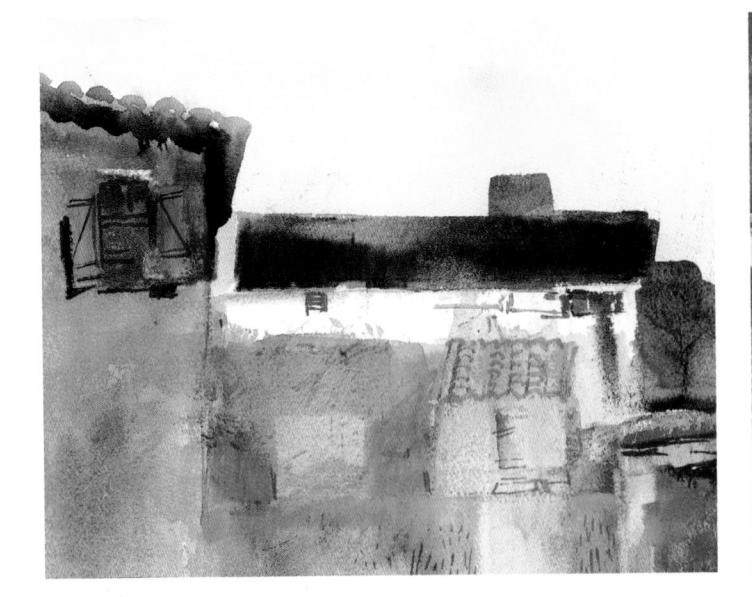

For a quick sketch of a Welsh barn, I used large slabs of tone and complementary colour. They give a geometric composition that could easily become an abstract painting

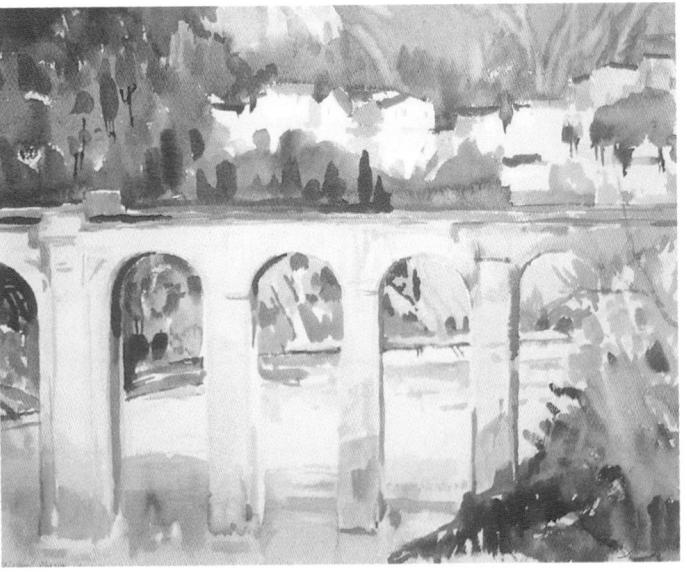

The strong shape of this big viaduct makes a powerful composition. Its industrial nature emphasizes the domesticity of the village huddled behind it.

BRINGING IT ALL TOGETHER

My painting of the church of Santa Maria della Salute in Venice may strike you as very complex in its subject of classical architecture and reflections in the Grand Canal. However, all paintings share the same beginnings of

decisions about composition, format and tone, followed by the first simple washes. If you get these right, you have laid the basis for a good painting which you can develop as far as you wish to.

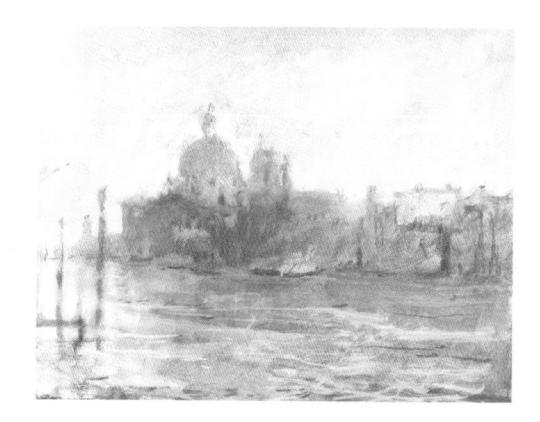

I began with a little study in oils, using a warm palette to see if a feeling of vitality would suit the subject and what I wanted to say about it.

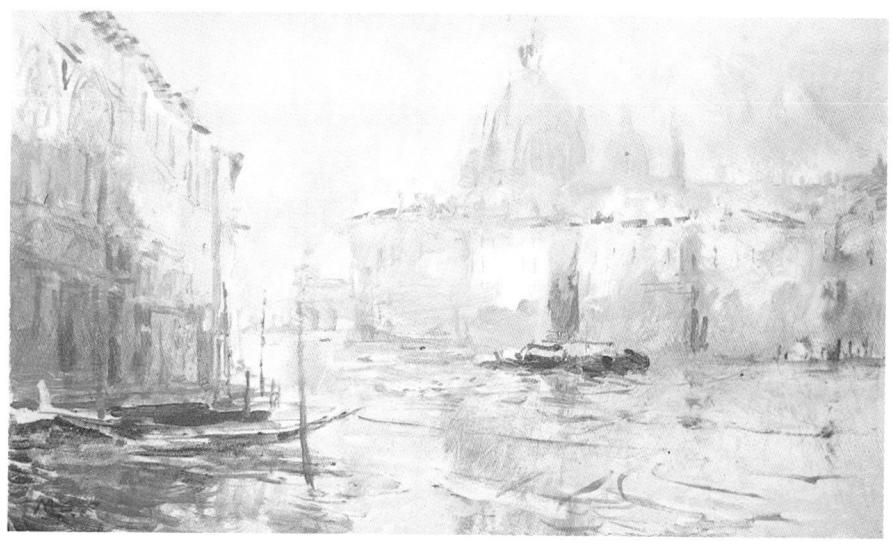

Next I tried a cooler palette to give a calmer mood and altered the composition, bringing in the buildings on the lefthand side so that they occupied nearly a quarter of the painting.

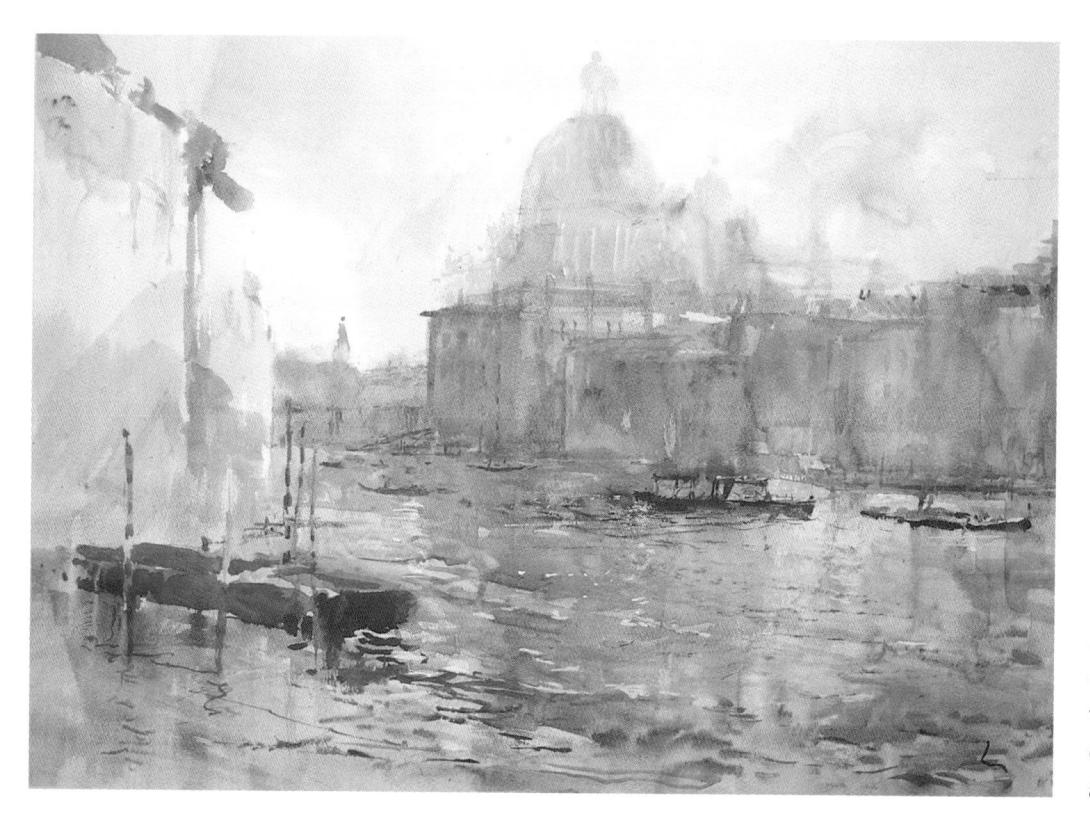

Deciding that I preferred the second composition, I now did a very loose version in watercolour to see what might arise.
Because watercolour is immediate and easy to use, this is commonly done by artists planning an oil painting. These preliminary sketches are never a waste of time; they help you start the painting proper confident about what you are trying to do.

BRINGING IT ALL TOGETHER

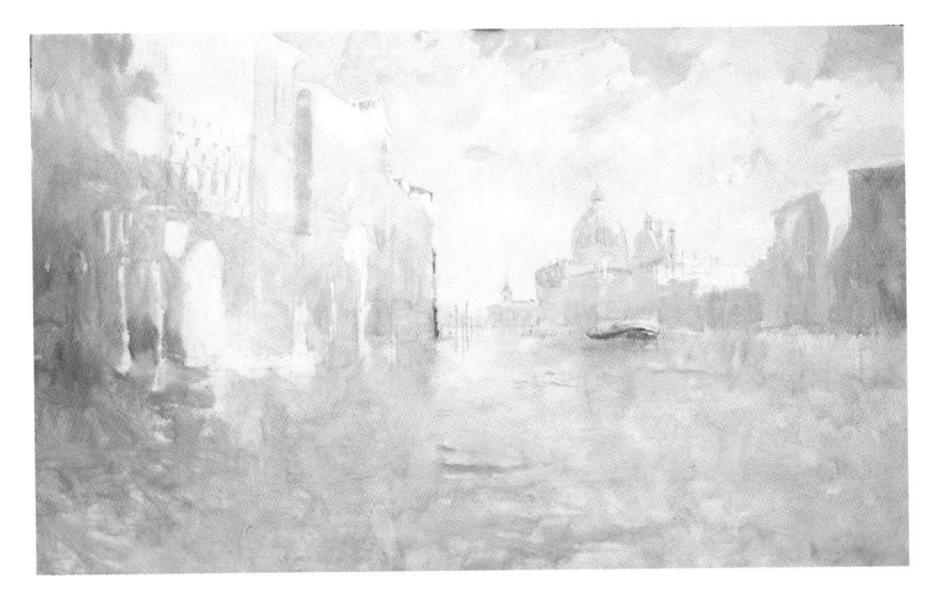

Working on MDF board prepared with acrylic primer, I laid in my initial colours with a large housepainter's brush. These first washes are crucial because they set the whole tone of the picture. The lefthand side of the painting is already starting to develop as strong colour where the light is hitting the buildings from the right.

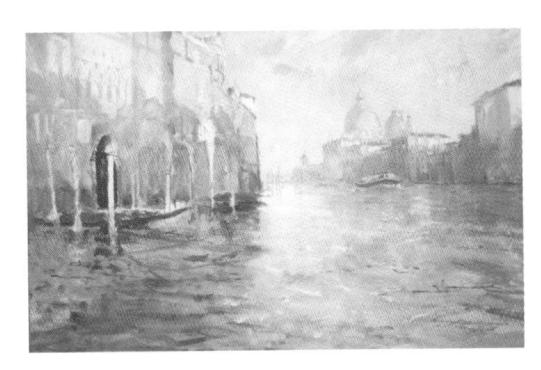

I had painted in the buildings on the far right almost in silhouette so the source of light was already strongly established even before I began to indicate it on the water. At this stage I was repainting over the first thin glazes of colour with much more full-bodied paint to establish some areas of final colour.

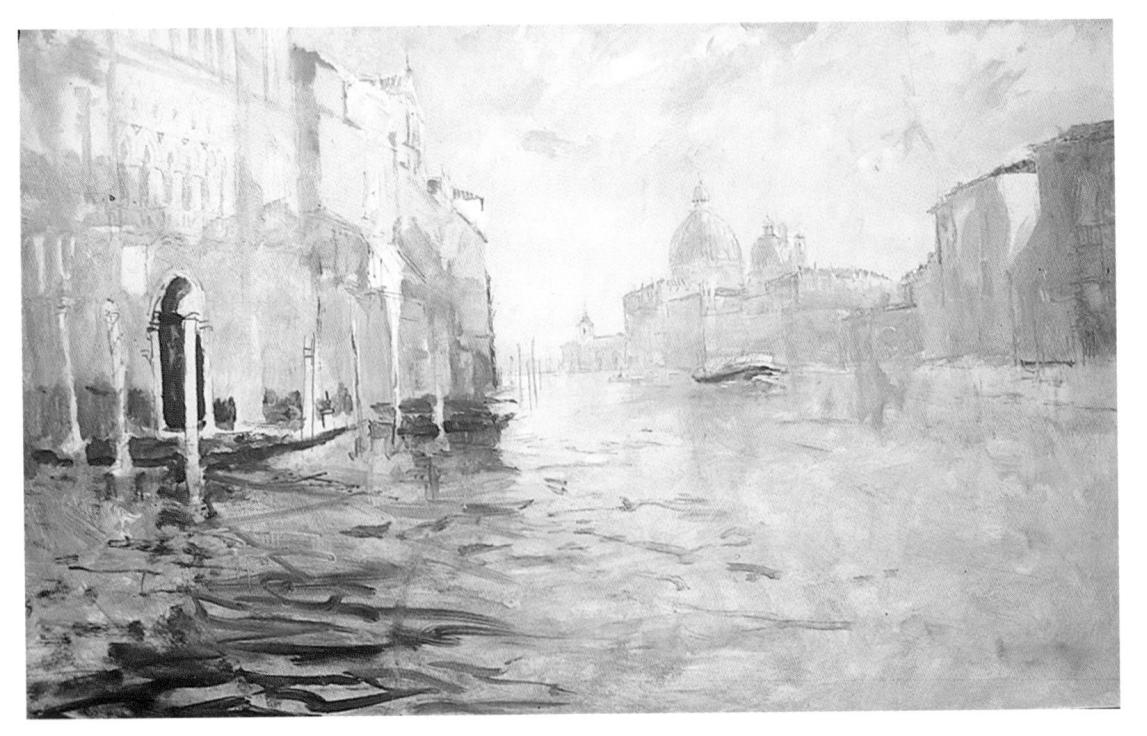

I now began more detailed work, such as identifying the boats more strongly and indicating individual waves. I strengthened everything up, putting stronger colour on the roofs and darkening the recessive areas on the left to make the light work well.

In this detail from the finished painting, you can see that the most distant building is a very simple soft-edged glaze of blues pulled together with some grey linework put in with a rigger.

Beyond that, the Lido is painted with very soft-edged brushwork.

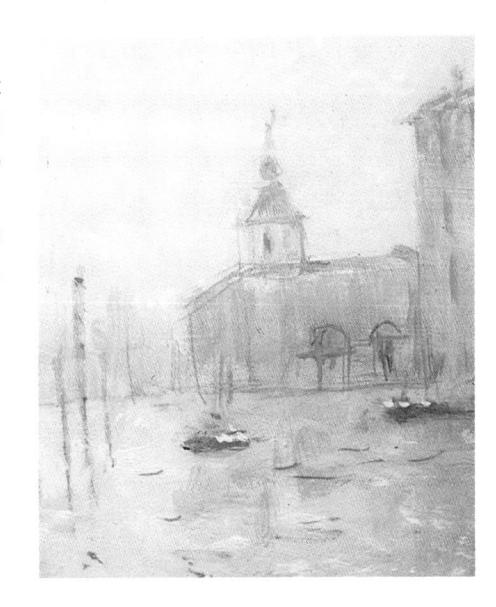

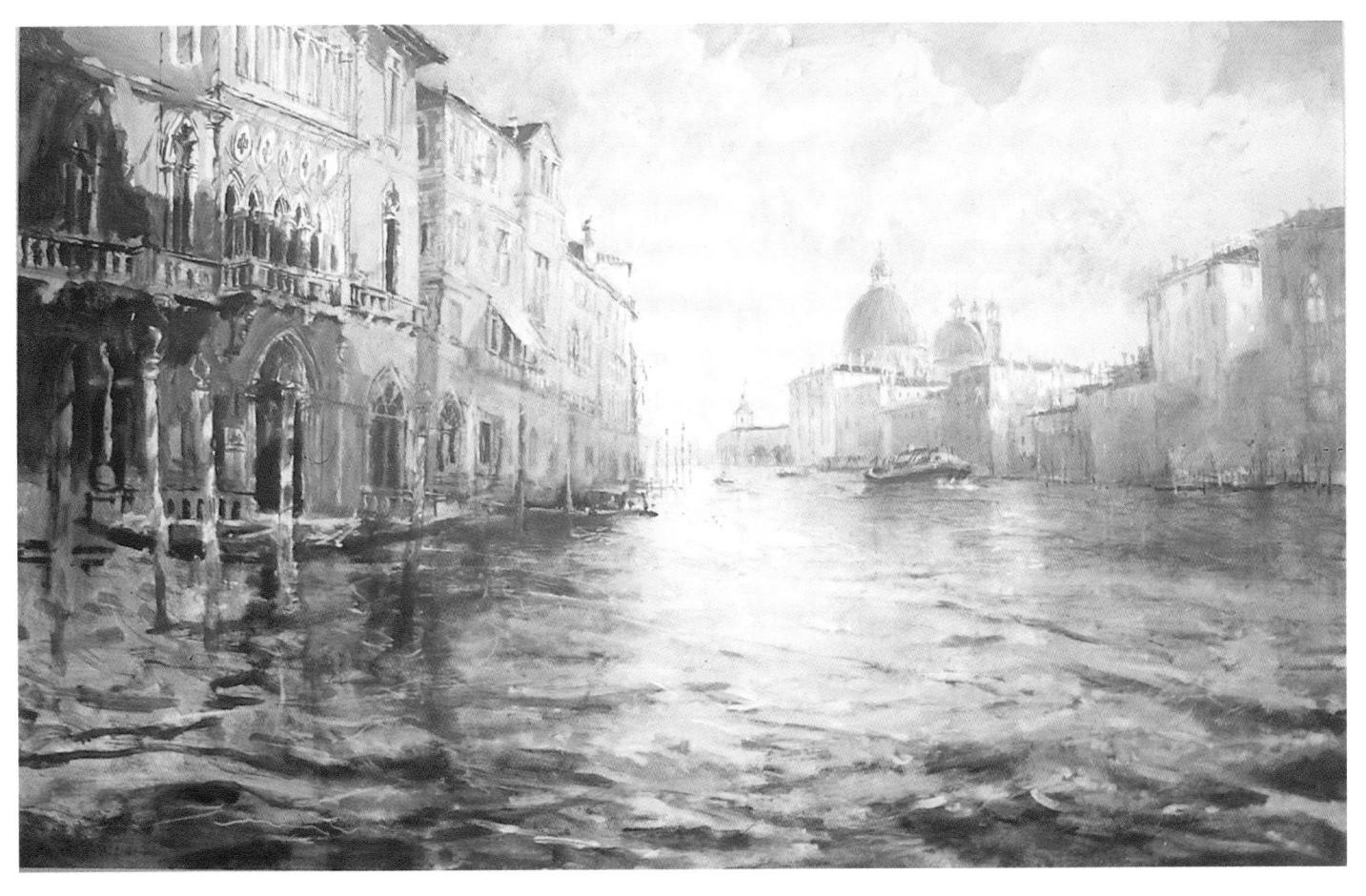

Santa Maria della Salute from the Grand Canal, Venice 76×122 cm $(30 \times 48 \text{ in})$ In the foreground, the movement of the water is described by energetic, rhythmic brushwork. Not every wave is painted in detail since this would distract attention from the main focus of interest, which is the far-distant warmth as we look down the Grand Canal. Note how the linework recedes in strength from the foreground to the distance.

INDEX

sky 42, 86-7 oils 136 Α snow 29, 169 putting down 58-61 hairdryer 56 aerial perspective 35, 115 soft marks 17, 70-1 watercolour 52 hard marks 17, 70-1 architecture 122-3, 150-1 space 152-3 painting as extension of drawing horizon line 116-17 areas of colour 99 spring 88, 168 44-5 horizontal lines 32 asymmetry 32 still life 118-19, 158-9 palette layout 140-1 autumn 89, 169 still life step-by-step 48-50 paper 10, 30, 95 stretching fabrics 137 paper surfaces 54-5 inks 11 R stretching paper 55 paper types 54 interior of buildings 123 ball pen 26 studio 138 pastels 11, 52 beach landscape 164-5 pastels and colour 94 subject choice 38-9 blenders 96 summer 88, 168 pastels and watercolour 106-7 landscape 116-17 Bonnard, Pierre 153 supports for oil paints 137 landscape step-by-step 46-7, 90pencils 10-11, 52, 124-5 brushes 53, 136 symmetry 32 pens 10-11 personal palette 64 left to right scan 33 С perspective 34-5, 78-9, 114-15, life drawing 120, 130, 162-3 chalk 11 texture 36, 109 lifting off 63, 141 150-1 charcoal 10-11, 12, 94, 130-1 texture paste 56 photographs 170 light 166-7 charcoal with watercolour 131 pochade box 138 tonal range 30 colour basics 64-5, 102-3, 148-9 light on dark 28-9 tonal strip 24 pointillism 16 complementary colours 102-3 light sources 37 tone 24, 66-7, 104-5, 146-7 priming 137 line 14-15, 32 composition, 32-3, 82-3 travel kit for oils 138 putting down paint 58-61 linear marks 98 contre-jour painting 67, 146 two-point perspective 79, 150-1 linear perspective 34, 114 cool colour 64-5, 68-9, 102-3 linseed oil 136 craft knife 12 quill 11, 26 u Lloyd, Gaynor 120, 130, 162 crosshatching 16 umbrella 12, 56 urban landscape 154-7 R M D urban scene step-by-step 84-5 rain 43, 169 manmade objects 40, 112-13, depth 80-1 rainbow spectrum 64, 102, 148 development of a painting 173-5 172 reflections 42, 43, 87 drawing board 12, 56 marks vanishing points 78-9, 150-1 removing paint 141 drawing 16-17 drawing practice 38 vertical lines 32 repetitions 33 dry pastel as wet medium 106-7 experimental 26 viewfinder 23 resists 62, 72, 108 hard and soft 70-1 visual vocabulary 40-3 rhythms in subjects 171 oils 140-1 Ε rule of thirds 32, 83 pastels 98-9 easel 12, 56 watercolour 70-1 elements 42 warm colour 64-5, 68-9, 102-3 masking fluid 56 water 42, 86-7 sable hair brushes 53 matchstick figures 31 F watercolour scale change 111 measuring, basics 18-19 felt-tip pen 26, 27 and pastel 106-7 scaling up 23 figures 31, 76-7, 120-1, 160-3 mid-toned paper 30 paint 52 scraping out 72 mixed media 132-4 fixative 96 pastels 52, 126-7 seasons 88-9, 168-9 flat wash 58 pencils 52, 124-5 seating 12 flowers 110 with charcoal 131 shadows 25 negative shapes 21, 72 format 22-3, 100-1, 142-3 shapes, basic 20 weather 42, 43, 166-9 white space 72-3 shapes, negative 21, 72 0 G wind 43 sharpeners 97 oil pastels 128-9 geometric links 19 winter 89, 169 sight-sized drawing 19 organic objects 41, 110 Gilpin, William 22 workspace 13, 57, 97, 138 single-point perspective 78, 150 gradated wash 59 sketchbook studies 144-5 grey 149

page position 33

paint

sketchbooks 12, 22, 74-5, 100-1,

142-3

gum arabic 56